The Potter's
Complete
Studio Handbook

QUARRY

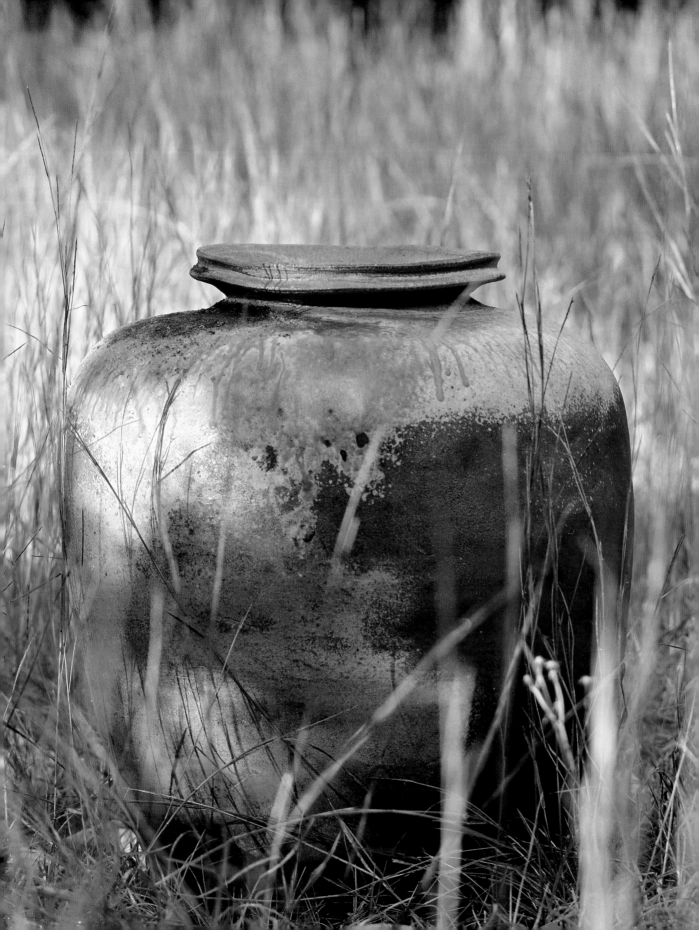

The Potter's Complete Studio Handbook

The Essential, Start-to-Finish Guide for Ceramic Artists

Kristen Müller & Jeff Zamek

BEVERLY MASSACHUSETTS

QUARRY BOOKS

First published in the United States of America in 2011 by
Quarry Books, a member of
Quayside Publishing Group
100 Cummings Center
Suite 406-L
Beverly, Massachusetts 01915-6101
Telephone: (978) 282-9590
Fax: (978) 283-2742
www.quarrybooks.com
Visit www.Craftside.Typepad.com for a behind-the-scenes peek at our crafty world!

10 9 8 7 6 5 4 3 2

ISBN-13: 978-1-59253-746-4

Digital edition published in 2011
eISBN-13: 978-1-61058-160-8

Library of Congress Cataloging-in-Publication Data available

Design: Dania Davies, Leslie Haimes & 4 Eyes Design
Cover Design: Quarry Books
Illustrations: Michael Wanke
Photography: Rob Cardillo & Randy O'Rourke
Special thanks to The Artisan Gallery of Northampton, Massachusetts, for location photography.

Printed in Singapore

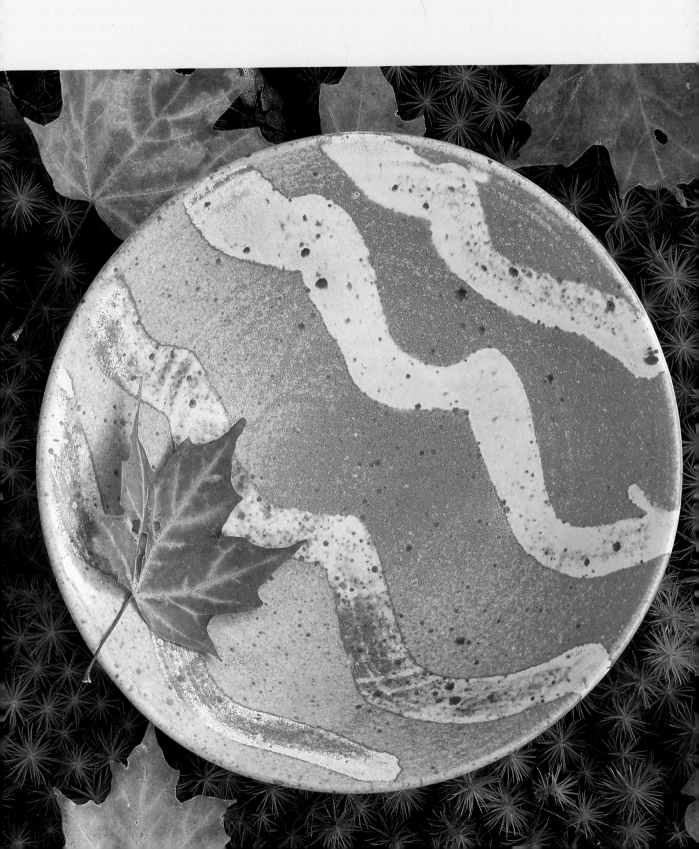

c🏺ntents

PART ONE

studio requirements

and properties of clay

16

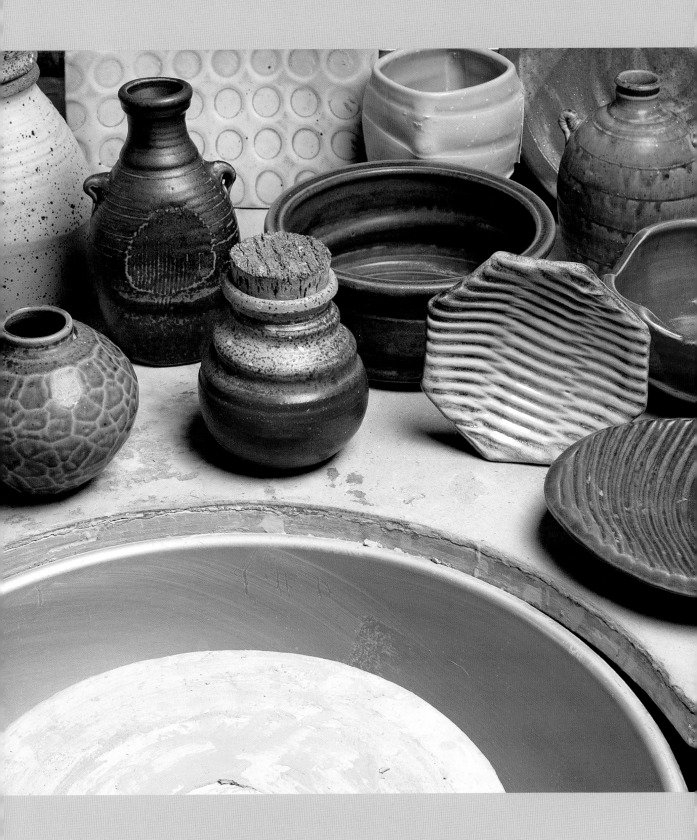

FOREWORD

by Brother Iain Highet,
Abbey of Regina Laudis, 2007

It might seem unusual for a beginner to write the foreword for a book about pottery. A well-known artist in the field might offer a better selling point. But in just three short years of studying and collaborating with the author, learning most of the techniques and projects found in this book, I have progressed to the point where I operate the pottery studio at the monastery where I live, make wares for use in the community, and offer work for show and sale in the monastery's art shop. Not bad for a beginner. But it is because I had such an enthusiastic, dedicated, and artistically gifted teacher, who brings to this book twenty years of study, practice, teaching, and creation in clay.

It is rare to find in one person the combination of artistic sensibility and communicative capacities as a teacher as I have experienced in Kristin Müller. Her gift of being able to present materials and techniques in a straightforward and confident manner, while at the same time conveying a wonder and enthusiasm for the potential and pleasures of pottery, comes from being a dedicated learner herself. She has studied and worked with some of the best and most-respected artists in the field, in techniques and styles that span from the most primitive traditions to the most advanced contemporary artistic expressions to be found in clay. From traditional Italian terra-cotta techniques taught by a master potter to Japanese wood-fired tea ceremony vessels, the depth of her immersion in the traditions and range of expressive possibili-

ties of the medium has given her unique knowledge of the world of clay. And she has a gift for being able to translate this wealth of knowledge into a practical, hands-on approach, making the traditions and artistic expressions of pottery available to her students, from children and adult beginners to university fine arts students. She is always ready to begin something new, to experiment and develop as an artist, and to grow as a person, mindful of and with a deep respect for what has come before. She has taught me that in pottery, as perhaps with all that is meaningful and valuable in life, we are always beginners.

To work with clay is to accept forever being a beginner. It is in this sense a tremendously rewarding creative and spiritual adventure. In every moment of the clay process—wedging, centering, throwing, forming, painting, glazing, and firing—there is an engagement with primal and elemental forces that awaken something at the origin and center of our humanity. Earth, water, fire, and the breath of life we potters give with our hands—these are the elements of working with clay. Pottery is after all one of the oldest continuously practiced crafts and most ancient technologies known to mankind. It is found in nearly every civilization, all over the world, in one form or another. And in most cultures, stories of the creation of human beings speak of our origins in clay.

So in this book you will find all you will need to begin. If you have already begun, you will also find all you need to advance more deeply, develop your basic skills, and hone your wheel-throwing and hand-building techniques. Whether you hope to be a professional potter, or to make fine gifts for friends, or simply to enjoy for yourself

the healthy, grounding, and creative experience that is pottery, I trust that you will find, as I have, an excellent way to begin.

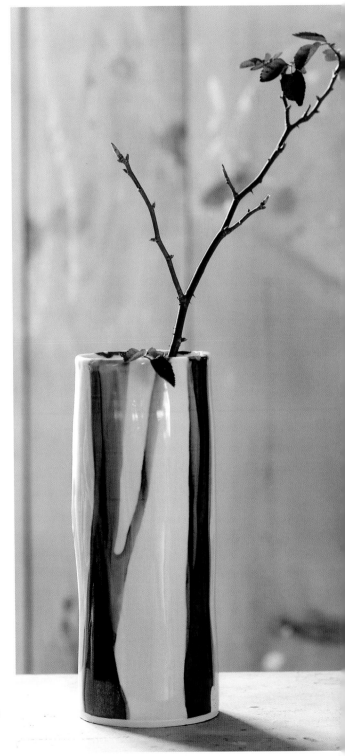

Porcelain vase by Brother Iain Highet; iron-saturated glaze and white glaze reduction fired to cone 10 in a gas kiln

INTRODUCTION

For years I have helped students discover the wonders of clay and answered their questions, wishing that I could give them all of my knowledge. My late father would often say, "My dear, unfortunately, experience is non-transferable." Luckily, knowledge is. This book is a step in that direction. You will have to gain the experience that will enrich your technical knowledge through trial and error. It is a journey that is both challenging and satisfying.

Ceramics is a universe unto itself, with many options for clays, firing temperatures, physical and chemical considerations, and aesthetic choices. This book is designed to help aspiring ceramic artists who would like to understand some of the technical aspects of working with clay. It is by no means the definitive text. This book is, however, designed to help the ceramic enthusiast take the next step. It contains basic information about the entire process of working with clay, including the types of clay, the manipulation and formation of clay, basic studio procedures, firing procedures, and instructions on how to set up a safe and well-equipped home studio. This book also includes many projects that can be achieved as skills are sequentially refined.

THE INTIMACY OF POTTERY

Everyone has a favorite cup, though most people don't really give it a second thought. Whether you drink coffee, tea, hot cocoa, or milk, when you reach into the cabinet full of assorted cups and mugs, you make a choice. The choice might be based on color, size, texture of the glaze, or sentimental value, but generally it will have more to do with the overall feeling of the cup.

A cup is an intimate object that delivers nourishment to your body. I probably sold several hundred cups before it dawned on me that I was making and selling objects with the potential of so much intimacy.

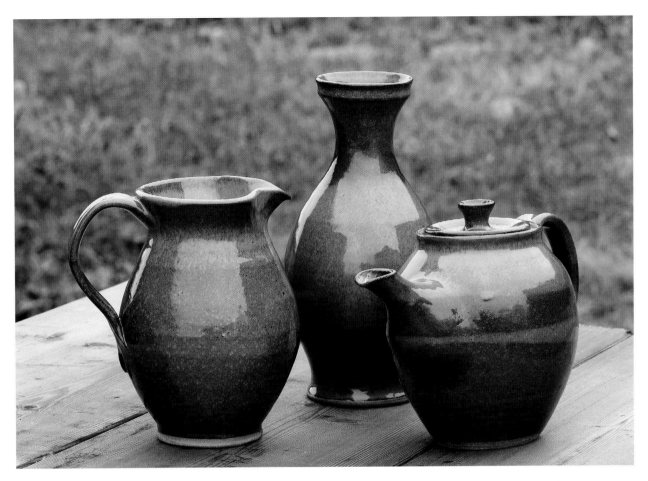

My favorite cup was made by Pete Callas, a wonderful ceramic artist known for his wood firing and powerful ceramic sculptures with whom I studied for years. It is wood-fired with no handles and deep throwing rings that spiral upward as if the cup were still rotating on the wheel. It fits perfectly in my hand. The surface is soft and smooth, but not glassy, because the only glaze it has is from the wood ash that melted on the surface during firing in an anagama kiln. The lip has a smooth, inverted-V shape that fits the shape of my mouth very comfortably when I take a drink. The wall thickness is perfect, and I know my coffee or tea is at the perfect drinking

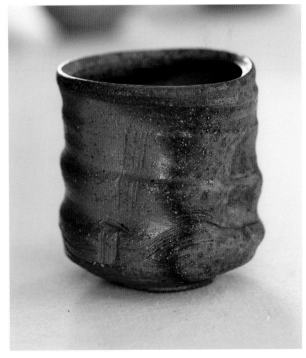

◎ Wood-fired cup by Peter Callas

temperature when I can hold the cup without burning my fingers.

When you make useful objects from clay, I hope some of your values and aesthetics will come through in the work. These preferences will define your creative efforts and develop your personal style.

THE SCIENCE OF POTTERY

In pottery, refining your technical skills is just as important as tapping into your creative well. Good work emerges when a balance of technical skill and personal vision merge successfully. This book is full of technical information that will help you understand how to shape clay into works of quality.

Working with clay is a scientific craft. Clay's utilitarian qualities—such as its durability and heat and water resistance—have helped advance society. People have used clay to create everything from religious artifacts, storage containers, and food serving utensils to modern plumbing, electrical transformers, parts for computer chips, space craft insulation materials, and replacement parts for the human body, some of the most inspiring expressions of human culture and intellect.

Though clay is relatively easy to shape, it requires an understanding of chemical and physical changes to transform it through fire into a permanent rock-like hardness. Glazing and decorating delve into some basic chemistry that, when combined with good design, can render beautiful works of art.

Most ceramic students have limited exposure to the scientific part of the ceramic process in a classroom environment. Teaching studios typically have one or two people in charge of mixing glazes and loading and firing kilns, and therefore stu-dents rarely learn those skills. The potter's cycle includes shaping raw clay, bisque firing, glazing, then glaze-firing. Students form pieces in class then place them on a shelf to dry in preparation for its first firing. In most cases, a supply of glaze is provided and the bisque-firing is done by staff members. The bisque-fired work is glazed or decorated, then fired again, whence it is transformed into finished ceramic pieces. The student assesses the success or failure of the work and the cycle begins again.

THE VERSATILITY OF CLAY

Clay is one of the few natural materials that can become nearly any shape desired. You can carve it, stamp it, pinch it, coil it, join it, turn it on a potter's wheel, and pour or press it into molds. You can easily combine small sections of clay to make larger pieces. The size of a finished piece is limited only by the clay's stability and by the size of the kiln you have available. (Some people even build special kilns around work that is too large or unwieldy for a typical kiln.)

BUILDING YOUR FOUNDATION

After you read this book, I encourage you to take workshops and classes with different instructors, as well as to read other books and magazines on ceramics. These experiences will build upon the information that you will gain from this text and will show you alternative ways of working. All clay artists develop techniques that are honed for their own designs and choice of clays. You will see that as your clay skills build, you, too, will develop unique methods and your own style of working with clay.

When I teach, students often ask me if they are "doing it right." My response is, "If it works, it's probably right." There will always be better

ways to render a technique, but you will find them by watching others work and through personal experience. Use this book as a guide and learn to trust the process and your instincts. Know that a fine craftsman is someone who has strong basic skills. The true craftsman is always honing the basics so that his or her use of tools and materials becomes second nature. The stronger the skills and knowledge base, the more focused one can be on the creative details of design and execution.

My hope is that this handbook will reside in your studio, not on a pristine shelf in the living room, and that it will be used as a primer and reference guide. The goal is for you to learn the basic skills to further your knowledge of the ceramic process in an accessible, non-intimidating way. Some sections of this book will seem technical. Know that you do not need to memorize the information, but you should know where to find it when you need it. Information is power! It will give you confidence to move forward with your work. The informed artist can make better decisions about process to strengthen aesthetic, expression, and functionality. Read on and enjoy!

Using handmade pots and other pieces will help enhance your artisan skills by bringing you closer to this personal craft.

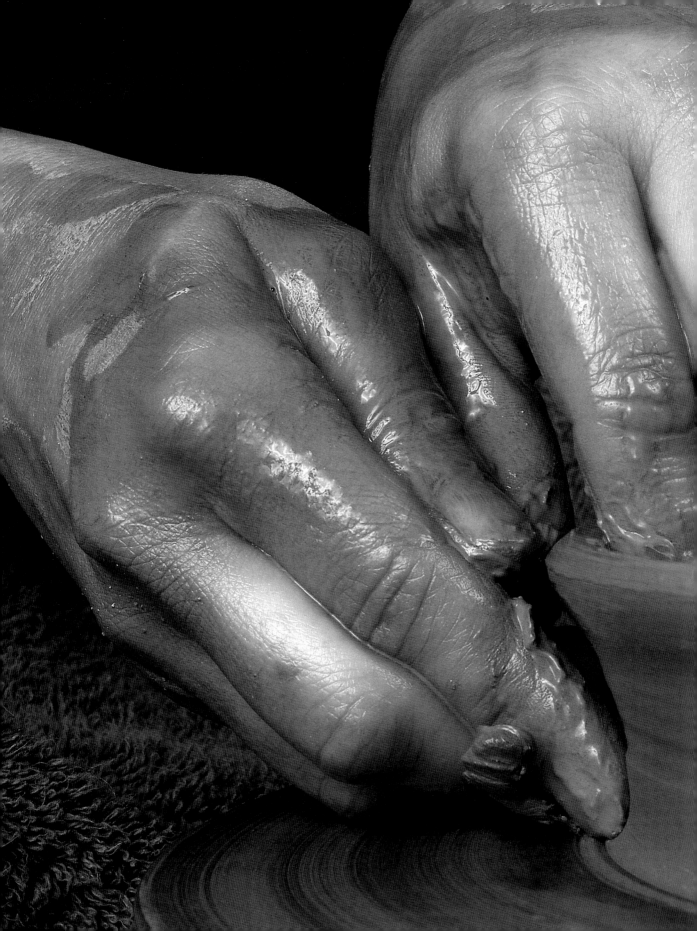

studio
requirements
and properties of clay

YOUR STUDIO

Although you may not have the ideal studio space built into your home, if you have a small space with good lighting and access to electricity, you can set up a serviceable work area. Some professional studios are surprisingly small, cluttered spaces. Others don't even have running water. There are also gorgeous, immaculate, uncluttered workshops reminiscent of fancy kitchens that no one cooks in for fear of making a mess. A studio is a workspace, a place that will house tools and equipment for the purpose of creating with clay— it will (and should) get dirty.

WORKSPACE CONSIDERATIONS

Probably the first question a person asks when thinking about building a studio is: How large should the studio be? There are no hard-and-fast rules about what size a studio should be because it depends on what you are planning to make, your budget, and how much pottery you are planning on producing. For the most part, a home studio can be anywhere from 400 to 1,200 square feet (37 to 111 sq m). But if you plan on constructing a studio and can create a larger space, by all means do so.

PHYSICAL REQUIREMENTS FOR SETTING UP A STUDIO

When planning the layout of your studio, consider allotting space for the following:

- A wet work area with a wedging table and/or work table and room for the potter's wheel, stool, and a low worktable

◎ A home studio space can be intimate, organized, and versatile.

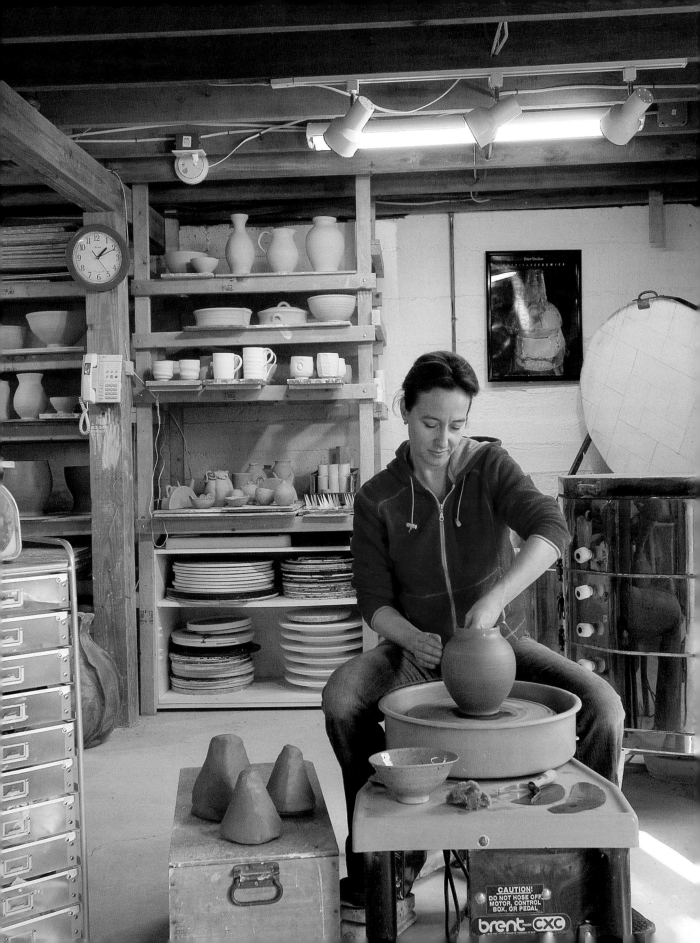

Here are some questions to ask yourself when you're in the beginning stages of planning a studio.

What am I going to be making? How much will I produce? How often will I work? Am I committed to one way of working or do I want to experiment with different clays and forming techniques? Will I want to make room for future growth? Do I plan on selling work or just enjoy making pieces to give as gifts? Do I want to share the space with anyone else? Do I want to mix my own glazes? What tools will I need? How do I want to fire work?

- Clay storage to keep clay cool and dry and protect it from freezing

- A glaze chemical storage and mixing area (This can be as simple as a few shelves in the studio or it can be a separate room, depending on your scale of production.)

- A ventilated kiln area (in the studio or in another space, such as a garage. See page 22 for more on ventilating your kiln area.)

- Shelving to store work in progress (The more space the better. You might have one shelf for wet work and another shelf by the kiln to place greenware that is ready to be fired, for example.)

- Separate shelving to store finished work (Or you might prefer to store your finished work outside of the studio, in a clean, dust-free environment.)

- Sink or clean-up area

As you design your studio, try to create a flexible layout. After working in a space for a while, you may want to change its configuration.

As you're planning your studio, there are several critical components to factor in, including electricity, lighting, studio location, air quality, water, ambiance, safety considerations, studio flooring, studio furniture, accessibility, posture considerations, and storage for ceramic ware and shelving.

ELECTRICITY

Of course, pottery has historically been made without electricity. Potters around the world still produce wonderful work in very simple workshops. In fact, some contemporary artists purposely choose "primitive" studios because they believe that the simplicity helps them achieve a deeper connection to their work.

Most potters need electricity to run their potter's wheel, to install lighting, and to power other tools such as mixers and fans. If you have an electric kiln, you'll also need electricity to power it. How much amperage depends on the size of the kiln. (See Chapter 2.)

If you plan on working with a simple kick wheel and a wood-firing kiln, you can stay off the grid in an unheated barn studio during temperate seasons.

LIGHTING

Lighting is a matter of personal choice, but it is essential and should not be overlooked. There are many lighting options. Some people love dim lights, while others prefer bright lights, and still others crave natural light. Ideally you will have

CHOOSE THE BEST BULBS

If you install fluorescent lighting, consider investing in full-spectrum daylight bulbs. They are more expensive than standard fluorescent bulbs, but the light is more natural.

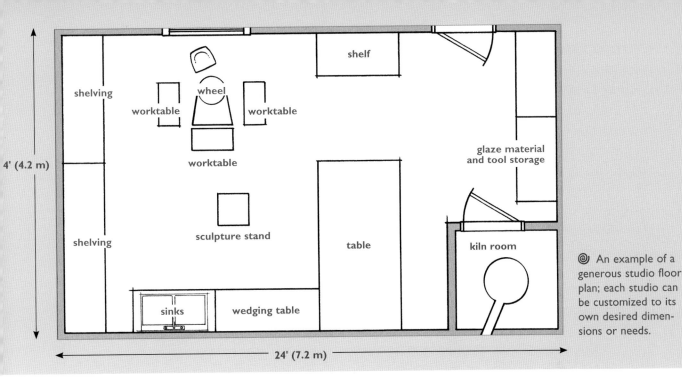

4' (4.2 m)

shelving

worktable · wheel · worktable

worktable

shelf

shelving

sculpture stand

glaze material and tool storage

table

kiln room

sinks · wedging table

24' (7.2 m)

An example of a generous studio floor plan; each studio can be customized to its own desired dimensions or needs.

all three options available. For example, many pottery workshops in Japan use natural light and a single bare bulb hanging over the wheel. I prefer natural light and a combination of fluorescent and incandescent lights. That way, I can choose to have both types of light on at the same time, or just one.

You have two main types of lighting—ambient lighting and task lighting. Each plays an important part in your studio and will affect the overall mood.

The ambient lighting is the overall light in a room. Light creates a mood in a room, and it can affect many aspects about the work you make. Think about the feeling you want in your studio. For example, you may want to have a brightly lit studio with a crisp, contemporary feeling or instead, dimmer yellow lighting that casts a dramatic, romantic feeling. Compositional elements of work will seem different under strong or soft lighting conditions. Texture and line quality on the surface of clay will also be affected by the lighting, making them too gentle or too stark.

VARY YOUR LIGHTING

Aesthetic decisions are made based upon perception. Consider changing the location of work to see how it fares under different lighting conditions and perspective. That's why it's helpful to have as many different lighting options in your studio as possible, including natural light, fluorescent light, and incandescent light.

This is an important issue because lighting used while working affects aesthetic decisions.

Task lighting is light you can direct toward the task at hand. A small lamp can be adjusted to direct light to a specific project, for detailed surface work or glazing. For example, I use a flexible gooseneck lamp to illuminate the interior of a piece while I'm forming it.

If you have natural light available in your studio, position your wheel and worktable so it has best access to the light.

STUDIO LOCATION

Just like they say in real estate, it's all about location, location, location. Where do you want your studio to be? Perhaps in the dim recesses of your basement is not the best idea. Access to the studio is fairly important because clay is heavy and greenware is delicate, making transporting clay at all stages a key issue. How to get clay into and out of the studio will become paramount when planning the location and layout of your workspace.

It may seem hard to imagine receiving a delivery of a ton of clay, but really, it is not that much clay. In the United States, clay is typically available from suppliers in 50 pound (23 kg) boxes. Just forty boxes weigh 2,000 pounds (907 kg). Because clay is less expensive if you purchase larger quantities, it is economically savvy to store quite a lot of it. True, it may be a few years before you order in such quantity, but it is not a bad idea to plan for the future.

Clay deliveries are made by truck on wooden palettes and dropped outside the studio. The truck driver usually does not carry the clay inside the studio. If your studio has wide doors and a smooth floor, the driver can just as easily roll the palette of clay into the studio. If not, you will need to bring the clay inside the studio yourself. A hand truck is very useful for this.

Carrying 50 pound (23 kg) boxes of clay down steps is definitely a challenge. If you have a basement studio, you may want to store a small amount in the immediate work area and keep the rest in the garage or a room upstairs. (If you go the garage route, though, remember that clay must be protected from freezing temperatures.)

AIR QUALITY

Air quality is often overlooked when choosing a studio space. Ventilation of the work area is important for a number of reasons, the most important of which is your health. Ceramic materials, glazes, ceramic dust, and toxic gases such as carbon monoxide given off by kilns can be hazardous to your health. Another reason to ventilate the area is because an open window or door facilitates air exchange during clean up. A third reason to ventilate the area is because circulating fresh air is essential for proper drying of work.

Kiln Venting Systems

A kiln venting system is a must. When clay is going through the bisque-firing cycle, it will burn off water and organic materials that are contained in the clay. During the glaze-firing cycle, organic materials contained in the wax used to resist glaze on the bottoms of pieces will be burned off, and heavy metal fumes from colorants in the glazes will emit gases. You don't want to be breathing any of this into your lungs!

You can purchase good venting systems that attach to kilns to draw the fumes out of the room. The ideal situation is to have the kiln in an area apart from the actual workspace, so that the fumes (not to mention the heat!) don't impede your work.

In my first studio, the wet work area was in the basement and the kiln was in the garage because I didn't have a venting system. I could simply open the garage door to let out the fumes. Because of space constraints, all of my studios since then have had the kilns in the wet work area. Even though my kilns are vented, I can still smell the fumes. The fumes are noxious enough that I open the window and doors during firing. I also avoid working in the studio until the firing is finished.

WATER

Water is an important consideration for your studio, especially if you are going to mix and apply glazes to a lot of pottery. Ideally every studio would have a double sink to wash large buckets

and tools. Another good option is a large, plastic laundry sink. They are inexpensive, and their depth is ideal for clay cleanup. Whatever type of sink you have, make sure it has a sediment trap to catch the slurry (the bits of leftover clay in water) before it goes down the drain.

As with electricity, many potters have studios without running water. In this case, you can use a spigot and a hose outside the studio to fill buckets and carry them into the studio to wash tables, tools, and wheels.

CLEANING TIP: SLURRY

If you are cleaning up with a bucket of water, don't immediately dump the clay water. Let the clay settle to the bottom, and then decant the clean water. The leftover clay, called *slurry*, can be recycled, or it can be thrown out without clogging your plumbing.

Even if you have running water and a sink, do an initial rinse of your clay tools in a plastic bucket. This bucket catches all the clay that would otherwise be in danger of going down the sink.

AMBIANCE

An inspiring workspace is as important as having the proper tools. Design your space so it suits your temperament. Fill your creative space with things that nurture you and reflect your personality. For example, many artists have bulletin boards in their studios that they cover with inspiring images and photographs. I make a point of drawing the shapes and sources of inspiration and hang them in the studio to remind myself of proportion, scale, texture, or subject matter.

If you like listening to music, get a nice audio system; if you like plants, put a few in the studio.

These details will help define your personal workspace and inspire your work.

SAFETY CONSIDERATIONS

Certainly, you don't want anyone—or yourself—to be hurt in your studio. Here are some safety considerations to keep in mind.

Powdered, raw ceramic materials—such as powdered glaze and clay—pose a serious risk to the lungs. It is very important to store these raw materials correctly. Most of these raw materials come in heavy-duty brown paper packages, though some of the dust still seeps out. It's a good idea to store them inside large plastic storage bins, especially after they've been opened.

As discussed earlier, it's important to have easy access for clay deliveries to preserve your back when trying to move boxes of clay.

Because you'll have water in your studio, whether portable buckets or actual running water, ground fault circuit interrupters (GFCIs) should be installed. These devices protect people from electric shocks.

Another major consideration is fire safety. A kiln is an insulated box that is resistant to heat. A kiln itself will not combust, because it contains the heat, however, it can create other fire hazards. The first, if you have an electric kiln, is incorrect wiring and electrical connection. Hire a licensed electrician to do the wiring. It is not a job for an amateur. Have the electrician read the kiln manual for detailed information about electrical specifications.

The other fire hazard created by kilns is its proximity to flammable materials created by (such as cardboard boxes, wooden or linoleum flooring, and the surrounding wall) and combustible chemicals (such as household chemicals and solvents and paint thinners) in the kiln area. A fire extinguisher should be available in your work area.

A kiln that has been moved incorrectly or used for many years could have damage to the bottom layer. Since the base rests on a kiln stand and carries the weight of the kiln furniture and the ceramic wares, it can pose a threat during firing because it could give way. Periodically check to make sure the base is not damaged. (I have heard of this happening only once, but it's better not to take chances.)

Place the kiln on the manufacturer's kiln stand, which is metal and elevates the kiln for air circulation. Inspect both the kiln and stand for wear and tear during the installation and periodically during the life of the kiln to ensure parts have not been damaged.

The most important way to prevent a kiln accident is to never leave a firing kiln unattended. Even if you do not work in the studio while the kiln is firing (to avoid the fumes), stay near the studio in order to monitor the kiln.

STUDIO FLOORING

It may seem like a minor detail, but the type of flooring in your studio is determined both for comfort and durability. Any material will have a set of pros and cons; be sure to evaluate a studio's needs when making a selection.

Concrete is easy to clean with a wet vacuum or a power washer. Some potters prefer concrete because of the absorbency and even use it as a surface to wedge and stretch clay. Standing on a cement floor for long periods, however, is tiring. Rubber anti-fatigue mats are used in the industry to provide a cushion. They relieve the stress on your body and are recommended for long periods of standing. In a pinch, even standing on a couple sheets of cardboard will make a difference. Be sure to wear shoes with good support when working on concrete floors.

If you have an electric or gas kiln, you need to have non-combustible flooring beneath it, such as concrete—rather than wood, linoleum, or plastic.

Wood flooring is much easier on the bones than concrete, and it's equally easy to clean. But it is combustible and will show signs of wear and tear from the abrasiveness of clay.

Linoleum and **plastic flooring** are soft to stand on, but they will show signs of wear more quickly, due to the abrasive nature of clay. They are easy to clean with a wet vacuum, but they can be very slippery when dusty and wet. If you want to use a linoleum floor, invest in industrial-grade flooring.

STUDIO FURNITURE

A few essential pieces of furniture are necessary for a workshop space.

Studio tables: A ceramic studio should have at least two tables: one used as an all-purpose work table for forming or glazing and another for wedging (which is the process of preparing clay by kneading it, to create a homogenous mound of clay) and clay preparation and reclaiming (which is the process of recycling dry unfired clay scraps into moist, plastic workable clay).

The work table must be strong enough to hold the weight of clay and the pressure of working with clay without buckling. It should be at a standard kitchen counter height—about 36

> ### TIP
> If you need additional table surface, you can place a hollow core door atop two portable saw horses. Hollow core doors are cheap, lightweight, and available from building suppliers. If you don't have room to store a hollow core door, you can place plywood sheets or three wide boards across the saw horses.

inches (92 cm) tall. Its surface should be of an absorbent material, such as wood, so the clay won't stick to the surface. Worktables can be little more than old desks with plywood screwed on the tops as well as homemade table bases with a full sheet of plywood mounted to the top. In the United States, a standard sheet of plywood from a building supply store measures 4 feet wide by 8 feet long (1.2 x 2.4 m), which is a generous size for a worktable.

A wedging table must be very sturdy to withstand the clay being wedged on the surface without moving. The height for a wedging table should be customized to suit your height. When your arms are at your sides, elbows straight, the top of the table should graze the area between the fingertips and knuckles to provide leverage from the body when wedging a mound of clay.

Like the work table, the surface of the wedging table should also be absorbent. Some potters like to use a plaster slab as a wedging surface. Plaster is very absorbent and helpful for recycling wet clay to a workable consistency. Plaster is easy to clean because when the clay is at the right consistency for wedging it pulls away from the surface. Other potters like to use canvas-covered tables, however, the canvas cloth builds up dry clay and can be a source of dust in the studio. Using smooth plywood allows you to scrape the wet clay with a plastic putty knife and sponge it clean, eliminating a source of clay dust.

If you have only room for one table to use as both your work table and wedging table, consider one of the following two options.

- If the table is at standard countertop height, 36 inches tall and 4 x 8 feet in surface area (92 cm tall and 1.2 x 2.4 m in surface area), build a small platform to stand on to elevate you for wedging at the proper height. (The table top should graze your knuckles.)

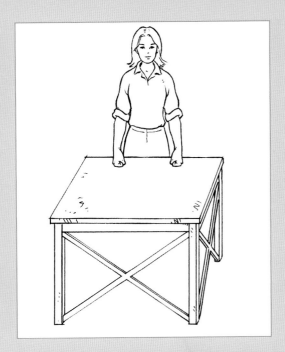

⊚ Diagram of ideal height for a wedging table. Note that it is lower than a standard kitchen counter and that it should be designed to the proportions of your body.

- If the table is low, approximately 30 inches (76 cm) tall for wedging, you can elevate the clay when working by using platforms, such as upside-down buckets and bowls.

Sculpture stand: If you're planning on doing a lot of hand building or sculpting, you may want to invest in a sculpture stand or a small table with casters that can be moved around easily. You may even want several sculpture stands.

POSTURE CONSIDERATIONS

Setting yourself up to ensure proper posture while working with clay will offset future back, neck, and shoulder pain. Maintaining good posture for particular work phases will be easier if certain considerations are tended to when laying out your studio. Posture needs will vary from hand building to wheel working.

Hand-Building Postures

Most hand-building techniques require that you

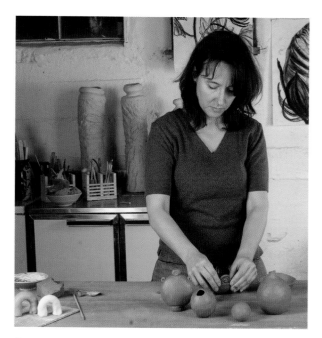

⊚ Creating a few work surfaces in the studio allows for finding the best working height for each project.

TIP
Use a level to ensure that tables, shelves, and the potter's wheel are level. Otherwise, your work will be lopsided from the beginning. Also, clay pieces stored to dry on an uneven surface will give in to gravity and tilt to the lower end of the shelf.

stand. Standing allows one to work around a piece and step away easily to check for composition and balance. Laying antifatigue mats on the floor is recommended.

For hand building, proper table heights are one part of the equation, and proper seating is another. Invest in a comfortable stool or chair at a height that will allow you to work at the table and keep your back and neck in a straight position. (A bar stool is perfect for sitting when you are fussing with details.) Avoid sitting with your back rounded and shoulders hunched over work. Remind yourself to keep your shoulders back. Elevate work if you are leaning over it.

Wheel-Working Postures

When working at the wheel, sit slightly higher than the wheel head with your thighs parallel to the floor and your back straight, not rounded.

An inexpensive seating solution is to buy an office chair with adjustable height and removable casters on the base. Take the casters off so that the chair doesn't move while you're sitting on it.

It does not need to have a back rest, but it is a nice luxury to lean back and rest a little. Another solution is to purchase a metal stool with adjustable legs. The stool's height can be adjusted by moving four screws in the legs. Some potters like to have the two front legs a little shorter than the back ones to help with alignment. Tall potters often elevate the potter's wheel and work on a tall stool. Some potters choose to throw standing up because it puts less stress on the back and eliminates the possibility of slouching over the wheel.

TAKE IT OUTSIDE
If you have easy access to the outdoors, consider using it for glazing, drying, or even making. Depending on location and climate, an outdoor studio can be very effective.

STORAGE FOR CERAMIC WARE AND SHELVING

One of the biggest challenges a potter has is making room for the storage of work in progress. Having ample shelving is helpful. There are a number of options available depending on the type of work that will be made.

Consider the dimensions and depth of shelving before purchasing or designing. The height of the shelving is important because if you make a lot of small shallow ware you may want less space between shelves. Conversely, if the work is

large or tall, larger spacing between shelves or more table surface to store work in progress will be necessary.

Ideally, the ware boards (special boards used to hold your work for drying) will be cut to fit the depth of the shelving, so that you can easily move them from the work area to the shelving and back to the work or kiln area.

Ceramic supply houses sell ware carts with casters that have racks for sliding ware boards on and off. They can be moved around the studio as needed, which is ideal for studios with lots of floor space, but they can be a bit pricey.

Restaurant supply houses sell wire shelves in a range of depths, from 12 inches (30.5 cm) to 36 inches (90.5 cm). They are versatile because they can easily be moved if you change your mind about layout. The wire shelves allow debris to fall through and don't build up dust, but attention must be paid to what may fall through the shelf onto the work below.

Large home building suppliers carry several metal and heavy-duty plastic shelving options that can withstand a lot of clay weight. They are assembled easily and are relatively inexpensive. Avoid metal frames with particleboard shelves; they don't hold up to moisture and will warp from the weight and dampness of clay.

It's probably the most expensive option, but shelving can always be custom built.

THE EVOLUTION OF SHELVING

Originally, my studio had a lot of shelving designed for production of smaller pieces, cups and bowls, and some larger space for vases and large bowls. My work has since evolved into more sculptural forms and the scale has increased so the short shelving has become unusable. I replaced some shelving with tables with storage cabinets underneath. Storing the pieces closer to the ground makes moving heavy or large delicate pieces much easier on my back, and it also allows me to go back to the work and make adjustments as it dries. If large work is placed on a high shelf, it becomes difficult to revisit.

PLANNING THE PLACEMENT OF TOOLS AND EQUIPMENT

As you plan your studio, there are a few critical tools and equipment that need specific locations. This includes your potter's wheel, kiln, glazing materials, and tools. Here's how to place them right.

Potter's wheel: For placement of a potter's wheel, access to electricity, lighting, space for a stool, and a low table are needed. Other space considerations include ample leg room for getting up and down from the wheel and maneuvering around the studio to store freshly thrown pots and get more clay. If the space around the wheel is too tight, it is cumbersome to access with your hands full and can be a tripping hazard.

Electric or gas kiln: Placement of a kiln requires more advance planning than most other pieces of equipment. Kilns require air space around them, non-combustible flooring such as cement, and access to ventilation. As mentioned earlier, fumes from a firing kiln are noxious and toxic, so place the kiln where it can be vented to the outdoors.

At the very least, it must be in a room with doors and windows that open. A garage with a cement floor is an excellent location for a kiln. If a kiln must be installed indoors consider lining the surrounding wall with fire-rated backer board. This material is available from building suppliers, comes in sheets, can be cut, and is commonly used behind kitchen stoves and fireplaces. It can even be used underneath the kiln stand to shield the floor.

If an electric kiln is being installed, its placement may be determined by the availability of an electrical connection. If a gas kiln is being installed, the size of the kiln, air exchange, and gas connection requirements will certainly determine the placement. (See Chapter 10 for extensive information on kilns.)

STORAGE FOR GLAZE MATERIALS

You can buy ceramic raw materials and glaze chemicals in small amounts, but you'll save money by buying in bulk. But of course, then you need to store it!

In the beginning, it's probably a better idea to spend some extra money and buy small amounts of materials. This way you can test many glazes and when you find that you are happy with a selection of them you can proceed to ordering materials in bulk quantity.

The best way to store ceramic raw materials and glaze chemicals is in stackable, heavy-duty plastic containers. They will keep the powders clean, dry, and properly contained to reduce the chance of cross contamination and dust in your studio.

Make a habit of labeling everything. Duct tape and a permanent marker work well for labeling plastic containers that could eventually be reused for something else.

At this point, you may be wondering what kind of glazes will you be using? In the beginning, you'll want to use commercially made

TIP
A kiln closet can be built into a room fairly inexpensively using fire-rated building materials and a metal door. The kiln can be hard wired and encased in the closet with proper space between the kiln and walls as per the kiln manufacturer. A vent system should be installed to draw fumes outside the building and should have access to air exchange. The electrical breaker should be placed outside the kiln closet for quick access in an emergency. Check with the kiln manufacturer and local building codes before designing a space for a kiln.

glazes instead of mixing your own. This is a great way to learn the process of firing because if you have problems, the ceramic supplier can often suggest remedies. Commercially made glazes should have fairly predictable results and if they are not performing it usually means that the firing cycle needs adjustment. Some of these adjustments might be calibrating the pyrometer or kiln sitter or lengthening the firing cycle.

Once you have hands-on experience and an understanding of how firing affects glazes, you will be ready to take on the next step: mixing your own glazes. Mixing glaze is fairly simple and is addressed in Chapter 7.

STORING CLAY TOOLS
Small containers, such as empty coffee cans, are practical for holding clay tools because they can be moved along with the work, from the wheel to the table.

Most potters are tool pack rats, collecting far more tools than needed. (You never know what you might need!) These extra tools can end up cluttering the work space. A small storage unit

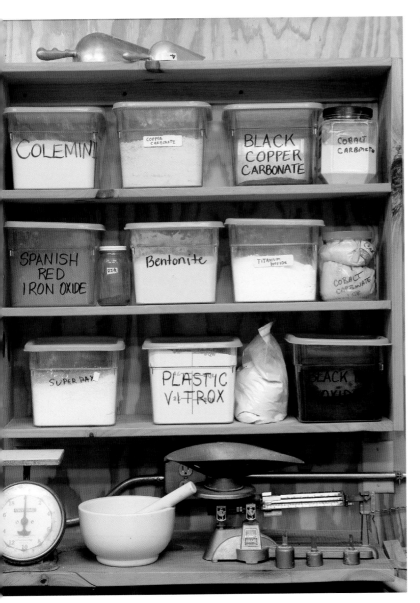

with drawers is a great way to sort and store the tools that aren't used very often as well as for keeping the tools that are used frequently handy.

For wheel work you will need many bats, which are discs made of wood, plastic, or plaster on which to throw clay. About a dozen small and medium bats and two or three large bats should suffice to get you started. Plan on storing them close to the wheel for easy access while throwing.

FLEXIBILITY

Above all, the studio layout should be flexible, offering space to grow into rather than out of. Allow yourself layout options. The ceramic process has different phases that require the space to be transformed from wet work area to glazing area. The type of work you make can go from small to large scale and from small quantities to large quantities. The option to move tables and equipment to suit your work patterns will give you the freedom to create your designs and tap into your creative flow.

Ceramic raw materials in proper storage containers and assorted tools for mixing glazes

TOOLS
AND EQUIPMENT

The previous chapter covered space requirements for basic tools and equipment. This chapter will address what specific tools you need to get started. Over time your space will develop into a complex workshop that has specific tools for particular needs. But in the beginning it can be fairly simple, a space you can develop to your liking.

ESSENTIAL EQUIPMENT

Quite simply, you will need clay (which will be covered in great detail in Chapter 3), a kiln in which to fire it, tools to manipulate it, and a surface on which to work.

THE KILN

The most important tool of all is the kiln. A kiln uses heat to transform soft, malleable clay into a permanent rock-like state. There are many types of kilns. Some use combustion for heat—such as gas, oil, or wood—and others use electricity for a clean source of heat.

FUEL-BURNING KILNS

Fuel-burning kilns include kilns that burn gas, oil, and wood. These types of kilns are commonly used by professional potters, colleges, and art centers because of their large capacity and firing results created. They are also cheaper to operate than electric kilns.

Fuel-burning kilns are typically fired in oxidation and reduction cycles; that is, at certain points during the firing the air is reduced and the gases from the combustion burn in reduction. This starves the flame of oxygen, thus the flame pulls oxygen from the clay and reacts with the base metals that are used as colorants in clay and glazes.

◎ Working outdoors offers a change of scenery and atmosphere.

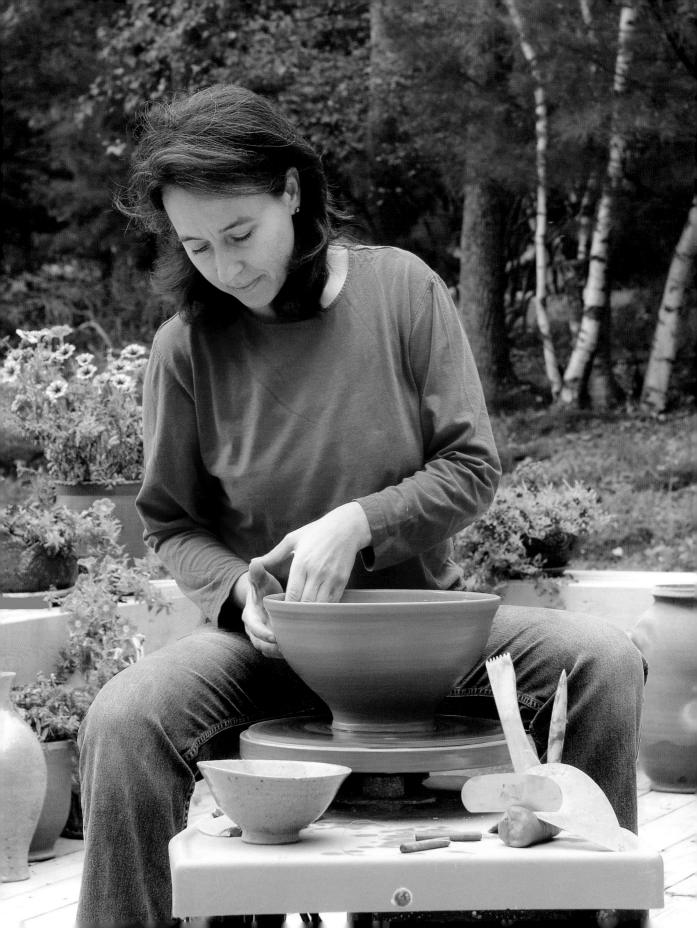

Reduction firing produces specific clay body and glaze color and depth. By pulling the iron to the surface of the clay, the clay color will become a toasty orange color. In reduction, metal colorants such as copper will go from green to red. Rutile will turn from a mustard yellow to a purple blue tint. As you might imagine, the firing results from a fuel-burning kiln are tricky to control, and require a fairly extensive knowledge of glaze chemistry and combustion conditions to achieve predictable results. (See page 197 for more information on fuel-burning kilns.)

Because fuel-burning kilns produce combustion gases, they are more difficult to vent than electric kilns. They are usually housed outdoors, such as in a kiln shed or kiln yard.

ELECTRIC KILNS

Almost every ceramic studio has an electric kiln even if it also has a fuel-burning kiln. Electric kilns are far more common than fuel-burning kilns in schools and home studios because they are easier to fire and to vent. Electric kilns are also smaller and render more predictable results. Electric kilns do not fire in reduction, therefore color and clay colors are more uniform.

The heat inside an electric kiln is clean and does not produce combustion gases from the heat source. There are gases emitted during firing, but they are from the clay and glazes as they burn off organic matter and fumes from the metals oxides and carbonates used as colorants in the glazes. These gases are easily vented with a standard setup. Therefore it is far more common to find electric kilns inside buildings than fuel-burning kilns. We'll talk in much greater depth about the kiln options available for home studios in Chapter 10, which covers kilns and firing techniques in depth. (See page 194.)

Even if you plan on building a kiln that fires with gas or wood at some point, having an elec-

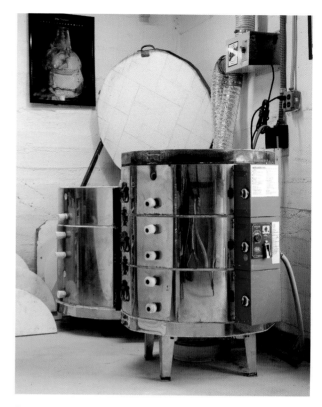

Electric kilns with manual controls and venting system

tric kiln in the studio is a great way to start, useful for bisque firing or for testing clays and glazes.

Space and budget limitations generally dictate the choice of a kiln for the home studio, but the most important issue is what types of items will be fired. You might not know exactly what type of projects you'll be making at first, but imagining future projects and scenarios will help determine the best kiln size. Kilns have specific interior dimensions that will dictate the scale of work you are able to make. Once the ideal size is determined, look at ceramic catalogs and find out what the electrical requirements are for the size kiln being considered. Also, consider the kiln's exterior dimensions and where it will likely be placed.

If you plan on working small or have limited electrical supply, you can buy a small electric kiln that will plug into a regular household elec-

trical outlet. This might be a good option to begin with because you can always use a small kiln later—after you've also purchased a larger kiln—for testing clays, glazes, and application techniques.

Ceramic suppliers provide information about purchasing a kiln; visit their websites. Shop around because prices vary by supplier. Ask potters and pottery teachers for their recommendations. They will have experience with different kilns and can suggest their favorite brands and features.

When you buy your kiln, you'll also need a venting system. The kiln venting system is sometimes available from the kiln manufacturer. There are aftermarket vents that work well too.

TEMPERATURE CONTROLS

There are two main ways to control the temperature of your kiln: with a kiln sitter and with a digital controller.

Kiln sitter: A kiln sitter is a device that measures the temperature and shuts off the kiln when the desired temperature is reached. Manual kiln sitters work with small pyrometric cones, which are small pyramid-shaped pieces of clay that are designed to melt at a specific temperature. (See the clay temperature chart on page 51.) When a cone melts, it triggers a relay switch that shuts off the kiln once the cone has sufficiently bent. A timer that can be set to shut off at a particular time backs this rather simple system.

If you use a manual kiln sitter, you will also need a pyrometer, a device to measure the temperature inside the kiln. Analog pyrometers are cheaper but not nearly as accurate as digital pyrometers.

A manual kiln sitter is great if you live in a rural area where there may be an inconsistent power supply. Also, a manual kiln sitter is easily calibrated, replacement parts are cheap, and even if you are not very handy the adjustments are simple.

Digital controller: On the other hand, digital controllers are becoming more and more popular because of their ease of use and pinpoint temperature control. They have ramp modes, which means that the heat cycles on and off to maintain an even, incremental heat rise.

Digital kiln controls are wonderful if you have consistent power supply (they are very sensitive to surges and outages) and provide exact temperature readings throughout the firing cycle because they have a digital pyrometer built in. You can also program them to specific firing cycles, temperatures, and cooling rates.

Potters who work with crystalline glazes prefer kilns with digital controllers because of the temperature precision needed for crystal development during the cooling cycle. Also, the capabilities of a digital pyrometer and temperature controller provide the opportunity for very precise record keeping and experimentation. Many schools use this type of kiln because it can be programmed to begin firing at any time and shuts off when the programmed temperature is reached.

TOOLS FOR HAND BUILDING

A sturdy table for working and or wedging is essential. (See suggested dimensions on page 25 in previous chapter.)

For hand building, the following basic tools are really helpful:

Toggle wire clay cutter: A wire or string with toggles at the end used to cut clay.

Assorted silk and elephant ear sponges: Used to hydrate the clay and smooth the clay surface.

Potter's needle (or sgraffito tool): This tool is used for cutting, scoring, and marking the surface of clay.

Fettling knife: Used for cutting and shaping.

Utility knife or hobby knife: Use these very sharp knives for precision cutting.

Metal ribs and rubber ribs or scrapers: Used for shaping and smoothing.

Serrated rib: Used for scoring clay.

Small paint brush: This is useful for applying slip.

Rolling pin: Used to roll clay slabs.

Plastic putty knife or scraper: Used to scrape clay from any surface.

Wooden paddle: Used for shaping.

Assorted boxwood modeling tools: Used for sculpting and modeling clay.

Canvas cloth: Used to roll clay on to prevent it from sticking to table also so that slabs can easily be moved.

Turntable or banding wheel: Used for hand building; it rotates and allows one to work on pieces from all angles.

Double pony roller (tiny rolling tool): Used for shaping and rolling small slabs of clay.

Wire loop tools in assorted sizes: Used to remove clay.

Assorted stamps and textured cloth: Used to decorate the surface of clay.

Metal fork: Used for scoring clay for joining.

Standard and mini compact discs: Used as shaping ribs.

Large sponge: Used for clean up.

Water bucket: Used for hydrating clay and cleaning up.

Small container with lid: Used for storing clay slip.

Ware boards: Used to store work in progress. Ware boards are best made of hard wood, such as oak, because the porosity of the wood helps absorb moisture from the clay and prevents it from adhering to the board.

Due to the absorbent nature of wood, the boards will tend to warp. To prevent this, ware boards often have two narrow strips of wood screwed into the base of the board a few inches

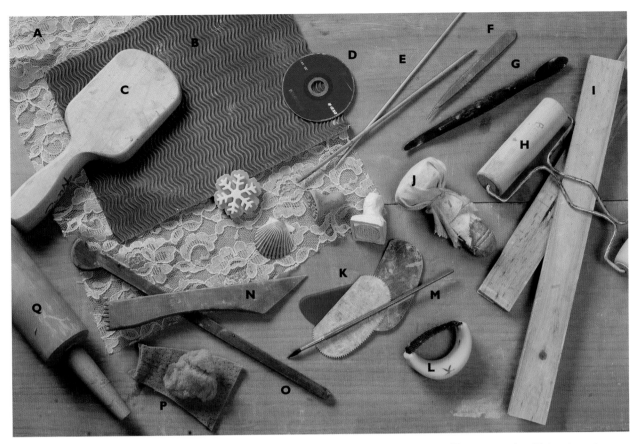

A selection of hand-building tools: **A**) Lace, **B**) textured craft paper, **C**) wooden paddle, **D**) compact disc, **E**) bamboo skewers, **F**) hobby knife, **G**) wood modeling tool, **H**) small roller, **I**) wood slats, **J**) rounded paddle with canvas, **K**) metal and rubber ribs, **L**) rasp tool, **M**) brush, **N**) wooden angle tool, **O**) throwing stick, **P**) natural sponges, **Q**) rolling pin

(about 10 cm) from each end of the board, widthwise. These two strips of wood prevent the board from warping by allowing air circulation under the board.

It's helpful if your ware boards are the same length as the storage shelves. That way you can simply set the ware board on an empty shelf.

Sheets of lightweight plastic: Empty dry cleaning bags are perfect for covering work in progress.

Hand towels: Used to clean and dry hands during the handling of plastic clay.

Newspaper: Used as a liner for ware boards, to prevent clay from sticking to surfaces.

Many potters adapt kitchen tools to clay work. A thrift shop can be an inexpensive place to buy tools such as small kitchen knives, forks, butter paddles, lace (for surface texture), and forms to drape clay into.

TOOLS FOR WHEEL WORK

Pottery wheel: First and foremost, you need a potter's wheel for throwing. There are many options and price ranges, depending on the size of the motor and pedal control features. For most practical studio applications, a wheel with a quarter to half horsepower will suffice. A full horsepower motor isn't necessary unless you plan on working on large-scale projects. Manufacturers of wheels offer a range of pedal features, which is important

because the pedal controls the speed of the wheel. The slow speed control is the most important for both large and delicate wheel work. Many pedals are adjustable but some are not, so be sure to check on these details.

Potter's wheels generally come with splash pans, but look for one that is removable. Splash pans can get in the way when throwing large plates or bowls, especially when cutting the piece from the bat with a wire. Also, a permanent splash pan can restrict the size of bat that can be attached to the wheel head.

Many of the tools you'll need for wheel work are the same as you'll need for hand building, including a toggle wire clay cutter, assorted silk and elephant ear sponges, potter's needle, ser-

rated rib, ware boards, standard and mini compact discs, and sheets of lightweight plastic. (See photo below.) But for throwing pottery, the following tools are also helpful:

Wooden angle tool: Used to compress clay at the base of a piece during throwing and remove clay from the base before wire cutting.

Assorted flat wire loop trimming tools: Used to trim clay from the base of a pot during the shaping of the foot.

Chamois cloth: Used to soften the rim of a pot when it is finished.

Calipers: Used to measure the width of a pot for making lids or joining two pieces.

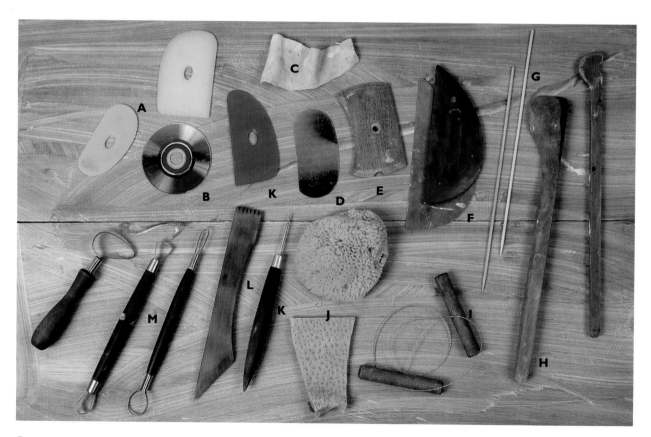

◎ A small selection of wheel working tools: **A**) rubber ribs, **B**) compact disc, **C**) chamois cloth, **D**) metal rib, **E**) wooden rib, **F**) large metal ribs, **G**) bamboo skewers, **H**) throwing sticks, **I**) toggle cutting wire, **J**) natural sponges, **K**) needle tool, **L**) wooden angle tool, **M**) assorted trimming tools

⊚ Bats come in an array of sizes and are made of a number of materials, including plaster, wood, particle board, and plastic. Shown here are a masonite bat and bat pins.

Bats: Removable discs made of either wood, plaster, plastic, or masonite that fit on the wheel head on which pots are thrown. Bats are essential for preventing warping. They are used as a foundation for the pot and lifted from the wheel head without deforming the pot itself. They come in different diameter from about 8 inches (20 cm) up to 24 inches (60 cm). They are especially useful when throwing thin large bowls, which are very susceptible to warping. Bats are a must if you plan on throwing plates and platters because of the wide space at the base. Vertical pots such as vases and pitchers can be thrown without bats because of the narrow base and lip that help hold the shape, while removing from the wheel head.

Bat pins: Most potter's wheels come with wheel heads that have been pre-drilled for bat pins. These are small bolts that attach to the wheel and allow bats that are drilled in the same proportion to drop into the bolts for easy attachment and removal.

Small food scale: Used for weighing equal amounts of clay for throwing the same size pieces. Choose one that measures up to 25 pounds (12 kg).

Wire cheese cutter: Used for faceting.

TIP: ATTACH BATS EASILY

Most bats have holes drilled into them that you use to attach the bat to the wheel. However, you can attach plaster bats and bats that are not drilled with clay. Center a small amount of clay and flatten it on the wheel head. Make ridges with your fingers in the flat clay, creating high points to which the bats adhere with the addition of a little slip.

TOOLS THAT EASE PRODUCTION

A number of nonessential tools streamline production in the studio by saving a lot of time. If a lot of ware is being produced and too much time is spent in preparation, it might be time to consider these options.

Slab roller: A slab roller has two rollers and a tabletop through which clay is fed, sandwiched in canvas, and rolled to a desired uniform thickness. A slab roller is well suited for slab construction and tile work because a large slab can be rolled rather quickly and effortlessly to a specific thickness.

Extruder: By using pressure to push clay through a shaped die in an extruder, a potter can extrude handles, parts for pieces, or hollow forms such as tubes, squares, and hexagons. An extruder's parts include a chamber that holds a die form and a lever to push the clay through. Clay is pushed through the chamber, through the die form, and an extrusion of a particular shape emerges. An assortment of die shapes—such as hollow circles, squares, hexagons, coils, and textured slabs—can be used to suit any number of designs. You can even buy or make custom-designed dies.

Pug mill: A pug mill is a powerful machine used to recycle clay. It has a chamber into which clay is placed with a large metal auger bit that rotates and mixes the clay. When the pug mill is on, it mixes and moves the clay forward to the front chamber, which extrudes a homogenous tube of clay. They are wonderful tools for a busy studio, but luxuries for a small studio—very pricey but worth the investment if you are using a lot of clay. They are useful for recycling clay and reducing preparation time, leaving more time free for the creative process. With infrequent use, however, pug mills will dry out and the clay will harden inside the chamber, making for a tedious clean up.

Pug mills and clay mixers should be used with extreme caution. Use care to ensure that no tools get into the chamber, especially metal tools that can shred into dangerous shards. Above all, keep your hands and clothing clear of all moving parts.

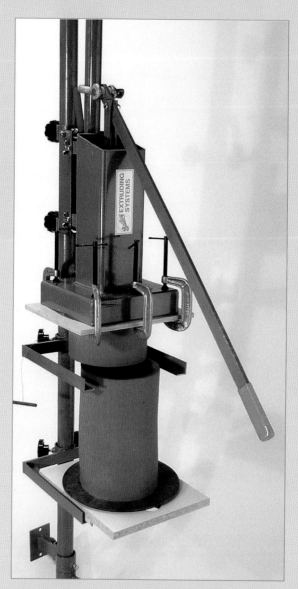

Extruder, courtesy of Bailey Pottery Equipment

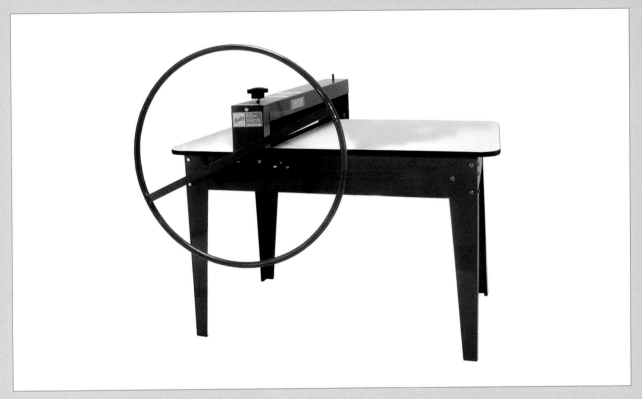

◎ Slab roller, courtesy of Bailey Pottery Equipment

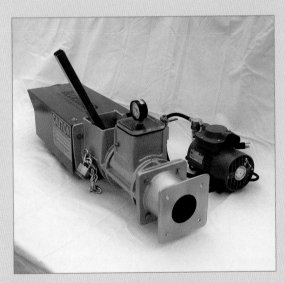

◎ Pugmill, courtesy of Bluebird Manufacturing

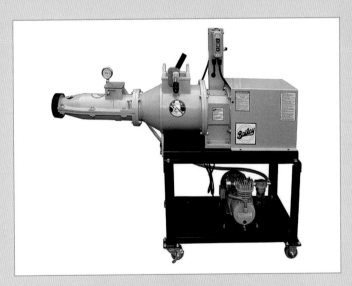

◎ Pugmill, courtesy of Bailey Pottery Equipment

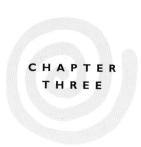
CLAY

Millions of years ago, the Earth's magma cooled slowly and formed rock on the Earth's surface. Over the course of time, some of the rock was broken down and pulverized by weather and erosion. In some places it stayed in the vicinity of the rock source and formed clay deposits. These deposits are called primary clay, and they are relatively free of impurities—such as iron—or other minerals. One type of primary clay is called kaolin or China clay. It is pure white, free of iron, and used to make porcelain and white stoneware.

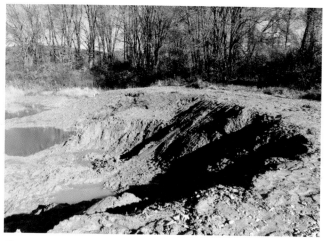

Sheffield Pottery clay pit, in Sheffield, Massachusetts.
Photo courtesy of Timothy Heffernan

More common than primary clay are secondary clays. Unlike primary clay, this type of clay was carried by water to secondary locations such as riverbeds. Over time, the pulverized rock mixed with other minerals—such as iron—and also with other clays, organic matter, and water. That's why secondary clay is a color other than white, such as gray or reddish. One type of secondary clay is called earthenware, and it is the most common clay found on earth.

Clay's exceptional maleability is apparent in this image of a coil-built jar. For the complete project, see the Coiled and Paddled Jar, page 239.

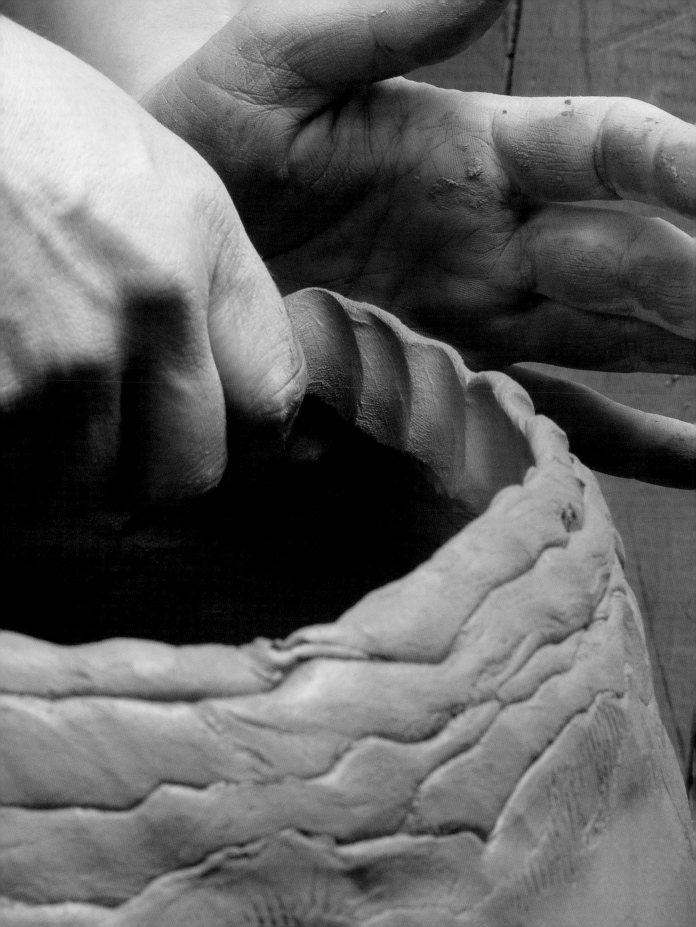

Through a series of chemical and physical changes, including hydration, primary and secondary clays became a malleable material that people have learned to use in diverse ways. When clay is exposed to high heat, it is transformed to a permanent, rock-like state, which is resistant to heat. Because of this transformation, people have used fired clay to make many useful items that have helped advance society.

TYPES OF CLAY

There are thousands of clay body formulations used throughout the world, each specific to an application such as bricks, industrial plumbing wares, scientific instruments, and dinnerware.

For the studio potter, however, the three most common types of clays that are the basis of clay bodies are earthenware, stoneware, and porcelain.

EARTHENWARE CLAY

Earthenware clays are secondary clays, containing iron and other mineral impurities that make the clay harden at relatively low temperatures, about 1742°F to 2012°F (950°C–1100°C). Nearly every culture that developed a ceramic tradition began with earthenware because of its abundance and ability to harden with primitive firing techniques.

These clays are generally red in color. For example, terra-cotta is earthenware, as is the popular *majolica* ware from Italy, Spain, and Portugal. However, earthenware clay can also be tan, grey, green, buff, and black.

Fine earthenware is used for dinnerware and decorative ware. Sandy earthenware is used for bricks and roofing tiles.

White low-fire clays can be bought at ceramic supply shops. They are specially formulated to mature at earthenware temperatures.

THE APPEAL OF LOW-FIRE CLAY

Because they harden at low temperatures, earthenware clays are often called low-fire clays. A disadvantage of earthenware clays is that they never achieve the hardness of stoneware and porcelain, and therefore they are not as durable. One advantage of low-fire clays is their ability to resist thermal shock (rapid temperature changes). Another advantage is that a vast color palette of low-fire glazes is available for use with these clays.

Some artists prefer to work at lower temperatures for a few reasons. The first reason is that because of the lack of density the clay tends to shrink or warp less than higher fired clays. The second reason is that the decorative possibilities are so abundant. The third reason is the energy savings. There has been an increase in "down firing" as the cost of energy rises. Schools as well as artists have to be resourceful to make ceramic wares affordable. Lowering the firing temperature saves fuel costs.

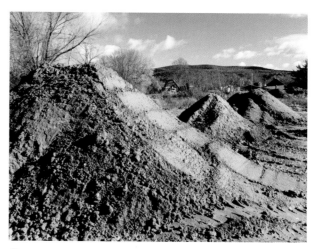

Clay drying at Sheffield Pottery deposit, Sheffield, Massachusetts. Photo courtesy of Timothy Heffernan

STONEWARE CLAY

Stoneware, like earthenware clays, are secondary clays. Stoneware varies in plasticity and color and matures at higher temperatures than earthenware. Stoneware becomes vitreous (hard, nonporous, and dense) if fired to the proper temperature in the range of 2192°F to 2372°F (1200°C–1300°C).

Usually stoneware clays are mixed with other clays to create clay bodies that have specific qualities. Commercially made stoneware clay bodies are finely tuned mixtures of primary and secondary clays that when combined will fire at a specific temperature and have particular colors, textures, and plasticities.

PORCELAIN CLAY

Porcelain clay bodies have a high percentage of primary clay, such as kaolin, combined with silica and feldspar to make a fine blend that when fired at temperatures of about 2372°F (1300°C) becomes tight, nonporous, vitreous, and semi-translucent to light if it's thin enough. Because the clay is more pure, its particles are more similar in size and porcelain clays are not as plastic as stoneware and earthenware clays. That makes them more challenging to work with. However, porcelain clays can be worked to extreme thinness and fine detail.

MID-RANGE STONEWARE CLAY BODIES

Mid-range clay bodies are porcelain and stoneware clay bodies that have been formulated to mature at lower temperatures. Standard porcelain, for example, needs to be fired to at least cone 9 and sometimes even cone 12 to reach maturity (2300°F to 2372°F [1260°C–1300°C]). Because of the popularity of electric kilns and the down firing trend ceramic suppliers now stock cone 5 to 8 porcelain and midrange stoneware clay, which become vitrified between cone 5 to 8

(2166°F to 2280°F [1186°C –1249°C]). If you plan to work with an electric kiln, it will be desirable to work with these midrange clays because it will reduce the wear and tear on the electrical elements.

If you plan on setting up a studio with an electric kiln, consider working with a mid-range stoneware clay body (cone 5 to 8) that has some fine grog added to it. Grog is previously fired pulverized clay that is added to a clay body formula to give it structural strength and plasticity. The addition of grog to a clay also reduces the shrinkage rate and therefore the chances of cracking during drying.

CONCERNS ABOUT UNDERFIRING CLAY

You may be wondering why you can't simply under-fire clays like porcelain and stoneware that mature at higher temperatures. This can provide nice results, but they are brittle and will chip and break easily. Under-firing does not allow clay and the silica (glass) particles in the clay to fuse and gain the maximum strength through vitrification.

CHOOSING A CLAY SUPPLIER

After becoming familiar with some of the clays available, locate a few ceramic suppliers in the phone book (which may have limited choices), online, and in ceramic journals and magazines, which are a great source of information. Then request catalogs from a few different suppliers.

Consider choosing a local supplier. Clay can be shipped or delivered by truck. Small quantities of clay can be mailed, but shipping will get expensive in the long run.

Take a trip to the ceramic supply shop. Your clay supplier can become a great source of infor-

mation as you work out the kinks of working and firing a particular clay. They can be a source for technical information and provide service to kilns and wheels that may need maintenance. Another advantage of visiting the supplier is that you can look at fired samples of clays on a **sample board**. Often the sample board will show the same clay subjected to different firing temperatures and either oxidation or reduction firing.

Be sure to discuss your level of experience with the ceramic supplier and talk about what fabrication methods you will be using (hand building or throwing).

STATES OF CLAY

Clay is a liquid solid: It acts as a liquid when hydrated and in motion but as a solid when it is still. This is why it is easily formed and can hold its shape.

In its raw state (before it has been fired), clay can be **powder, liquid**, **plastic**, **leather hard**, and **bone dry**. In order to work with clay, it is important to understand the consistency of the material as it progresses through its various states.

Each of these five states allows for certain manipulation but also has limitations. The following information is important to read through carefully so that when you begin to work with clay you will have a point of reference and understand each state's inherent qualities. A clay's consistency is determined by moisture content, plasticity (ability to be manipulated and hold the shape), and ability to endure the stress from the shrinkage during drying. These are the three most important features to pay attention to when working with unfired clay.

POWDER

Clay powders can be mixed to formulate clay bodies as well as added to glazes. They are mixed with water to create clay.

SLIP

Slip (which is also called slurry) refers to clay that is super saturated with water and is runny and slippery. Slip cannot be used to hand build or throw pots on the wheel; however, it can be poured into molds (slip casting). Toilets, sinks, commercially made dinnerware, house wares, and other industrial ceramic products are made by using specifically formulated slip. These slips have a specific shrinkage rate, density, and firing temperature. They are poured into plaster molds, dried, cured in a controlled environment, and then fired.

Ceramic artists pour slip into molds to create multiples of a specific form. Potters and hand builders use slip to lubricate clay on the wheel and to attach leather-hard clay pieces together. For example, if you want to attach a handle to a mug, put a small amount of slip on the mug where the handle will be attached. Then place the handle on top of the slip. When two pieces of clay of different moisture content come together to be joined, the slip hydrates both pieces thus allowing the clay to shrink and dry evenly, reducing the chance of developing cracks.

PLASTIC

Clay in the plastic state is used to throw pots on the wheel, roll coils for coil building, pinch pots, extrude shapes, and roll out slabs for slab construction. Clay will hold its shape in this state, but it is susceptible to oversaturation and the effects of gravity.

Clay particles are flat and vary in size. Some clays have many different-sized particles that are bonded by water. When the clay is thoroughly mixed with just enough moisture, it is considered plastic and can withstand forming without deforming and can be stretched and thrown with great ease.

Plasticity is the most appealing and versatile state of clay. It refers to the responsiveness of the material to touch. Ceramic artists often will use the terms short, tight, greasy, very plastic, or as having tooth (strength and grittiness from grog) to refer to the properties of clay. Stonewares tend to have a lot of tooth because of the particle size variation and the addition of sand or grog. Porcelain is an example of a clay body that has much larger and uniform particle size and therefore is less tolerant of too much manipulation. It has less plasticity than stoneware and is susceptible to over saturation and collapsing.

If you have purchased clay that doesn't seem workable, try adding some water to the bag of clay and leave it overnight. If the clay is stiff, wrap the clay with a moist towel and place it in a plastic bag overnight. Check to see if the clay is then workable or if it needs more hydration.

One way to make your clay more plastic is to wedge and knead it. By rotating the clay into itself, particles become aligned and the water molecules are spread evenly, creating a homogenous mass of clay that can be easily manipulated and will hold its form. Wedging is an essential part of working with clay (see Chapter 4).

Another way to make your clay more plastic is to age it. Potters will allow clay to sit in a plastic state for a period of time. Whether you buy or mix a fresh batch of clay, it may take a couple of weeks for all the particles to become evenly hydrated. Organic matter in clay and the water create a colloid, a suspension of small particles of clay displaced in water, that impart plasticity to the clay.

The late Doc Crespi, a professor at Southern Connecticut State University, often told a story about people adding a bottle of beer to a fresh batch of clay because yeast encourages plasticity (and a strong stench). He also shared that in some cultures clay bodies are mixed years in advance for the next generation of potters.

LEATHER HARD

The leather-hard state of clay refers to clay that has been formed in the plastic state and has had a chance to begin drying. The clay has lost some moisture content and therefore can hold its shape yet still be manipulated. When clay is leather hard, it can be carved, textured, and joined.

A sample of plastic and non-plastic clays

There are many subtleties to the leather-hard state. It can be **soft leather hard**, **medium leather hard**, and **stiff leather hard**, which is almost too dry to work with.

Mastering these intermediate stages of leather hard is one of the most important principles of working with clay. Learning to recognize the effects of moisture content of the stages between plastic clay and leather-hard clay will be valuable as you encounter soft leather-hard, medium-leather hard, and stiff leather-hard clay. For example, when coil building, a piece can only go so high before the vessel begins to lose its shape. This is a cue to the builder to stop and allow the piece to dry for a few hours until it can handle more weight from additional coils. To construct a form with slabs of clay, allow the slabs to dry slightly so that when the slabs are cut and held vertically they will not deform.

Soft leather-hard clay is tricky to work with but great for retaining certain marks on the surface. Some potters use this in their work to create soft lines and forms that look like they have air pushing through and out of the forms. When clay is soft leather hard, it has a sheen or reflection of moisture on the surface. It is easily shaped, yet still susceptible to collapsing if overworked.

Medium leather-hard clay is the most versatile stage of leather-hard clay because of its structural strength and malleability. Lines with clear margins and surface quality can be carved or drawn on the surface. Detailed texture and surface decoration can be added during the medium leather-hard stage. There are many joining options such as attaching clay handles, embellishments, and sections of previously formed clay to one another or in case of sculptural forms, fresh clay can be added to clay that has set up to increase volume. Many large pots are made in sections and joined in this state. There is no sheen on the surface of the clay yet it is receptive to touch. It cuts easily, joins easily, and the surface can be decorated easily, but the shape cannot be altered at this point without causing internal stress and cracking.

A potter who has thrown a bowl and wants to trim the base needs to wait for the form to be medium leather hard to trim a foot that will not collapse when placed upright. Medium leather-hard clay is the ideal consistency to join sections of clay and handles to a vessel.

Stiff leather-hard clay is the strongest version of clay's consistency before firing. This consistency of clay is easily recognized because it looks dull, has lost about two-thirds of its moisture, has begun shrinking, and will not give way to soft pressure. It holds its shape, and if greenware (raw clay pieces) needs to be transported for firing, this is the best stage at which to do so. Very crisp lines can be drawn on the surface of the piece and some very detailed carving can be done in the stiff leather-hard state.

When clay is in the stiff leather-hard stage, it is nearly impossible for the potter to trim excessive clay from a piece on the wheel. It is not a good time to join clay because it has already lost too much moisture. If a handle is attached or parts are joined at this time, the surface must be scored, a lot of slip must be added, and drying must be slowed down, otherwise parts will separate. This is due to shrinking of clay as it loses water. Stress cracks and separation may not show up until the piece is bisque fired.

GREENWARE: CLAY IN ITS BONE-DRY STATE

Greenware is clay that is bone dry, the only stage at which it is ready to be fired. When clay is bone dry, it is most delicate because moisture has evaporated out of the clay. Water acts as an adhesive bonding agent to the particles in clay. Once clay dries, it loses all plasticity and is susceptible to cracking, chipping, and breaking.

Greenware should be handled with the utmost care. Never pick up greenware by handles, rims, or extremities. Instead use two hands to carefully lift pieces from the bottom to move them. A little care will go a long way. When clay is bone dry, fresh clay cannot be attached. The loss of moisture content has diminished a piece's size; any addition of fresh clay will simply shrink off the dry piece.

When clay is bone dry, it is a good time to inspect pots and check for rough edges or unsightly seams. You can remove rough edges and imperfections simply by sanding the greenware very gently with a dry, plastic scrubbing pad. This should be done outside while wearing a respirator mask to avoid inhaling ceramic dust.

Note: Ceramic dust is hazardous. Clay contains silica, which is not soluble in the body. When silica is present in the lungs, it will be encapsulated by lung tissue and create scar tissue that will eventually lead to silicosis. Always take the necessary precautions to work in a safe environment.

Other Considerations

Fine clays are less forgiving but good for delicate work. Very coarse clays are good for large hand built work but not for fine details. Coarse clays are not good for throwing on the wheel because they are too abrasive. Clay that has the addition of some fine grog is a perfect to begin with. Ultimately the choice is up to you. Try different clay bodies. They will provide a frame of reference for plasticity and properties of clays and glazes. Consider the color of the clay; the fired piece will become a canvas for glaze. Glaze color and texture may vary dramatically from one clay body to another. Keep an open mind and experiment—experimentation leads to the knowledge that can only be gathered from experience!

CLAY SHRINKAGE

As mentioned earlier, clay particles are bonded by water. Water occupies volume in the clay, therefore as it evaporates clay shrinks. The shrinkage rate becomes apparent when you find that the large piece you remember making has gotten smaller. Clay shrinks more when it is bisque fired, and shrinks even more when glaze fired or fired to maturation. See Chapter 4, page 98, for more on clay shrinkage.

The ceramic supplier should provide the shrinkage rate of clay bodies in relation to temperature. Some clays have a wide firing range and will shrink less at lower temperatures and more at higher temperatures. Clay actually becomes denser when fired to maturity. Porcelain tends to have the highest rate of shrinkage because it becomes the most densely fused of all clay bodies when fired to maturity. Clay bodies with high shrinkage rate tend to warp more easily during drying and firing.

CONVERSION OF CLAY THROUGH FIRE

No other material on Earth undergoes such dramatic transformation as clay through fire. Most materials on Earth are obliterated by high heat. Originally when people learned to fire clay, it was at low temperatures (less than 1900° F [1037° C]). This temperature is called a bisque temperature. The most common clays found on Earth are earthenware clays that are low fire and therefore do not vitrify and remain porous when fired at bisque temperatures. To get around this problem, people found ways to seal the clay. One technique is to burnish or rub the surface of leather-

hard pieces to really integrate the finer particles. This works to help seal the clay at least temporarily. Another technique is to apply animal fat or milk on the surface of the clay to seal it. Then the resulting ceramics can be used to store and cook foods (although not to modern food safety standards).

In order for ceramic wares to be strong and durable, they must be fired to maturation. This means pieces fired in a kiln must reach a temperature that will fuse all the silica (glass) and clay particles to produce a dense vitreous ceramic piece.

Typically, ceramic ware is fired twice to transform the raw clay into ceramics. The first firing is called a **bisque firing**. The firing temperature is about 1648°F to 1940°F (898°C–1060°C) or in potters' terms, cone 010 to 04. The second firing is called a **glaze firing**, the firing of the glaze coating to bond it to the clay surface. The firing temperature ranges vary depending on the clay and glaze formulation but will generally be between 1800°F and 2379°F (982°C to 1304°C) or in potters' terms, cone 06 to 12. Of course, there are exceptions to this! Some potters **single fire**. Single firing is when glaze is applied to leather-hard ware and fired slowly to the desired glaze temperature, thereby skipping the bisque firing. But in most modern applications, single firing is difficult to do because electric kilns and small gas kilns rise in temperature too quickly, increasing the possibility of cracking and breaking during the firing. Let's talk about the two types of firing in greater detail.

BISQUE FIRING

In bisque firing, which is sometimes also known as biscuit firing, bone-dry pieces of greenware are heated slowly in a kiln in order to drive off the chemical and physical water molecules that are present in clay. The temperature needs to be just right. If the rise in temperature is too fast, the water will create steam. If the steam is too strong, it will explode the ware. Often, trapped air bubbles cause breakage during bisque firing because they contain air and therefore moisture. These moisture pockets can be problematic if a kiln fires too quickly. One way to avoid this is to warm the ware inside the kiln and keep the temperature below the boiling point of water until all steam is driven off.

During firing, clay particles go through a process called the **quartz inversion**. This is the conversion of quartz from alpha crystals into beta crystals during temperature rise, followed by a reverse conversion in the cooling. In short, the clay will expand and then contract when it reaches certain temperatures (about 900°F to 1200°F [482°–648°C]). (Think of a cake baking. At one point it rises and then settles down again.) During quartz inversion, care should be taken to not have a rapid temperature change. A rapid heat rise can cause stress cracks in ceramic ware.

One of the most important actions of bisque firing is the burning off of carbonaceous materials and impurities in the clay. It is very important to burn out the organic matter before the clay seals when it reaches high enough temperature to sinter. (**Sintering** is when the clay particles begin to fuse together to form the rock-like bisque fired clay that will be porous enough to absorb glaze.) Otherwise the organic matter remains in the clay and can cause bloating during glaze firing.

Most earthenware clays are fired only to bisque temperatures because these clays do not withstand higher temperatures. There are many primitive firing techniques—such as pit firing and American-style raku—that require temperatures on or under bisque-firing temperatures. (See the clay temperature chart on page 51.)

GLAZE FIRING

After a coating of glaze is applied to bisque ware, it needs to be glaze fired. The glaze melts onto the clay surface, and the clay body is also fired to its maturing temperature.

As people developed ways of achieving higher temperatures (such as by burning harder woods and containing the heat inside primitive kilns), they began to see what they thought was glass forming on the wares. In fact, it was fly ash from the burning wood deposited on the hot surface of the clay and bonded to form a glass-like surface. People soon developed ash glazes by applying an ash, clay, and water mixture to the ware. When ash is combined with feldspar or clays, it lowers the melting point and helps form the glass-like coating. The ash acts as a flux, or a melter.

Glazes vary in color depending on the ingredients. Different clays have different mineral and metal content, and therefore their glazes vary in color. The development of glaze formulations is called glaze chemistry, and it is an area of study in ceramic science. Ceramic engineers specialize in this study and work to produce consistent, replicable properties in glaze and clay chemical formulations for the industry.

CERAMIC TEMPERATURES

Before the twentieth century, the temperature of firing kilns was judged by eye, observing the color of heat to gauge ideal temperature. Another method used to measure the temperature inside the kiln was to make **draw rings**, small glazed clay circles placed inside the kiln near a spy hole. The draw rings were pulled out and quickly cooled when the kiln master wanted to check temperature. These testers let the potter know if the glaze had sufficiently melted. If the glaze was dry and rough, they would keep firing; if it was satiny and smooth, they knew the kiln had reached ideal temperature and they could shut down the firing.

READING KILN TEMPERATURES

Modern technology provides us with two tools to measure kiln temperature: pyrometers (an instrument that measures high temperature) and pyrometric cones (clay pyramids that melt at specific temperatures and are used to measure heat work inside a firing kiln; see cone temperature chart on page 50).

Pyrometers

The instrument used to measure high temperature inside a kiln is called a pyrometer. Pyrometers are usually built into electric and gas kilns that have digital controls, but on manual control kilns they are an option that can be installed. Some old electric kilns have analog pyrometers with a needle that indicates temperature. Without a pyrometer, pyrometric cones are used to gauge the temperature of the kiln during firing.

Pyrometric Cones

The less–high tech way to gauge the temperature in a kiln is by using pyrometric cones. Cones are made from clay compositions that melt and bend in a predictable manner, at certain temperatures. Their behavior changes depending on firing conditions, but they are the most reliable way to read heat absorption in a kiln. You can place cone plaques, which are three or four cones of ascending temperatures, on a clay coil on different levels in the kiln and then read them after the firing. As they bend, they will show how high a temperature was reached. In order to read the temperature during a firing, cone patties or cone plaques are placed in front of a peep hole in a kiln (which is sometimes also called a spy hole). During the firing, you can don UV-protective eyeglasses and quickly remove the peep hole cover to look inside the kiln and see if the cone has bent.

TEMPERATURE RANGES FOR KILNS

You don't need to memorize cone temperature charts. What you do need to know is what temperature your kiln is capable of reaching. This will determine firing limitations. For example, an electric kiln typically reaches a maximum temperature of cone 8, which is 2277°F (1247°C). A gas kiln will typically fire to cone 12, which is 2379°F (1304°C), although generally people don't fire higher than cone 10, which is 2340°F (1282°C) because of clay and glaze limitations. Knowing the firing temperatures of the work that you want to make will be helpful when choosing kilns, clays, and glazes.

There is a lot of technical information involved with managing firing temperatures. Be sure to talk to the ceramic supplier about the details of kiln-firing temperatures for both clays and glazes to ensure success.

TIP

UV rays emitted during a firing are hazardous to your eyes. Never look into a firing kiln without proper eye protection. I keep a pair of welding glasses near my kiln. They are relatively cheap and help you see the cones when the kiln is really hot.

PYROMETRIC CONE AND TEMPERATURE EQUIVALENTS

Use this chart to determine the firing temperature for clays and glazes. The chart provides temperature equivalents for large pyrometric cones fired at a rate of 180°F (100°C) per hour at the end of the firing. Courtesy of the Edward Orton Jr. Ceramic Foundation.

CONE	°F	°C
019	1249	676
018	1314	712
017	1357	736
016	1416	769
015	1450	788
014	1485	807
013	1539	837
012	1576	858
011	1603	873
010	1648	898
09	1683	917
08	1728	942
07	1783	973
06	1823	995
05½	1854	1012
05	1886	1030
04	1940	1060
03	1987	1086
02	2014	1101
01	2043	1117
1	2077	1136
2	2088	1142
3	2106	1152
4	2120	1160
5	2163	1184
5½	2194	1201
6	2228	1220
7	2259	1237
8	2277	1247
9	2295	1257
10	2340	1282
11	2359	1293
12	2379	1304
13	2410	1321
14	2530	1388

CLAY BODY TEMPERATURE CHART

This chart shows the effects of temperatures on clay and at what temperatures certain effects are achieved. Understanding the effects of temperature rise will help you eliminate problems during firing.

Temperature		Color	Cone	Effect
°F	°C			
212	100	no glow	n/a	Boiling point of water. Moisture in the clay will steam off during the heat rise. Be sure to allow the evaporations to occur slowly. The pressure from steam will cause the work to explode if the evaporation is too fast.
392	200	no glow	n/a	
572	300	no glow	n/a	Fast cooling will cause the clay to crack because the cristobalite (crystalline form of silica) shrinks suddenly at 428°F (220°C). Slow cooling is important.
752	400	no glow	n/a	Chemical water is driven off between 895°F and 1292°F (480°C–700°C). This should happen slowly.
932	500	just starting to glow	n/a	
1112	600	dark glow	022–021	Beginning of cones that measure heat work. Quartz inversion begins at 1063°F (573°C). Every time the clay is at this temperature the quartz will invert from alpha to beta crystal and then back again. It is very important that this process happen slowly to avoid cracking in the work. The bigger the work the slower it should be.
1292	712	dark	018	Between 572°F and 1472°F (300°C–800°C), there is a reddish glow in the kiln. The clay will gas out the carbonaceous materials or organic matter. After this heat is achieved the clay will seal off, trapping the organic materials that have not gassed out. The kiln needs to be vented properly to release the gases.
1652	900	brighter red	010	Sintering occurs between 1472°F and 1652°F (800°C–900°C). The clay particles fuse together to create the hardness of bisque ware.
2012	1100	orange glow	1	At this temperature glass particles fuse with the clay and shrink, resulting in a dense clay. If the firing progresses slowly, a denser clay is created.
2192	1200	yellow	5–5.5	Earthenware clays do not tolerate higher temperatures than this. Usually they mature between cone 02 and 3 and begin to melt if they get hotter.
2200	1220	white	6	Mid-range stonewares mature between cone 5 and 8.
2372	1300	white	11	Stoneware clay bodies mature between cone 5 and 11.
2552	1400	blinding white	14	Porcelain clays mature between cone 8 and 12.

Note: If clay is overfired it will bloat and melt on the kiln shelves.

THE ORIGIN OF CLAY

Clay is formed by a series of geological events that break down rock formed by volcanic action. The deposit can remain on-site as primary clay, which is white in color, with large particle sizes lacking in plastic qualities. Secondary clays are transported by wind and water action and can accumulate impurities before settling into a sediment layer. Secondary clays are darker in fired color, and they have smaller particle sizes, causing greater plasticity than primary clays.

At some point in the primary or secondary transformation process, clays are mined from the ground. There are many individual clays within the primary and secondary clay categories. There are wide ranges of particle size, chemical composition, organic content, and contamination that can fluctuate over short or long periods of time. Considering that inconsistencies are always present in any one batch of clay, it is remarkable that clay body failures do not occur with greater frequency.

CLAY MINING OPERATIONS

In a typical clay mining operation, test holes are drilled in a geologically likely place, which will indicate the estimated reserves of a particular type of clay deposit. A specific block or area of clay is defined, and the overburden or topsoil is removed, exposing the underlying seams of clay. In some deposits, the overburden can be screened to remove sand or gravel, which can then be sold to construction and landscape contractors. Most deposits have overburden stockpiled for later use in reclaiming of the mine. (Overburden is the top sand or soil that contains trees, shrubs, and brush, which, after mining operations, is replaced to make the land look like it did before excavation.)

One clay deposit can cover approximately 20 acres (80,937 m²) and produce 4,000,000 tons (3,628,739 metric tons) of clay. Most clay companies mine fewer than 20 end-point clays, which they blend into market-grade clay. Clay mining companies may sell dozens of different blended grades of clay and have more than 100 years' reserve, depending on geological conditions at each site. A clay mine's objective is to consistently blend individual clays to ensure uniformity of products for their major market customers.

If you visit a clay mining operation and see how the material is harvested, processed, packaged, and shipped, you'll gain some insight on why clay body inconsistencies exist and just how many "blips" can occur that will affect your finished product.

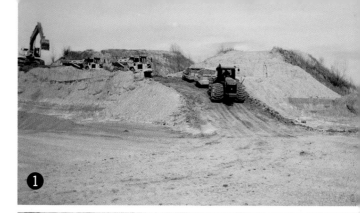

① After the clay deposits are located, scrapers and tractors remove an overburden consisting of sand, shale, or mineral content.

② The open clay pit is exposed, and different clay seams of clay are excavated.

③ An excavator places clay in a truck. The clay truck goes to a drying area, and then the clay is sent to the grinding operation, where it is reduced in size and eventually separated by particle size.

④ At a screening operation, sand and gravel are separated from the overburden

⑤ Air-floated clay is stored in these silos.

⑥ Clay is packed in 50-pound (22.7 kg) bags and 2,000-pound (907-kg) bulk sacks for shipment.

⑦ The overburden is returned to the site.

Slab Construction Oval Platter by Jim Fineman
See page 287 for formula

DYNAMIC CLAY

The one constant when working with any raw material is ongoing change or alteration. The actual raw materials that comprise clay bodies are always shifting in mechanical water content, chemical water content, organic content, pH level, particle size, mineral content, and tramp material. Several factors can alter a clay body. Some of these factors take place subtly over years, but others are more dramatic, occurring immediately after the first bag of clay is opened.

Changing clay can affect a finished product's color and glaze fit. For example, higher iron content in a clay can result in a darker fired color. Or a shift in a clay's silica content, which changes the rate at which a clay body shrinks or expands, can adversely influence glaze fit. Sometimes a change will occur in a single bag of clay, causing clay or glaze defects. Occasionally, a clay alters over a period of months or years, causing a slow transformation in a clay body color or texture. While mines and ceramics suppliers strive for consistency—and for the most part they succeed—a few small changes in clays can add up to a big change for the entire clay body formula. Unfortunately, clay variations are mostly reflected in the finished ware.

If you choose to mix your own clay body formula, as opposed to ordering clay from a supplier, you will have more immediate control over the weighing and mixing process. But direct control does not always translate into improved quality. Even when mixing one's own clay, a defective clay component in the formula is often discovered only when the finished ware is removed from the kiln. There are many reasons for a clay body to fluctuate, some of which involve a predetermined adjustment by potters who mix their own clay or the ceramics supplier who mixes and sells moist clay. A clay body can also fluctuate, due to inaccurately weighing the dry materials or incorrect mixing procedures. Knowledge and expertise in mixing clay can prevent these problems. You will decide whether it is appropriate and efficient to mix clay yourself or to purchase it from a supplier.

ACQUIRING CLAY:
BUY PREMIXED OR MIX YOUR OWN?

All potters wrestle with what is the best method of ensuring a good supply of moist clay. Beginning students are supplied with premixed clay at school, camp, or craft centers. Their main concern is mastering the skills needed to form pottery or sculpture. Clay was clay, as long as you could mold, shape, and work it into a finished product. But years later in your ceramics education, you may ask yourself: Should I mix my own clay or buy it premixed from a supplier?

Potters bounce back and forth on the clay supply issue. A defective shipment of clay might inspire you to try your hand at mixing your own. Or, the labor-intensive experience of doing just that may cause you to seek a reliable supplier who can do the work while you concentrate on producing pottery to sell or show. There are pros and cons to mixing your own and to ordering premixed moist clay from a ceramics supplier. Mixing clay is labor-intensive and requires time, tools, and practiced technique—not to mention the appropriate clay body. There is no cheating. On the other hand, just because you purchase premixed moist clay from a supplier does not mean the material will be flawless.

What is the best solution to the clay supply question? Only you can decide.

CLAY BODIES

The combination of clays, feldspars, talc, grog, and other materials constitute a clay body. Clay bodies include various blends of these raw materials, depending on the temperature range, forming method, shrinkage, absorption, fired color, and function of the finished ceramic object in mind. Some clay body formulas contain only one ingredient; others contain many different clays and raw materials.

Making good pots or sculpture depends on the suitability, accuracy, and consistency of the clay body formula, whether the clay is mixed in the studio or arrives premixed from a ceramics supply company. The first question potters should consider is whether their clay body produces the results they need. If so, the next question is how to obtain a consistent supply.

Left to right: ball clay, talc, kaolin, bentonite, feldspar, and flint are used to create a clay body formula.

Clay Body Components

The success of a clay body formula depends on the reliability of its components. Clay bodies contain several raw materials, which are quality controlled in relation to particle-size distribution, organic content, pH factor, and chemical composition. Many ceramics suppliers will reveal the types of clays used in a clay body, which gives clues to the clay body's dependability. However, suppliers will rarely give the exact amounts of each clay or other material used in the clay body because that is proprietary information. A more accurate indication is the clay's track record with other potters who are using it in similar applications and firing conditions. Here are a few generalities to keep in mind:

- Established materials—such as kaolins, ball clays, talcs, whiting, wollastonite, bentonites, feldspars, and flint—are used in the paint, paper, sanitary ware, glass, and other large industries and are best suited for pottery production.

- Earthenware, stoneware, and fireclays can be more trouble-prone, due to their unrefined nature.

- Fireclays can contain high levels of contamination from manganese and iron nodules, coal, lignite, sand, and other contaminants.

- Some earthenware clays have random deposits of lime, which can cause lime pop, producing a semicircular crack in the bisque or glaze fired ware.

Stock Clay Body Formulas and Custom Formulas

Ceramics supply companies sell stock clay body formulas of different firing ranges, colors, and forming qualities for hand building or throwing. They are usually characterized by stability and consistency of performance. Another category of moist clay consists of custom clay bodies or, as they are called, private formulas. Individual potters develop custom clay bodies, which are mixed either by the potter or by the ceramics supply company. The reliability of the clay body depends in large part on the ability of the ceramics supplier to adhere exactly to the amounts of raw materials specified. In private or custom clay body formulas, the potter's knowledge of ceramic materials is critical in obtaining a good result.

The predominant materials in a clay body formula will indicate how the clay will behave in the forming and firing stages. For example, if a clay body contains high percentages of ball clay, a very plastic clay, it can be smooth in handling operations but shrink excessively during drying and firing. Because of their small platelet size, ball clays require greater amounts of water to achieve plasticity. Upon drying, the clay body can shrink excessively and/or warp.

On the other hand, if a clay body contains high levels of fireclay, a refractory coarse clay, it can be nonplastic and difficult to form on the potter's wheel. Clays with high iron content, such as low-temperature earthenware, Redart and high-temperature stoneware Newman Red, can produce darker clay body colors depending on the percentage used in the clay body formula. With a thorough knowledge of each type of clay used in the clay body formula, you can estimate the clay body's handling and firing characteristics.

Reliable Formulas

When mixing your own clay body, research the reliability of the formula to reduce potential defects. A reliable clay body formula can function with slight variations in raw material, and it can also accept slight variations in kiln atmosphere and firing temperatures. Deviation of 1 or 2 percent in raw materials will not cause a significant difference in the clay body's forming characteristics or fired qualities. The best situation is to produce pottery or sculpture that allows for slight variations in size, texture, and color. Some potters make the mistake of trying to produce items to exact specifications, only to find that their raw materials and forming methods cannot meet such an ideal. Large commercial dinnerware manufacturers invest millions of dollars in forming perfect plates, and, even then, 30 percent of their production can have defects.

Test for Reliability

Whether you mix your own clay or buy it premixed, mark a few pots from each new batch of clay to distinguish each batch as it goes through the production process. If a problem develops, the entire production from the suspect batch can be set aside for further testing. If the pots were not coded, it may be hard to figure out which batch of clay was responsible for the defects.

A ceramics supplier's screening operation will improve clay body quality by eliminating unwanted contaminants.
① **Screen.** An adjustable series of 30 mesh to 150 mesh, 72" (1.8 m) diameter stainless steel screens vibrate to trap oversize clay particles or contaminants from entering the clay batch.

② **Magnet.** Reduces iron specks in white or red clay bodies passing through to the clay hopper.

③ **Clay hopper.** The stainless steel container captures the processed clay, which is then taken to the clay mixer and pug mill.

TIP

Screen Contaminants

Some clay body formulas require fireclays, earthenware, and stoneware clays, but their use must be monitored. Ask your supplier about screening to decrease the amount of contaminants that have accumulated in the mining and processing stages.

Consistency in a clay body allows potters to create sets and series.

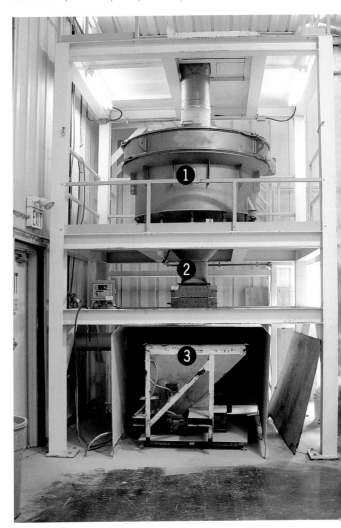

MIXING YOUR OWN CLAY

Mixing your own clay offers the intangible benefit of being completely involved in the pottery endeavor. Many people first started to realize their artistic goals in ceramics and, for them, the whole activity of mixing clay and making pots or sculpture are intrinsically tied together. Monetary rewards and the breakdown of production costs are not relevant factors in such situations. For potters pursuing a total involvement in all aspects of ceramics, the process is equally as important as the final product.

One major advantage of mixing your own clay is the

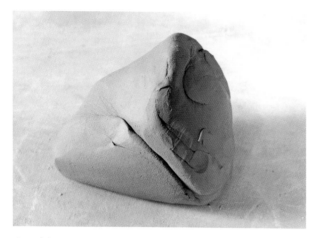

The ability to customize clay bodies lures potters into mixing their own formulas.

greater flexibility in adjusting the clay body formula and moisture content, which gives you overall quality control. However, carefully weigh whether the process is worth the labor, effort, and expense.

Before mixing your own clay, ask yourself: Does the clay body depend on a specific finished color? Do the forming qualities of the moist clay require an exact clay body formula? Does the clay require a specific moisture content? If yes, consider mixing your own clay. For example, clay bodies containing nylon or fiberglass fibers used for structural strength are difficult for ceramics suppliers to mix, due to the time-consuming process of cleaning clay mixers and pug mills. Ceramics suppliers are not set up to mix such custom formulas, leaving potters to mix it themselves.

Another advantage of mixing your own clay is that, as long as you have the raw materials on hand, you'll have a ready supply of moist clay. You can mix the amount of clay desired and control the supply, which is especially important in a production situation.

A third advantage of mixing your own clay is that you can mix and test a variety of clay bodies and make timely revisions to clay body formulas. However, understand that mixing your own clay will require knowledge of raw materials and the ability to formulate a clay body.

Should You Reprocess Trimmings?

Reprocessing trimmings prevents waste; however, clay is dirt-cheap, and your labor is expensive. Is reprocessing worth the effort? The time and labor required to store and mix clay trimmings might be better used for more profitable projects. Plus, if you mix your own clay, reprocessing scraps also means incurring the same clay mixing time and labor efforts expended the first time the clay was mixed. Remember, more time spent reprocessing clay is less time spent making pots.

Recycling clay allows potters to maximize raw materials, but the process is not always efficient.

MIXING EQUIPMENT

Mixing your own clay can be capital intensive: it requires the purchase of clay mixers and pug mills. An added cost is inevitable maintenance and repairs. The money you spend to buy and maintain a clay mixer and pug mill could be spent instead for other purposes that might return a greater profit. If you try to get by buying smaller clay mixers and pug mills, your unintended result could be slower clay production and possibly higher maintenance costs with underpowered, inadequately designed machines. But if you buy larger machines, they'll cost more upfront, and they can result in unused production capacity. That's why it's important to take time to research and find the best machines for your individual production requirements.

MIXED CLAY STORAGE

If you mix your own clay, you'll also need to purchase and store your materials. Plan your dry clay orders so a steady supply is always available, causing no delays in mixing operations. Buying in bulk results in a lower cost per pound of materials, but you also must have the space to store dry clay. Designate areas close to your production space for clay mixing and storage for dry and wet clay. This will save labor and time—and, remember, the more you touch the clay, the more it costs.

Get Equipped to Mix Clay

Simply mixing the dry clay body formula and adding the appropriate amount of water is all that is really required to achieve a plastic mass of usable clay. Traditionally, hand mixing or blending clays and other ceramic raw materials was the only method available to achieve workable consistency clay. Today, hand mixing clay will accomplish the goal, but mixing machines and pug mills will save labor and time when you require greater quantities of uniform-consistency, moist clay.

Whatever method is used, each clay platelet should be surrounded by a film of water with all the other raw materials in the clay body blended into a uniform mass for optimum plasticity.

A pug mill extrudes a compacted cylinder of clay.

These super sacks of dry clay require plenty of storage. While your studio mixing operation won't require these large bags, you still must plan space for raw materials and mixing equipment.

CLAY MIXER AND PUG MILL

The most efficient and popular way to mix clay is with a clay mixer and pug mill. Ceramics supply companies use both machines in their productions. Specific amounts of dry clay and water are blended in the mixer, and then the moist clay is placed in the pug mill and compressed by a mechanical screw. The compressed clay then goes through a chamber where the air is removed, and then the clay is extruded out of the pug mill nozzle in a usable condition.

The compaction of the clay causes a denser fired clay body. Compacted clay platelets fuse faster and more completely during the firing than noncompacted platelets. The extruded clay can average 20 percent moisture before it is placed in plastic bags.

FILTER PRESS

Dry clay body formula is mixed with excess water to form liquid slurry. It is then pumped into a series of absorbent leaf-shaped bags. As the bags are compressed, excess water is pressed from the liquid clay. The leaves of moist clay then can go onto the pug mill for further mixing and de-airing. In filter pressing, each clay platelet is effectively surrounded by water in the slurry stage. The water-soaking period produces greater plasticity in the clay than other mixing methods. The filter press procedure is costly and time-consuming for a ceramics supplier to use in producing moist clay. Individual potters would further incur higher production costs using the filter press method.

Mixing Tips

First, whether you've mixed your clay yourself or bought it premixed, any clay should be wedged before hand forming or throwing. That's because during pug mill extrusion, the direction of dry clay platelets is changed and disrupted. Wedging clay aligns the clay platelets for forming. As you wedge and discover clay's moisture level, you can make adjustments for softer or harder clay by adding incremental amounts of water or wedging the clay on an absorbent surface to remove excess moisture. Many ceramic pieces fail simply because the potter has not determined the correct moisture content for the specific project.

Second, whether you've mixed the clay yourself or bought it premixed, cover the moist clay completely in plastic and allow it to rest—or age—for several days before any forming operation. After mixing, the moist clay is pliable and plastic and can be bent into shapes. However, each clay platelet is not thoroughly wet, resulting in a lack of plasticity. (Though it's true that filter press clays do wet a higher percentage of clay platelets than other mixing methods.) If you wrap the clay in plastic and allow it to rest, a few days or weeks later, it will have most of the clay platelets saturated and surrounded with water, causing a greater increase in its plasticity.

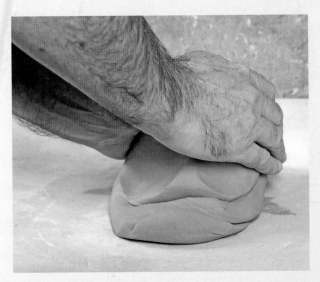

Wedging moist clay on an absorbant surface.

BUYING PREMIXED CLAY

When you buy premixed clay, you let the professionals take charge of what they do best: blend clays with the required amount of water under accurate quality-controlled conditions. Ceramics suppliers should be knowledgeable about the current track record of the contents of their clay body formulas and notice any irregular shipments from the mine. Suppliers want to stay in business and be competitive, so they try to keep their customers satisfied with a good product. By relying on suppliers to do what they do best—mix clay—you can concentrate on producing work to sell or show. The convenience of ordering ready-to-use moist clay cannot be overstated.

EVALUATE THE FORMULA

Premixed clay is only as good as the clay body formula and the quality-control practices of the ceramics supplier. An advantage of using a stock clay body is that many potters of various skill levels have already used it with acceptable results. This does not guarantee the clay body will perform well in every situation, but it does indicate better odds of a reliable outcome.

Ceramics suppliers list the stock clay bodies' names along with brief descriptions of handling and firing characteristics in oxidation and reduction atmospheres. Also listed are shrinkage and absorption figures at various temperatures and pyrometric cone ratings. Remember, all descriptive information is gathered from conditions that might not be

A ceramics supplier loads material into an industrial clay mixer. Many studios do not have room for large equipment, so ordering premixed clay is a space saver.

present in your own kiln. Your kiln size and firing cycles can change both shrinkage and absorption rates of the fired clay. Use the catalog description only as a guideline. Before purchasing a stock clay body, ask the supplier for the names of other potters who are using that clay. One or two phone calls will produce more information about the handling and firing qualities of the clay than the brief descriptions in the catalogs.

QUALITY CONTROL

Buying premixed clay reduces the quality-control aspect to one of monitoring the moist clay as it arrives in the studio. Check each batch for raw color, consistency, and fired results. Most potters do not have the time to take a small sample from each box of clay and fire it. However, any amount of testing before committing to a new load of clay is worth the effort. Here are a few things to keep in mind.

Buying premixed clay means relinquishing some control of the production operation. Because monitoring every aspect of production down to the smallest detail is impossible, the potter should carefully choose the areas where control is critical. Most ceramics suppliers regard their stock clay body formulas as proprietary information and will not reveal exact formulas. When problems with forming or firing occur, the cause can be difficult to track down because the clay body formula is unknown. Reputable suppliers will give any information on bad shipments of clays from the mine or mixing irregularities that might help in resolving the cause of the defect. In many instances, without the clay body formula, it becomes impossible to resolve problems. The potter must decide if the occasional mixing irregularities and loss of control are worth the advantages of premixed clay.

Buying premixed clay means being an informed consumer. Occasionally when a raw material is not readily available, the ceramics supplier will make a substitution. Always ask about any material substitutions before ordering clay. Over the years, many stock clay bodies change so much that very little is left of the original formula. As mines exhaust their supply of clay or, frequently, the clay is present but not economically profitable to mine, substitute clays have to be found. It is a challenge to incorporate the correct substitute into the formula without changing the working properties, fired color, shrinkage, and absorption qualities of the original. Do not assume that because the moist clay body's name stays the same that the formula does also.

Buying premixed clay is relying on another person or company to supply your studio with a vital raw material. As with any cooperative enterprise, problems occur and rational compromises have to be worked out to gain an objective. Some people cannot find a reputable ceramic supplier or do not want to compromise their requirements for moist clay. Continuing to use suppliers' premixed or custom clay bodies in such situations will only cause more problems. In short, some potters and suppliers cannot function together effectively. Recognize this situation, choose another supplier, or make your own clay, but do not remain in a problem-producing cycle.

Buying premixed clay can allow the potter greater flexibility in trying several different stock clay bodies. Many suppliers will give free samples of stock clay to potential customers.

TIP

Timing Clay Orders

Potters often wait to order a new batch of moist clay until their supplies are gone. At this point, production has fallen behind, and you might hurry to make new pieces without testing the clay first. If the new batch is defective, time and money will be lost. Try to time the next clay delivery while old clay is still available, then work the new clay into the firing schedule slowly. This planning will give some measure of insurance because a whole kiln load of work will not be based on a new batch of clay.

CHOOSING A CERAMICS SUPPLIER

Most ceramics suppliers carry a line of clays, ranging from low-temperature, white casting slips to dark stoneware for throwing on the wheel. Specialized blends of clay are frequently available for salt/soda firing, Raku, mid-range porcelain, and slip casting. The appropriate choice for moist premixed clay depends on several factors that are distinctive to each potter: forming method, firing temperature range, kiln atmosphere, glaze, and fired color. Ceramics suppliers usually have several different premixed clays within a given range.

Before you choose a supplier, ask other potters for their recommendations. For example, choosing a supplier that sells low-priced clay but doesn't have a good reputation ultimately can be very expensive, due to improperly mixed clay, random delivery schedules, lack of technical support, and substandard business practices. The price of a stock moist clay or private formula clay is really not relevant; the rate of defects produced by a given batch of clay is. (Ceramics suppliers for the most part do not keep these types of records, or if they do, they don't tell this to customers. However, other potters can relay their experience with a particular clay, helping you choose a clay body with a good result for others.)

Establishing a good professional relationship with your supplier has several benefits. The ceramics supply company's sales and technical staff can be an added help in obtaining information about premixed clays. They can offer advice on how other potters are using the clay and supply information on dry clays that are available for use in private clay body formulas.

Another thing to keep in mind when buying premixed clay is that your shipping costs will be lower from a supplier that is nearby. But keep in mind, the overriding consideration when choosing a ceramics supplier is not the cost or delivery charge, but the quality of the clay. Any small savings in choosing a clay just for its low price can be a negated if the clay formula is not sound or the mixing procedures inaccurate.

ORDERING MOIST CLAY

If you choose a local clay supplier, visit the clay mixing operation. This is a valuable opportunity to determine how seriously a ceramics supplier regards the clay mixing part of the business. Simple observations lend significant clues. Are the clay storage and mixing areas reasonably clean and well organized? Do the people mixing clay appear motivated and knowledgeable? Are any special cleaning procedures enacted when mixing white clays or porcelain? (They are easily contaminated with non-white firing clays.) What quality control measures are taken when different clay body recipes are mixed?

If you are not satisfied with your observations, look for another supplier.

Order Early and Often

Always reorder moist clay when only half of your current supply is exhausted. This will allow an opportunity to randomly test fire the new clay while you are still using a proven batch of old clay.

Also, keep careful records for each batch of clay, noting the production code on each box. A shipment containing several batches may have more than one production code. Most suppliers package moist clay in 50-pound (22.7-kg) boxes that contain two 25-pound (11-kg) bags of clay. The clay is packed in plastic bags, which are semi-permeable, and air will begin to harden the clay within a few months. Check the moisture content of clay in plastic bags periodically to ensure it has not hardened. If it has, spray some water on the clay and reseal the plastic bags. You might have to repeat this procedure several times to achieve a higher moisture content in the clay and a softer clay.

Report Problems Immediately

If you have problems with the premixed clay, report them immediately to the supplier, listing the production code and a description of the fault, and be prepared to send a sample of the defect for evaluation. Do not continue to use a clay—or any product for that matter—once you have encountered a problem, because this can constitute acceptance.

As a standard business policy, ceramics suppliers have limited liability on dry and moist clay, which means, at best, they will only replace the product if it is defective. Suppliers will not replace kilns, shelves, or posts damaged by defective clay. Nor will they compensate you for lost time or potential sales caused by defective clay.

Keep in mind that suppliers will replace clay only if it can be proven the clay was at fault and you did not cause the defect through improper forming, glazing, or firing. So for example, if you mistakenly fire a cone 06 (1828°F

Shrinkage and Absorption in Moist Clays

Obtain information on how the clay will look at your particular firing temperature and kiln atmosphere. The supplier will provide premixed moist clay descriptions, photos, and small sample chips of the fired clay.

Suppliers also publish shrinkage and absorption percentages for every moist clay they sell. Shrinkage and absorption percentages can give an indication of how a clay reacts when fired to its maturating range, but the percentages are most useful when comparing different moist clays fired in the same kiln.

Remember, these statistics are based on how the clay shrinks and absorbs water in the ceramics supplier's kiln, not yours. For the same reason, do not compare one company's shrinkage and absorption figures with another's.

[998°C]) clay body to cone 10 (2345°F [1285°C]), it is unlikely you will receive a free replacement batch of clay.

PRIVATE CLAY FORMULAS

When you buy premixed clay, you might discover that no ceramics suppliers' stock clay bodies meet your specific needs. Perhaps you need a private clay formula, a formula designed just for you. Some suppliers offer this value-added service. You find or create a clay body formula, which the ceramics supplier will then mix.

Bear in mind that when a supplier mixes a private formula, the supplier does not assume any responsibility for potential defects caused by the formula. You must feel confident that the private formula clay will work in the following respects: forming method, kiln atmosphere, glaze interaction, temperature range, and fired color.

Because it is not economical for a supplier to mix up a small test batch of private formula clay, there is usually a minimum amount required to fill the order, which can range from 1,000 to 2,000 pounds (about 450 to 900 kg). If a supplier mixes a small test batch, be prepared to pay for this special service. The fee is well worth it, because a ton of untested clay can be a very expensive test. If your supplier doesn't offer to sell you a test batch, mix your own test batch before committing to a larger quantity.

CLAY BODY FORMULAS

Clays that are formulated and mixed by potters or sold by ceramic supply companies are called clay bodies. A clay body is a combination of clays, fluxes, and fillers. Each serves a function to help determine forming characteristics, drying shrinkage, surface texture, fired absorption, fired shrinkage, glaze interface, and fired clay color.

Clay body formulas, as in cake-baking recipes, can encompass subtle variations, which bring distinctive forming and firing characteristics to the whole mix. For example, if a medium- to high-temperature clay body requires flux to help bring other materials in the clay body into a melt, there are many types of feldspar that could fill that requirement. However, you must decide which of the available feldspars will be appropriate for the clay body. The best clay body formulas contain appropriate raw materials and the correct ratios of clays, fluxes, and fillers to achieve their desired result.

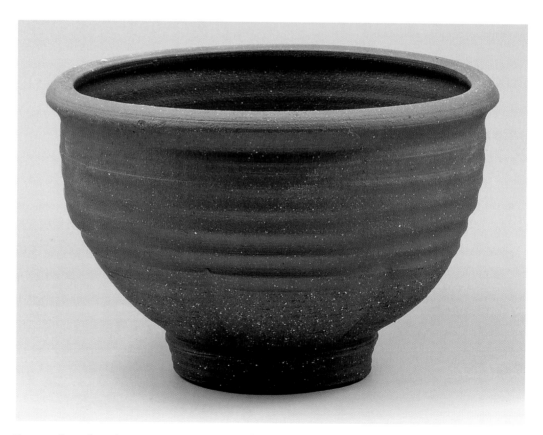

The use of metallic coloring oxides such as manganese dioxide, iron oxide, chrome oxide, and cobalt oxide can produce a dark-colored clay.

In a white clay body, cobalt oxide can produce a blue clay.

In a white clay body, chrome oxide can produce a green clay.

For a list of common clay body formulas, see page 284.

TYPES OF CLAYS

Clay, the first of the three essential ingredients of a clay body, is grouped depending on refractory qualities, particle size, oxide composition, loss on ignition, shrinkage rates, absorption rates, and other defining characteristics. The basic clay groups found in clay body formulas are fireclays, ball clays, kaolins, stoneware clays, bentonites, and earthenware clays. We'll go into further detail about ball and fireclays below.

Understand that not every clay group will be used in every clay body formula. For example, some earthenware clays, due to their relatively high iron content and low maturing range, would not be found in porcelain clay body formulas, which require low-iron-content, refractory kaolins to achieve their white fired color.

Within each major group of clays are subgroups that further define a particular clay characteristic, such as plastic kaolin (such as grolleg clay) and non-plastic kaolin (such as English China clay). Further, each group and sub-group contains many individual brand names of clay. Some of the many ball clays are Tennessee ball clay #9, Taylor ball clay, Kentucky ball clay OM #4, Zamek ball clay, Kentucky Special, and Thomas ball clay.

Each group of ball clays, stoneware clays, kaolins, bentonites, fireclays, and earthenware clays contributes specific attributes to the total clay body formula. Those qualities include particle size, green strength, fired strength, fired color, shrinkage, plasticity, deflocculating potential (also known as Zeta potential), texture, forming abilities, and low amounts of warping in drying and firing stages.

Ball Clays

Ball clays are characterized by their plasticity. The small platelet or particle-size structure of ball clays imparts great plasticity to the clay in the moist state. However, ball clays require large amounts of water to achieve plasticity. Plasticity and water can result in dry shrinkage, fired shrinkage, and warping. That's one reason why ball clays are not the sole component in any clay body formula. Another reason is because they can contain elevated amounts of carbonaceous matter, which aid in plasticity but can lead to burn-out problems in firing stages. Burn out is when carbonaceous matter is trapped in the clay body and begins causing carbon deposits in the clay body.

Ball clay is one component of a clay body formula that can contain other types of clays, feldspar, flint, and other raw materials. The raw materials determine the clay's eventual forming method, firing temperature, and fired color.

Relative Sizes of Clay Particles

Fireclay

Stoneware Clay

Ball Clay

Bentonites

Bentonites and ball clays have the smallest platelet size, followed by stoneware clays, kaolins, and fireclays. Earthenware clays can vary in platelet size depending on their individual location and the geologic forces used in their formulation. Generally, the platelet diameter of clays can range from 100 microns to 0.1 micron. (1 micron = 1/24,500 of an inch.)

Several common types of ball clay are used in clay body and glaze formulas. There are variations in particle-size distribution, organic content, and chemical makeup, along with other variables throughout this group. However, each clay has a data sheet that can offer information on its eventual use in clay bodies and glazes. Data sheets can be obtained through the clay mine or ceramics supplier. Ball clays vitrify at approximately 2000°F to 2200°F (1093°C to 1204°C).

Fine Ball Clays: A typical data sheet listing ball clays will indicate which clays have finer or coarser particle size distributions. Particle size can be charted on a graph, giving a fingerprint (or unique formula) for each ball clay. The distribution can be complex because all clays have particles as large as 100 microns and as small as 0.1 microns (1 micron = 1/24,500 of an inch). The number of particles in each range determines the overall fineness or coarseness of the clay.

Fine ball clays have greater plasticity and increased strength when dry, which makes them suitable for plastic-forming operations, such as throwing and hand building.

Finer clays can tighten a clay body structure, causing an exothermic reaction (releasing heat), preventing the oxidation of organic matter when heated in the 572° to 932°F (300° to 500°C) temperature range.

Coarse Ball Clays: Coarse ball clays are less plastic and better suited for casting slip clay formulas. Coarser ball clays allow water to "wick" through the liquid clay into the mold, building up an acceptable clay thickness in the cast piece. Coarse particle–size ball clays also allow the clay body to "firm" quickly, or develop durability after draining out the excess slip from the mold. The leather-hard piece can be handled faster when it is taken out of the mold. Coarser ball clays will contribute to greater durability and firmness in a cast piece when it is removed from the plaster mold.

Coarse ball clays also can be used in clay bodies that do not require the degree of plasticity needed in throwing bodies. Larger particle-size ball clay can be used in hand building, coil, Ram press, or dry press forming clay bodies.

Ball Clays for hand building and sculpture: The percentage of ball clay used in a clay body formula is directly

TIP

Ball Clay Quantity

Greater amounts of ball clay in a clay body formula can negatively affect the mixture in the following ways.

- Excessive dry shrinkage, fired shrinkage, and warping during firing/drying

- Cracking where thin and thick sections meet
- Unequal shrinkage and stress cracks, because thin sections dry faster than thick areas
- Moist clay that is sticky and deforms under pressure during the forming process
- Gelatinous quality that makes shaping difficult

related to the forming process. Ball clays are often used to increase a clay body's plastic qualities. The goal is to use enough ball clay for the degree of plasticity needed. The amount and type of ball clay used in hand building and sculpture clay bodies will depend on several factors, such as the forming method (coil, clay slab construction, pinch construction), clay body fired color, and the clay bodies' fired shrinkage and absorption rates.

The amount of ball clay used in hand building or sculpture bodies can range from 1 to 15 percent. Clay bodies intended for Ram press or dry press operations, where the clay is compressed by hydraulic forming action between molds, do not require significant percentages of ball clay. Because of the pressure put on clay during these forming processes, the clay body does not need to be especially plastic.

Clays for throwing: Ball clay adds much-needed plasticity to throwing clay bodies. The amount and type of ball clay used in throwing bodies can vary, depending on other clays in the formula, such as fireclays or stoneware clays. It can also depend on other ceramic materials in the formula, including feldspar, flint, talc, or grog. Generally, the percentage of ball clay in throwing bodies can be as low as 5 percent or as high as 30 percent of the total clay body formula.

When ball clay is not balanced with other materials in the clay body formula, your thrown pots will suffer. In higher percentages, ball clay can result in the moist body taking on water too fast when it is being thrown on the wheel. Excessive ball clay also can cause thixotropy, or deformation under pressure, as your fingers manipulate the form. The moist clay body may sag or sink, resulting in the inability to pull up tall forms on the wheel.

Ball Clays in glaze: Ball clays supply silica and alumina to glaze formulas, affecting raw glaze fit, glaze maturation temperature, glaze opacity, and glaze surface texture. Ball clays or other small "plate" structure clays, such as bentonites,

Moist clay can lack plasticity, which is often revealed by cracking along the edges when a slab of clay is rolled out.

help glaze materials stay in suspension. However, in some glaze formulas that require a clay component, ball clays can cause a clear glaze to fire semi-opaque or cloudy because they contain higher amounts of iron and manganese compared to kaolins, which are also used in glaze formulas. However, in opaque or colored glaze formulas, the metallic oxide concentrations in ball clays generally do not affect a work's fired appearance.

Ball Clays in casting slips: Most casting slip formulas consist of 35 to 50 percent ball clay. Coarser particle-size ball clays are better suited for slip casting than finer particle-size clays because they allow a thicker wall section to build in the mold. Ball clays in casting slips contribute green strength and plasticity in the pouring and drying stages. Green strength is the property that allows

the piece to resist mechanical shock. Plasticity is required in the casting process from the moment the body begins to shrink until the point it reaches the bone-dry stage. Some potters argue that plasticity remains even in the dry state and allows the piece to flex a little instead of breaking.

Fireclays: Another common clay found in clay body formulas is fireclay, named such because it is primarily associated with fire or heat. Fireclay contributes to particle-size variation, enhancing a clay body's forming characteristics. Fireclays enable the clay body to withstand high-temperature pyroplastic deformation, which can result in the clay body slumping, bloating, or fusing to the kiln shelf. Potters use fireclays in diverse ceramic products, such as floor and wall tiles, functional pottery, and sculptures.

However, fireclays should be carefully examined before adding them to a clay body formula. Fireclays are more likely to cause problems in the forming, drying, and glazing processes than ball clays and others, such as stoneware clay.

Fireclays are refractory and are able to withstand deformation temperatures above 3000°F (1648°C).

Fireclay consistency: Platelet-size distribution simply means how many small, medium, or large platelets are in a clay. The distribution of platelet sizes affects the texture, or "tooth," of the moist clay during forming operations. The shape of the platelets, their direction in relation to each other, and the colloidal water adhesion forces that bind them together also play a part in determining the handling characteristics of the moist clay.

Platelet-size distribution can influence plastic qualities, shrinkage rate, forming potential, and drying characteristics. Fireclay with a greater percentage of larger platelets will produce a clay body formula that is less plastic with decreased ability to bend when moist. Fireclays with a finer platelet size shrink more, have greater plasticity when moist, and take longer to dry. Mixing fireclay with feldspars, flint, and grog can mitigate fireclay platelet-size distribution side effects.

Contaminants in fireclays: Fireclays are the weakest link of the clays in a clay body formula because of contaminants, including carbonaceous materials such as lignite, peat, coal, and other associated tramp materials. Fireclays can also contain inconsistently sized particles of silica, iron, and manganese.

Technically, all of these negative (or unpredictable) qualities can be refined out of the clay. But fireclay is most often used by steel mills, casting foundries, and brick manufacturers, which can use the material with minimal processing in their forming processes. Potters represent less than one-tenth of a percent of sales. Therefore, manufacturers may not concentrate on filtering out impurities that cause problems in pottery forming.

The following contaminants are prevalent in fireclay.

Iron: Potters want small, random brown specks (0.5 mm to 1 mm in diameter) in the fired clay body. However, large nodules of iron (4 to 6 mm in diameter) in the fired body can cause outsized brown blemishes.

Manganese: Fireclays also can contain aggregate lumps of manganese, which can cause brown/black concave or convex defects in fired clay surfaces.

Lime: Nodules of lime can expand in the fired clay body as it takes on atmospheric moisture. The resulting half moon–shaped cracks in the fired clay body disrupt the surface. Lime nodules or gypsum formed alongside seams of fireclay or in pockets contained in the clay seam can range from pebble to fist size and can result in a clay body defect called lime pop. (See "Lime Pop" on page 92.)

Silica: The larger particles of silica in fireclay that convert to cristobalite will produce a larger expansion/contraction, exerting a greater pressure on the body during firing and cooling than small particles. Seemingly intact functional pottery with a buildup of cristobalite can crack later when heated in a hot kitchen oven due to cristobalite inversion in a similar cooling range. Cracks can occur anywhere on the pot and have a sharp edge, as though hit by a hammer.

Earthenware clays: Earthenware clays are characterized by their porosity between cone 010 and cone 02 (1657°F-2016°F [903°C-1102°C]). They can have high levels of organic material, which may cause the raw color to appear gray, green, or black even though they fire white or off-white. Some earthenware clay deposits have high levels of iron, which can fire to red or brown. Their particle size range and the plastic qualities vary depending on the individual deposit.

Stoneware clays: Stoneware clays have a medium platelet size compared to the fine platelets of ball clays and the

large platelets of fireclays. They are fairly plastic, and they have refractory qualities slightly below those of fireclays. They mature at a temperature between cone 6 and cone 12 (1222°F-2383°F [661°C-1306°C]). Stoneware clays vary in raw color, fired color, and plasticity. They compose a large percentage of high-temperature clay body formulas.

Kaolin clays: Kaolin clays have low iron content and are known for their purity and their white fired color. They are formed by the decomposition of feldspathic rock and are found in pockets rather than seams. Kaolins are very refractory, melting at temperatures higher than 3200°F (1760°C). They have a coarse grain that exhibits low shrinkage rates and little plasticity. As a group, kaolins are frequently used in porcelain clay body formulas.

Bentonites: Bentonites are the most plastic clays, have the smallest platelet size, and are formed by the weathering of volcanic glass.

This sharp-edged cooling crack in ware was caused by cristobalite inversion in the kiln. The wider part of the crack (right side) is where the crack started to form.

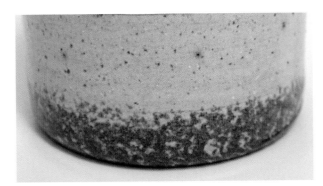

The chemical composition of fireclays can change from one shipment to the next. Fireclays can contain nodules of chalcopyrite ($CuFeS_2$) and erubescite (Cu_5FeS_4), releasing copper, which can cause green specks in the fired clay body.

Due to their small particle size, they have high shrinkage rates and can have high dry strength. Small additions of bentonite (1% to 2% based on the dry weight of the clay body) can increase the plastic properties of the clay body.

FLUXES

Fluxes are the second component of a clay body formula, and they are responsible for lowering the melting point of heat-resistant clays and fillers. Flux helps a clay body melt in a predetermined maturing range. In functional pottery, the maturing range occurs when absorption, shrinkage, and fired color are compatible with the glaze, producing a dense, vitreous nonabsorbent clay body.

Every temperature range has the appropriate choice of flux materials that will work compatibly with the raw materials and clays contained within the clay body. If a low-melting flux is used in a high-temperature clay body, the result is over-vitrification. An over-fluxed clay body can bloat, slump, shrink excessively, and fuse to the kiln shelves.

Feldspars are the best flux for clay bodies in medium- to high-temperature ranges (above cone 6, 2232°F [1222°C]). The three basic groups of feldspars used in ceramics are soda feldspars, potash feldspars, and lithium feldspars. Within the three groups, many individual feldspars can be chosen for a clay body formula. A beneficial quality of feldspars in medium- to high-temperature clay body formulas is their ability to enter into a melt slowly over a wide temperature range. Talc is sometimes used in stoneware clay bodies, but it can have active and fast melting characteristics if used in inappropriate amounts.

TIP

Mesh Size

The mesh size of the screen is a factor in determining the amount of contaminants that are allowed to pass through with the fireclay. A large, 20x mesh screen can allow greater quantities of tramp material or contaminants (twigs, stones, coal, or processing debris such as bolts, wire, and metal parts) to enter the final bag of clay. A smaller, 50x mesh screen that traps more contaminants will produce higher-quality fireclay.

FILLERS

Fillers, the third clay body component, reduce clay body shrinkage and warping in the drying and firing stages. The most widely used fillers include flint, pyrophyllite, silica sand, sawdust, mullite, calcined kaolin, kyanite, calcined alumina, and grogs of various sizes. The amount of filler used in a clay body formula depends on how you will form the clay. For example, clay bodies designed for slab forming and tile making usually have more filler or non-plastic material than throwing bodies. But, as with anything, there is a happy medium for fillers. If the amount of filler is too high, the clay body's plastic qualities are decreased.

Flint as a filler is often called a "glass former" and needs high temperatures (3200°F [1760°C]) to melt by itself. But when flint is combined with a flux, its melting temperature decreases. Flint reduces dry shrinkage and warping in the clay body. It also promotes glaze fit by contracting the clay body to match the contraction of the covering glaze layer.

CLAY BODY CHARACTERISTICS

Before mixing a clay body formula, it is important to first decide what parameters and conditions the clay body will encounter. Formulas can fail due to the inappropriate use of raw materials or an unsuitable use of the clay body formula. For example, a clay body formula using only ball clay, which is very plastic, can shrink, warp, and crack excessively in the drying and firing stages. Or, when a frit (low-melting glaze or clay body flux) is used in a medium- to high-temperature clay body, excessive glass formation can occur, along with slumping, bloating, and other defects in the fired ware.

Your first job is to decide on the correct mix of materials for your clay body. You do this by asking what characteristics will be essential in the clay body. Then, develop a list of criteria so you can choose the best raw materials for your application.

As you decide on raw materials for your clay body formula, ask these questions.

Wheel-Thrown Jar
See page 295 for formula

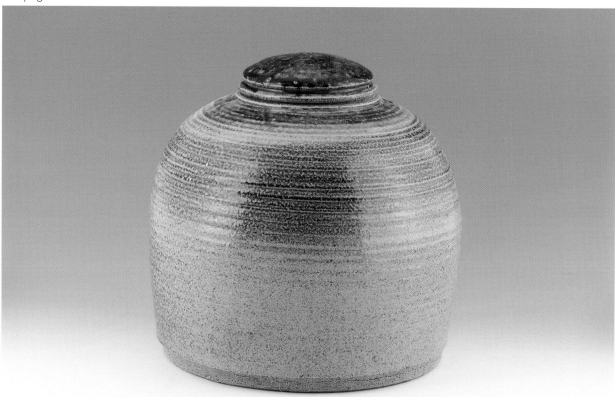

What is your forming method? Potter's wheel, slab construction, slip casting, Ram pressed, dry pressed, jiggered, or extruded—each method will require a specific combination of raw materials. For example, clay bodies used on the potter's wheel will require higher percentages of plastic ball clays compared to dry-pressed clay bodies, where the extreme hydraulic pressure of the press forms the object. Slip-casting clay bodies will require a deflocculating component, such as sodium silicate or Darvan #7—soluble electrolytes that create clay that can be poured. Some clay bodies can be used for more than one forming method; however, it is unusual to achieve optimum performance in each forming method.

What color do you prefer for fired clay? White clay bodies can be developed into yellow, blue, green, or other colors with the addition of body stains or metallic coloring oxides. Clay bodies that originate as brown can be developed into dark brown or black with the addition of high iron-bearing clays or metallic coloring oxides.

How hot will your kiln get? Clay bodies will act differently when heated. The higher the temperature, the less absorbent the clay body due to increasing vitrification.

What is your kiln atmosphere? A clay body can be formulated for oxidation, neutral, or reduction kiln atmospheres. In oxidation atmospheres, the air-to-fuel ratio is higher, causing a cleaner ignition to the fuel. In neutral kiln atmospheres, there is an equal air-to-fuel ratio. In reduction kiln atmospheres, the fuel-to-air ratio is greater, causing carbon monoxide to pull oxygen from the oxides contained in clay and glaze. In reduction kiln atmospheres, metallic oxides such as iron and manganese tend to flux the clay or glaze to a greater degree. Each atmosphere can influence the fired color, density, glaze interaction, and surface quality of the clay.

How available are raw materials? Before you develop a clay body formula (on paper), be sure all raw materials are available. Check with suppliers to ensure they still stock the feldspar you're seeking or the ball clay you want. If not, ask suppliers for logical substitutions for discontinued materials.

Clay Body at Work

Clay bodies are designed for various functions, including the following:

Sculpture: large scale and/or thick cross sections, low shrinkage and warping

Freeze/thaw conditions: allowing for expansion and contraction

Wood-fired kiln effects: shows random flashing effects of ash deposits on ware

Soda/salt effects: unglazed areas of clay reveal a glossy "orange peel" surface texture

Once-fired or raw glazing: clay allows for a compatible glaze fit and single firing

Porcelain: white clay color, translucent when thin

Flame ware: clay body exposed to direct flame in use

Functional pottery: durable, nonabsorbent, compatible with a wide range of glazes, can be used in indirect flame situations

Slip casting: a fluid clay that can be poured into plaster molds

Ram press: a clay body that can be formed by the hydraulic action of the press

Jigger/jolleying: a clay body that can be formed when a template is drawn against a spinning mold

Dry press: a low-moisture clay body formulated for extreme hydraulic pressure forming

TIP

Test Kilns

When increasing the flux component of a clay body formula, always shape test pieces and place them in a regular production kiln. Assume the clay body might fuse, so use extra kiln wash on the shelf. Firing clay and glazes in small test kilns can produce inaccurate results. Smaller kilns have faster firing and cooling cycles and less thermal mass compared to larger production kilns. In order to accurately conduct testing, it is important to reproduce the heating and cooling cycles in any kiln firing.

CLAY PLASTICITY

Two important factors determine moist clay's plasticity: the individual clay body formula and the amount of time it spends in the moist state. The forming process you plan to use (throwing, hand building, etc.) will determine how plastic your clay must be. You can increase clay plasticity with the following additives.

Bentonite: Bentonites are an extremely plastic group of clays, and they can enhance the working qualities of the clay body. Bentonites have very small platelet structures, which physically touch larger platelet structure clays in the moist mix. The small platelet size of bentonites also increases the water-film bonding of the entire clay water structure.

As a rule, never exceed 2 percent bentonite in a clay body. Otherwise, the clay body will become gummy when used on the wheel or in other forming operations.

Ball clay: Ball clays also have small platelet structures that increase the surface areas touching other clays and raw materials in the clay mix. Ball clays also increase the colloidal film action in the clay body.

Be sure that ball clay is less than 25 percent of your total clay body formula. Otherwise, the moist clay will take on water at a faster rate during the throwing process, resulting in the clay slumping and sagging during the last stages of forming on the wheel. (For more on ball clay, see page 47.)

Mold and other organic agents: Most types of mold growth in moist clay can increase plasticity because it augments the binding action and attraction of clay platelets. Enhancing the film of water between clay platelets with mold will increase the clay-to-clay attraction. One recipe to encourage mold growth in clay starts by mixing a 100-pound (45.4-kg) batch of clay formula. Add $^1/_2$ cup (118 ml) of beer, coffee, or apple cider vinegar, or 3 ounces (85 g) of yeast to start mold growth in the clay/water mixture.

Depending on the pH level of the clay-mixing water, the individual clay's organic matter, and the studio temperature conditions, mold can grow on the surface of moist clay. Most types of mold are beneficial, increasing the plastic properties of the clay. Simply wedging the clay will evenly disperse the mold.

However, if you keep moist clay long enough in a warm, dark place, it will grow mold without any additional organic materials being added to the mix.

Epsom salts: Adding Epsom salts (magnesium sulfate) will increase the attraction of clay platelets in the moist clay state, causing the clay to become flocculated. Add 5 ounces (142 g) of Epsom salt for every 100 pounds (45.4 kg) of dry clay formula (0.3 percent). Add Epsom salts to water before mixing with clay so it disperses efficiently. Clay platelets will draw together just like north and south poles of a magnet. The overall effect is a tight, plastic clay body with good throwing properties.

Note: Excessive levels of Epsom salts can cause salt migration to the drying clay surface, which will create a white powdery coating. The salt can result in blistering and carbon trapping in the fired clay.

Additive A: Additive A is a blend of water-soluble lignosulphonates and organic/inorganic chemicals that is a byproduct of the paper manufacturing process. When used in amounts of $1/16$ to $1/8$ percent of the dry weight of the clay, Additive A can increase moist clay plasticity without changing its fired shrinkage, absorption, or clay color. Additive A is produced in several versions, some of which contain barium in a safe, nontoxic form. Additive A in barium versions can eliminate scumming, which can occur when a moist clay body begins to dry, carrying soluble salts to exposed clay surfaces. The soluble salt layer (scumming) can fuse at high temperatures, creating a glass-like irregular surface on the clay. When glaze is applied over the scumming area, it can result in a glaze defect such as blistering. (See page 177.) Any type of Additive A, when used in a clay body, will increase plasticity and green strength without causing excessive shrinkage rates in the drying and firing stages, as with excessive additions of ball clay.

WATER AND PLASTICITY

The chemical composition of the water used in mixing the clay body can alter the plastic properties of the moist clay. The amount of water required to form the clay into a plastic mass is called the water of plasticity. The percentage of water required can vary with the individual clays and raw materials contained within the clay body. Some clay bodies, due to their high percentage of ball clay (small platelet sizes), might require 40 percent more water for plasticity than clay bodies containing higher levels of coarse fireclays (large platelet sizes). Stoneware clay body formulas require only 25 percent water.

If the water contains soluble salts of sodium or calcium, they can migrate to the clay surface in the drying stage, causing an irregular surface interfering with the subsequent glaze application. The soluble material forms a glaze, which can result in blistering and carbon trapping. Household water softeners can introduce sodium into the mixing water, which can alter the handling qualities of the moist clay body. Sodium also can cause deflocculating characteristics in the moist clay, resulting in very soft clay under forming pressure. Although the chemical composition of the water has a larger effect on slip casting clay bodies, do not overlook discoloration or soluble salt crystals that can occur when the clay body is drying. Also note whether the moist clay is too soft or rubbery in forming stages.

Note: Generally, the standard percentage of water by weight found in moist plastic clay bodies used on the potter's wheel or in hand building is 20 percent.

TIP

Raw Material Substitutions

When a clay or raw material is not available, choose a substitute from the same group of clays as the original. Fireclays, ball clays, stoneware clays, bentonites, kaolins, and earthenware are all common clay groups. The three basic groups of feldspar are sodium based, potassium based and lithium based. A feldspar substitution should come from the original feldspar grouping.

When possible, always test a one-for-one substitution. If this does not work, you'll have to recalculate the clay body formula.

MINING CLAY

To get an idea of where, exactly, clay comes from, let's take a photographic tour through Christy Minerals, located 50 miles (80.5 km) west of St. Louis, Missouri. This mine uses selective open-pit excavation to extract Hawthorn Bond fireclay. The top layer of overburden is taken away and the clay seam exposed. After carefully removing the clay, it is stockpiled and weathered for twelve to eighteen months, causing it to break down. The natural freeze/thaw conditions plus rain and sun hydrate and dehydrate the clay platelets, ultimately improving consistency and plasticity.

The clay is then transported to the plant, where it is dried and placed in a covered shed until it is ground to the appropriate mesh size. There are several grinding methods, depending on the desired grain size and distribution of the product. Finally, the material is tested for particle size distribution and placed in packaging ranging from 50- and 100-pound (22.7- and 45.4-kg) paper bags to larger 3,500-pound (1,588-kg) super sacks.

Raw clay is rarely taken from the mine site without some form of processing. More than 99 percent of clays are used by industrial and commercial sectors. Potters represent less than 1 percent of the total market, and their limited role affects the quality of clays they can purchase. Clays for commercial applications require a degree of uniformity and quality control, but not necessarily the same kind of processing that potters demand. Two machines used in the preparation of raw clay are the roller mill and the hammer mill.

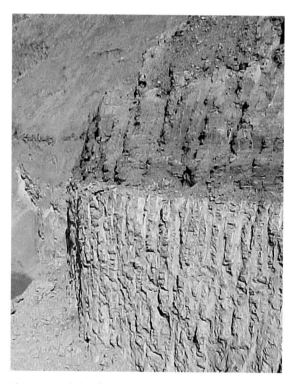

This exposed clay face shows overburden on top. The surface material—such as soil, branches, shrubs and other covering—is removed, exposing the various seams of clay.

Notice the different qualities of clay and higher-iron-content seams on top. Depending on the geological formation of the clay pit, the various levels can contain clays having different mineral, organic particle size, and tramp material content.

Mining clay for movement to processing plant. A careful survey of the clay field is made, plotting the different layers of clay. After that, clay is excavated from the various pits in a very precise manner and then taken to the processing plant.

The Roller Mill Process

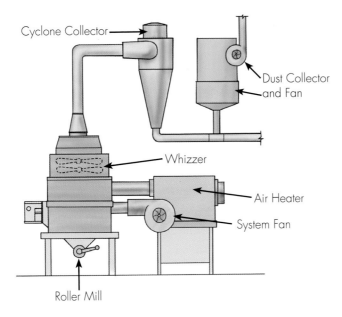

Cyclone Collector

Dust Collector and Fan

Whizzer

Air Heater

System Fan

Roller Mill

During the roller mill operation, some free moisture is removed from the clay and fed between a ring and a series of spinning rolls. Clay is ground and dried, then thrown between the ring and rolls. A stream of air lifts the finer clay particles up to a whizzer (fan blades). The faster the blades spin, the finer the clay particles need to be to pass through the whizzer. Once through the whizzer, the clay/air stream goes to a cyclone collector, where the clay is separated from air during the air-floating process. The clay then goes to a packer, where it is bagged and ready for shipment. Greenstripe is an example of a roller-milled air-floated fireclay.

The Hammer Mill Process

Crushed clay 2" enters mill

Rotating Hammers

Screen

Pulverized clay exits through screens

Clay crushed into 2-inch (5-cm) bits and smaller enter the hammer mill. Hammers rotate and pulverize the clay, which is then pushed through screens at the bottom of the mill. Screen size determines the mesh size of the clay and the size of possible contaminants processed with the clay. Hawthorn bond is an example of a hammer-milled fireclay.

TESTING CLAY BODY FORMULAS

Many potters, from novice hobbyists to veteran ceramic artists, have made the mistake of mixing a large quantity of clay from a given formula without testing a small batch.

Once you choose a clay body formula, mix an appropriate amount of moist clay for shrinkage and absorption testing. Ten pounds (4.5 kg) of dry clay body formula should yield approximately 12 pounds (5.4 kg) of moist clay. This will make six clay test bars, measuring 5" x 2$\frac{1}{2}$" x $\frac{1}{4}$" thick (12.7 cm x 6.4 cm x 6 mm), allowing for plenty left over for forming sample pots. These pots are then used for a test firing. It's better to create larger test pieces that give a more accurate representation of the clay body. Also, test the clay in multiple firings with many glaze combinations to ensure the clay body formula's reliability.

Test firings will ensure that the raw materials in your clay body act as planned. We discussed earlier the problems that adding too much or too little of a material can present during the firing/heating process—or during forming, for that matter. Not every kiln produces an even atmosphere or temperature. Placing test pieces in various locations within the kiln will offer an accurate indication of the clay body temperature range and color variation caused by the kiln atmosphere.

Fired clay bars ready for an absorption test

TESTING FOR FREEZE/THAW CONDITIONS

When ceramic forms are placed in freeze/thaw conditions, they can fracture and spall (chip due to internal stress). Think of what happens when you leave a favorite flowerpot outdoors during winter. Strong environmental forces are at work, and the pot cracks as a result. Why do clay bodies exposed in more temperate climates remain stable and intact? What are the factors causing freeze/thaw failures, and how can we eliminate them?

Most materials shrink when frozen. However, water expands because of the formation of ice crystals. The open-pore structure of fired clay traps atmospheric moisture by capillary action, in the form of rain, snow, and humidity. Upon freezing, ice crystals expand in the confined, unyielding pore structure of the clay, causing cracking or chipping.

Moisture retained in the fired clay can come from water

You can use a few different methods to determine a clay body's likelihood to crack, and therefore leak, in freeze/thaw conditions: the Standard Absorption Test, the American Society for Testing and Materials (ASTM) test, or a simple pinch-pot test, which is a less-formal method. We'll talk about each of these in turn.

This earthenware flower pot cracked because of freeze/thaw conditions.

in the atmosphere, from the pottery being used in a dishwasher, and from any cleaning procedure. Moisture can also accumulate in clay bodies that are used to store food or liquids. As stated, if a clay body contains the appropriate materials and is fired to its maturity, it can have a low absorption percentage or zero-percent absorption and will not subsequently leak. It's important to note that the relationship between clay body shrinkage/absorption and glaze fit determines if a glaze will be stable once it is fired on a clay body.

Testing Kiln Atmosphere

With hydrocarbon-based fuels (natural gas, propane, wood, oil, coal, sawdust), the kiln can be manipulated to produce oxidation, neutral, and various intensities of reduction, all of which can affect clay body color. Oxidation atmosphere in hydrocarbon-based fueled kilns can cause variations in clay body color when compared to oxidation atmospheres produced in electric kilns. This is because of impurities in the hydrocarbon-based fuel and water vapor present during the combustion process. Reduction kiln atmospheres also can cause increased clay body vitrification, because the metallic coloring oxides contained in the clay body are subjected to increased melting.

In electric kilns, the uniform oxidation atmosphere causes little or no variation in clay body color. Still, temperature variations could affect shrinkage and absorption of the fired clay body. Higher temperatures can flux (melt) metallic coloring oxides in the clay body, causing darker fired colors along with increased vitrification.

STANDARD ABSORPTION TEST

This test measures the percentage of water entering a fired clay body when it is soaked and boiled in water. This test replicates how the clay body will react in natural freeze/thaw environments. During this test, the pores of the clay body absorb water. The clay is soaked in water for 24 hours, then boiled in water for 5 hours.

Consistency of the technique when performing this test is vital to arriving at an accurate absorption rate. The same person should conduct each clay's test, and the test should be repeated to check the results. The absorption percentage should be the same for each test.

Equipment

- Fired test clay bars
- Scale accurate to $\frac{1}{100}$ of a gram
- Container to boil water
- Calculator
- Damp, lint-free towel
- Metal pin stilt
- Container

Instructions

① Make at least five test bars that are $\frac{3}{8}$″ (10 mm) thick, 1″ (2.5 cm) wide, and 5″ (12.7 cm) long from the same clay you will use for your outdoor ceramics project. Averaging the absorption percentage of several bars will ensure testing accuracy. The bars should be free of cracks, indentations, or surface blemishes that could trap water when the fired clay surface is dry. Round the edges of the bars to prevent chipping. Any small change in weight from imperfections can result in a significant error in the final calculation. To ensure accuracy, space out the bars and fire them in the same kiln, selecting the identical kiln firing cycle and stacking arrangement you will use with your project.

② After firing the test bars, each bar is placed on the scale and carefully weighed. The exact amount is written on a notepad.

③ Place the test tile on pins inside a container, then fill with tepid water. Soak the test bar for 24 hours. Then, wipe off the tile with a damp, lint-free towel. Carefully weigh the test tile.

④ Now, boil the tile for 5 hours. Use a large enough container so the water does not boil off. Also, check the boiling water level periodically to ensure water is present in the container. Wipe the tile off again with the damp, lint-free towel. Carefully weigh the tile and record the measurement.

⑤ Calculate the absorption percentage by using the following formula:

[wet weight − dry weight]/dry weight = absorption percentage of 24-hour soaking absorption

[wet weight − dry weight]/dry weight = absorption percentage of 5-hour boiled water absorption

Compare the percentages between the 24-hour soaking absorption and the 5-hour boiled water absorption:

24-hour soaking absorption percentage/5-hour boiling absorption percentage = the ratio of soaking absorption to boiled water absorption

The above calculation, the absorption rate, should be less than .78 percent, which would make it safe for freeze/thaw conditions.

FOR EXAMPLE:

(96 g [wet weight] − 93 g [dry weight])/93 g [dry weight] = 0.03 or 3%

(97 g [wet weight] − 93 g [dry weight])/93 g [dry weight] = 0.04 or 4%

0.03 divided by 0.04 = .75

This absorption testing procedure used by the ASTM is as effective as the standard test described earlier.

Step ① Fired clay bars lined up for an absorption test. It is always best to test more than one bar and use the average absorption percentage for a more precise calculation.

Step ③ Place the test tile on pins inside a container, then fill with tepid water. Soak the test bar for 24 hours.

Step ④ Boil the tile for 5 hours. Carefully dry each test bar before weighing

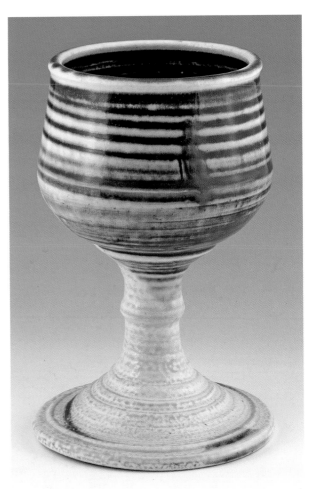

Wheel-Thrown Goblet
See page 291 for formula

Equipment
- Fired clay
- Scale accurate to $1/100$ of a gram
- Container to boil water
- Calculator
- Damp, lint-free towel
- Metal pin stilt

Instructions

① As in the standard absorption test (see page 80), create fired test bars. Weigh the bars and record the measurements.

② Place the bars in boiling water for 5 hours. Then turn off the heat, and let the bars soak for 24 hours.

③ Remove the bars from water and carefully wipe all sides with a lint-free towel. Be sure to remove excess moisture from every facet of the clay bar, without wicking any moisture from the bars' surfaces.

④ Immediately weigh the bars.

⑤ Calculate absorption using this formula:

(saturated weight − dry weight)/dry weight x 100 = percent absorption

The absorption test bars should be smooth on each of their six sides. An indentation or void in the surface can trap water, which will alter the test results.

THE PINCH POT ABSORPTION TEST

In addition to the ASTM test and standard absorption testing techniques described, you can perform a pinch pot test to determine the likelihood of water leaking from a fired clay body.

Equipment

• Fired clay

Instructions

① Make several pinch pots and place them, unglazed, throughout your kiln.

② Fire the pinch pots with other pottery in the kiln, and fire to the clay body's maturity.

③ Once pots are out of the kiln, fill them with water and allow them to stand for 24 hours on a nonabsorbent surface. If you notice moisture under the pots the next day, the clay is absorbing water and leaking.

CORRECTING ABSORPTION PROBLEMS

There are several corrections to solve absorption problems, such as firing the clay to a higher temperature, firing the clay over a longer time period, or adjusting the clay body formula by increasing the amount of flux materials (feldspar). The type and amount of additional flux will depend on the firing temperature of the clay body. If you are using a commercial clay, simply purchase a different clay body. This is a safer bet than adding materials to a supplier's clay body formula. (You don't have the exact recipe, so you could do more harm than good by mixing in additives.) Many ceramic suppliers sell several clay bodies in each temperature range.

Most important, remember when buying a clay body from a ceramics supplier to test several clay bodies at one time for shrinkage, absorption, and glaze fit before committing to an individual clay body for use in functional pottery or sculpture.

These fired unglazed pinch pots containing water show the right bowl leaking over 24 hours. When performing this test, assume that if one bowl leaks and the other bowls hold water, the reason could be a different amount of heat treatment in the kiln. Because it might be difficult to fire the kiln evenly, adjust the clay body or use another clay body formula.

A bisque-fired cup (left) compared to a higher-temperature glaze-fired cup (right). Notice the increased shrinkage in the glaze-fired cup due to clay body vitrification.

The shrinkage-test clay bar determines the fired shrinkage of the clay. The moist clay is measured and marked at 10 centimeters (not shown). After the clay bar has been fired to maturity or vitrification temperature, the clay has shrunk by 1.5 centimeters or 15 percent (8.5 cm on plastic ruler scale as measured by vertical black line drawn in clay bar).

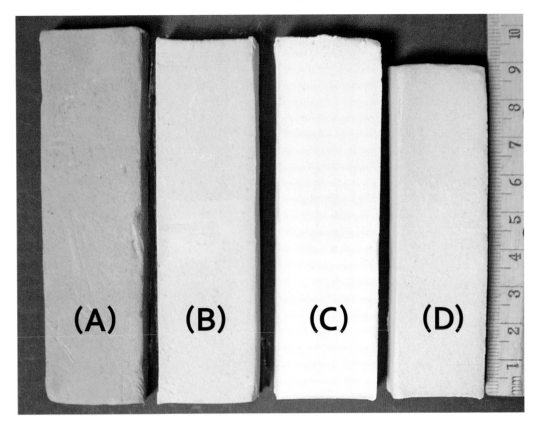

(A) Moist clay bar; (B) Bone-dry clay bar; (C) Bisque-fired clay bar; (D) Bar fired to cone 9 (2300° F [1260°C]) with total shrinkage rate of 12 percent.

INTERPRETING ABSORPTION AND SHRINKAGE

Both clay shrinkage and absorption cause significant changes in the ceramic form as clay dries and is eventually fired to maturity. The bars pictured here represent the same clay body in leather-hard, bone-dry, bisque-fired, and fired-to-maturity stages. With higher temperatures, increased vitrification occurs in the clay body causing greater shrinkage and lower absorption.

Bar A: Moist clay was rolled out into a slab 3.9″ (10 cm) long.

Bar B: A bone-dry bar that still contains atmospheric moisture and chemical water.

Bar C: This bisque-fired clay bar was heated to cone 06 (1828°F [998°C]) and has an absorption rate of 14 percent. With such a high rate of absorption, it will leach water; however, it will be ideal for the absorption of a glaze application. The shrinkage rate is 7%.

Bar D: The bar was fired to cone 9 (2300°F [1260°C]) and has an absorption rate of 1.5 percent. Ceramic forms made from the clay fired at this temperature will hold water because of the relative nonabsorbency of the clay body. Clay bodies approaching zero-percent absorption, which can be beneficial in the translucent quality of porcelain, can develop too much glass and become brittle. The shrinkage is 12%.

TESTING FOR CLAY SHRINKAGE

Moist clay shrinks and loses moisture over time. Most commercially prepared clay bodies have a "storage life" of one year. Once the clay is formed into an object, the drying process continues. However, clay is only truly dried out after it has been fired in the kiln.

Firing conditions also can cause clay shrinkage. If clay is heated too fast, steam will develop, causing the clay to crack or explode in the kiln. While this violent reaction is not strong enough to damage the kiln, it can ruin adjacent pots in the kiln. Clay also shrinks as higher temperatures trigger glass formation within the clay. If the temperature increases beyond the clay body's maturity range, excessive glass formation overtakes the clay, resulting in deformation of the ware.

The shrinkage rate for a clay body is important when making wall or floor tiles, which can require exact dimensions for installation. It might also be useful to know the shrinkage rate when calculating whether functional objects—such as plates, casseroles, covered jars, and cups—can fit inside kitchen cabinets or dishwashers.

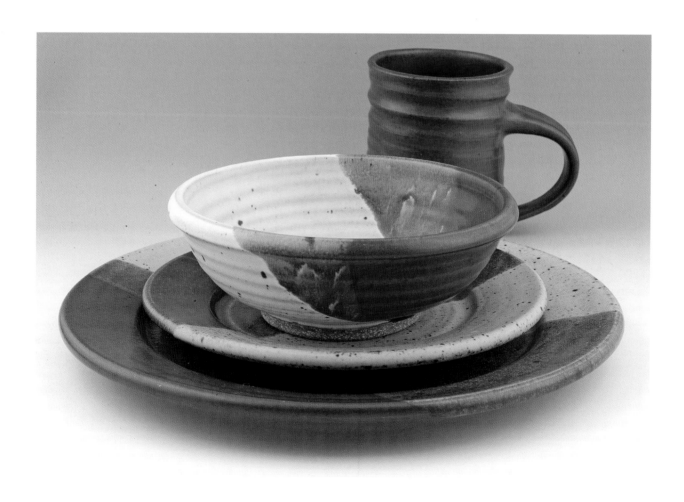

THE SHRINKAGE TEST

Here's an easy way to test for clay shrinkage.

Equipment

- Moist clay bar
- Needle tool
- Ruler

Instructions

① Start by creating 6 test bars at least 4"x 2" x ¼" (10.1 cm x 5.1 cm x 6 mm) You'll take the average shrink rate of these bars to get the most accurate shrinkage measurement.

② Measure 3.9" (10 cm) from the edge of each test bar and draw a line using a needle tool. Allow the test bars to dry naturally until they feel bone dry. Remeasure this space (10 cm before fired). The difference indicates the clay's dry shrinkage.

③ Measure 3.9" (10 cm) from the edge of each test bar and draw a line using a needle tool. Fire the test bars in the kiln and remeasure this space (10 cm before fired). The difference indicates the clay's fired shrinkage.

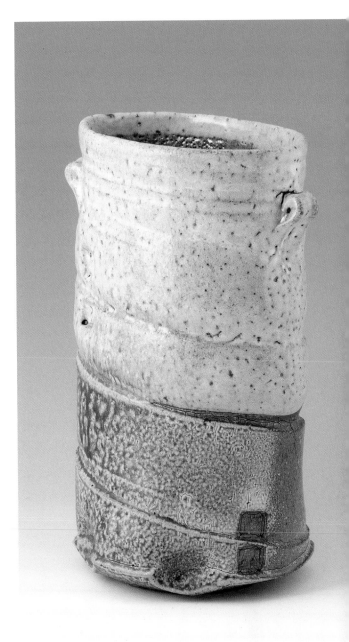

Thrown Cylinder by Tom White
See page 289 for formula

TROUBLESHOOTING CLAY IMPERFECTIONS

Manufacturers' catalogues list clay's shrinkage and absorption percentages near the rated firing temperature of the clay. Percentages are best when compared with the shrinkage and absorption rates of other clays. They less accurately determine the exact shrinkage and absorption rate for the clay in your own kiln. The ceramic supplier's kiln could be fired at a slower rate of temperature increase. All of these factors cause more or less melting in the clay and a higher or lower absorption rate. Allow for a deviation of plus or minus 1 percent when testing absorption rates yourself.

Imperfections can be introduced into a clay body during the mining, processing, packing, or shipping processes. Potters have found everything from roots and stones to cigarette butts and keys in raw clay. Even in careful mixing operations, objects can find their way into clay. In general, foreign objects in clay indicate poor quality-control procedures on the supplier's end.

Imperfections can result during the mixing process (marbling of moist clay and jelly roll lamination resulting in spiral cracking in the moist clay), such as variations and inconsistencies of organic materials mixed to produce a clay body formula. This chapter addresses common imperfections in premixed clay and their basic fixes.

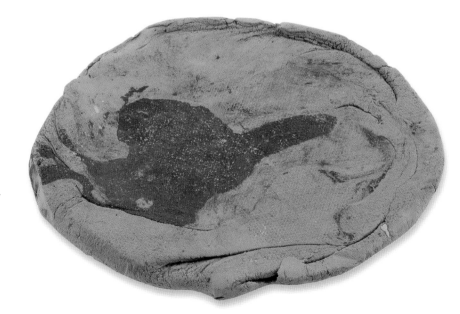

Marbling in moist clay can occur when the raw materials are not well mixed. Depending on the raw materials used in the clay body formula, the marbling effect may be visible in the fired clay body.

FOREIGN OBJECTS

Ceramics suppliers have reported gloves, bolts, feathers, rocks, nuts, roots, wood, and cigarette butts in raw clay shipped from the mine. Anything that can be found on a clay loader—jewelry, shoes, even a wallet—can crop up later in raw clay. Potters working in their studios should remove any foreign objects from their moist clay before beginning any forming operations.

MARBLING

If two different clay body formulas are not separated during the mixing process, they can combine during any stage of the process and cause a marbled effect in the moist clay. Marbling can also occur when a clay body is not allowed to mix sufficiently in the clay mixer, producing an inconsistent batch of moist clay.

When clay is extruded through the pug mill (mixer), fragments of the clay body previously passed through the mill can enter the current clay mix. If the preceding clay is the same temperature range, a discoloration is evident when the clay is at its maturing range. If the preceding clay happens to be a lower- or higher-temperature clay, the contamination can result in a fired clay with fluxed (melted) or overly refractory (cracked) areas. Finally, if one of the clays mixed in the clay body formula has a higher level of organic material, this inconsistency will show up in the form of marbling.

JELLY ROLL LAMINATION

Under certain pug mill conditions, the resulting mixed clay can exhibit a circular series of fault lines. The concentric shear lines look like a cross-section of a jelly roll cake. The defect is produced by the auger blades in the pug mill that create a rubbing action, separating the coarse and fine particles in a clay mix. The auger's rubbing action causes an effect similar to troweling the top layer of wet cement so fine particles migrate to the surface. Bend a thin slice of clay, and you'll see the concentric ring pattern. The defect occurs because of the combination of particle sizes in a clay body and the speed with which clay moves through the de-airing chamber of the pug mill.

One way to prevent jelly rolls is to slow the auger and thus clay movement through the chamber. Some clay bodies can tolerate fast speeds through the chamber, but others cannot. Ultimately, the side effect potters experience because of jelly roll lamination is uneven particle distribution, which results in cracking in the drying, bisque-firing, or glaze-firing stages.

Here, a low-temperature red clay is mixed with a high temperature stoneware clay. This combination can cause discoloration in the fired clay and significant fluxing action when the clay mixture is fired to high temperature.

Always wedge clay before forming to equalize the moisture content of the clay, and thoroughly mix any shear lines created by the extrusion process, which will prevent a jelly roll lamination crack in the drying or firing stages.

CONTAMINATED GROG

Grog is added to moist clay bodies to increase the "tooth," or stand-up ability of the clay in the throwing or hand building process. Grog also reduces the rate of dry and fired shrinkage and can add texture to the clay body surface.

Grog can either be mined as a virgin material, which contains high amounts of alumina and silica, or it can be crushed from reprocessed firebricks. Depending on the firebricks' original use, the grog can include contaminants that cause green specking in the fired clay body. While this is rare, it is always best to use virgin grog in the clay body.

The particle-size distribution of grog can shift, depending on the care with which it is processed. Coarser grog will make moist clay feel gritty, and large particles of grog may disrupt the surface texture of the clay. Finer grog particles can make the moist clay feel gummy and lacking "tooth."

A jelly roll lamination is revealed in the extruded clay. Always wedge clay before forming it to disperse uneven particles.

Lamination patterns in a clay extrusion.

RAW AND FIRED CLAY COLOR DIFFERENTIATION

Individual materials used in the clay body formula can determine its moist color but not always its eventual fired color. The raw color of a clay body can differ considerably from its fired color, depending on the organic materials and sulfates found in any of the clays or raw materials. Metallic coloring oxides found in clays, such as iron and manganese, also can influence raw and fired color.

Firing a clay body will drive off organic materials and sulfates. Clays high in organic content can appear almost black and, with the correct firing procedure, fire out to a bright white. Raw fireclays range from light gray to brown, depending on their organic and sulfate levels. Raw ball clays, depending on their lignite content, range from cream to gray. High sulfate levels in ball clays can give them a yellow cast.

A raw material left out or added (a mixing error) in an extra quantity could change the raw color of the moist clay and the clay body's handling and firing characteristics. If a refractory fireclay component was left out of the formula, the clay body might become extremely plastic and gummy, causing it to slump or melt in the firing stages. If dark iron-bearing clays were mistakenly used in the clay body, it would be revealed in white or porcelain clays only after they have been fired.

If your moist clay is colored differently than usual, be sure to create test bars and fire the moist clay, to see if the fired color is correct.

Opposite: Wheel-Thrown Raku-Fired Vase by Steven Branfman
See page 293 for formula

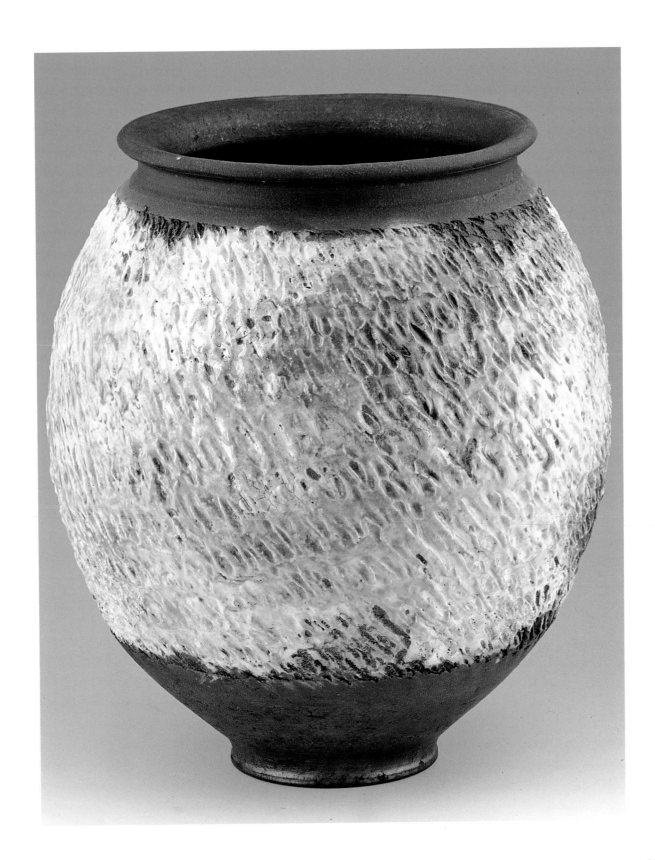

Spotlight on Lime Pop

Lime pop occurs when moisture in the air comes into contact with a carbonized lime nodule, causing its expansion in an unyielding fired clay body. This can occur when the pottery is removed from the kiln. It can also happen years later, as lime expands (in the form of calcium hydroxide). Lime pop is a semi-elliptical 1/8- to 1/2-inch (3- to 13-mm) crack in low-temperature bisque or high-temperature fired ware. A conical hole reveals a black or white nodule (lime) at the bottom.

If lime is present in the clay body as a powder, the forces of expansion are not sufficient to crack the clay. In low-fire white clay bodies, powdered limestone (composed of more than 80 percent calcium or magnesium carbonate) is often added to prevent glaze crazing (see page 182).

When used in earthenware glazes, large percentages of lime can cause crystal growth. In high-temperature glazes, limestone in powder form acts as a flux, causing other glaze materials to melt.

Limestone contamination in moist clay comes most frequently from plaster wedging tables or plaster bats. Soft or brittle plaster nodules of greater than 1/2 mm can enter the clay body during wedging or the reprocessing of scrap clay. Eventually, plaster will degrade, causing the moist clay to grab particles from the weakened plaster surface. To counter this type of mishap, staple a canvas cloth on top of the plaster wedging board and inspect plaster bats for any soft spots or concave areas.

Lime Pop Diagrams

Top View: Half-moon shaped crack with lime nodule at bottom of conical hole.

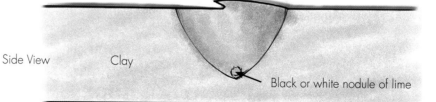

1/8" to 1/2" (3 mm to 1.3 cm) hole in clay surface.

Side View Clay

Black or white nodule of lime

A white lime nodule at the bottom of a conical hole in the bisque-fired clay body. Note any white specks in dry or moist clay, which can be an indication of limestone particles. If only a few hard white nodules are found in the clay, simply remove them to prevent a potential lime pop.

This cross-section of a fired clay body shows voids that contain a white particle of limestone.

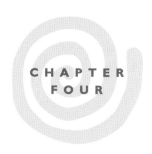

PRELIMINARY
CLAY TECHNIQUES

As you experiment with clay, you will enjoy learning the basics of clay preparation and manipulation. Every step is important to the process; there are no shortcuts when working with clay. Timing is crucial when working with plastic clay, drying clay, and firing clay. Generally, if the clay is provided an environment that is conducive to a slow transformation, it will come through the forming, drying, and firing stages without incident.

If the steps are rushed, however, there will usually be signs of stress on the clay such as slumping and deforming during the forming process, cracking during drying, or exploding or melting during firing. All of this can be avoided with patience and attention to the clay's consistency.

Clay bodies that are prepared at a clay facility are blended in industrial mixers then extruded through a pug mill to form logs of clay that can easily be weighed, packaged, shipped, and used right out of the bag. Commercially packaged, corrugated boxes of clay should be stored in a dry space, such as a palette on a garage floor or on a sturdy shelf, so that cardboard boxes can be stacked and maintain their structural integrity.

Buying clay in bulk is more cost effective, but until you are committed to using a particular clay body, it is best to buy only a few more boxes than you think you will use for your starter projects. This will prevent your studio from being filled with unused clay boxes.

Clay's tactile nature informs all styles of pottery making.

MANAGING CLAY CONSISTENCY

The previous chapter addressed clay's plasticity, which is especially important as you begin to work on projects. Clay should give easily to hand pressure but not be sticky. If the clay is sticky, roll it into arches and leave it to air dry for a while or wedge it on a plaster slab that will absorb moisture quickly. If the clay is stiff and hard to wedge, try wrapping it in a wet towel, then in plastic, and leave overnight. It should be easier to work with by the next day. If the clay is really hard, soak the entire quantity of clay in a bucket of water for 8 to 10 hours and then proceed to wedge.

Another way to achieve a desirable consistency is to wedge slightly stiff clay with soft clay, creating a mixture. With a little elbow grease, you will be able to control the consistency of your clay and it will make the forming process much more rewarding.

WEDGING

Before forming clay, it is important to wedge (or knead) it for several reasons.

Clay is wedged to create a homogenous mass of clay of uniform moisture content. Sometimes clay that has been in storage is stiffer in the center than at the surface where moisture condenses.

Conversely, clay that has been set out to dry in arches may be stiffer on the surface than at the center.

Clay is wedged in order to align particles. Clay particles are flat and held together by water. Through the action of wedging the clay particles become aligned and charged by the water that is bonding them to make it plastic. Wedging makes the clay easier to manipulate and the fiber of the clay stronger and removes air bubbles.

Aside from rendering a homogenous clay mound, a key component of wedging is to remove air bubbles. For that reason, it's imperative that you not fold air into the mass of clay. Sloppy wedging will trap air and make throwing on the wheel very difficult.

There are many ways to wedge clay and all styles take some practice to master. All involve layering and compressing the clay through some kind of rotation or pounding. This text will show one technique, called spiral wedging.

Spiral wedging is believed to have originated in Asia. It has a beautiful shell- or flowerlike shape that results from the rotation of clay on the point of the cone. The dynamics of spiral wedging allow even a small-framed potter to wedge a significant amount of clay without too much effort because of the momentum that develops as the rotation progresses.

The photographs on the next spread show the proper hand position of movements. Read through the steps, try one position after the other, then string all of the movements into a continuum of motion. You will find as you get better at wedging that the clay will move in a rocking motion. It will require some muscle, but the clay should be partially displaced and shaped by the rotation of the clay itself. Wedging clay should not require too much effort, but it does take some practice to master.

The wedging table should be at knuckle height so that you're in the best position to use your shifting body weight in the rotating process.

After wedging, clay will stay workable for a few hours if kept in plastic. If left out it begins to stiffen up, even from the underside on the ware board. Kneaded clay should be rewedged if unused within a few hours.

Avoid taking shortcuts when preparing clay because they tend to make the forming of clay more difficult. Remember that wedging clay will establish strength in the body by aligning particles with water through compression and spread moisture to create a homogenous mass. Poor wedging will add air bubbles and weaken the integrity of the clay thus making the clay difficult to work with.

SPIRAL WEDGING

Wedging motion and the rotation can be like a little dance. It is a good workout and an opportunity to assess the consistency of the clay that is going to be shaped. If the clay is very soft, it may be best suited for shallow wide forms, but if it's a little stiffer, it might be good for larger vertical forms.

TIP

Plaster and clay don't mix. If plaster particles get mixed into the wet clay, they will cause blemishes in the fired piece and may even cause a piece to break. To keep plaster particles from getting into your wet clay, use plastic tools to remove excess clay from plaster surfaces. Metal tools are too sharp and will loosen plaster particles.

WEDGING CLAY

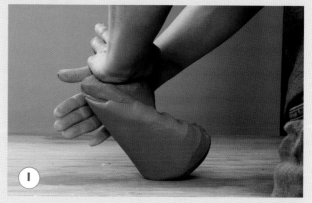

1. Place your clay slightly to the left of your body and think of an ice cream cone. Place your left hand on the top of the "ice cream" mound. The left hand will always stay on the top of the mound and pivot the clay around on the tip of the cone. The right hand will drive the displacement of the clay.

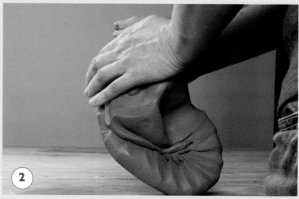

2. Place the right hand over the clay diagonal to your body covering part of the ice cream ball and the cone. The left and right hands will work together to roll the clay forward and push down. The right hand will be doing most of the pushing using force from your upper body. Thumbs can touch, forming an upside-down V and then come together side by side.

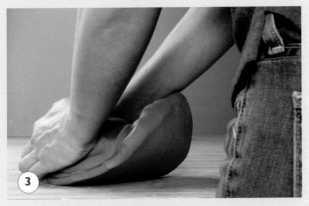

3. Some of the clay from the cone will be flattened on the table. Repeat the steps of rolling the clay away, up, and toward you. Now try and connect all the movements to create a rhythmic rotation of the clay.

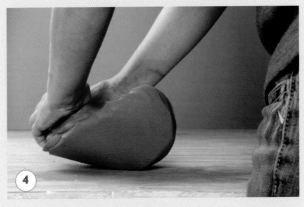

4. Keep your hands toward the top of the cone. A shell pattern should develop underneath your hands. If clay is displaced with too much force, there will be too much clay on the table that will trap air when folded. Work the clay gradually into shape through the rotation without excessive force.

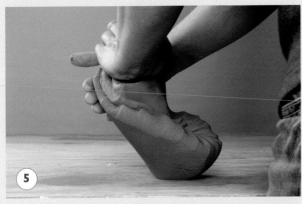

5. The clay will tighten slightly as it is wedged. When it tightens, it is ready to be formed into a cone. As you rotate with the left hand, lower the right hand each rotation until the shell pattern is integrated into the mass of clay.

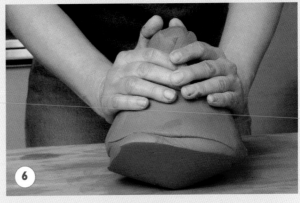

6. Place the cone spirals side down on the table with the fold/seam on your right. Place both hands on top on both sides and rock the clay around and around to flatten and compress the spirals. This will eliminate uneven clay and air bubbles at the base.

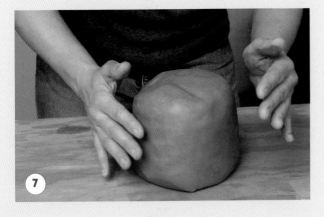

7. Keep the clay fold on the right side. Tamp and roll clay to form a cylinder. Mark the right side where the fold was. This mark will indicate the top of the mound when you work on the wheel. It is the weakest part of the wedged clay, and if it's placed on top it will receive the most compression through the action of centering. For hand building it will not be as important, because the clay will be compressed by slab, coil, extruding, or pinching methods.

⊚ Properly wedged clay is very plastic and able to stretch without showing signs of stress.

SHRINKAGE AND DRYING

The water contained in a plastic clay will evaporate during the drying of a piece, causing the clay to shrink and shift shape as it moves from the plastic to leather-hard to bone-dry stages. It is important to consider the size of the work, the effects of gravity, and the humidity in the studio.

One way to control the drying is to cover your work with plastic dry cleaning bags. They are light and can be layered to maintain moisture content. You can create a damp ware box or area

SEASONAL CHANGES IN DRYING

I work in an old barn that is very cool and damp in the summer, and it can take weeks for work to dry during the summer months. During the winter months the central heating system dries the environment so much that pieces can dry in a day. This requires that I keep an eye on work during the winter because the fast drying means fast shrinking and this can promote cracks on areas of uneven thickness and anywhere that clay has been attached, such as a handle to a mug or the head or tail of an animal body form.

by securing contractor plastic around a metal or plastic shelving unit or placing your work in an old refrigerator that is not plugged in. If you want work to dry evenly and slowly, you can a make a tent of paper (newspaper is great for this) around the work. This allows air to circulate around the work slowly and evenly and slows the evaporation of moisture. Some universities and professional studios have damp ware rooms that are kept humid to keep clay in the plastic to leather-hard consistency, thus allowing for longer periods of workability.

TYPICAL CLAY CHALLENGES

Getting your clay to dry without problems can be challenging.

Potters often refer to clay as having memory. The concept is fairly simple: Clay likes to return to its original shape. Clay will move during drying and firing, and you will recognize it the more you work with a particular clay. For example, when a slab of clay is rolled out in only one direction, as it dries it will tend to pull back to the direction from which it was rolled. Another example is how a spout on a teapot might twist slightly as it unravels in the drying.

Just the action of cutting the ware off the bat can warp it ever so slightly, but it will show up in the firing as the clay shrinks and becomes dense. It is important to not disfigure vessels when handling leather-hard clay because although they can be reshaped, as the piece dries it will disfigure slightly again in the firing.

Finer clays (which have uniform particle size) are more susceptible to warping during drying. It is always desirable to have a slow, even drying environment for clay pieces.

HELPFUL TOOLS

A tool that can be very handy during the drying process is a fan. It can be used to circulate air and evaporate ambient moisture. Always point a

fan away from work to move air around the entire room. Beware of placing work in front of a fan. This will cause the section facing the fan to dry much faster than the rest and create stress in the piece. Ceiling fans work much better than box or standing oscillating fans.

Other tools that potters use to aid drying include heat lamps and hairdryers. Some even use torches. It is true that just a little heat will evaporate enough moisture to allow one to continue working or secure a section of work so that it won't collapse. However, one must be very cautious of quick drying. Even direct sunlight can be problematic; dried clay on the surface creates a skin that does not allow moisture to evaporate from the core of the wall which, in turn, creates a weakness in the piece.

As mentioned previously, there really are no shortcuts. The best way to dry clay is to allow time for moisture to evaporate gradually and evenly.

KEEPING THE STUDIO CLEAN

By taking the following simple steps to develop clean work habits, you will have a pleasant, inviting, and safe workspace in which to be creative.

- Make a point to clean up any clay before it dries and creates dust. Keep several plastic putty knives and large car washing sponges on hand. The putty knives are cheap and very useful for scraping up clay that gets stuck on the table or on boards when wedging or forming. Plastic putty knives are not sharp and won't gouge tables, plaster, or boards. The goal is to scrape up moist clay to reclaim and to avoid wood chips or plaster from contaminating it.

- A spray bottle filled with water is great for spot cleanup with a sponge.

- Keep your wire cutter tool clean. After each

cut, run your finger on it and pick up the fresh clay before it turns to dust. Clean your tools after each use and you will eliminate a dusty toolbox too.

- An ample supply of plastic sheets will perform a number of functions. Plastic becomes dusty after several uses since it usually sits on fresh clay and then dries on the surface. Plastic dry cleaning bags are free for the taking at most dry cleaners. I replace my plastic bags regularly and reduce the dust in the studio.

- It is tempting to keep all of the plastic bags that clay comes in but I have found that it's better to dispose of them as soon as they are empty because they get really dusty. Furthermore, the dry clay chips that are left inside clay bags bond to fresh clay, causing uneven, chunky surfaces. Instead, use new garbage bags. Plastic storage containers are cheap, washable, and ideal for storing clay, too.

- Wash all towels and aprons regularly.

- Line your ware boards and work area with old newspapers, when applicable. At the end of the work session, the cleanup is quick and dust free. Just gather up the newspapers and recycle them.

- Pick up any dropped clay and wipe up any spills or splatters of clay or glaze from the floor or work area promptly.

- Keep your clay scraps hydrated by placing them in a bag or small bucket (spraying them with water to keep them workable). When you finish for the day, you can quickly wedge it and have it ready for use the next day.

- Designate a recycling bucket for dry scraps of clay. I keep a 5-gallon (about 20-L) bucket and force myself to recycle often. This way the process is manageable.

- Beware of electrical shock hazards in the studio. Be sure that your hands are dry and that plugs are grounded.

RECLAIMING AND RECYCLING CLAY

One of the marvels of clay is its capacity to be worked and reworked until one is satisfied with the outcome and can proceed to firing. Clay in its raw form can be easily recycled by rehydration and wedging. The easiest way to keep clay workable is to keep it hydrated.

MAINTAINING MOISTURE

Whenever you are working, keep the moist clay under plastic and have a container, such as a plastic bag or a small plastic bucket, available to collect any trimmings and scraps. When the clay starts to dry out, spray water on it and cover it. If at the end of the work session it feels stiff or not very plastic, wedge it and spray it with water before storing in plastic overnight.

Keep a larger reclaiming bucket for larger scraps or failed attempts. Not every piece made needs to go through the firing cycle. If there are flaws or cracks in a piece, or if a piece just isn't working, break it up and place it into the reclaiming bucket.

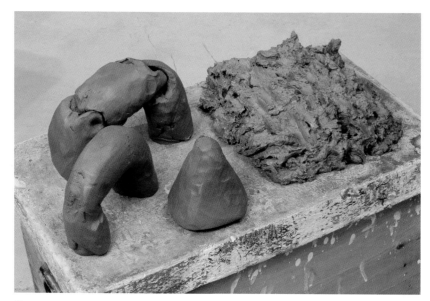

◎ Clay drying on a plaster slab

◎ These dry scraps in small pieces are ready to be hydrated in a plastic bucket.

TIP

For reclaiming very wet clay, I use plaster slabs that are small and light enough for me to move. They can be placed outside on a nice day or stacked with clay in between to help draw moisture out of the clay.

REHYDRATING DRY CLAY

There are a couple of ways to approach the rehy-drating process. The best way is to let all the scraps get bone dry and then add water. The bone-dry clay will slake down into slip in a mat-ter of hours, and you can decant or siphon off the excess water. Alternatively, you can keep a wet reclaiming bucket. This is a bucket that holds moist scraps to which water and wet work are added. It can take a few days for leather-hard clay to slake down, but it will.

DEHYDRATING WET CLAY

A plaster slab is very useful for drying clay slurry, as plaster absorbs moisture very quickly. Place the plaster slab on a table, elevate slightly with wooden slats, and scoop the soft clay onto the surface. Keep an eye on it. Depending on the humidity levels, temperature, and amount of clay it might be ready to wedge overnight or in a week. As soon as the clay can be formed into a coil, it is ready for the next phase of recycling.

Roll the clay into fat coils the width of your hand and length of your forearm. Shape them into arches on the table to air dry. Arches allow air to circulate around the clay, evenly drying it.

Check for a soft plastic consistency. As soon as the clay can be wedged without sticking to the plaster or table, it should be wedged and stored or worked with.

If you do not have a plaster slab, line a table with contractor plastic and lay the clay out on that until it sets up. A thin layer will work best since it will dry only from the top surface.

Potters often have several plaster slabs so that they can layer them with clay and dry it from both the top and bottom. They may also desig-nate certain slabs to use with specific clays.

Keep in mind that the sooner the clay is wedged the easier it is on your body and the bet-ter mixed the clay will be.

CREATING A PLASTER SLAB

Plaster slabs can be purchased or made at home. To make a plaster slab, buy plaster powder that is especially formulated for pottery from a ceramic supplier. Pottery Plaster #1 or Hydrocal are popular plasters. The plaster available at the hardware store is not strong enough for clay work and will disintegrate easily, contaminating the clay. The supplier should provide you with mixing ratios of plaster to water and instructions. Be sure to follow instructions carefully.

RECLAIMING WITH A PUG MILL

Some potters love using the reclaimed clay because it feels much more plastic and responsive than machine-pugged clay. However, for ease of production and saving time, most production potters invest in a studio-size pug mill to pug scraps and reclaimed clay. Pug mills are really helpful for pre-wedging clay. There are some models that mix and de-aerate the clay very well too. A production potter I know claims he doesn't even wedge his clay because his de-airing pug mill compresses his clay so thoroughly.

A pug mill is a major studio purchase, often costing as much as a potter's wheel and kiln. It is usually one of the last tools to be added to the studio.

HAND BUILDING

Hand building is a great way to get to know the properties of clay. If you have never worked with clay or have very little experience, you will benefit from working on a few hand-building projects before trying your hand at the potter's wheel. You will quickly become familiar with degrees of plasticity and feel the difference in leather-hard clay. You will also develop skills that will help you craft unique vessels and design and embellish your wheel-thrown pottery. Some people prefer working with hand-building techniques because there are so many possibilities that are not dictated by a rotating potter's wheel and the round forms that result. In fact, many ceramic artists work with hand building or a combination of wheel and hand building. I encourage you to try each of following hand-building techniques. It may take more than one attempt to get results. Remember that it's part of the learning curve.

PINCH POTS

Pinching pots from a ball of clay is probably one of the simplest ways to form clay into useful containers. All you need are your hands. If you have a few tools, the pots can be embellished. Pinching clay will introduce you to the wonderful sculptural potential of clay. You can make forms quickly and recycle the ones you do not like.

Launderette, clay horse by Louise W. King, hand built and fired in a low-temperature salt firing, using pinch, coil, slab, and stamping techniques

PINCH POT TECHNIQUE

Wedge a 2-pound (1-kg) ball of clay that is soft and plastic and slice it into four equal sections. Form four round balls and wrap three in plastic.

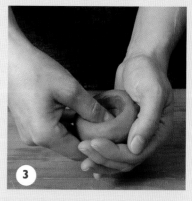

1. Sit on a comfortable stool and put the ball of clay in the palm of your left hand, which is resting on your thigh. (You can reverse the instructions if you are left handed, but pottery is an ambidextrous activity and it's good to train both hands to work with the clay.)

2. Find the center of the mound of clay and gently press into it with the right thumb. Turn the ball of clay slightly, press down with the right thumb again, and turn again. Do this several times until you have drilled a hole into the ball of clay and have a little less than 1/2 inch (1 cm) at the base. You will see that you have displaced some of the clay.

3. Begin to squeeze the clay between the thumb and index finger as you rhythmically turn the ball of clay with your other hand. Once you have made a full circle, move the thumb and index finger up to the displaced clay and repeat the steps.

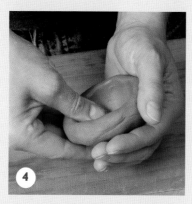

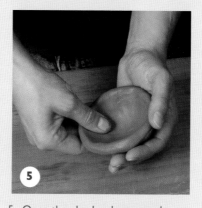

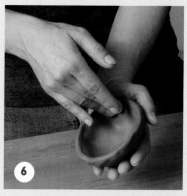

4. You will notice that if your pinching hand is at a 90-degree angle with the other hand the clay will be displaced vertically. If the pinching hand is at a 60-degree angle the clay will be displaced in a diagonal and will form an open shape. It's great fun to see that for each action there will be a reaction in the clay.

5. Once the clay has been evenly pinched all the way up, you can smooth and stretch the clay with the index and middle finger from the inside of the shape out towards the edge.

You will see the clay's stretch marks on the outer surface. This surface can be organic and beautiful.

6. At this point, the ball of clay is beginning to take shape and may need to set up for a little while before it gets thinned again. It's easy to judge when to let the pot set up; if the clay is holding a round shape, it's okay to repeat the pinching sequence. If the pot is losing the shape as you are pinching, place the partially pinched pot upside down to set up.

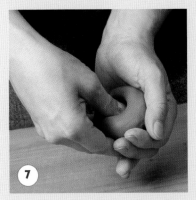

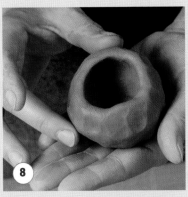

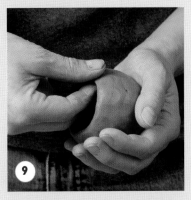

7. Pick up another ball of clay and start from the beginning. Make the center opening and this time change the angle of the pinching hand to a 90-degree angle.

8. Try to keep the opening narrow. See what shape you can get.

9. When the stretch marks appear on the outer surface, smooth them over to compress the wall. (Note the difference in texture on the surface.)

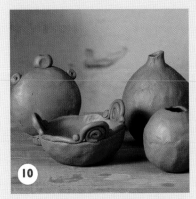

10. Experiment with several balls of clay to get a sense of displacing clay by using the pinching method.

To even the lip of the pot, place it on the center of a turn table, and hold a needle tool steady to mark the surface as the pot is slowly turned. Score the lip until it is sliced of. Soften the edge with a moist sponge.

◎ Pinch pots with iron oxide wash on the exterior and glazed interiors by Teresa Genovese

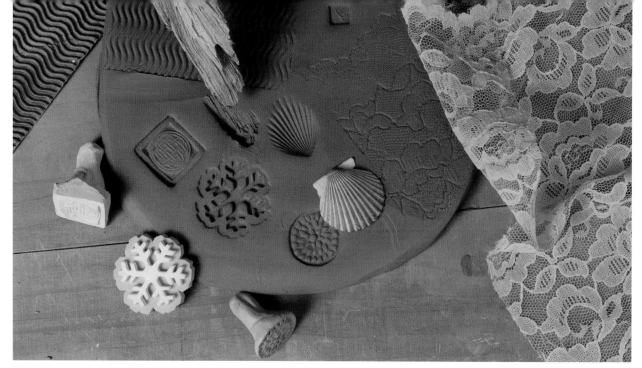

⊚ Clay slab with stamped decoration

STAMPING CLAY

Clay is very responsive to the impression of stamps and textures. Roll slabs of clay and press leaves, fabric, buttons, shells, and homemade stamps into the surface to see the different marks that they will leave on the clay. The detail that clay retains is remarkable.

Open your eyes to all the textures around you; soles of shoes, kitchen tools, and trinkets all can make great marks in clay.

It is fairly simple to make your own stamps out of clay. Using fine clay, such as porcelain, for these stamps is best but not necessary. Shape a little knob of clay in your hand, flatten it on the table, and impress into the flattened end the texture of your choice.

While the stamp is still leather hard, press it into soft clay to see the mark it makes. This is the time to test it because you can still clean up the lines at this point. Once the clay is bone dry, clean off any burrs of clay by using fine sandpaper. Once you are happy with your stamp design, bisque-fire it so it keeps a permanent shape.

Another idea is to make an insignia stamp for your ware. Many potters have logo or initial stamps. Play around with your initials to create a symbol on paper, place it against the flat area of the clay, and gently trace it in reverse onto the clay with a toothpick or pencil. Remove the paper and use a pencil or needle tool to carve the an impression in the clay and let dry. Follow the instructions above for finishing the stamp.

SLAB CONSTRUCTION

Constructing vessels with slabs is great fun because you can build pieces easily and work in large scale. The trick to working with slabs is timing the drying and moisture control. It is best to roll slabs from very plastic clay because it far less work to flatten soft clay. Stiff clay will be more difficult, and it will show signs of stress early on in the process. All you need to roll a slab is a flat work surface, a heavy rolling pin, canvas or fabric, and two slats of wood that are of the same thickness you want your slabs to be.

1. Wedge about 3 pounds (1.5 kg) of clay and slam it onto the canvas. Pound it with your hands or a paddle and then begin rolling the clay.

2. Lift the clay off the canvas and flip it over to release the tension from the fabric and also to change direction of the rolling. Remember that clay has memory and it is good to work it in several directions to minimize warping when it dries.

3. Place the slats on either side of the clay slab and glide the rolling pin over the slats, displacing the clay evenly onto the fabric. (See photo, above right.)

4. Once your slab is rolled, you can move the fabric onto a board and let it set up while you roll another.

5. You can stamp or impress texture in the slab by laying a piece of textured material over the slab and rolling gently with the rolling pin. Peel the material back and see the texture. (See photo, right.)

6. Drying stages will be very important when slab building. If you want to make cups and cylindrical forms, it wise to use soft slabs that can hold their shape but can curve without stressing or cracking. If you see cracks emerging, the clay is too dry. If the slabs collapse when you cut and hold them, they are too wet. Timing is everything!

Rolling a slab of clay (step 3).

Adding texture to a slab of clay (step 5).

TIP
There are industrial-scale slab rollers for people who produce a lot of slab ware. I have one in the studio but use it rarely because hand-rolled slabs are more plastic and easier to work with. They are handy if a lot of slabs are needed and if a consistent thickness is desired. (See page 38 for more on slab rollers.)

CUTTING AND JOINING SLABS

Building with slabs offers so many possibilities. This section will cover how to cut and join slabs into three-dimensional shapes. Later in the book you can find projects with slabs that will elaborate on the basic construction techniques.

To cut slabs that will be joined, it is important to use a thin, sharp knife. A fettle knife (potter's knife), or a hobby knife is perfect for cutting into slabs with precision.

Whenever a section of slab is cut that is to be joined to another, bevels can be cut along the edges for better attachment. For this example, we will first make a mug using a clay slab (continued on the following page).

SLAB CONSTRUCTION OF A MUG

Begin by rolling a slab of clay to the desired thickness. Make a paper template of the size cylinder you wish to make. (The circumference of the mug is the length of the template, the height of the mug is the width.)

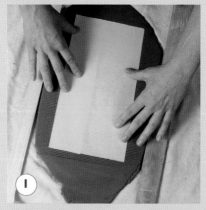

1. Lay the slab on newspaper or fabric and place the template on top of the slab.

2. Cut the edges that are to be joined at an angle to create a bevel.

3. Score and add slip to the seams.

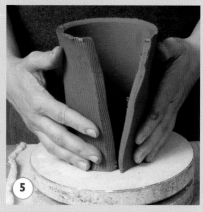

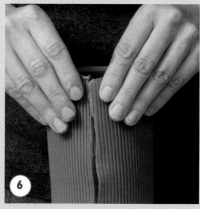

4. Place the cylinder over a slab to trace the circumference and determine the size for your base, then cut the base with a beveled edge, score, and apply slip. Align the slab over the base to form a cylinder.

5. Align the seams and press gently to join them.

6. Notice that with the bevel the seam will have far more integrity than it would with a 90-degree edge. Gently press the clay together with dry hands so as not to deform the shape. Score and smooth the inner seam.

TIP

Paper templates can be used to create specific shapes of slabs for precision building. They are very useful in determining design elements and proportions, and they save a lot of time and clay.

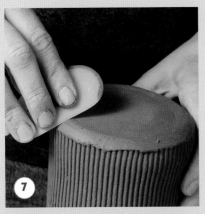

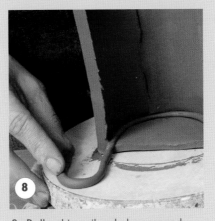

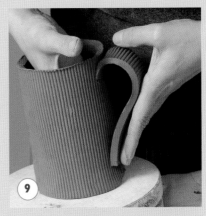

7. Press gently, then turn the cylinder upside down in order to score and smooth the base. If you do so at an angle, you will create a nice beveled bottom and line that will visually lift the piece from the table surface.

8. Roll a thin coil and place around the inner seam of the base. Using a round-tipped wooden modeling tool, smooth the interior. Once the piece is leather hard, use a damp sponge to soften the seam. If you do so too soon, however, the piece will deform.

9. Cut a strip of clay to make a handle; smooth the edges with a wet hand. Score the areas to be joined and apply pressure to the seam. Be sure to join the handle thoroughly from the underside.

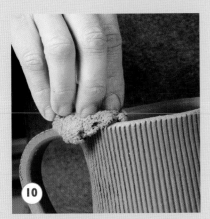

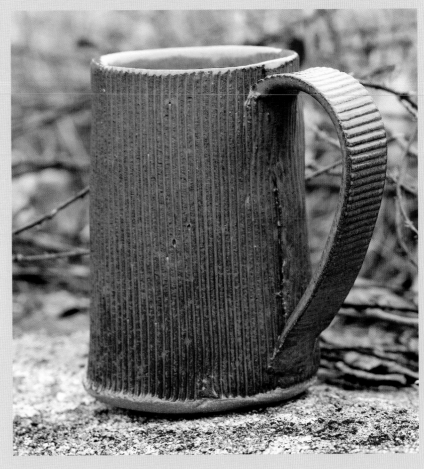

10. Using a rubber rib, smooth the outer surface and finish off the lip edge with a damp elephant ear sponge.

◎ Slab-constructed mug fired to cone 6 in an electric kiln

SLAB CONSTRUCTION WITH A SLUMP MOLD

1. Roll a slab slightly larger than the mold you want to drape it into.

2. Lift the slab and drape over and onto the plaster mold.

3. Lift the mold and drop it lightly to encourage the clay to drape into the form.

4. Use a damp sponge to gently press clay into the mold.

5. Place a ware board on the mold to use as a cutting template.

6. Trim the edges with a wooden or plastic tool so as not to damage the mold. When the piece is leather hard, clean up the lip of the piece with a damp elephant ear sponge (not shown) and remove from the mold. Removing it from the mold as soon as the clay will hold its shape is important to prevent cracking due to uneven drying.

7. To clean up the edge, use a rasp tool. (You can buy one at a ceramic supply house or a hardware store. Rasps are used for wood working and plaster drywall and look like cheese graters.) If you rasp at an angle, the result will be a nice beveled edge that can also be softened with a damp sponge.

SLUMP AND HUMP MOLDS

Clay slabs can be draped into slump molds to make forms. Any bowl or tray can be used as a slump mold, but it must be lubricated with a spray lubricant in order to prevent sticking and cracking. The best slump molds are made of plaster. A plaster mold should be dampened before placing clay on it to slow down the absorption of moisture. Economical and practical slump molds can be made by using coils of clay covered in newspaper or paper towel, formed to the desired shape. (See photos at left for an illustrated guide to using a slump mold made of commercially available plaster.)

Any shape over which a slab of clay is draped is a hump mold. Some commercially sold hump molds made of plaster are great and work quickly because of the moisture absorption. Some potters use balloons and plastic beach balls as hump molds because the air inside can give way to the shrinking clay. Note: Since clay shrinks as it dries, you absolutely must remove the clay as soon as it is stiff enough to hold shape. Otherwise the clay will shrink and crack.

COIL BUILDING

Coil building is a method that was—and still is—used by potters in many cultures to build ceramic vessels, with or without using pottery wheels. Many primitive cultures still use coiling to build large storage jars or traditional and ceremonial pottery forms, preserving their cultural heritage.

Coiling is a wonderful way to create large vessels or sculptures. It is a useful way to embellish work and can be used to increase the volume of wheel-thrown pots. I highly recommend practicing some coil building before or while you are learning to work on the potter's wheel. Even if you prefer to use a wheel, working with coils will improve your throwing skills by giving you a clear sense of what clay can do and when it is ready to do it. Plasticity, structural strength, joining methods, compression, and timing (clay consistency) are keys to success.

You can make coils by hand or you can extrude clay coils through die forms to quicken the process. As a student, I learned to hand-roll coils on a table. This was tricky because often the coils dried out in the process of rolling. Then I saw Korean potters hand building huge pots. In a matter of hours, they completed pots that were 3 feet (about 1 m) in height. They rolled the clay between the palms of their hands, not on the table. I tried to imitate this technique and refined it when I took a few classes with Peter Callas, who uses traditional Japanese and Korean coiling techniques, and then with Joyce Michaud, a professor at Hood College in Maryland who specializes in Eastern coiling techniques. The fact is, when you roll coils in the palms of your hands, you are wedging the clay as you roll. The coil that is formed is very plastic and compressed. The compression of the rolling has much more structural strength than an extruded coil. This is why one can build faster and more efficiently with this technique.

Some potters use extruded coils because they are so quick to make. However, because the clay particles are forced through a die form, they tend to have far less plasticity and structural strength than hand-rolled coils. The plasticity of the clay is key to coil building. Clay that is too dry does not like to stretch and is difficult to hand build with.

ROLLING COILS IN THE PALMS OF YOUR HANDS

With this technique there is no need to pre-wedge the clay as it will be wedged in the rolling. Lay some plastic on the table to keep your finished coils moist.

1. You should stand to make coils. Pinch a handful of clay from the clay mound and squeeze it into a fat coil shape.

2. Place the base of the coil in your palms. Hold your hands parallel to the floor. Begin with the right hand rolling forward and the left rolling gently backward. The movement is in opposition (from front to back) to the base of your fingers on the left hand and the bone of your palm on the right and back again. Use gentle but firm pressure to roll the clay between the base of your palms and fingers. The movement is back and forth with the finger tips moving slightly upwards as they move forward and then slightly downwards as the hand moves closer to the body.

3. The coil will emerge at the base of your hands. Once you are finished, place the coil in plastic and form another. You can store the coils in plastic for up to 24 hours, until you are ready to use them.

4. If the coils are squared, it's because they are not making a full rotation (360 degrees) in the hand. Pay attention that the clay is making a full rotation and that it is rolling from the fingers through the palms of hands. If a half rotation is maintained, the coils will become misshapen.

COIL ROLLING TIP

Rolling coils is a rhythmic skill that takes practice to master. Some of the most common problems are that the clay is too dry and that hand pressure is too strong. Clay prefers to displace gradually. This principle will become ever more evident as you work with clay and build larger forms and especially when working on the wheel.

MAKING A BASE
AND BUILDING WITH COILS

To form the base, prepare a small ball of clay, about 1 to 1¹/2 pounds (0.5–1 kg).

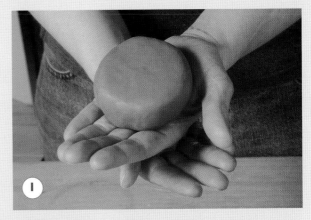

1. Roll the ball into a patty.

2. Place the clay on your left hand and with your right strike from the center of the patty, displacing clay against the base of your thumbs in the palms of your hands.

3. Turn the patty and strike it again. Repeat this rhythmic striking until the patty is flat and has even wall thickness.

4. Gently pinch up the walls to create a base for the first coil to attach. Place the base on a small piece of cloth on a turntable.

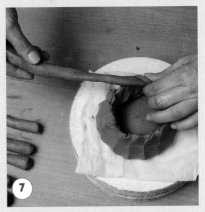

5. Take the first coil and place it on end on the inside of the base with the index, middle, and ring fingers along the top of the coil and the thumb underneath on the outside. The other hand holds the coil. You can choose to use either hand for this process.

6. With your fingers in position, apply pressure upward with the thumb on the outside wall, apply pressure in a downward fashion with the top fingers. The movement is in opposition. This will wedge the coil into the wall and stretch it.

7. Slightly turn the turntable and feed more coil into the pot. Align your finger on the top and your thumb on the bottom and repeat until you are finished with the coil. Then add another in the same fashion.

(continued next page)

MAKING A BASE
AND BUILDING WITH COILS *(continued)*

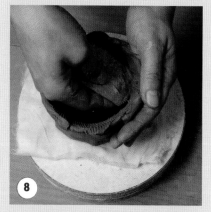

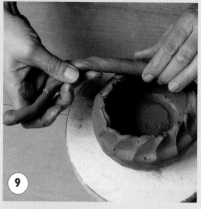

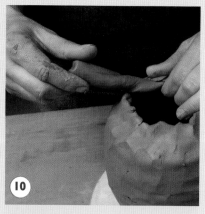

8. Once you have 3 to 4 coils on the piece, use the serrated scraper or rib to score the inside of the walls. As you score the inner walls, rotate the vessel and support the outer wall with the outer hand. You can decide how open or how closed you want the shape by how you support the outer wall and how much pressure you apply from the inside.

9. Smooth the interior using a curved rib. (I like to use a mini-CD.) Continue to build upon the newly compressed wall. If the walls of the vessel begin to show signs of weakness, take a break and let it dry for a few hours before continuing to build.

10. Shown here is the texture from the coil building that has created a pattern. Everyone will develop their own unique patterns; it's like handwriting.

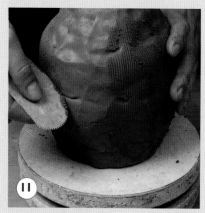

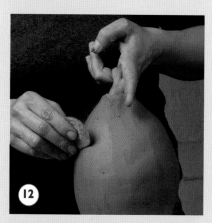

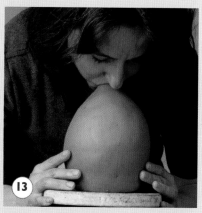

11. To smooth the pattern, score the surface in one direction and then in the opposite direction.

12. Finish by scraping the textured surface with a smooth metal or rubber rib. If you still have bumps or low areas, try scraping the high points with the serrated rib and smoothing again. With a little patience and perseverance, the surface can become very smooth.

13. To give a closed form more volume, try blowing into it while it is fairly soft.

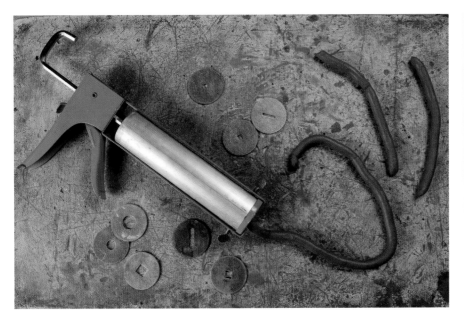

Hand-held extruder with metal die forms and freshly extruded coils

A NOTE ABOUT JOINING CLAY

Joining clay is easy if the clay is plastic; it will want to stick to itself. Through pinching and wedge coiling techniques, there is so much compression and stretching that the clay particles become easily aligned and stay together.

However, with slab construction or when adding one consistency of clay to another it is important to score the surface of the clay and add a little slip. The slip helps even out the moisture content in the clays and acts as a bonding agent.

There is an ongoing debate about scoring in the potting community, however. Some potters work quickly with soft clay and don't score at all. Others, like me, believe it's important to score the surface of the clay.

Some clays, such as porcelain, require slip in order to bond. The point is to reduce disparity of shrinking between two consistencies of clay.

USING EXTRUDED COILS

Extruded coils are a great shortcut to making coils, though this method has its flaws. Clay needs to be very soft to extrude properly through the round die forms. Extruding forces clay particles through and weakens the structural strength and compromises some of the plasticity. This can be remedied throughout the building process by allowing more time between layers of coils and through compression.

Another consideration with extruded coils is that the process requires many coils be extruded at once. Because coil construction requires drying time every 4 to 6 coils that are applied, coils must be kept wrapped until they are used. Otherwise the surface of the clay will dry and create a skin that compromises the plasticity.

THROWING
ON THE POTTER'S WHEEL

Watching someone form a pot from a mound of clay on a potter's wheel is breathtaking. In no time the lump of clay is opened, raised, and formed seemingly without effort by the potter. But in fact, any potter will tell you a lot of practice is necessary to master throwing on the wheel.

The hand-building projects in the previous chapter clearly illustrate how pinching pots and coiling both require the clay to rotate in order to create even wall thickness. Potters around the world have devised different ways of making turntables to facilitate the forming of vessels. Up until the twentieth century, potters worked with kick wheels and treadle wheels that used manpower to rotate. Motorized kick wheels revolutionized the pottery industry by speeding up production.

Some contemporary potters prefer kick or treadle wheels because of the rhythmic nature of throwing and the subtle control over wheel speed that they provide. However, in most schools and modern potteries, electric wheels are used for several reasons. First, they occupy less space and are easier to move. Second, because they can be set up at different heights, potters can choose to work sitting or standing. And third, motorized wheels are less fatiguing for extended periods of throwing.

Choosing a wheel is a personal decision. Some models boast large motors that will center 100 pounds (50 kg) of clay, others claim silent motors, yet others better pedal control. They come in all price ranges. Smaller models ($1/4$ to $1/2$ horsepower) are great for home studio use because it is doubtful that anyone will have the need to center 100 pounds of clay. However, in cases where the potter intends to start a production line for sale or plans to work on a larger scale, a full horsepower is recommended.

Wood-fired stoneware bottle by Kristin Müller

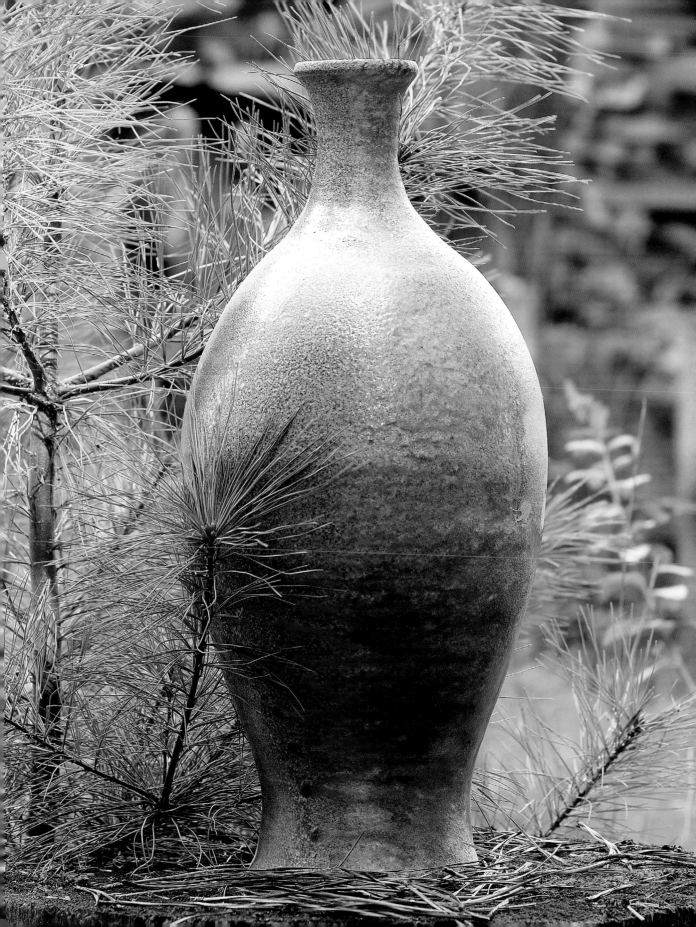

SETTING UP THE WHEEL AND STOOL

Place the wheel near an electrical outlet so that the wheel can easily be plugged in. A surge protector is recommended to protect the motor in case of power surges. (Newer wheels have computer chips and circuit boards.) The stool should allow the potter to sit with thighs parallel to the ground and not at an angle. An adjustable stool is a versatile choice. When sitting in front of the wheel the potter should be seated slightly higher than the wheel head. If necessary, the wheel can be elevated by placing bricks underneath the legs. Check that the wheel is level with a level and use shims to make adjustments as needed. Maintaining a level wheel is very important or the pots will always be crooked.

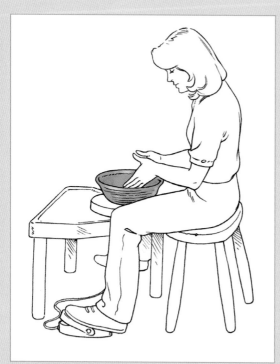

◎ Proper wheel alignment: Be sure that the stool you are sitting on is about 1 inch (2.5 cm) or more higher than the wheel head and that your thighs are parallel to the ground for proper posture. Adjust the wheel and stool height accordingly.

CLOCKWISE AND COUNTERCLOCKWISE ROTATION

Western-style wheels turn counterclockwise, Eastern-style wheels turn clockwise, and most wheels can be reversed. In this text, instructions will be for western-style, counterclockwise rotation of the wheel. (If you choose to work in reverse, reverse the instructions and hand positions.) It doesn't matter whether a potter is left or right handed because pottery is an ambidextrous activity. One of the benefits of working with clay on the wheel is the development of dexterity in both hands. To balance the body during throwing, place the control pedal on the left side and a brick on the right side to elevate the right foot. (The pedal can go on either side, but the left side allows for more balance during throwing.) The concept of body mechanics will be elaborated on in the following section.

POTTER'S WHEEL DYNAMICS

Understanding certain forces at work when clay is rotating on the wheel can save the potter a lot of work and frustration. Three principles will affect the clay in motion: centrifugal force controlled by speed of the wheel, gravity, and pressure from the potter's hands. The potter controls the wheel speed and learns to use the pedal to increase and decrease speed dependant on the amount and consistency of clay and the stage of raising and shaping. This requires coordination, good body mechanics, and an understanding of the forces at play.

Simply put, gravity applies downward pressure on particles of clay and centrifugal force pulls particles away from the center of the vessel. The potter applies pressure accordingly and displaces clay in ways that work with these forces rather than against them.

Centrifugal force displaces matter from the center out in the form of a dome. When clay is

EFFECTS OF CENTRIFUGAL FORCE

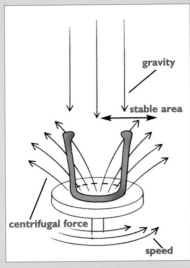

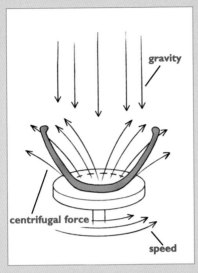

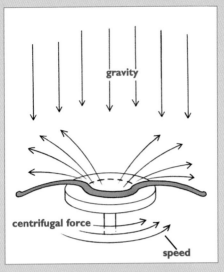

◎ If the wall is kept vertical during raising, it opposes gravity and centrifugal force. The wall is in the stable area and the wheel can rotate at a medium to fast speed and resist the pressure the forces are exerting on it.

◎ By slowing the wheel speed, centrifugal force is reduced. During shaping, the inner hand works with gravity and centrifugal force to splay out the clay wall and create a curve.

◎ The forces take over if the wheel speed is too fast. Also, if the clay is too wet, the piece collapses.

raised, if kept aligned in an inward and upward position, the centrifugal force cannot overtake the clay. There is a stable area in which rotating clay can resist the outward pull of centrifugal force and the downward pull of gravity. In order to raise a tall cylinder, the clay wall must be raised quickly and the rim must never leave the stable area. If a bowl form is desired, the wall of clay will be raised within the stable area and the shaping will occur by reducing the wheel speed thus reducing the centrifugal force as the rim moves outward. If this step is carried out with too much speed, the centrifugal force will dominate. When gravity and centrifugal force take over, the form will collapse on the wheel.

Constant balance of centrifugal and gravitational forces is needed to control shapes. Most beginning potters struggle with the combination of forces at play and usually fight rather than work with them. Experienced potters make pots quickly because they have mastered the ability to harness the forces and use the dynamics to their advantage.

With practice, muscle memory and kinesthetic cues develop, which will inform the potter about how much pressure to apply to the moving clay. A novice needs to think about everything that is applied to the clay (speed, pressure, lubrication) and is usually happy to make anything at all. However, the repetition of movements builds and refines skills that signal when to increase or decrease wheel speed and how much pressure to apply or release as walls are raised and shapes are formed. As throwing skills develop, forming a pot will be quick and easy, allowing the focus to be on composition and design elements of the vessel. The artist builds and refines basic skills to make beautiful work that can be both expressive and well-crafted.

DEVELOPING SKILLS THROUGH REPETITION

Muscle memory skills are developed by repetition throughout our lives. All of our voluntary movements are based on muscle memory, which send messages to our brain to control activities such as walking, driving, and writing. We have learned how to gauge our motions based on practice.

Working in series is the only way to develop the muscle memory skills required for pottery. In fact, working in series is a common principle in all art disciplines because in doing so one builds the skills necessary so that the mind can direct the creation of meaningful and beautiful work.

To facilitate learning how to throw, the potter should work with a series of mounds of clay that are the same size and weight. This also applies to learning how to throw specific shapes, including intermediate and advanced pottery techniques. This is why production potters will dedicate a throwing session to a specific form. They are aware of the power of muscle memory and know that the first few bowls of the day are never as good as the bowls that emerge from the clay toward the end of the session. Many potters throw a number of cups to warm up before launching into the days production schedule.

In many ways learning to throw on the wheel is like learning to play a musical instrument. You must begin with the basics—reading music, playing scales, and playing measures of music—and then eventually by building these skills, you will play songs. Once comfortable playing songs, it's easier to compose original ones. In much the same way, potters begin by learning to center and raise walls efficiently to make simple forms and progress to making forms that are uniquely theirs. The potter's wheel is a tool that provides rotation for the clay. The potter provides the force and finesse to move and shape vessels from mounds of clay. Potters, like musicians, must warm up before every session so that the steps to making a specific form are focused and fluid.

POTTERY FORMS

Vessels made on the potter's wheel are all derivative of the cylinder. Platters are formed from low cylinders, vases are formed from tall cylinders, and bowls are formed from cylinders with interior curves. There is structural strength in straight walls because clay particles are flat and they maintain their alignment if raised vertically without the change of direction of a curve. No matter what shape the potter aims to make, it will require centering, raising, and thinning walls before introducing curves and final shaping.

BASIC WHEEL TECHNIQUES

Working with the potter's wheel is both challenging and fascinating. Read through all the steps a couple of times before you begin. This will help you connect the steps in a fluid manner. (Remember, have fun while you practice maneuvering and gaining control of the clay, too!)

THROWING AND CENTERING CLAY

Gather the basic throwing tools: a sponge, cut-off wire, throwing rib, wooden angle tool, small bucket of warm water, absorbent towel, and ware board. Weigh out and wedge 5 mounds of clay that each weigh 2.5 pounds (1 kg) and place them on a ware board by the potter's wheel. Place the water bucket and tools on the wheel's work table and drape the towel over your legs. The potter sits at 6 o'clock and all hand and finger positions will be assigned according to their position on the clock. An illustrated guide to centering follows on page 123.

Stage One

Sit comfortably with your thighs parallel to the floor and practice bracing your elbows on your

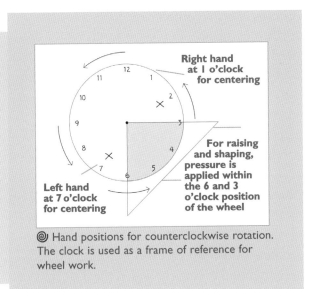

The clock is used as a frame of reference for wheel work.

 Hand positions for counterclockwise rotation. The clock is used as a frame of reference for wheel work.

torso and thighs. The potter uses power from the entire body to throw pots. Body mechanics are key to controlling rotating clay. Remember that your hands will tell the clay how to move. Turn on the wheel and make sure the pedal is in the off position.

Place a mound of clay on the center of the wheel head, depress the pedal to a medium-fast speed, wet your hands with water or slip, and apply pressure to the clay from the top down. Your left hand should be at 9 o'clock and your right at 3 o'clock, with your elbows and upper arms supported by your torso. Gently lessen pressure on the clay while the wheel is spinning. Place your left hand at 7 o'clock with your elbow braced between the thigh and hip. Using the bones at the base of the left hand, apply steady pressure from the base of the clay and move upward. The clay should begin to move up.

Stage Two

With the wheel spinning at a medium-fast speed, lubricate the clay. Go back to 7 o'clock with the left hand, place the base of the right hand at 1 o'clock, begin applying pressure from the base, and steadily move hands up coming together at

the top of the cone. Gently release pressure while the clay is moving. If pressure is applied or removed when the clay isn't rotating, the clay may go off center. Make sure that any pressure changes (applied or released) occur gradually while the clay is rotating. Sudden pressure changes and abrupt movements are a potter's worst enemy.

It may take several attempts to get the body mechanics in line with wheel speed to move the clay upward. Make sure that the pressure at the base is held long enough for the base of the clay to fall into a centered alignment, because as the clay is moved upward, so is the unevenness.

Once the cone is formed, the clay must be lowered. Place your left hand at the top of the cone at 7 o'clock while the wheel is rotating at medium speed and push slightly forward and down. About halfway down you will feel the clay pulling in toward the center of the mound. The inward pull is centripetal force.

Stage Three

After lowering the cone of clay with one hand it may have gone off center due to lack of opposing pressure. Raise the cone again by placing your left hand at 7 o'clock and your right hand at 3 o'clock and move the hands up, coming

CENTRIPETAL FORCE

This center-seeking dynamic is created by the pressure of the hands in opposition to centrifugal force that draws the clay to the center of the axis (center of the wheel head). It is very helpful for the potter to become aware of this center-seeking dynamic when centering clay. Feeling this phenomenon is one step toward working with the dynamics of the rotating wheel rather than fighting them.

together at the top of the cone with the wheel spinning at medium speed. Maintain a steady (medium-fast) speed, relubricate if necessary, place your left hand at 7 o'clock just below the top of the cone and your right hand over the top of the cone, with the bones from the side of the palm in contact with the clay. Apply forward pressure with the left hand and downward pressure with the right. As you begin to feel the centripetal force pulling the clay toward the center, brace the left arm into your torso, finishing with the elbow between the thigh and hip. The left hand is in charge of keeping the base of the clay centered. The right hand lowers the clay and keeps the top of the mound centered. With the wheel rotating at a slightly slower speed, keep the left hand at 7 o'clock with the bones of the base of the hand perpendicular to the wheel head. Use the bones from the side of the palm of right hand to apply a steady gentle pressure parallel with the wheel head.

Troubleshooting

Centering clay is challenging, but once the potter practices speed and hand control to harness the forces at play, it will become a simple task. Remember, you are in control. If the clay isn't moving in the way you want it to, ask yourself what your hands are doing. When the mound of clay is rotating smoothly in your hands the clay is centered. Gently remove pressure and proceed to the next stage.

OPENING CLAY

Opening the mound of clay will establish the diameter of the base of the pot and the true base. Every shape will require a certain amount of clay to achieve desired dimensions. Opening requires two steps; first, the hands must press the clay from the center down to the desired depth, and second, the hands widen the base of the clay to determine the true base. An illustrated guide to opening clay follows on page 126.

During the opening, place hands on the centered mound with thumbs in the center and pinky fingers touching the wheel head at 9 and 3 o'clock. With the wheel spinning at a medium speed and thumbs on center, apply pressure equally, lowering the fingers to the desired depth. Make sure to leave about 1/2 inch (1 cm) at the base. Release pressure gently and lubricate the newly formed well. Place your hands on the mound with thumbs at 9 and 3 o'clock on the interior of the well and the other fingers on the outside of the clay. Apply outward pressure from the thumbs to widen the well, and be sure to release pressure within the dimensions of the mound. Be careful not to stretch beyond the mound because the integrity of the walls will be weakened and it will be nearly impossible to raise a wall. A proper base will have a 90-degree angle at both interior and exterior bases.

Re-center the open clay by compressing the lip. This is done by holding the rim of the clay between the thumb and index finger of the left hand at 6 o'clock and gently applying pressure from the right index finger until the rim of the mound comes into center. Clean the wheel head and compress the interior base of the mound by holding the sponge in your right hand and placing pressure on the base moving from 2 o'clock to the center and then counter spin to 6 o'clock. Repeat this step until the base is level and centered.

Troubleshooting

Remember to keep elbows anchored to the torso for stability. The most common problems during opening are not enough lubrication, uneven pressure from hands, not leaving enough clay at the base for removing from wheel, and widening the base beyond the mound.

GUIDE TO CENTERING CLAY

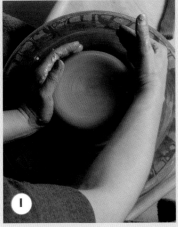

1. Center mound with left hand at 7 o'clock and right hand at 1 o'clock.

2. The clay mound is attached and lubricated. With the left hand at 7 o'clock and right hand at 1 o'clock, begin to apply opposing pressures from the base and raise the clay into a cone.

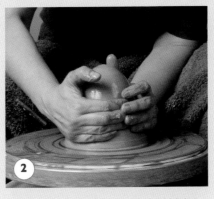

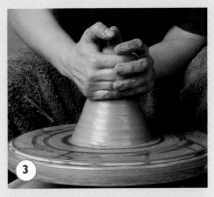

3. Lubricate and repeat the raising move, gradually displacing clay. Be sure to bring your hands together as they approach the top of the mound.

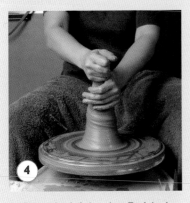

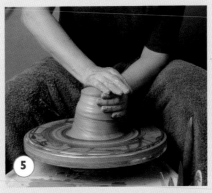

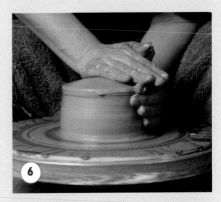

4. Place the left hand at 7 o'clock just below the top. Place the right hand on top of the cone. At a medium speed, apply pressure forward and down. You should feel the clay pulling toward the center of the wheel.

5. As the clay is pushed into center, the left hand assumes a braced position at 7 o'clock perpendicular to the wheel head. The elbow rests on the thigh for support. The right hand applies pressure with the bones of the palm of the hand at an angle. Fingertips are pointing to 11 o'clock, and the base of the palm is at 5 o'clock. Notice that thumbs are touching to create a bridge for stability.

6. The left hand at 7 o'clock holds the edge of the mound at a 90-degree angle and gives way to the downward pressure from the top. Notice the angle of the right hand creating isolated pressure.

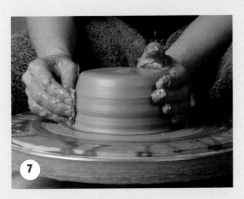

7. To ensure proper centering, it is important to align the clay at 90-degree angles before opening. The right hand holds an elephant ear sponge to lubricate fingers while applying opposing pressure at 2 o'clock. The left hand counters the pressure of the right hand, placed at 7 o'clock. This fine-tunes the mound.

CENTERING PROBLEMS AND TROUBLESHOOTING

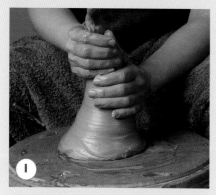

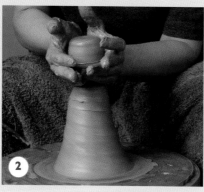

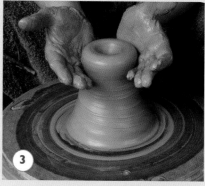

1. **Problem: The base of the mound is off center and has formed a spiral.** This occurs when hands apply pressure and move up too quickly. Squeeze and wait for clay to move upward before raising hands. Make sure that your hands are moving with the wheel speed and not faster.

2. **Problem: The top of the cone is severed from the rest of the clay.** This occurs because the hands stopped moving up and continued to apply pressure, cutting through the clay.

3. **Problem: There is a well developing at the center of the cone.** This will trap air in the clay. It is caused by the hands not coming together but instead only applying pressure from the side of the hands parallel to the wheel head rather than applying pressure perpendicular to the wheel.

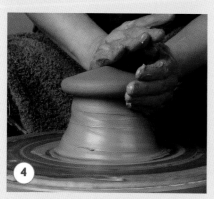

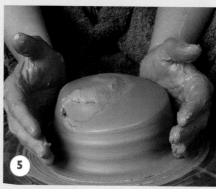

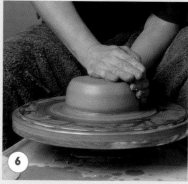

4. **Problem: The cone has a mushroom top.** This is caused when the hands are not aligned. Notice that the top hand is applying too much pressure and the left hand is angled out. Solution: Be sure to maintain the left hand angled inward at 7 o'clock. This counters the pressure from the right and keeps the mound in proper shape.

5. **Problem: The clay mound has an uneven top.** This unevenness is caused by sudden pressure release or stopping the wheel before releasing pressure.

6. When clay rotates without hesitation, the clay is centered. Gently remove pressure while the clay is spinning to maintain the center.

RAISING CLAY

Before the walls of clay are raised, the rim and base of the clay should be compressed and centered. Hydrate a sponge with some water and clay slip from the water bucket and drip it onto the wall of the mound (both inside and outside) while the clay is spinning. This disperses the lubrication evenly. Wipe the excess moisture from the interior base and clean the wheel head. The speed of the wheel should be medium-slow until you develop a sense of how quickly to move the pressure from your hands up the sides of the clay and maintain even wall thickness. The left hand will work the interior while the right hand works the exterior, moving clay up and into the core of the wall. With your arms braced against your torso, place the middle finger of the left hand, supported by the other fingers, at the transition point of the interior base and the wall at 3 o'clock. Bend the second knuckle of the right index finger and place at 3 o'clock on the exterior base. Apply inward pressure at a 60-degree angle for a few revolutions until the clay moves up. (It's okay to gently release pressure to re-lubricate and check the newly established high point of the clay.) With the wheel spinning at medium-slow speed, place the right knuckle underneath the highpoint, apply steady pressure, and begin to turn the knuckle in to achieve a 90-degree angle. Pressure from the left middle finger will be slightly higher than pressure from the right knuckle. With hands in position, work hands together to apply steady pressure and raise them in sync with wheel speed to thin and raise the wall. As the small pressure points displace the clay upward, ease then gently remove, pressure as the lip is approached. Compress the rim by supporting the top of the clay wall between the left thumb and index finger, applying gentle pressure over the supported clay to define the lip and re-center the newly raised walls. It will take a few attempts before the throwing rhythm becomes fluid. Most pots take 2 to 3 upward pulls to raise the clay before shaping. An illustrated guide to raising follows on page 127.

COLLARING CLAY

Collaring clay, which is also sometimes called choking clay, is an efficient technique for raising clay quickly without saturating it. It also helps build structural strength, gaining height in the cylinder while thickening the walls. To collar, apply equal pressure at three pressure points at the base of the mound. This moves clay upward, displacing it and narrowing the diameter of the cylinder. An illustrated guide to collaring follows on page 129.

Turn the wheel speed to a medium-fast speed. Lubricate the outer wall, and touch your thumbs together at 6 o'clock with left middle finger at 10 o'clock and right middle finger at 2 o'clock. Beginning at the very base of the cylinder, squeeze the clay, lock into position, and move

GUIDE TO OPENING CLAY

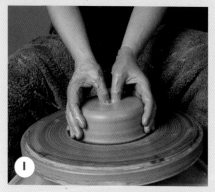

1. With the wheel in motion, place thumbs on the center of the mound with pinky fingers touching the wheel head for stability. When you feel the center, apply downward pressure.

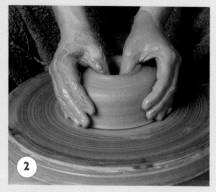

2. Maintain a medium to fast wheel speed while pushing down with equal pressure. Leave about a 1/2 inch (1 cm) thick base for the foot that will be trimmed later.

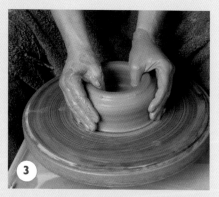

3. Once you reach the base, gently release pressure and relubricate the interior walls of the clay. Place thumbs at 3 and 9 o'clock and apply outward pressure. Be sure not to open beyond the base of the mound.

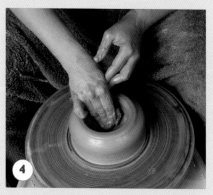

4. Use the throwing sponge in your right hand to compress the base of the clay and get rid of any bumps or ridges that will unsteady the interior hands during raising. Begin with the sponge at 2 o'clock and move toward the center, then counterspin to finish at 6 o'clock. Repeat until the base of the well is level.

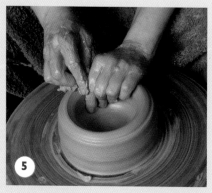

5. Compressing the rim or recentering the rim is done by gently squeezing the wall with the left hand between thumb and index finger and applying pressure from the right index finger with a sponge until the rim sinks into the center.

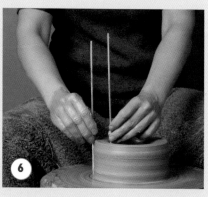

6. A good way to measure depth of the base is to use two bamboo skewers or chopsticks. Place one on the inside and one outside the mound, touching the wheel. Thickness, is shown by the different heights of the tops of the sticks.

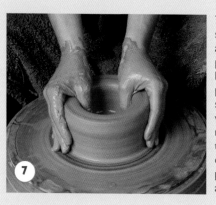

7. Sometimes it is necessary to recenter the clay after opening by compressing the rim. Place hands in the opening position and apply equal, symmetrical pressure while the wheel is spinning until the clay is centered. I call this doughnut centering because the pressure is equal all around the doughnut ring.

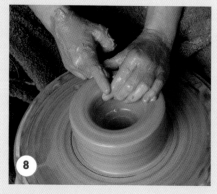

8. Finish setting up the mound by compressing the rim. This will ensure evenness as the raising begins. In fact, compressing the rim after each pull will recenter the piece.

Guide To Raising Clay

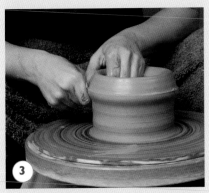

1. Lubricate the walls evenly. Place the right hand with the knuckle against the base at 3 o'clock. Place the left hand inside the well with the middle finger slightly bent at 3 o'clock.

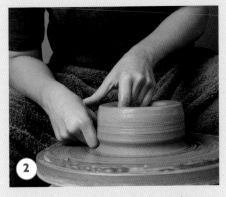

2. With the wheel spinning at a medium-fast speed, apply pressure with the right hand at the base. Counter the pressure with the inside hand and wait for the clay to begin moving up. The inside pressure point is slightly higher than the outside pressure point. Notice the left thumb touches the right hand to stabilize the raising.

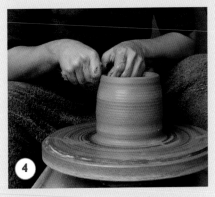

3. Both hands move up in sync with the wheel speed. The outer pressure point remains under the highpoint to evenly displace into the core of the wall and gain height. It is important to gently release some of the pressure from both hands as the clay is raised to maintain even wall thickness.

4. When the top of the cylinder is approached, be sure bring the clay in the center to keep the rim within the stable area. Gently release pressure.

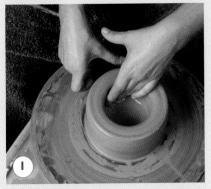

5. To lubricate the wall evenly, spin the wheel and make gentle contact with the rim. Drizzle slip down your hand to make a curtain of lubrication all the way around the piece. Remove excess moisture from the interior of the base.

Repeat the raising and pulling steps one more time and proceed to the collaring steps.

your hands swiftly up to the top of the clay. Gently release the pressure and compress the lip to strengthen the rim and re-center the cylinder. After the collaring is complete, return both hands to 3 o'clock and raise the clay as described earlier. This pull will thin the walls and straighten them too.

Trimming an Uneven Lip

Sometimes, the top of the piece will become uneven. The lip can be trimmed with a needle tool.

With the wheel rotating, place a needle tool at 4 o'clock. With your arm braced on your torso, hold the tip of the needle against the clay just under the uneven top to cut off a ring. The interior hand must be ready to meet the needle as it cuts through the clay, lifting the ring of clay off the piece while the wheel is in motion. Complete the trimming by compressing the lip.

Troubleshooting

Common problems with raising and collaring are due to unsteady hands, uneven pressure, uneven speed, excessive moisture, and air bubbles.

Potters don't often feel air bubbles until the wall of a vessel is thin enough to feel the bump. Air bubbles cause breakage during firing. During throwing, they are like speed bumps on the highway and will cause unsteady hands, throwing off the balance of pressure.

Excessive moisture (or saturation) happens when the clay is worked for too long. If clay is over-saturated, it will collapse from gravity and centrifugal force as soon as curves are introduced. The goal is to shorten the steps and displace clay quickly and efficiently so that it maintains the structural strength and can be shaped with confidence.

SHAPING CLAY

Once the clay has been centered, opened, and raised, it is ready to be shaped. For a pot to be balanced and have even wall thickness, the profile of the exterior wall must follow the profile of the interior wall. The interior hand adds shape and volume to a form. The exterior hand brings clay into the form and defines exterior lines. For shaping a cylinder, the wheel should turn at a slow speed so the pot does not collapse as curves are introduced. An illustrated guide to shaping follows on page 130.

Place the fingers of the inside hand and the fingers of the outside hand at 3 o'clock. With the inside hand, begin to draw a curve, pushing outward and upward before coming back in. The outside hand follows along to compress the wall and control the shape of the vessel.

Production potters often use throwing ribs to make specific curves. Ribs can work the clay with much less lubrication than is possible with fingers and place isolated pressure on the clay surface with the sharp edge. Metal ribs are especially good for sealing and compressing the clay wall, making it stronger more easily manipulated with bare hands. Too much friction on the surface of the clay will cause problems in the long run.

FINISHING YOUR POT

When the pot is complete, compress the base of the wall with an angle tool at 3 o'clock. Trim any excess clay so there is a slight undercut or bevel at the base. Put some slip on the wheel head at 12 o'clock and pull the cut-off wire taut and level with the wheel head, releasing the vessel from the wheel. Remove all clay and moisture from both hands with a towel and gently but swiftly pick up the vessel from the base and place on a paper-lined ware board. An illustrated guide to finishing follows on page 132.

GUIDE TO COLLARING CLAY

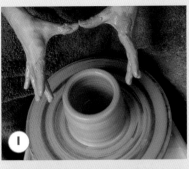

1. Collaring requires establishing three isolated pressure points. Lubricate the exterior wall. Touch thumbs at 6 o'clock and have middle fingers ready to apply pressure at 10 o'clock and 2 o'clock.

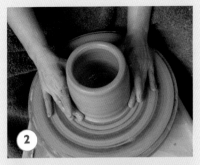

2. Apply inward and upward pressure at the very base of the clay with the wheel rotating at a medium speed. When you feel the clay narrowing and moving up after a few rotations, hold the inward pressure steady and move the hands up the cylinder wall.

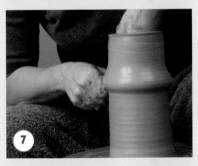

3. It's important to keep your hands moving up the wall of the cylinder with pressure points locked in position all the way to the top.

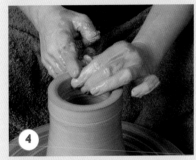

4. Be sure to re-center the rim by compressing the lip. The rim is supported by the left index finger and thumb; compression is applied by the right index finger. Sometimes a sponge to lubricate the top of the piece is helpful.

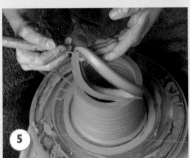

5. To remove an uneven lip, hold the needle tool at 4 o'clock, with the wheel rotating, and slice underneath the uneven lip. Lift the ring of clay off the piece while the wheel is rotating. Compress the lip.

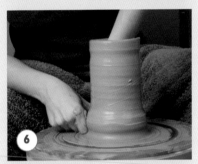

6. After collaring, raise the clay again by applying pressure from the outside at the base to create a new high point.

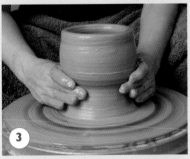

7. Notice the outer hand is dominant during raising. It is guiding the clay up and in. The left hand is receiving the pressure and raising the clay but not fighting the outer pressure.

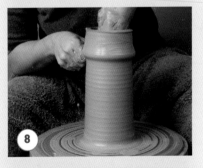

8. With each subsequent pull, the pressure is diminished and the speed of the wheel is reduced. If the wall remains straight and the rim remains within the stable area, clay can be raised and thinned to shape extremely fine forms.

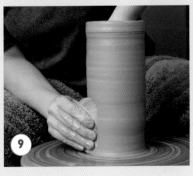

9. Try using a metal rib to compress and seal the wall of the clay. Gently approach the clay at a 2 o'clock angle. As the rib rides the outer wall, turn the edge of the rib slightly toward you until the top is reached. This will remove excessive slip and tighten the wall for shaping.

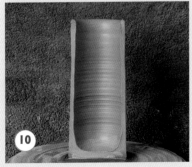

10. In this cross-section of a cylinder, notice the walls are fairly even and there is some extra thickness at the base of the pot. This extra clay can be trimmed when the piece is leather hard, but try to pull as much clay from the base as possible into the core of the wall before the clay dries.

GUIDE TO SHAPING CLAY

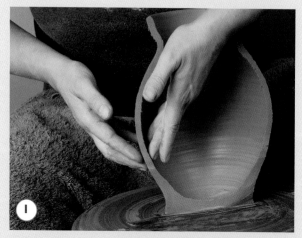

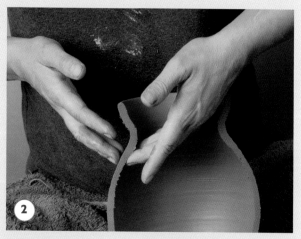

1. The inside hand is used to create the vessel's curve. The middle finger applies isolated pressure, and the others are there to support it. Apply pressure from the base slightly down and out and then up again to create a smooth curve. The outside fingers steady the curve and seal the clay as the curve shapes the pot.

2. Shaping requires a dialogue between the inner and outer hands. The first part of the curve is dominated by the inner hand, but as the neck is approached, the inner hand releases pressure and the outer hand applies pressure to bring the curve in.

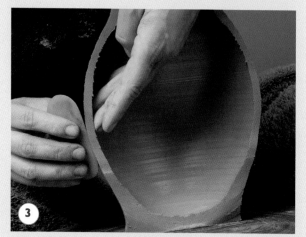

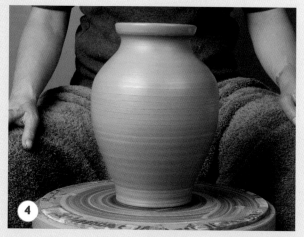

3. Many potters use ribs for shaping because they have a sharp edge that applies isolated pressure, allowing the potter to work without using slip. Shaping without lubrication allows the pot to be thinned while maintaining structural strength. Notice the angle of the rib and the pressure point slightly under the inner hand that is doing the shaping. Ribs can also be used on the inside or two at a time, one inside and one out.

4. Contours and shapes introduced to cylinder forms are the bases of most pottery forms. Fingers create a dialog with the clay. The inner and outer pressure changes as the shape is defined.

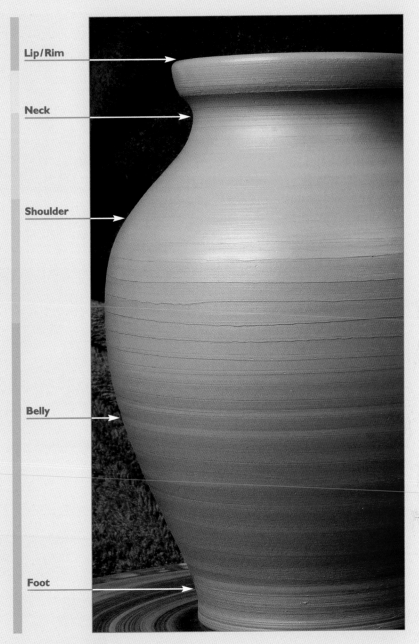

Lip/Rim

Neck

Shoulder

Belly

Foot

◎ The terminology used to describe the components of vessels is based on the human body. The image above reveals the anthropomorphic nature of pots. The arrows indicate basic components of a vase: Lip, neck, shoulder, belly, and foot

TROUBLESHOOTING COMMON THROWING PROBLEMS

When you are learning to throw, it is normal to have pots that are uncentered or that collapse as you finish the forms. Here is a list of common problems and remedies that you can use as a quick reference.

- If the clay is too stiff, it is nearly impossible to center and very difficult to throw. Check for softness when wedging. If you have to use too much force, try spraying water into the clay as you wedge to soften it or layer some soft clay and wedge until it is a nice plastic consistency. If you don't want to work at it, put the clay back in a bag with a wet washcloth overnight.

- If you find that you have air bubbles in the walls, go back to wedging and check to see that you are not folding air into the clay. This can happen easily when the clay is being folded into itself rather than gradually wedged into itself. If you can't seem to get rid of the air bubbles, try slamming the clay on the table in different directions and then wedge carefully, rolling clay into itself. Or try piercing the air bubble with a needle and filling in with soft clay during throwing.

- If the clay is off center, be sure the mound is absolutely centered before you open. When the mound is opened, be careful to release the pressure gently while the wheel is moving.

- If the clay mound seems off center once it's opened, make sure the opening is centered. Place your right hand on the wall with your thumb on the inside and your fingers on the outside, squeeze and hold steady until the clay travels without hesitation through your hand, then gently release the pressure.

> **TIP**
> Keep a clean towel handy to wipe your hands between moves and before removing a pot from the wheel.

FINISHING YOUR POT

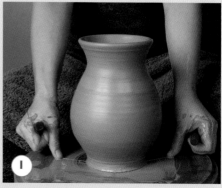

1. Clean the base of the pot. Lubricate the wheel head and pull the cutoff wire through the base of the vessel.

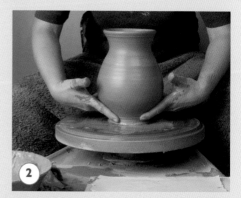

2. Clean and dry your hands. Use the index and middle fingers to lift the pot off the wheel.

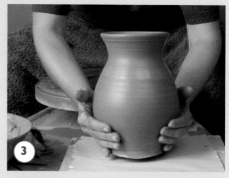

3. Place vessel on a paper-lined ware board.

- If the top of the wall lip seems off, compress the lip between two fingers and then apply gentle pressure from the top until it comes to center. Try to compress the lip after every pull; the action of pulling brings the unevenness to the top in a spiral-like form. It also serves to strengthen the lip of the pot.

- Remember to always make sure that the pot is centered throughout the throwing process. This will give you symmetrical shapes.

- If your pots are collapsing, pay attention to how much water is being used and to how long you are throwing. Chances are the clay is oversaturated. Try using clay slip instead of water; it is less prone to penetrating the clay wall. Set a timer for ten minutes throwing time. If you pass ten minutes for an average-size pot, it is probably becoming weak. Try throwing with either a metal or flexible rubber rib to remove excess slip and compress the wall. Using a rib allows potters to throw longer while staying relatively dry.

- Think about wheel speed. The thinner the walls or the further along in the shaping process, the more vulnerable to speed the piece will be. Slow down the wheel as you proceed, and you will see that the work won't collapse as often.

- If you are tearing the walls as you pull, try pulling with less pressure. Remember, clay likes a gradual transition. Also, be sure the walls are properly lubricated to avoid the drag or pull that can cause the piece to go off center or tear.

- If you find that you are going through the bottom of the base, try checking your depth as you approach the bottom of the piece. Use two chopsticks, placing one on the inside and one on the outside of the walls to see the difference in height (see also page 126). Make a mental note of how far you are going down into the mound by gently stopping as you reach the bottom and proceeding if you feel there is too much clay.

THROWING TIPS

Don't stress about making the perfect pot when you are learning to throw. The potter's wheel is a tool and a means to an end. In fact once you learn to make perfect pots, you may want to experiment by allowing some of the process of throwing show in the work. Some potters purposely avoid perfectly centered pots and leave the rims slightly off center or throwing marks on the surface of the clay to evoke a sense of movement in the pots.

When learning to shape particular forms, try shaping when the walls are slightly thicker than you would want in a finished pot. This will give you strong clay to work with while honing your techniques. As you master shaping. thinner walls will become easier.

Always turn off the wheel's power switch when not in use. This should be done for two reasons. First, curbing the constant electrical current going through the circuit board will reduce the wear and tear on the foot pedal control. Second, it will prevent accidentally depressing the pedal and sending a freshly thrown pot flying off the wheel.

DECORATIVE AND FINISHING TECHNIQUES

This chapter will focus on the basics of glazes, including choosing, mixing, applying, and firing them. Many books focus on the topic of glaze mixing and others focus on the decorative applications of glaze. These will be a lot of fun to read once you become comfortable with simple glaze preparation.

Glaze is a glass-like coating that is applied to ceramic ware and fired to cover the surface of the clay. Practically, it makes a pot nonporous, but it has many decorative applications, too. The glaze mixing and firing aspects of the ceramic cycle require a scientific approach that will aid your understanding of how to work with the materials. Fear not, the science can be fairly basic, but it can evolve into a very precise chemical process if you choose to investigate glaze chemistry at a deeper level.

CHOOSING GLAZES

A very important thing to consider when choosing a glaze is the maturing temperature of the clay being used. This is important for several reasons. First, a clay body should be fired to its maturing temperature to achieve the strongest density in the body for durability. Second, the glaze should have a good fit on the fired clay. When melted, glaze should expand and contract with the clay body and not craze, crawl, or run off the pot during the firing. Sometimes a glaze will shrink more than the clay and create an interrupted surface. (For functional ware this is

Faceted utensil jar holds an assortment of brushes used for decorative glazing. (For project instructions, see page 244.)

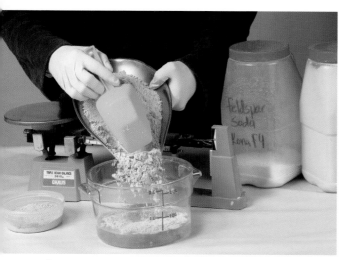

◉ Glaze-mixing aspects of the ceramic cycle require a scientific approach to precision and record keeping.

have an open clay that can resist the thermal shock of cooking because of the lack of density.

There are beautiful examples of burnished earthenware pots in native North and South American, ancient Middle Eastern, and African pottery traditions, to name a few. Ancient Greeks applied and burnished fine clay slips called *terrasigillata* onto the surfaces of their famous jars. They developed ways of applying particular *terrasigillatas* and firing them in very controlled environments to develop incredible detail and colors on the surface without a glass-like sheen. The clay surface maintains a warmth and soft quality that glaze would cover up. Traditional Native American potters use several different fine clay slips to paint decorative patterns on the surface of the clay.

In the Middle East, there is a long tradition of glazing architectural tiles and ornamental vessels with a basic white glaze that is painted over with

undesirable yet for aesthetic reasons some potters choose to work with this discrepancy.) And third, if you put a high-fire glaze on low-fire clay and high fire it, the clay will melt into a puddle during the glaze firing. Conversely if you put a low-fire glaze on a high-fire pot and over fire the glaze it will run off the pot onto the kiln shelf and create a puddle of glaze on the shelf. A good way to avoid some of these problems is to think about the type of work you want to make, talk to the ceramic supplier, and begin with the appropriate clay for a particular temperature range of glazes.

HISTORICAL LOW-FIRE GLAZES AND DECORATIVE TECHNIQUES

Even the oldest historical pots have some sort of decoration on them. Some have just simple textures and patterns carved on them and are marked by the fire. Others have a burnished surface, which is created by rubbing the clay with a smooth stone while it's still leather hard. The action of burnishing compresses the smallest particles of clay into the surface, making a shiny smooth surface. Many functional pots such as primitive cooking vessels were burnished and sealed with animal fat post-firing. Low-fire earthenware pots

◉ Majolica-glazed pitcher in white earthenware by Maggie East de Muller

⊚ Goat bowl by Ron Meyers. Terra-cotta clay with under-glazes applied to leather-hard bowl, bisque fired, and clear glazed and fired.

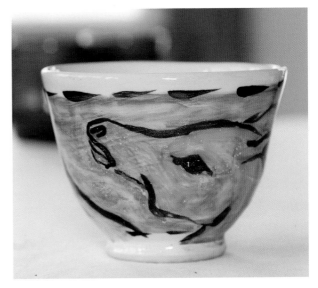

⊚ Porcelain bowl by Karen Copensky fired to cone 6 with mason stains painted over white glaze

pigments to develop ornate painterly surfaces. They, too, develop color and effect and luster surfaces by controlling the firing temperature and atmosphere.

In Italy, Spain, and Portugal there is a strong tradition of *majolica*, said to originate from Majorca. This ware features a white glaze applied to red terra-cotta clay, which is then overglazed with pigments such as metal oxides and carbonates and in modern day with commercial stains and colorants. This technique renders beautiful painted surfaces and can be very ornate. The color palette can be very bright because of the low firing temperatures, as some colors do burn out at high temperature. Potters who like to approach vessels as a blank canvas really enjoy the *majolica* process.

Many historical European, especially English, pots were made using a technique called slip-ware. A small variety of different colored clay slips are used to create low-relief decoration on the surface of pots, which is then covered with clear glaze. Some pots had extensive writing and were created to commemorate special events.

UNDERGLAZES

Underglazes are commonly used to paint bisqued ceramics before being coated with a second, clear glaze. Underglazes are available in hundreds of bright colors and textures and can be used as paints. Some artists embrace underglazes because of their painterly quality. They differ from *majolica* in that the glass coating covers the painting underneath instead of the painting being fused to the surface of the glaze.

LOW-FIRE COMMERCIAL GLAZES

Commercial stains, which are additives to clays and glazes, can be mixed with a little water to paint on the clay surface. They contain base metals and other synthetic ingredients to achieve very specific colors. They allow potters an unlimited amount of color and decorative development in glazes.

A lot of **commercial glazes** are specifically formulated for low-fire use. The colors are predictable and controllable if fired to the correct temperature. They are ideal for many school applications because the glazes are brushed on

the work. Thus, you can glaze many pieces with a small jar, eliminating the need for chemical storage and larger buckets of glaze. Potters that are just starting to fire their own work enjoy commercial glazes because they come with instructions. If the glaze does not fire correctly it is a usually a sign that something went wrong in the firing, not the glaze chemistry itself.

AMERICAN RAKU FIRING

American Raku firing is a low-fire technique in which pots are glazed and quickly fired to about 1800°F (982°C), swiftly pulled from the kiln with tongs, and placed in a post-firing reduction atmosphere. (A reduction atmosphere is typically a container with combustible material that is ignited by the hot pot and covered to create an oxygen-starved environment.) The fire burns and pulls the oxygen from the clay and glaze, which causes a chemical reaction with the copper (in some of the more typical Raku glaze) and beautiful iridescent colors develop. Any unglazed clay will turn black from the carbon impregnation that occurs from the reduction. Raku firing provides near instant gratification because the pots are quickly fired and cooled in about an hour. All other types of firing take many hours to reach temperature and usually just as many to cool down.

Raku is a high-risk technique because of the thermal shock that the clay goes through during the quick heating and cooling. But the results are worth the risks for the clay artists who work with this technique.

HIGH-FIRE GLAZES

Glazes that mature at temperatures of 2100°F (1149°C) are commonly referred to as **high fire**. They are applied to stoneware and porcelain clays that mature at higher temperatures. The advantage of this type of clay is that they are much

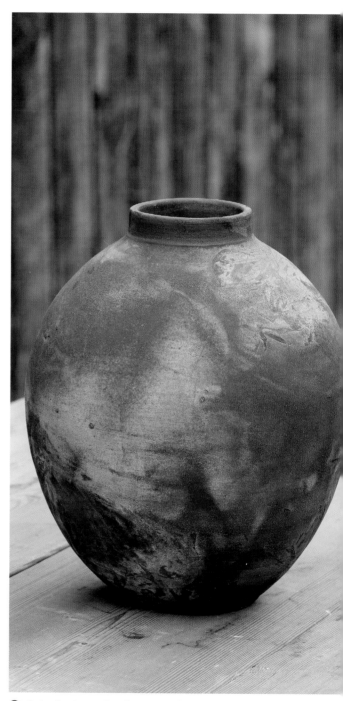

◎ Raku-fired vessel with copper glaze by Kristin Müller

denser than low-fired clays and earthenware. When a clay is fired to maturity, the clay particles fuse together, forming a nonporous clay body. A glaze applied and fired to the maturing range of a clay body creates a very strong bond. There is a depth to the color and quality of a high-fired glaze that is just not achievable at lower temperatures. The glaze bonds to the vitrified clay, melting onto the surface, allowing the iron particles in stoneware to speckle the glaze. A rich depth is apparent in the reflective quality of the glaze. High-fired glazes on porcelain are incredibly tight and bright. The effect is that of a coating of colored glass fused to the pure white form.

ELECTRIC KILNS AND MID-RANGE FIRING

With the popularity of electric kilns, mid-range clay bodies and glazes have become more popular, firing in the cone 5 to 8 (2201°F to 2316°F [1205°C–1269°C]) range. The heating elements in electric kilns last longer when they are fired at lower temperatures. Even though most electric kilns fire to at least cone 8 (2316°F [1269°C]), most potters fire to cone 6 (2201°F [1205°C]) to conserve energy and extend the life of the heating elements.

If an electric kiln will be fired in the studio, a good mid-range stoneware, one that matures at cone 6, will produce functional work. A glaze palette that works with that temperature should be developed.

Mid-Range Glazes

A benefit of the popularity of mid-range firing is that in the past decade many cone 6 glaze recipes have been published in ceramic magazines and books. Many more commercial glazes are now available in this firing range, complementing any glaze palette.

MIXING GLAZES

Let's begin with some simple concepts that will help you understand what glaze mixing is all about.

BASIC GLAZE COMPONENTS

Silica is the glass component of glaze. It has a melting temperature of about 3092°F (1700°C). Since we don't have clays or kilns that fire that hot, a melting ingredient is added to act as a flux. **Flux** lowers the melting point of the silica. **Alumina** naturally occurs in clays and is refractory (heat resistant) by nature. It is used to control the viscosity or flow of the glaze. Alumina helps control how much the glaze will flow on the pot when it is melting. It can also be used to control certain qualities in a glaze, such as texture and opacity.

These three ingredients make up the actual glaze coating. A **colorant** is added as a decorative feature and is generally a base metal such as iron, cobalt, or copper, rutile, or a combination of metal colorants. The many synthetic colorants on the market have helped modern potters broaden the color spectrum available for glazes.

Any glaze batch recipe that you see in a magazine or book will contain the three basic ingredients and colorant. These ingredients are weighed as powders and mixed with water to make the glaze a liquid.

There are many different sources of silica, flux, and alumina in ceramic raw materials used for glazes. So when you read a glaze batch recipe, you won't know which ingredients are the source for each of the basic components unless you

memorize a few. The good news is that you don't need to know the chemical breakdown of each ingredient to mix a glaze, but it does help to understand what they are and their purpose in the glazes. The ceramic process is a scientific craft and the more you know, the more control you will have of your finished work.

Glaze Calculation

The **unity molecular formula** is the proper combination of silica, flux, and alumina to achieve a particular maturing temperature and quality in a glaze. It lists the glaze ingredients in parts by weight that add up to 100. The colorants are added in a quantity that is a percentage of the

glaze batch. For example, here is a glaze batch recipe for a cone 6 satin white glaze:

Nepheline Syenite	54 grams
Dolomite	11 grams
EPK	6 grams
Zircopax	12 grams
Gerstley Borate	7 grams
	100 grams

To make the glaze green, add 1 percent of the total weight of the glaze of copper carbonate to the glaze batch.

To make blue glaze, add 1 percent of the total weight of the glaze of cobalt carbonate to the glaze batch.

A glaze formula in parts per weight can be measured in grams, ounces, or parts as it is based on proportion. As in the example above, most recipes are listed in grams. It will be easier and more conventional to use a gram scale to measure raw materials rather than convert.

The example above makes 100 grams of glaze, which is less than a stick of butter in volume and won't do much more than cover a test tile. When testing glazes, aim to mix at least 500 grams of glaze, how the glaze handles in application and how it will fire on different pieces can be adequately tested.

To convert a 100-gram recipe to yield larger amounts, simply multiply each ingredient by the desired factor. For example, multiply quantities by 5 to make 500 grams, 10 to make 1,000 grams, and so on.

The calculation will look like this:

Nepheline Syenite	54 × 10 = 540
Dolomite	11 × 10 = 110
EPK	6 × 10 = 60
Zircopax	12 × 10 = 120
Gerstley Borate1	7 × 10 = 170
	100 × 10 = 1000

For green glaze add copper carbonate 1% 1 × 10= 10

TIP

Determining how much glaze to mix is entirely personal. A word of caution, do not mix a large quantity of a glaze until you have already tested it. Mix a 500- to 1,000-gram recipe and glaze several pieces to see if you really like it. Then mix a larger batch; a 4,000- to 6,000-gram batch of glaze will fill a 5-gallon (about 20-L) bucket and should provide a generous amount to glaze for dipping and pouring lots of ware.

At first, the names of the materials in a glaze recipe may seem daunting. If you read the supply catalogs and ceramic magazines the names of chemicals will become familiar and it will be less intimidating. Ceramic suppliers usually list their raw materials and what they're used for in clays and glazes in their catalogs. They are a quick resource when you have a question about an ingredient. I recommend reading this section on raw materials to build knowledge base. As familiarity with raw materials develops, reading books on glaze chemistry will be much easier.

Experimenting with recipes from books without knowing what the glaze solution looks like or how it was fired is a challenge. Many times books and magazines fail to mention the color of the clay being glazed. If the clay is white, colors will be very crisp; if the clay is dark, the iron in the clay will create a dark undertone to the glaze. Think of the clay color as a colored canvas on to which glaze will be applied.

Beware of old books that use outdated ceramic materials that are either toxic or no longer available. It's better to look at more recent glaze books that will have up-to-date information, including safety warnings and chemicals that are readily available. It's a good idea to ask a trusted potter for a glaze batch recipe to try. An experienced potter can be a sounding board for questions, and the recipes provided are sure to be tried-and-true.

Keeping Glazes in Suspension

Glazes are suspensions. They are made up of a range of materials with different particle sizes and weights that once stirred are suspended in the water. After the mixture sits for a while, the heaviest particles begin to settle out.

Commercial glazes contain binders, such as gum-based products, to keep the ingredients suspended. These commercial binders are available for home use, as well. You can aid the suspension of the glaze mixture when mixing your own glazes, too. Add 1 percent Epsom salts or 2 percent bentonite in a water solution to the mixture. Neither addition will change the glaze formula, but either will help suspend the heavier particles. Some glaze recipes already list bentonite in the recipe. If you are mixing a glaze that contains bentonite, you won't need Epsom salts. If a glaze has been stored for a while, stir a little more Epsom salts (or bentonite) solution to the mixture.

SAFETY PRECAUTIONS

Following basic safety precautions in the glaze studio is necessary. Always read all product labels before experimenting.

It is essential that you avoid using toxic chemicals and follow all warnings about potentially toxic materials. It's a good practice to treat all raw materials as toxic. When handling powdered ceramic materials, always use an approved particulate mask to block the inhalation of ceramic dust. Inhaling ceramic materials can cause damage to the lungs. Consult your physician before using a respirator mask because they can be a risk to people with certain health conditions.

If you have cuts or abrasions on your hands, use surgical gloves, and make a habit of using gloves when you glaze to avoid the absorption of heavy metals into your bloodstream.

Do not pour unused glazes down the drain—they pollute the water supply. Instead, allow the glaze to settle out, then decant the water and allow the glaze to dry. It can be thrown out as is or fired in a bisque-fired bowl or clay cylinder, creating a solid mass that can be disposed of. An environmentally friendly approach to dealing with unwanted glaze is to have a mystery glaze bucket where all unwanted glaze is added and samples are test fired. Colorant can be added to be used as liner glaze for the inside of vases and bottles. Sometimes the resulting mystery glaze will be beautiful enough to use for exterior glazing, too.

Some common sense rules apply, too. Never eat, drink, or smoke in a studio when mixing glazes. Covering the mixing and glazing area in paper makes cleaning up quick and easy—just roll it up and dispose of it afterwards.

GATHERING SUPPLIES

When you are ready to begin mixing a glaze, get all the tools and supplies ready.

- Newspaper (for lining table)
- Plastic bucket with lid to mix glaze in
- Additional bucket to sieve glaze into
- Assorted buckets and bowls
- Marker to label bucket
- Gram scale
- Calculator for calculating amount of ingredients
- Rubber gloves
- Scoops and spoons
- Pitcher with water
- Dust mask rated for small particles and fine dust
- Clean-up sponge

◎ Two types of particulate masks: Above, top is a disposable particulate mask, available at hardware stores. Above, bottom is a higher quality, heavy-duty particulate mask, with disposable filters, available from ceramic suppliers and some larger hardware stores.

- Cloth towels
- Paper towels
- Brushes: watercolor, hake, and sponge brushes
- Rubber spatula and large stirring spoon
- Scrub brush for cleaning dishes and plastic putty knife
- 60 or 80 mesh sieve
- Glaze batch recipe and pen

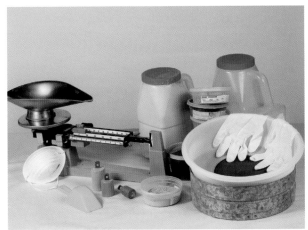

Glaze mixing supplies: Gram scale, sieves, mask, glaze chemicals, and scoops

MEASURING INGREDIENTS

A gram scale is a precision instrument that is used to measure specific amounts of material to the tenth of a gram. Gram scales are easy to use, but they demand attention to detail.

When you purchase a scale, be sure to buy the container that accompanies the model so the manufacturer's scale can be properly tared. Any plastic container can be used, but it must be placed empty on the scale with all the markers on the balance beam at 0 grams. The container should weigh in at zero on the balance marker. This way, the weight of the container will not count toward the amounts of ceramic materials you are weighing. There is a small dial on every scale for adjusting the balance beam and aiding in achieving the proper tare. Read the instruc-

tions that come with the scale.

Digital scales are also commonly available, and they make it very easy to weigh materials.

Choose a glaze recipe that will suit the firing temperature or cone of the clay that is going to be glazed. Mix a small test batch of 500 grams. (Most books suggest 100 gram recipes, but they are too small to really coat a small pot and see how the glaze works.) After testing, if you like the results, mix a larger batch.

Good glaze mixing habits from the beginning will keep you organized and focused. One of the most useful habits is to write down the recipe in the quantity that you are going to mix on an index card. Mark off each ingredient as it is measured and poured into the bucket. When mixing large quantities it is not uncommon to measure out the same material in small increments. Making note of each addition will ensure an accurate glaze batch. It is easy to get distracted and lose count of the mixture. When weighing materials, it is essential to concentrate so as not to waste time, materials, or a finished piece of ware.

MASTERING CONSISTENCY

Determining the consistency of the glaze is tricky because each glaze behaves differently, depending on thickness of the coating. It will also depend on method of application and the thickness of the ceramic ware. Bisque ware is very porous and if the pot is thick it will tend to absorb a lot of glaze.

Some glazes are applied thinly because they bring out the color and textures in the clay. There are other glazes that benefit from a generous coating for depth in color and richness in texture. If a glaze is too thin, the result typically is more of a sheen on the clay with little to no color. If a glaze is too thick, it will tend to crack as it dries and will be prone to crawling off the pot and also

A Guide To Mixing Glazes

1. On a level surface, set the scale for the desired weight. After each weighing, make sure that all three markers on the balance beam are set to zero and set the next weight. This will ensure that you don't incorrectly weigh any ingredient.

Place the ingredient in the measuring container until the balance beam begins to rise and reaches the middle marker that indicates the proper weight. If the beam moves higher, remove some powder until it levels off.

2. Set the balance beam markers to the next desired weight and add the next ingredient until the balance beam is level. Pour the ingredient in the glaze bucket.

3. Place the powder in the glaze bucket and check off the ingredient on the index card with the recipe. The glaze bucket should have some water in it to slake the powder. Wipe off any excess powder from the container and the scoop. Set the balance beam markers to zero.

4. Cover the glaze bucket after each addition of powder to keep the dust contained. After all the ingredients have been weighed and added to the glaze bucket, add some more water then slake the dry ingredients into the water. How much water depends on how much glaze you are mixing. Add the Epsom salt solution, 1 percent of the total weight of glaze.

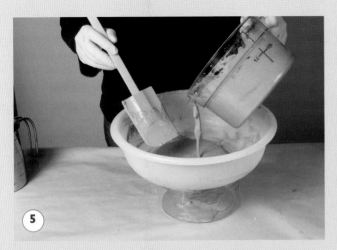

(5)

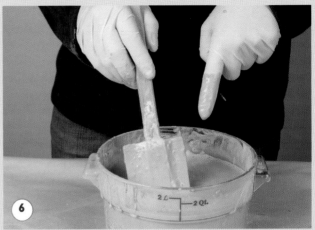

(6)

5. Stir thoroughly and sieve. When you sieve the glaze, be careful not to use too much pressure on the sieve. A plastic putty knife or a dishwashing brush is really useful to promote the mixture through the sieve. Sieve the mixture two to three times until the clumps are gone. Sieving a glaze a few times really integrates the ingredients.

6. Check for consistency of the glaze. It should be like heavy cream, not like pudding. If it's too thick, add water to the mixture and stir until when you dip your gloved finger it coats evenly and drips one or two drops off the tip.

TIP

The rule of thumb is to use about the same weight in water as is the total weight of the dry ingredients. I usually put a little less water than I expect to use. This method prevents the clumping of dry material. Keep in mind that it's easier to add water than to remove it.

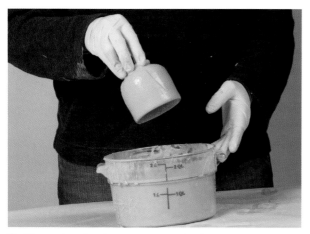

Try testing the glaze consistency by dipping a test cup in the bucket.

running during the melting, which runs the risk of adhering the pot to the kiln shelf.

Some potters measure the ratio of water to glaze to ensure consistent results. You can train yourself to do it by eye, or a tool called a hydrometer, which measures percentage of water in a glaze, can be purchased instead.

How the glaze will be applied also determines the consistency. For brush application, a thicker consistency is good. For dipping and pouring, a thinner consistency is preferable. For spraying, the size of the nozzle may require an even thinner consistency to prevent clogging.

Make sure that glaze chemicals are stored in sealed containers and that they are not cross-contaminated. Label everything from chemicals to glazes—write the name, recipe, and firing temperature on the bucket, not the lid, as lids get easily separated from the glaze bucket. Glazes in the raw state look nothing like they do once they are fired, so labeling is essential. Making test tiles, or test cups, of each glaze will help you stay organized, too.

Many factors determine the end result and so there really is no absolute answer, just guidelines to help you find your way with the process.

KEEPING A GLAZE JOURNAL

A glaze journal is a very useful tool. I still use my college journal on occasion. When I started keeping recipes and notes in college, I could have never projected that some of that information would be applicable years later. Here are some things you may want to track.

Keep a record of the clay bodies that you use, including supplier, clay code, and temperature range.

Write down glaze recipes, including amounts mixed and how they were applied, and if possible, take a picture of the test piece or results. I know potters who take digital images, creating a computer journal. The results can be printed as desired.

Make notes about the glaze application method and the firing results. Over time you will see patterns emerge that will inform your approach to working with glazes.

PREPARING WARE FOR GLAZING

Work should first be bisque fired to a temperature of at least cone 010 up to cone 04, depending on the type of clay. The convention is cone 06 for commercial clays and glazes. The higher the firing temperature, the less absorbent the bisque ware will be. Before you begin to glaze work, examine the bisque ware to see if there are any clay burrs or highpoints that need sanding. Particular care should be paid to functional pots at the lip or handle section. Any clay debris that gets glazed will become sharp.

You can use a piece of kiln shelf or sand paper to sand any rough surfaces. Be sure to do

this outdoors and with a mask on for protection. You do not want to create dust in the studio.

Quickly rinsing the bisque to remove dust and debris and to add a little moisture to the ware. Let it stand a few hours before glazing. This way it will absorb just the right amount of glaze. If work has sat around for a long time it does get dusty, but if you keep your bisque covered you may not have to rinse it. Some potters use a damp sponge to wipe off excess dust, but sponge debris can get caught on textures.

Other potters briskly rub their bare hands on the bisque to remove dust. This works, but it can be abrasive if you have a lot of work to glaze. Do not blow on the bisque to dispel dust because it will send debris right into your eyes and nose.

It is important to have clean hands that are free from oils when handling bisque. Wash any hand lotion off with soapy water before handling bisque; otherwise, the oils will resist glaze.

APPLYING WAX RESIST

Wax resist is used to coat the base of pieces before they are glazed. The purpose of this is to ensure that glaze does not adhere to the base of a piece. If there is glaze on the base, it will fuse to the kiln shelf and crack.

You can buy a number of latex-based wax resists. They are easy to use and clean up. Some potters use hot paraffin wax, which is quick to use but highly flammable if it gets too hot. Latex wax can be applied with a brush, a sponge brush, or a small piece of sponge, which can be pinched for more control. Be sure to work carefully and not get wax on other areas because the wax will resist the glaze. If you do get a drip, use a lighter or other source of flame to heat the area, melting off the wax. Gently sand the surface. If this doesn't work try re-bisque firing the piece.

A good rule of thumb is to apply wax to your piece ¼ inch (½ cm) up from the base. Liquid

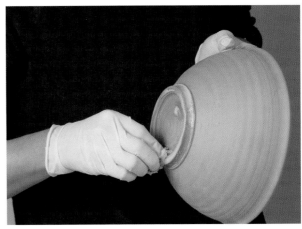

Latex wax applied with a sponge to the foot of a bowl

wax resist works best if applied at least four hours before glazing. This way it has a chance to dry and resists glaze more efficiently. The bottoms of pieces will need to be checked and wiped before loading the kiln.

Glaze can be brushed, dipped, poured on, sprayed, sponged on, and slip trailed for different effects. The ultimate goal is to get an even coat of glaze on the piece and then decorate. You can overlap glazes but be careful not to overlap more than two glazes and test for results. Often glazes that have a different glaze batch recipe will combine and lower the melting point. This can be beautiful on the top of a vessel but disastrous at the base of a piece.

Keep in mind that glazing takes as much practice as making the pottery itself, so keep some of your not-so-favorite pieces to practice

TIP
Most glazes are applied to bisque-fired pieces, but there are potters who single fire; in other words, they glaze greenware and fire only once. This is a tricky process and usually used with wood-fired kilns because the ware can be fired very slowly to draw out the moisture.

Applying Glazes

Commercial glazes are easy to use and are usually applied in two to three coats. Each coat applied with brushstrokes in opposite directions. For dipping glazes you will need enough glaze and a container that is large enough to accommodate the shape to be dipped.

There are several different ways to apply glaze to work.

Dipping

1. The easiest way to dip a bowl is to hold it and dip into the glaze bucket two-thirds of the way.

2. Let dry and hold the bowl from the opposite side and dip two-thirds of the way again. If you use the same glaze, you will get a thicker coat in the middle, creating a color variation.

3. If you use two different colors, you will get three different color effects in one piece.

Pouring

1. Another way is to pour glaze into the vessel to be glazed and swish around.

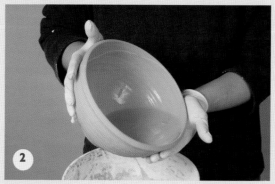

2. When the glaze has covered the inside, quickly pour the glaze out. When the glaze has dried, dip the outer surface into the glaze. You can use the same glaze or two different glazes.

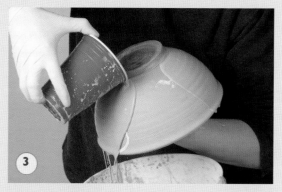

3. Glaze can be poured on the exterior of a vessel if the hand is placed inside the vessel so that it can be turned while the glaze is being poured.

Dipping a Cup

1. To dip a cup, hold the handle and dip into bucket. Be sure to empty the glaze as you lift the cup out of the bucket.

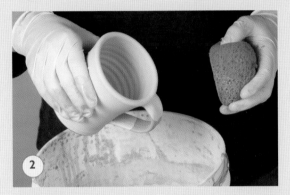

2. When the glaze has dried, dip the handle.

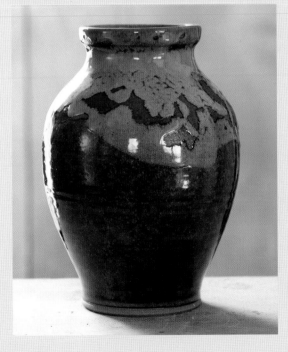

◎ Cone 6 electric-fired vase with overlapping glaze at the top. The combination of two glazes caused a crawled effect.

Spraying

Spraying imparts an even application of glaze.

Spraying can also be an effective method for applying glaze in once-firing, as the atomized glaze contains less water, allowing for a better mechanical glaze fit on the leather-hard or bone-dry clay.

The liquid glaze is poured into the spray gun container. After each spraying application, the container should be shaken to prevent the glaze from settling. Agitating the glaze will ensure a uniform glaze content in the spray.

The spray gun should be thoroughly cleaned after any spraying application.

Brushing

Brushing allows for the glaze to be applied to specific areas of the pottery. Care must be taken to ensure an even glaze coating.

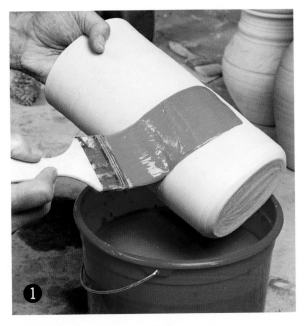

① Carefully brush the glaze on the bisque pot.

② Clean the brush after any glaze application.

Touch-up Tips

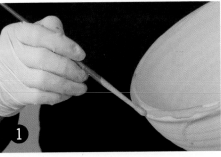

1. To cover bare spots the glaze, try touching up glaze with a brush.

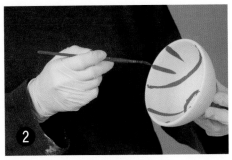

2. It is possible to paint over the glaze with wax resist and then apply another glaze for a wax resist decoration. Or use an oxide such as iron oxide or cobalt oxide mixed with a little water to paint a design over the glaze.

TIP

Studio Note

The depth of the glaze layer can play an important part in duplicating a glaze effect. If a glaze layer is too thin, the color of the clay body predominates. Often a thin application can slow the development of color, texture, and opacity in the fired glaze. If a glaze layer is too thick, a glaze layer can cause the glaze to run off vertical surfaces or pool excessively in horizontal areas. Unfortunately, most glaze formulas do not contain a notation section offering information on glaze thickness or application techniques.

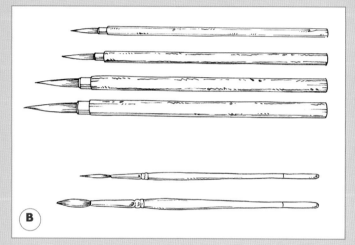

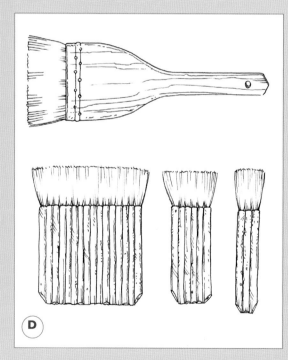

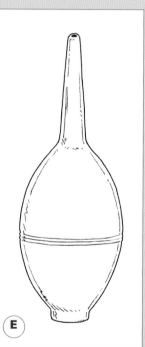

Here are some helpful tools that offer a range of glazing effects and techniques:

A. Dipping tongs are used to hold pieces while dipping into glaze buckets.

B. Assorted watercolor brushes are used to paint details or correct glaze application.

C. A fine-tipped squeeze bottle is used to trail glaze in a detailed fashion.

D. Hake and bamboo brushes hold a lot of glaze and are good to use for brush applications of glaze.

E. A bulb syringe is used to apply glaze to isolated areas.

GLAZING TIPS

Here's how to fix some common problems with glaze application.

If the dry glaze looks crackled, the chances are the coat of glaze is too thick. Try scraping it off with a metal rib and re-glaze with a thinner coat.

If you have glaze drips, wipe them off (especially from the base of the piece) or let them air dry and scrape it off with a metal rib.

If the surface looks blistery or bubbly, try rubbing the surface of the dry glaze with a paper towel to smooth it out. Be careful not to chip the glaze or inhale the dust.

(continued from page 147)

applying glazes. If you practice on your least favorite pieces, you will do a great job on the pieces that you're most proud of.

When you are finished glazing, be sure to wipe the bottoms of pieces with a clean damp sponge to remove any glaze that may have beaded up. Then place the pieces on clean paper-lined ware boards to carry work to the kiln. Do not forget this step—it is too easy to place a piece of work on dirty paper. It will pick up any glaze drips and cause problems in the kiln.

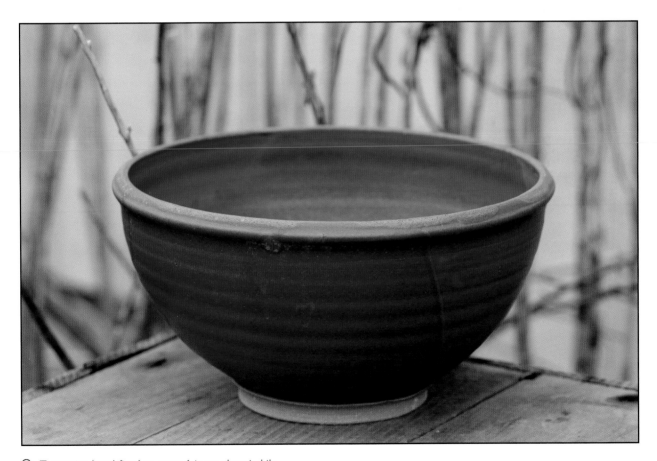

Turquoise bowl fired to cone 6 in an electric kiln

GLAZE CHEMISTRY

Defined in the simplest terms, glaze is liquid glass subjected to heat. When glazes are fired in a kiln, they melt and adhere to the clay body, eventually hardening and forming a glossy, satin matte, or matte surface texture. Glazes contain silica, alumina, and any combination of flux oxides. Various raw materials—calcium, magnesium, frits, boron, and a multitude of others—are combined to form glazes that act differently, depending on the clay body and firing conditions. Ultimately, you will choose a glaze based on the purpose of your clay piece and your kiln's firing temperature and atmosphere.

Glazes can serve many functions. Base glazes appear transparent, semi-opaque, or opaque when fired. As the name implies, these glazes often serve as a "base" for adding other materials, such as metallic coloring oxides, stains, gums, or suspension agents that alter the fired outcome. Liner glazes are applied to functional pottery, such as mugs or plates—anything you plan to use that will come into direct contact with food or drink. Liner glazes are inert when in contact with acidic or alkaline food or liquids. These glazes are durable enough to withstand dishwashing soaps—even dishwashers. Liner glazes do not contain lead or soluble materials that could leach into food or beverages, but can contain coloring oxides or stains.

The way glaze melts onto clay is like magic, or so it seems. You apply a milky white liquid to a pot, fire it in a kiln, and the final product is a rich, cobalt blue. As with many things in pottery, what you see when glaze is in its raw, pre-fired form is not what you get once the clay piece has been heated in the kiln.

Wheel-Thrown Covered Jar by Tom White
See page 290 for formula

DESIRABLE GLAZE

Reliable, defect-free glazes share certain characteristics. They apply easily onto the clay surface, whether sprayed, dipped, or brushed. Glazes that require minimum touch-ups after dipping save the studio potter time, especially if production and sales are considerations. Also, quality glazes have a temperature buffer in the kiln; preferably a two to three pyrometric cone maturing range. At any point in the cone range, the fired pot should have a smooth, non-pitted surface. An abrasion-resistant surface is important for functional pottery. Functional pottery glazes should not leach when in contact with acidic or alkaline foods. And, most important, the best glaze formulas are reliable and yield consistent texture and color time after time.

Achieving such desirable glaze characteristics is only possible with raw materials that are reliable and stable in particle size, chemical composition, and organic content. You should examine a glaze's solubility, stability, and firing conditions to ensure the best results.

SOLUBILITY

Soluble materials will leach into the water system of the glaze, changing its chemical composition over time, which can result in multiple glaze defects. As water evaporates from the glaze layer during application, soluble materials travel by wicking action, drawing higher concentrations of material to the ridges and edges of the pot. Essentially, the glaze formula in the elevated edges of the pot is different, due to the concentration of soluble materials. The altered glaze area can cause blisters, pinholes, dry surfaces, or changes in the glaze color.

When soluble materials are required in a glaze formula, store them in waterproof plastic bags. A conservative approach is to mix only enough glaze containing soluble material for one glazing session. Remember, the stored liquid glaze can change over time.

Soluble materials include boric acid, Gerstley borate, colemanite, soda ash, wood ash, Gillespie borate, Boraq, potassium bichromate, and pearl ash (potassium carbonate). Other glaze materials, such as lithium carbonate, magnesium carbonate, nepheline syenite, strontium carbonate, and some frits, can have lesser degrees of solubility. These soluble materials can be found in glaze formulas, and they generally do not interfere with the glaze application or fired glaze effects.

STABILITY

When glazing pottery that you plan to use for food or liquids, you must know how the glaze will react in acidic and alkali conditions. Acidic or alkali conditions from lemons or dishwasher soap can attack glaze surfaces, resulting in discoloration, pitting, or penetration of liquids into the glaze. Extracted elements from the glaze can contaminate food or liquids.

In the presences of strong alkali (high pH) silica, the glaze converts to caustic sodium silicate, altering the original glaze as well as feeding on itself and causing further damage. In extremely acidic (low pH) conditions found in food or drink, alkalis are drawn out of unstable glazes. The leaching effect can discolor or mar the glaze surface. This reaction is often observed when tomatoes, limes, or lemon juice (all acidic) are left on compromised glazed surfaces for any length of time.

Any concave or convex disruption of the glazed surface, such as blisters, pinholes, or clay body eruptions through the glaze, are possible sources of entry for contaminants and/or corrosive reactions. Glaze defects such as crazing (see page 182), which is a fine network of recessed lines, can provide a place for bacteria and mold to grow and contaminate food or drink.

Liner Glaze Requirements

While potters have a good idea of what characteristics constitute a glaze—color, light transmission, temperature range, and surface texture—liner glazes can offer some challenges to achieve their intended function. Here are a few things to keep in mind.

- Liner glazes should not contain lead or lead frits. Although such glazes can be formulated for safe use, many variables make the formulation process and storage of raw materials impractical for most pottery operations.

- Test for solubility if the glaze contains more than 5 percent of metallic coloring oxides or stains. Metallic coloring oxides or their carbonate forms, such as cobalt oxide, cobalt carbonate, and iron oxide (which are readily soluble in the glazes) can also be used in small amounts, less than 3 percent.

- Glazed surfaces should be smooth, without concave or convex irregularities.

- Glazes should be free of crazing, a fine network of cracks in the glaze surface, and shivering, when the glaze peels off the fired clay surface similar to paint chipping.

- Glazes should apply evenly to the pottery surface by dipping, brushing, or spraying.

- Glazes should have high abrasion resistance when fired, creating a strong blemish-free surface when in contact with household utensils.

- Glazes should resist high alkali and acidic conditions in daily use.

- Glazes should be easily reproducible, giving consistent results in every kiln firing.

- Glazes should be stable when fired slightly above or below their recommended firing temperature because not all kilns will fire evenly.

- Field-test glazes in actual heating, freezing, and cleaning conditions.

- Send suspect glazes to a testing laboratory before using the formula in your studio.

FIRING CONDITIONS

Every clay body and glaze combination will react differently to the rate of temperature increase in the kiln. As a general guideline, take at least 12 to 14 hours total firing time to reach cone 6, or 2,232°F (1,222°C), in a fully-loaded, electric kiln. In a computer-controlled electric kiln, use the "slow" setting with a fully-loaded kiln. (For more information on kiln temperature, see page 164.)

If there are not enough pots to fill the kiln, place shelves and posts in the kiln to create greater thermal mass, which will contribute to an even heat distribution and slow the rate of heating and cooling. Hydrocarbon-fueled kilns and/or larger kilns with greater thermal mass may require different firing cycles to achieve glaze and clay body maturity.

Glaze maturity is especially important in liner glazes, because they are often applied to enclosed forms, such as covered jars, teapots, or casseroles, which can be insulated somewhat from outside heat sources. Ceramic materials are good insulators of heat, and an enclosed interior glaze surface will not mature like the outside glazed surface if the kiln is fired too fast or does not reach glaze maturing temperature. Determine kiln temperature by placing pyrometric cones inside the kiln, or by taking a pyrometer reading.

Firing the glaze too fast to its end-point temperature can result in rough, jagged surfaces. Kiln firing conditions can change the glaze surface and clay body maturity, causing it to leach its oxides or trap food particles. Also, glazes and clay bodies can become unstable in over-reduced or under-reduced kiln atmospheres, or when exposed to wood, salt, or soda firing. Atmospheric kiln firing conditions can introduce variable factors that slow or intensify the melting action and surface texture of the glaze formula.

In other instances, the clay body itself can alter the glaze by drawing out oxides from the glaze. This will inhibit the glaze's melting potential, resulting in a surface that leaches water or an unsanitary surface that traps food particles in its microscopic voids (due to glaze not melting completely). Some matte glazes can be unstable, leaching their oxides into foods or liquids because they achieve their matte effect through under-firing or fast firing. Such glazes also can cause chipping, crazing, and scratching, or display a bleached lighter fired color.

TIP

Using Trial and Error

Test kilns allow the trial and error adjustments of several different glaze formulas. If successful, glazes can be produced in larger amounts for pottery production.

TESTING GLAZE

Always test glazes before applying them to pottery. Glazes will react differently on brown and white clays and when subjected to different firing temperatures. Because you are not using the same kiln as the ceramics supplier, do not rely on their test tile samples as a completely accurate depiction of how a glaze will look after it is fired.

Equipment

100-gram test batch of glaze

80-mesh sieve

4″ (10-cm) test tiles, with smooth and textured surfaces

Bucket

Instructions

1. Measure out a 100-gram test batch of glaze (dry material).

2. Add enough water to achieve a glaze thickness of 0.5 mm to 1.5 mm or the equivalent of 3 business cards stacked together.

3. Strain the mixture through an 80-mesh sieve, allowing the glaze to collect in a bucket.

4. Apply the glaze to several 4″ test tiles with smooth and textured surfaces. Allow for a 1″ unglazed area on the bottom of each tile, because some glazes might drip.

5. Place the test tiles on the top, middle, and bottom shelves of the kiln. Not all kilns fire evenly, so this will give an indication of how the kiln's heat work affects the glaze. The multiple tiles will indicate the temperature range at which the glaze will mature.

If the kiln were firing to a higher temperature, on the top, the glaze might have an exceptionally high-gloss surface and run on the vertical tile. If in another part of the kiln the temperature was too low, the same glaze might have a dry matte surface and not run on the vertical tile. If the same glaze looks identical despite variations in temperature throughout the kiln, it is an indication of an adequate glaze maturation range.

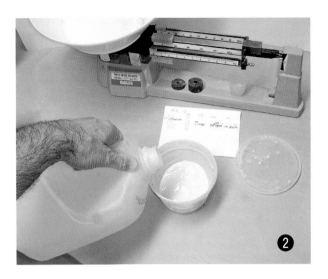

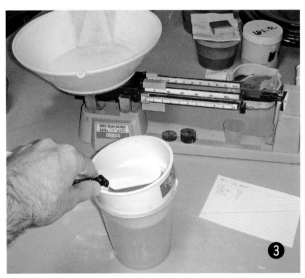

GLAZES FOR FOODS AND BEVERAGES

Many potters will use a glaze habitually without considering how it will react when coming into contact with food or drink. Some potters believe any glaze that melts can serve as a liner glaze. However, not every liner glaze can stand up to alkaline/acidic conditions or produce an abrasion-resistant surface.

The three factors that influence more than 90 percent of attack by acidic and alkali substances on unstable glazes are time, temperature, and extreme pH levels. The remaining 10 percent encompasses the hardness of the water, sanitary condition of the container, and any suspended material in the water. The longer a glaze is exposed to acidic or alkali substances, the greater the chance of leaching. Additionally, the higher the temperature of acidic or alkali substances, the greater the possibility of leaching. Extremely low or high pH levels can increase leaching in glazes. It's important to note that with normal pottery use, time, temperature, and pH conditions will have no adverse effect on *stable* glazes, only unstable glazes.

ACID/ALKALINE RESISTANCE

Several selections of raw glaze materials can enhance glaze stability in acidic and alkali conditions. Acidic conditions attack alkaline materials in the glaze such as feldspars or high-alkaline frits. To a lesser degree, they also react with alkaline earth materials in the glaze, such as dolomite, calcium carbonate, or magnesium carbonate and strontium carbonate.

Often, decreasing a glaze's alkaline-earth oxides (such as barium oxide, calcium oxide, or magnesium oxide) and substituting alkaline oxides (such as sodium oxide, potassium oxide, lead oxide, lithium oxide, or titanium oxide) will increase its resistance to acid/alkaline conditions. However, high percentages of a single alkaline-earth material can contribute to a matte surface texture and glaze instability. Alkaline-earth oxides can be found in several ceramic materials, such as barium carbonate, whiting, magnesium carbonate, dolomite, and talc. Alkaline oxides can be found in several ceramic materials such as feldspars, frits, lead, lithium carbonate, and titanium dioxide.

Because both groups of alkaline and alkaline-earth materials act as fluxes in varying strengths, they should be used in the lowest amounts possible to achieve a glassy melt. Alkaline and alkaline-earth fluxes will not contribute color to glazes, but they do influence color when metallic coloring oxides are present in the glaze. Greater glaze stability can be achieved by using combinations of fluxes, as opposed to a single flux.

Increasing the silica content of a glaze can prevent acidic and alkali reactions on the glaze surface. However, a glaze with not enough flux and too high a silica content will be immature and subject to chemical attack, while additions of alumina, titania, and zirconia improve a glaze's acid resistance. A common source of titania is titanium dioxide. Superpax, Opax, and Ultrox (or their equivalents) are glaze opacity–producing agents that contain zirconia. A balance of fluxes, alumina, and silica will produce stable glazes along with the appropriate firing conditions.

A surprising number of glazes, when critically examined, are overly fluxed and can accept more silica (flint) to achieve a resilient glaze. One indication of overly fluxed glazes is running on vertical surfaces or even a slight beading on the bottom of the form where the glaze ends and the foot begins.

Some glazes are "soft" when fired, meaning they can be easily abraded by utensil marks in daily use. Glaze designed for functional pottery must meet the test of abrasion resistance.

ABRASION RESISTANCE

When a glaze shows scratch marks, the physically soft quality of the glaze is giving way to a harder material moving across the surface. Some glazes are soft compared with household utensils and scrubbing pads. Glazes can be scratched when they have not reached their maturation temperature or if they reached their correct temperature too quickly. Both conditions can result in insufficient glass formation in the glaze. Often, immature glazes are incorrectly classified as satin matte or matte, with a semi-opaque or opaque light transmission and a rough surface texture.

The simplest solution is to fire the glaze to a higher temperature and/or longer time to temperature, which will result in glaze maturity. Both firing methods subject the glaze to greater heat work in the kiln. This causes silica and alumina contained in the glaze formula to reach a glassy hard consistency. Or, try increasing the primary glaze fluxes, such as feldspars or frits. (Remember, adding too much feldspar or frit can subject the glaze to acidic or alkali attack.) A careful balance of flux materials, silica, and alumina fired to maturity in a compatible kiln firing cycle will develop glazes that resist chemical attack and abrasion.

Using Metallic Coloring Oxides

Do not overload a durable, safe glaze with metallic coloring oxides, such as cobalt, copper, or chrome. When multiple metallic oxides are used, even in low levels, their combined effect can cause leaching in a stable base glaze. The amount of oxides it takes to overload a base glaze depends on the base glaze formula, firing temperature, time to temperature, kiln atmosphere, glaze application thickness, and clay body composition.

Liner glazes should have a smooth surface that can contain food or liquid in an inert condition. The fired glaze should be easy to clean and not subject to alkaline or acid attack. Below, a stoneware bowl

ADJUSTING AND TESTING GLAZES

At some point, you will want to experiment with glazes. Whether using commercial premixed glazes or your own formulas, venturing outside of the familiar into new glaze palettes is important. Before you do so, understand how raw materials, particle size, kiln atmosphere, and other variables affect a glaze formula.

This pitcher was dipped in ZAM Gloss Blue cone 9 glaze.

ASK THE RIGHT QUESTIONS

Each ceramics supplier can use different sources for the raw materials they sell to potters. To further complicate things, generic names are often used for raw materials that are often not an accurate representation of specific materials. Also, each processor or wholesaler of raw material can have several different grades of that material. The result is a common name for a raw material that can be completely different depending on where it is processed and eventually sold.

Nevertheless, the largest areas of misunderstanding occur when potters do not fully appreciate the effects of heat work on clay and glazes. Every kiln heats and cools differently. Sometimes, the difference is enough to change a glaze radically. When a glaze formula states it should be fired to cone 9 (2300°F [1260°C]), do you know what size kiln the glaze was fired in or how long it took to reach the glaze maturing temperature?

Following is a sample of a typical glaze formula and questions you should ask a ceramics supplier concerning the raw materials it contains. These questions address particle size, chemical composition, solubility, and the existence of additives such as metallic coloring oxide.

Glaze Contents	Questions
ZAM Gloss Blue c/9	What is the kiln firing atmosphere?
Nepheline syenite 55	What mesh size?
Flint 27	What mesh size?
Whiting 8	What is the chemical composition and particle size?
Gerstley borate 10	Is this variable in chemical composition, and is it soluble?
Cobalt oxide 6%	What is the strength of the metallic coloring oxide?

A functional piece is dipped into a bucket of glaze. Stir the glaze periodically during glazing operations to prevent it from settling in the bucket. Each glaze might require a shorter or longer interval between stirring due to the density of its raw materials.

TIP

Ceramic raw materials are processed in different mesh sizes. The higher the mesh number, the smaller the particle size. For example, flint can be obtained in 60x—a granular particle, 200x—a powder, or finer grades up to and exceeding 400x.

PARTICLE SIZE

The particle sizes of ceramic raw materials are critical factors in their ability to melt. A smaller particle size denotes increased surface area, which melts more efficiently than a larger particle size. A finer mesh material might cause a lower melting point, which can result in the fired glaze dripping or a semi-opaque glaze appearing transparent. All glaze materials look like powder, so knowing the actual mesh size is important for duplicating any glaze formula. For example, flint, a glass-forming oxide and major component in any glaze, can be purchased in 60x mesh, 100x mesh, 200x mesh, 325x mesh, and 400x mesh. (Larger numbers indicate finer particles.) Even finer mesh sizes are available by special order. Frequently, a glaze formula will not specify a mesh size for flint. In such instances, use 325x mesh flint.

When you screen glaze material in your own studio, reach for the 80x mesh sieve. The small size of the screen causes a mechanical mixing action of the glaze materials suspended in the glaze water. The sieve breaks down any nodules or conglomerate particles into a homogenized mixture of material and water. A coarser open-mesh sieve can allow large particles of material such as kaolin or flint to mix into the glaze and appear as small specks on the glazed surface. The screening process is especially important for soluble materials, such as Gerstley borate, colemanite, soda ash, borax, or pearl ash (potassium carbonate). These can clump together in storage and must be broken into smaller particles.

It's important to note that metallic coloring oxides and their reaction with glazes can also be influenced by the size of the screen. For example, cobalt oxide, when used in a satin matte or matte glaze, can sometimes reveal itself as a blue glaze with blue specks in the fired glaze surface. The larger particle size of cobalt oxide as compared to cobalt carbonate will pass through undisturbed in a coarser mesh sieve.

Testing glazes can offer the potter an assurance of a good result. Pottery is time- and labor-intensive, and it can be discouraging to unload a kiln with glaze defects. Always test any glaze before committing yourself to a large body of work.

KILN SIZE AND ATMOSPHERE

When selecting a glaze, keep in mind how that glaze will be affected by your kiln's size, atmosphere, and firing cycle. As a general guideline, the chart below illustrates what happens to a clear, transparent glaze when subjected to a cone 6 (2232°F [1222°C]) firing in small, medium, and large kiln electric kilns. The time to cone 6 was approximately the same in each kiln firing, with the only difference being kiln size. The larger kilns, having more thermal mass, created more "heat work" in the kiln with greater glaze maturation, resulting in a smooth, transparent glaze with a hard durable surface. The craze lines produced by the 1-cubic-foot kiln were due to the immaturity of the clay body with the glaze under tension upon cooling.

The size of the kiln can play an important part in the development of surface texture (gloss, satin matte, dry matte), light transmission (clear, semi-opaque, opaque), color (red, green, blue, brown etc.) and glaze hardness (soft surface, easily scratched or hard surface-abrasion resistant). Ceramic materials melt under several conditions aside from the absolute, or end-point temperature, they reach in the kiln. The time it takes to reach that temperature and the rate of cooling are factors that inhibit or promote more melting in clay bodies and glazes.

Kiln size also influences the vitreous quality of the clay body. Larger kilns have greater thermal mass. Kiln bricks, posts, shelves, and stacked pots are all factors that radiate heat. Larger kilns radiate more heat during their heating and cooling cycles than smaller kilns. The larger kiln promotes more heat work and greater melting in clay bodies and glazes. Larger kilns can cause a different glaze reaction compared to smaller kilns with less thermal mass, which dissipate heat at a faster rate. Because small test kilns have less thermal mass, they are an inaccurate indicator of clay body and glaze reactions if you will use a larger kiln in production.

KILN FIRING CYCLE

Do you know the kiln firing cycle of the glaze? If so, there is a greater chance of duplicating the glaze. A fast-kiln firing cycle will produce an immature clay body that can be highly absorbent, less durable, and contribute to glaze problems such as crazing. A fast-kiln firing cycle can alter the fired color, texture, glaze durability, and light transmission of the glaze, while an excessively long firing cycle can cause the glaze to become markedly glossy or to run off vertical surfaces. Some glazes work best when held at their maturing temperature for a given period of time. Other glazes, when held at temperature, can blister or run down vertical surfaces due to increased heat work on the glaze at the high end of glaze vitrification. The kiln cooling cycle also can play an important part in the development of a glaze. Devitrification or crystal growth can cause small or large crystals to develop in the cooling glaze. The growth of crystals is dependent, in part, on the glaze formula, clay body, and rate of cooling.

While there are no perfect kiln firing cycles that will work for every glaze, a 75°F to 80°F (24°C to 26°C) heat increase per hour from cone 06 (1828 °F [998°C]) to cone 9 (2300°F [1260°C]) using self-supporting Orton cones is a recommended starting point for high-temperature cone 9 glazes.

Do you know what kind of atmosphere was used in the glaze firing? Electric kilns generate clean oxidation atmospheres. However, carbon-based fuels such as natural gas, propane, wood, coal, oil, and sawdust can produce oxidation, neutral, and reduction atmospheres. **Oxidation** is when there is more oxygen than fuel in the combustion process. **Neutral** occurs when there are equal amounts of oxygen and fuel in the combustion process. **Reduction** atmospheres have more fuel than oxygen in the combustion process. Reduction kiln atmospheres can cause greater melting, due to the increased fluxing action of the metallic coloring oxides contained in the clay body and glaze. Variations in the duration and amount of reduction can also change clay body and glaze colors and glaze surface textures. The variability of the reduction kiln firing atmosphere is usually responsible for glazes not firing as expected.

Kiln Size as a Determinant of Fired Glaze Characteristics			
Size of Kiln	Surface texture	Light transmission	Glaze hardness
Small: 1 cu/ft.	dry rough	opaque/crazed lines	easily scratched
Medium: 5 cu/ft.	slightly rough	semi-opaque	hard
Large: 12 cu/ft.	smooth	transparent	hard

Kiln atmosphere can affect any glaze color, texture, or melting capacity. For instance, the cobalt oxide in ZAM Gloss Blue will fire blue in almost any kiln atmosphere, but its color intensity will vary, depending on the atmosphere in the kiln and fuel used to maintain that atmosphere. In soda and salt firings, ZAM Gloss Blue can run or drip on vertical surfaces or pool in horizontal areas, due to the fluxing action of sodium vapor in the kiln atmosphere. In wood-fired kilns, the alkaline content of the wood ash during the firing can flux the glaze excessively, causing glaze dripping. In many instances, the glaze reactions to salt and wood firing are aesthetically positive. But both atmospheres can flux or melt the pyrometric cones prematurely if they are not protected.

Do you know the exact position of the cone in the glaze firing? Potters read the melting of pyrometric cones at different positions. Some potters consider the cone at its correct temperature when it bends at the 3 o'clock or 9 o'clock position (or, bending over half way in relation to the bottom of the cone pack). Other potters read the cone as being down when it actually touches the cone pack. Certain glazes are very sensitive to slight temperature variations indicated by the exact position of the pyrometric cone. In these glazes, the exact position of the cone can alter color, opacity, or glaze texture.

Keep in mind kilns can "coast," or continue to supply more heat work to the clay body and glaze after the kiln has been shut down. This condition can be observed when the potter turns off the kiln and notices that the position of the cone has fallen as the kiln cools.

RAW MATERIAL SUBSTITUTIONS

Many glaze formulas were first developed using feldspars, clays, or other raw materials that are no longer in production. Even if the raw material is still in production, it might have subtly changed in chemical composition, particle size, or organic content, all of which can alter the current glaze result.

The best course of action, though time-consuming and somewhat inefficient, is to test raw materials before committing to a large production batch of glaze. You should also ask the ceramics supplier if there have been any current problems or customer complaints with a raw material. Apply the same "always changing" mentality for clay with glaze materials.

If a substitution is required, clays in the glaze formula should be replaced within the same general group, such as ball clays, kaolins, or fireclays. Each group has subgroups based on metallic oxide content, plasticity, organic content, and particle-size distribution. However, a good starting point is to obtain a chemical analysis sheet from the ceramics supplier. The information listed will determine the most suitable substitution.

Typical cone pack configuration for a kiln being fired to cone 6 (2232°F [1222°C], second cone from left.)

TIP

Studio Note

Test-fire different glazes in close proximity to find out how they will react in the same kiln.

Fuming occurs when part of the glaze formula vaporizes during the firing. A fuming reaction is most noticeable when a glaze containing chrome oxide is placed next to a glaze containing tin oxide. A pink blush on the glaze containing tin is the result.

METALLIC COLORING OXIDE/ CARBONATES

Use the same processor of metallic coloring oxides when ordering materials. If this is not possible, test the oxide. Metallic coloring oxides and their carbonate forms are processed by different international companies. Oxides include cobalt oxide, cobalt carbonate, manganese dioxide, manganese carbonate, copper oxide, copper carbonate, nickel oxide, and nickel carbonate, along with chrome oxide, iron chromate, rutile light, rutile dark, llmenite powder, red iron oxide and its variations. Each can differ in purity, particle size, and trace material content, depending on the processing plant. For example, cobalt oxide (Co_3O_4) is processed in three grades: 71.5 percent, 72.5 percent ceramic grade, and 73.5 percent. The percentage represents the cobalt contained in the oxide. Each grade can affect the intensity of the blue that will be generated in a glaze.

In addition, the quantity of trace elements in a metallic coloring oxide can influence its effect on the glaze color. Although slight differences in trace metallic oxide content usually will not cause a radical color change, particle size can affect the look of a glaze. A coarser particle size of cobalt oxide can cause blue specks in a glaze; a finer grind of the same oxide (or cobalt carbonate, which is a finer grind) will just produce a blue color glaze field.

GLAZE WATER AND SOLUBLE MATERIALS

The amount of water used in a glaze formula is rarely stated. The volume of water added to a dry glaze is one of the major areas of miscalculation, and that can result in too thin or too thick of a glaze layer on the ceramic ware. Each formula requires a specific amount of water, due to the particle density of the raw materials, glaze suspension additives, glaze gums, glaze material solubility, and the chemical composition of the water used in mixing the glaze. The method of application—sprayed, dipped, or brushed—also affects the water needed for success.

Water quality can affect the glaze viscosity (thickness or thinness). The hardness of the water can cause the glaze to flocculate (liquid glaze appears thick in the bucket), and soft water can deflocculate (liquid glaze appears thin in the bucket). Soluble glaze materials can break down in the water system of the glaze, depending on the chemical composition of the water and the level of soluble materials in the glaze. Excess water poured from a glaze can alter the chemical composition of the glaze, since soluble material may have dissolved in the water.

Dry soluble materials can also take on moisture in storage. Soluble material weight can change, depending on the amount of moisture it has absorbed, with such transformations having an effect on the total glaze formula.

Notice the fuming reaction on this test tile. A metallic salt (stannous chloride) is introduced into the kiln while it is still hot, leaving a colorful film on the previously fired glaze surface.

Pottery fired in an oxidation kiln atmosphere, which can produce consistent clay body and glaze colors.

Vitreous Qualities

When testing a glaze formula, consider the vitreous characteristics of the clay body.

The clay body and glaze interface is where fired clay and glaze meet and fuse together in the ceramic structure. The interface plays an important part in the development of the fired glaze. The interaction of clay body and glaze can influence the texture of the glaze, depending on the clay body formula, glaze formula, kiln atmosphere, and clay body maturity. Some clay bodies will draw part of the flux content from the forming glaze during the firing process. This reaction can cause opacity in light transmission or dry surface textures in the glaze.

Examples of opaque, semi-opaque, and transparent glazes.

ADJUSTING CLAY CONTENT

While any glaze can be altered by several methods, a simple technique is to manipulate its clay component. You do not have to know how every possible raw material reacts in a glaze, but it's a good idea to study ten to twelve of the most commonly used raw materials. Clay is a component in a large percentage of glazes.

Even if clay is not part of the original formula, you can add it to glaze as a suspension agent. Added clay will stop a glaze from dripping or will create matte, opaque surfaces. However, note that clay additions will also increase the glaze opacity and cause a rough surface texture, depending on the amount of clay introduced into the formula.

On the other hand, removing the clay component from glaze creates a more fluid mixture with less opacity. Remove clay from a glaze mixture in 5- to 10-part increments.

Transparent to Opaque-Matte Glazes: Modifying Clay Content Cone 6 (2,332°F [1,278°C] Glaze

The clay component of this glaze is called E.P.K. (Edgar Plastic Kaolin), a plastic, high-temperature kaolin. Increasing the E.P.K. component of a transparent, glossy glaze by 15 parts and 30 parts, based on the dry weight of the glaze, causes it to become opaque and matte.

Transparent Gloss Glaze (original glaze formula)	Parts
Nepheline Syenite 270x	20
Whiting	20
E.P.K.	20
Flint 325x	20
Ferro frit #3124	20

Matte Glaze (addition of 30 parts of E.P.K.)	Parts
Nepheline syenite 270x	20
Whiting	20
E.P.K.	50
Flint 325	20
Ferro frit #3124	20

Semi-opaque Satin (addition of 15 parts of E.P.K.)	Parts
Nepheline Syenite 270x	20
Whiting	20
E.P.K.	35
Flint 325x	20
Ferro frit #3124	20

CREATING TEST TILES

Occasionally, a glaze formula will not work as expected. Start by mixing a small batch of glaze; the main goal when testing glazes is to find out how they react on a small scale. If the tests are not successful, you have a chance to adjust the glaze for further testing before mixing a large volume.

When you test, keep a notebook at hand so you can write down each weigh-out of material. Record all tests in your notebook. In a very short time, the number of test pieces can grow. A notation system allows you to refer to past glaze test results without guesswork. You'll avoid making the same mistakes twice.

PREPARING TILES

Vertical test tiles should be at least 4″ (10 cm) in height and 2″ (5 cm) wide. Test tiles must also be of sufficient surface area to approximate the actual pottery. Many times, a small test tile will be successful because the molten weight of the glaze is not heavy enough to cause it to run down vertical surfaces. However, when larger areas are glazed, the weight of the fluid glaze might cause it to be pulled down, causing drips or runs on the pots or kiln shelves. The lesson: Don't skimp on size when creating test tiles for glaze.

Place the test tiles in many kiln locations to give an indication of how well the glaze responds to different temperatures. Not every kiln fires evenly, and the test tiles will show the maturing range of the glaze. Also, the results of one glaze test should not be the determining factor indicating a successful glaze. It should be followed by placing more glaze tests in several different firings.

For accurate results, form test tiles from the same clay and technique you'll use in production. Your goal during the testing process is to obtain as much information as possible from the test tile, so you know what to expect when you apply glaze to your bisque-fired work.

Clay extrusions glazed in (left to right): transparent gloss, semi-opaque, and opaque matte.

TIP

Test Glaze Batch

A 300-gram batch of glaze with the appropriate amount of water should be adequate to glaze several test tiles. The tiles can then be placed in a number of different kiln firings. If the test glaze does not need an adjustment, it is often a good policy to mix up a pre-production batch of 4,000 grams, or roughly 1 liquid gallon. This larger batch will allow you to glaze several pots and place them throughout the kiln.

PREPARING THE GLAZE MIXTURE

As a general guideline, approximately, 4,000 grams (141 oz) of dry glaze materials will yield 1 liquid gallon (3.8 L) of glaze. Following are steps to make 1 gallon of glaze. Not every glaze will conform to this ratio, but it is a good starting point whenever a dry raw material has to be added to a liquid glaze. Such additions can occur when adding a suspension agent, metallic coloring oxide, gum, stain, or dye to a glaze.

Equipment

- Triple beam balance scale with scoop and counterweight
- 80x mesh sieve
- Glaze bucket
- Mixing spoon
- Test tiles ready for glazing

Instructions

① Measure out 4,000 grams (141 oz) of dry glaze material.

② After the dry materials are accurately weighed, add water to the mixture. Every glaze will require different amounts, but it is best to use less water at first. You can always add more later.

③ Place the glaze mixture through an 80x mesh sieve 3 times. In most instances, a 60x mesh sieve is too coarse and will allow larger particles of raw materials to remain in the liquid glaze. A 100x mesh sieve will take longer for the wet glaze to pass through. If a wet glaze is stored for a week or longer, it should be sieved again.

④ Glaze settles over time. Add 2 percent bentonite (80 grams [2.8 oz]) to ensure that the glaze mixture stays in suspension.

⑤ Bentonite will not completely blend into the liquid glaze. Therefore, sieve the entire mixture (80x mesh) three times.

TIP

Safety in the Studio

Always wear protective glasses, gloves, and approved respirator when performing any pottery test.

Wheel-Thrown/Hand-Built Sculptural Disk
See page 287 for formula

DIPPING TEST TILES

This procedure allows before and after comparison of how thick to apply the glaze in the next glazing session.

Equipment

- Triple beam balance scale with scoop and counterweight
- 80x mesh sieve
- Glaze bucket
- Mixing spoon
- Test tiles ready for glazing
- Needle tool

Instructions

① To obtain the optimum glaze layer on test tiles, start with an application thickness of 3 cardboard matchbook covers stuck together, or slightly thinner than a dime. About 80 percent of glazes will work successfully within these parameters.

② Leave several glazed test pieces out of the firing. Compare the unfired pieces to the test pieces that went into the kiln.

③ Using a needle tool, scratch down through the unfired glaze test to the bisque surface, visually noting the glaze thickness.

Test tiles that have been glaze fired; unfired tile

USEFUL GLAZE TESTS

No two glazes will react the same on a clay body, or in your kiln, for that matter. Before you dip a prized piece into a glaze mixture, be sure the glaze has been tested. You can test-glaze for its reaction to alkaline and acid exposure, its resistance to abrasion, and ability to withstand thermal shock. (You want to know your teacup will tolerate near-boiling water.) Following are some practical tests you should execute on test tiles.

ALKALI EXPOSURE TEST 1

Remember, dishwasher liquids have relatively high pH levels, which can create alkaline exposure to glazed surfaces.

Equipment

- Glazed and fired tiles
- Dishwasher
- Dishwasher detergent

Instructions

① Run several glazed and fired test tiles through multiple dishwasher cycles and note color or texture differences. Reserve a control tile that has not been placed through the dishwasher for comparison.

ALKALI EXPOSURE TEST 2

Baking soda (sodium carbonate) also has a relatively high pH level, which can duplicate alkaline exposure from other sources that might come into contact with glazed surfaces.

Equipment

- Hot water
- Baking soda

- Glazed and fired tiles
- Control sample of the fired glaze

Instructions

① Mixing solution: Start with hot water and slowly add baking soda (sodium carbonate) until the mixture has reached a saturation point where no more of the baking soda can be suspended in the water. Mix the solution until it is a thick soup consistency. Stir the mixture until all particles dissipate. Some potters will compare an ideal mixture thickness for application to a cross between thin cream and half-and-half.

② Place the glazed tile into the solution. Withdraw the tile and allow it to sit for 24 hrs.

③ Rinse the glazed tile with water and wipe dry. Note any color or texture differences as compared to a control sample of the fired glaze.

ACID EXPOSURE TEST

Many foods are acidic. Often, staining can occur when acidic foods such as blueberries, tomatoes, or limes are left on an unstable glaze surface.

Alkali discoloration on glazed plate.

Equipment

- Lemon
- Glazed and fired test tile
- Control sample of the fired glaze

Instructions

① Cut the lemon in half.

② Leave the lemon, exposed surface down, on the glazed/fired test tile.

③ Wait 24 hours. Note alterations in glaze color by comparing it with the control sample of the fired glaze. If any discoloration or bleaching is evident, the glaze will not be stable in everyday use.

ABRASION-RESISTANCE TEST

Pottery that fails abrasion resistance testing might also be subject to alkali/acid attack. Plus, scratches can collect bacteria and mold, therefore contaminating food.

Equipment

- Glazed and fired test tile
- Steak knife
- Fork

Instructions

① Run a steak knife over the glazed surface, as though you are cutting food.

② Make similar movements against the test tile with the tines of a fork.

③ Continue this abrasion and observe results. Look for scratches.

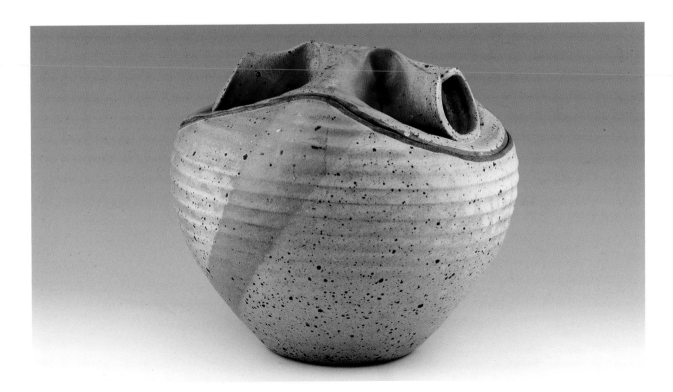

Wheel-Thrown Covered Jar
See page 291 for formula

THERMAL SHOCK TEST

If the clay body/glaze combinations are unstable, the pot will eventually break when in contact with boiling water. Sharp, jagged cracks can also occur when pots are taken from a refrigerator and placed in a hot oven. Both failures are due to thermal shock. Ideally, clay and glaze should cool in the kiln at a compatible rate, with the glaze staying under slight compression. If the glaze is under tension, crazing (a fine network of fault lines in the glaze) can result. Shivering can occur if the glaze cools under extreme compression, causing slivers of sharp glaze sheets to break off from the underlying clay body. Unstable clay body/glaze combinations and extreme temperatures can stress the pottery's ability to remain intact. We'll discuss crazing and shivering more in a later chapter, page 176.

Perform a thermal shock test to find out how your finished pottery (fired clay and glaze) will handle extreme heat and cold.

Equipment

- Glazed and fired test pot
- Freezer
- Clean, lint-free cloth
- Water-based ink (optional)
- Metal screwdriver

Instructions

① Place the pottery in the freezer for 3 hours. Remove and carefully fill the pot with boiling water.

② Pour boiling water out of the pot and dry it with a clean, lint-free cloth.

③ Examine the pot carefully for defects. You may wish to apply a water-based ink to the surface of the pot to identify craze lines. When testing dark glazes, which can hide defects, place the pot over steam and study the surface. Caution: Always protect yourself from the boiling water and steam by wearing long oven mitts.

④ Test for shivering by tapping the side of the pot with a metal screwdriver to see if sheets of glaze begin to peel off. If so, you can assume that all glazes with the same clay body/glaze formula combination are suspect.

ASTM THERMAL SHOCK TEST

This stock test conforms to the American Society for Testing and Materials.

Equipment

- Glazed and fired pot
- Oven
- Clean, lint-free cloth

Instructions

① Place the pottery in an oven heated to 250°F (121°C) for at least 45 minutes. Remove the pottery from the oven and carefully pour room-temperature water into the form. Allow the water to cool. Dump out the water and dry out the pot, using a clean, lint-free cloth.

② Examine the pot for defects. If the pottery is still defect-free, repeat the test 3 times, increasing the oven temperature by 25°F (12°C) each time, until the final oven temperature is 325°F (162°C).

GLAZE CALCULATION SOFTWARE

Formulating new glazes or adjusting existing formulas is much easier and faster today, thanks to glaze calculation software. These programs give you the ability to add or delete materials from the glaze and observe the results on several levels, such as batch weight and unity formula. The impressive factor in calculation programs is their ability to compress the whole process of formulation, allowing the potter to obtain an overall picture of the glaze at every step of adjustment.

One of the most effective ways to use the software is in conjunction with actual glaze testing. If the fired glaze needs revising, you can quickly recalculate it with the software. One or two cycles of calculation and testing should yield a successful glaze.

When using glaze calculation programs or developing your own glaze formulas, always use the recent chemical analyses of the raw materials. Over time, raw materials such as feldspars and clays can shift in their oxide content. A ceramics supply company might not have the current chemical analysis sheets on each raw material. In such cases, contact the mine or processor for up-to-date information.

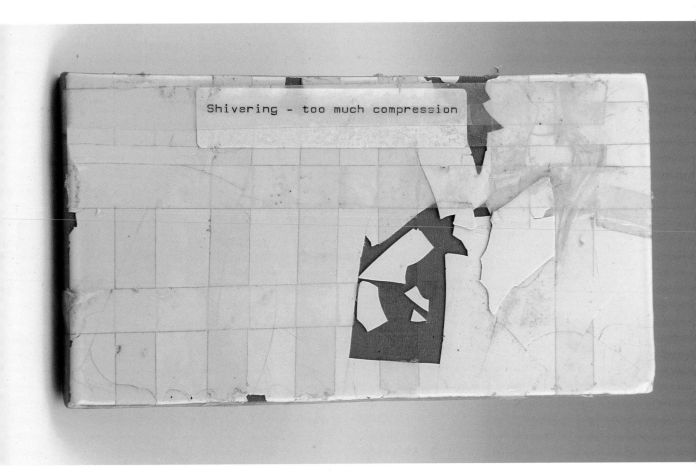

Glaze shivering. As the glaze cools in the kiln, it comes under extreme compression. Glaze peels off like a paint chip.

TROUBLESHOOTING
GLAZES

We noted symptoms of crazing and shivering during our glaze test discussions. These glaze defects and others—such as blistering—are not always easy to diagnose. Now we'll review the symptoms of blistering, crazing, and shivering and ways you can avoid these defects.

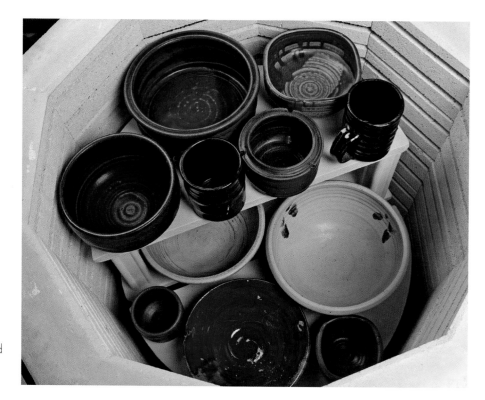

A kiln densely stacked with pottery, shelves, and posts will reduce the chance of glaze blistering (from fast heating and cooling) by increasing the thermal mass within the kiln.

Glaze blistering is also called "boiling," which is an appropriately vivid term.

GLAZE BLISTERS

Blistering appears as a pronounced, sharp-edged burst bubble. It looks like a crater on fired glaze and often reveals the underlying clay body.

Blisters occur in some of the following kiln firing conditions.

Kiln-Firing Conditions That Cause Blistering

Problem	Correction
Overfiring can result when any glaze is taken past its maturation temperature and lower melting point oxides within the glaze volatize. The effect is similar to water taken past its boiling point.	Firing the glaze one or two cones lower will bring it into its maturing range.
Excessively long firing in the glaze maturing range can cause volatilization of oxides, resulting in blisters. A longer time to temperature imparts additional heat work to the glaze, even if it is taken to its correct maturating temperature.	Shorten the firing cycle while still firing the glaze to its maturing range.
An excessively long cooling cycle in the glaze kiln contributes more heat work when the glaze is in the molten state, causing oxides to boil in the liquid glaze. Similar results can occur in overinsulated kilns, which allow the glaze to remain in its maturing range for extreme periods of time.	Long cooling cycles are more prevalent in hydrocarbon-fueled kilns (natural gas, propane, wood, oil, sawdust), which tend to be better insulated and larger in size, having more thermal mass than electric kilns. Upon reaching temperature, pulling the damper out and unblocking the secondary burner ports for a short time will cool the kiln faster.
Down-firing the kiln, or leaving burners or electric elements on after the glaze has reached maturity, exposes it to excessive heat work when molten.	In most instances, it is not necessary to down fire a kiln to achieve a stable glaze. However, if a particular glaze requires down firing, progressively shortening the down firing interval will decrease its time in the maturing range.

Kiln-Firing Conditions That Cause Blistering

Problem	Correction
Fast firing leaves blisters in the glaze that would have healed in a longer firing. Some glazes go through a heating period when they boil and blister on their way to maturity. If this interval is too short, blisters are "frozen" in place and do not heal. Fast firing can also trap mechanical and chemical water locked in the glaze materials, which are not completely driven off until above 932°F (500°C).	Extend the length of time to reach the end-point temperature.
Firing the glaze below its maturation range can leave a dry, pale color or blistering in the glaze surface.	Fire the glaze to its correct maturing range.
Fast firing of the bisque kiln can trap organic materials in the clay, which can then volatize during the glaze firing. The gas exits through the stiff liquid glaze, causing a blister.	A longer bisque firing cycle will enable organic material to escape.
Non-oxidation bisque firing can trap organic material in the clay, which exits at higher temperatures as a gas through the molten glaze as a blister. Large platters stacked together or tiles placed atop one another do not allow for combustion and removal of organic material because their relatively large surface areas touch.	In hydrocarbon-fueled kilns, always use more air than fuel to create an oxidation atmosphere. In electric kilns, an active venting system will remove organic matter from the kiln atmosphere.
Direct flame impingement can result in an over-fired and/or over-reduced area on a glaze, causing a blister.	Moving pottery away from the heat source will stop over-reduction and over-fired areas on the glaze.
Early and/or too heavy reduction in the glaze kiln can trap organic material in the clay or add carbon through excessive fuel introduction. Carbon trapped in the clay body can release at higher temperatures as a gas through the molten glaze, causing a blister.	Use an excess of air-to-fuel ratio in the burners until 1860°F (1015°C). This will remove organic matter from the clay body. Then, use a slightly reducing atmosphere until the end-point temperature is reached.
A loosely stacked glaze kiln reduces thermal mass and subsequent radiant heat in the transmission to pottery.	A densely stacked kiln can produce slower increases and decreases of temperature while radiating more heat between pottery, kiln shelves, and posts. A densely packed kiln will increase the thermal mass and apply more heat work to the glaze, which liberates gases trapped in the glaze.

Clay Body Conditions That Cause Clay Blistering

Problem	Correction
Higher than normal levels of organic material not removed from the clay during bisque firing. Periodically, some clays (notably fireclays) can contain abnormally high percentages of organic material. In such instances, a normal bisque firing cycle will not remove all the organic material from the clay. During the subsequent glaze firing, organic material carbonizes and releases as a gas through the clay body into the molten glaze, causing a blister.	A clean oxidization atmosphere in the bisque kiln, fired to the correct temperature in enough time, will release organic material from the clay.
Raw glazing an unfired clay body can drastically increase its absorbency. When glaze is applied, it can be drawn into the clay body too rapidly, causing bubbles and air pockets as the glaze dries. During firing, the bubbles migrate to the surface, causing a blister.	The use of gums such as C.M.C. (carbonxymethylcellulose), Vee Gum CER, or other binders (1/8 to 2 percent added to the dry weight of the glaze) can slow down the drying rate of the glaze, preventing fast absorption.
Raw glazing can trap organic matter and/or moisture in the clay body or engobe, which at higher temperatures exits as a gas through the glaze layer.	Slowing down the rate of heat increase in the 572°F to 1292°F (300°C to 700°C) range can safely release visible organic materials and moisture from the clay body.
Soluble salts in the clay body can migrate to the surface as the clay dries, leaving a disruptive layer of sulfates releasing gas into the covering molten glaze.	The addition of barium carbonate (1/4 to 2 percent based on the dry weight of the clay body) can neutralize soluble salt migration.
Thin-walled pottery saturated by water during spraying, dipping, or painting during glaze application can result in blisters. Trapped moisture on the clay surface can be released as a vapor during glaze firing, causing blisters.	Use less water in the glaze batch and wait until the first glaze layer dries before applying another to prevent blisters.
Low bisque firing can yield extremely absorbent ware that sucks in the wet glaze. If the glaze is highly viscous, air pockets formed in the application process can migrate to the surface, leaving blisters in the stiff glaze.	Increase the bisque firing by one or two cones to decrease the absorbency of the pottery. Also, add gums such as C.M.C. (carbonxymethylcellulose), Vee Gum CER, or other binders to the glaze (1/8 to 2 percent based on the dry weight of the glaze) to slow down the drying rate of the glaze.
Contamination in the clay from plaster molds or deteriorating wedging boards can impart plaster chips into the moist clay, which, upon heating, release gas and/or water vapor in the covering glaze layer.	Cover the wedging board with canvas to prevent chips from entering the clay. Mix plaster with the correct ratio of water to ensure maximum set strength. Discard plaster molds that show signs of wear to prevent plaster contamination in the moist clay.

Glaze Conditions that Cause Blistering

In particular, bubbles commonly form in leadless glazes, and some of these bubbles will break the surface as blisters. When lead was used in glazes, it caused a strong reactive effect with other oxides and increased the release of glaze bubbles, creating a smooth, blemish-free surface. But because lead is not a recommended glaze material, greater care must be taken in glaze formulation and application and kiln firing to ensure a defect-free glaze surface.

Problem	Correction
High-surface-tension, high-viscosity glazes that contain zirconium can trap escaping gases from other glaze materials, metallic coloring oxides, stains, gums, and binders. This type of stiff glaze is less likely to heal itself of surface irregularities, due to its inability to flow when molten.	Lower the percentage of zirconium in the glaze or substitute other opacifiers, such as titanium dioxide or tin oxide.
Cobalt oxide in an underglaze or glaze, along with copper oxide and iron oxide in reduction atmosphere, loses oxygen at 1652°F (900°C) and can migrate through the glaze layer, causing a blister.	Slow down the rate of heat increase until 1652°F (900°C) so oxygen in the underglaze will dissipate.
Glazes containing an overload of metallic coloring oxides in reduction kiln atmospheres can blister, due to excessive fluxing of the glaze.	Decrease the percentage of metallic coloring oxide and/or decrease the amount of reduction atmosphere in the kiln to eliminate blistering.
Contamination of the glaze with materials such as silicon carbide, wood, rust, salt, or other pottery shop materials can cause blisters.	Carefully clean and maintain the pottery shop, tools, equipment, and supplies. Always sieve the wet glaze before application to remove any unwanted particles.
An excessive amount of medium, such as C.M.C. or other gum binders, used in underglazes, engobes, glazes, or overglazes can cause gas bubbles exiting as blistering in the glaze layer. The rate of fermentation, if any, is determined by the wet storage life of the materials, storage temperature, water pH, and organic materials in the mixture.	Use less medium and keep wet mixtures in cooler storage areas.
Glaze viscosity in the fluid state can promote blisters. High-viscosity stiff glazes can trap bubbles, which break at the surface, forming blisters.	Lower the viscosity by increasing the time to maturity or firing the glaze to a higher temperature. This will increase the flowing characteristics, allowing bubbles to rise to the surface, break, and heal. Also, increase the flux content of the glaze, so the mixture will flow when mature.

Problem	Correction
Excessively thick glaze applications can delay the time for bubbles to reach the glaze surface. Once bubbles are at the surface, the firing cycle can already be completed, leaving a blister.	Apply thinner layers of glaze.

Glaze Blister Q&A

As you diagnose the cause of glaze blistering, ask yourself the following questions:

Does the blistered glaze heal when fired again? A general rule for any glaze defect is that if the glaze can be refired successfully, it should have been fired longer during the first glaze firing. The second firing supplies more heat work to the glaze, which can bring it into a defect-free configuration.

Are different glaze formulas in the same kiln blistered? If yes, the problem probably originates in the firing procedures, glaze mixing errors, or a common clay or glaze raw material.

Are the blisters only on one side of the pot? If so, direct flame impingement might cause an over-fired area and/or an over-reduced area in hydrocarbon-fueled kilns. In electric kilns, the pottery could have been placed too close to the kiln elements.

Are the blisters only on overlapping glaze surfaces? Incompatible glazes when overlapped can have a eutectic effect with resulting over-fluxed areas and blisters.

Are the blisters only on horizontal surfaces? High-surface-tension glazes with high viscosity do not move when molten. Gravity on the vertical molten glaze pulls down, causing the formed blister to heal. Another possible cause occurs when flat pots are placed directly on the kiln shelf. If the glaze is not formulated or fired correctly, the radiant heat from the shelf upon cooling can cause it to remain in its maturity range longer, causing a blister.

Are the blisters only on the edges or high areas of the pots? Fast cooling of the kiln and/or pottery loosely stacked can "freeze" the glaze in its maturation process.

Are blisters present only in one kiln and not in others? This could be an indication of an error in kiln firing.

Are blisters present in only one part of the kiln? Check for direct heat source impingement or kiln atmosphere irregularities.

Are blisters present on one clay body, but not another? Check the level of organic material in the clay body. Has the clay body been bisque fired long enough in an oxidation kiln atmosphere? If the clay body contains high levels of iron-bearing clays or iron oxide, it can be more reactive to extreme reduction atmospheres produced in hydrocarbon-fueled kilns, which can cause glaze blistering.

Are blisters present only on underglaze, engobe, or overglaze areas? Check levels of gums and metallic coloring oxides in the underglaze, engobe, or overglaze. Gums during the first stages of the firing process can volatize, causing the overglaze to blister. Some metallic coloring oxides can make the underglaze, engobe, or overglaze extremely refractory, causing the glaze layer to blister.

Does the glaze have a high percentage of whiting? Whiting, calcium carbonate ($CaCO_3$), is one of the leading causes of glaze blistering. Wollastonite, which is calcium silicate ($CaSiO_3$), dissolves more readily in the molten glaze, does not release a gas, and can be substituted for whiting with an adjustment to the silica content of the glaze.

Are blisters present only on one color glaze and not on other color glazes that use the same base glaze formula? Some glazes have an excessive percentage of refractory metallic coloring oxides. Also check if the kiln atmosphere has been too heavily reduced.

Are blisters present only after a new batch of glaze is used? Often, a new bag of material is mislabeled, causing a glaze-blistering defect. Many glaze defects can be traced to incorrectly weighing out the glaze raw materials. Also, consider any kiln firing or clay body changes that might have taken place before the defect occurred.

CRAZING

Understanding glaze theory is an important tool if you want to solve any glaze problem, the most common of which is crazing. Glaze crazing can happen at any temperature range and can occur in oxidation- or reduction-kiln atmospheres. Crazing occurs when glaze is under tension; it is ten times more likely to happen than shivering, which is when the glaze is under extreme compression.

Crazing presents as a series of lines or cracks in the fired glazed surface. The craze pattern can develop after removing a piece from the kiln, or it can appear years later (called delayed crazing). While crazing is classified as a glaze defect, you can correct the problem by adjusting the glaze and/or the clay body to cool at a compatible rate with the glaze coming under slight compression.

IS CORRECTION POSSIBLE?

Before starting a correction, consider the following factors:

- The closer the craze lines, the harder the fix. If craze lines are tightly packed and close together (spaced less than $1/8$-inch [3 mm] apart), there is a decreased chance of eliminating crazing lines using this simple method. In such instances, the entire glaze formula will have to be recalculated, which is best accomplished by any one of the glaze calculation software programs that are now available. The eight steps that follow likely will not solve the problem. Conversely, if the craze lines are wider spaced (more than $1/4$-inch [6.35 mm] apart), the fix is easier.

- Consider the absorption rate. If the clay body absorption rate exceeds 4 percent after firing, correcting crazing is more difficult.

- Try another glaze formula. If you've tried several corrections with no success and the glaze is common (such as gloss transparent, satin matte, matte, gloss blue, black, or brown) try to find a better glaze fit for the clay body.

- Choose another clay body. If you cannot change the glaze, change the clay body, with the possibility of obtaining a compatible clay body/glaze fit upon cooling.

Glaze crazing occurs when the glaze is under tension (stretching on the clay body as it cools).

Crazing develops during the cooling process or after removing a piece from the kiln or, in some situations, years later, as in the case of this dish. Notice the craze stains, which resemble hairline cracks.

Glazes that are under tension when cooling in the kiln can create a fine network of stress lines called crazing, which can be visible when subjected to food or liquids.

CORRECTING CRAZING

After considering the points on page 182, attempt a correction, or a combination of corrections, to solve glaze crazing. Depending on the severity of crazing, you may try several of these corrections until test results show craze lines moving farther apart, which is an indication that you are alleviating the problem. The following eight steps are not the only crazing corrections available, but they have shown consistent results.

Equipment

- Gram scale
- Glaze bucket
- Mixing spoon

Instructions

① Most flint used in glazes comes in 200, 325, and 400 mesh. Finer-grind sizes might be available on special order from a ceramics supplier. Also try fused silica, which has been calcined (fired) and has a very low shrinkage rate, which will help stop crazing. Most glaze formulas can accommodate additions of flint, without the glaze becoming opaque or dry when fired. Try additions of 10, 20, or 25 units of measure. For instance, if the glaze has 50 grams of flint, increase flint to 60 grams, 70 grams, and 75 grams. Do not change the other glaze materials.

② Prolong the last third of the glaze firing by two to three hours. This will give the clay body the best chance to tighten up, or reach its maturity, which will help in achieving a good glaze fit. The kiln should be fully loaded with pottery or shelves and posts to ensure greater thermal mass and increased radiant heat transmission.

③ By firing higher and/or longer, the glaze and clay body have a better chance of maturing for a better fit. Remember, what must change is the rate of shrinkage in the clay body, glaze, or both, which results in the glaze being under slight compression. However, if the clay body is already over-fired or on the edge of its maturity range, firing higher will cause more crazing in the glaze.

④ Add flint 200x mesh to the clay body. Increase flint by 5, 10, or 15 units of measure. Flint found in clay bodies remains a crystalline solid that has different characteristics than flint in a glaze, but it will still work to stop crazing in a glaze.

⑤ The kiln should be cool enough to unload pottery without gloves. Waiting for the kiln to cool will cause no problems; fast cooling increases the chance of crazing. If the pots are "pinging" when you open the kiln door, the glaze is under stress and is more likely to craze.

⑥ When using a low-fire clay body, bisque-firing one or two cones higher will bring the glaze under slight compression, preventing crazing.

⑦ The ceramics supplier or the manufacturer of the frit will have the coefficient of expansion rates for each frit. Materials with low coefficients of expansion (for example, flint) are less likely to cause crazing.

⑧ A thinner coat is not an option for all glazes, but even a slight decrease in thickness can stop crazing. Still, a thinner application does not address the underlying cause of crazing, which is the glaze being under tension as it cools on the clay body.

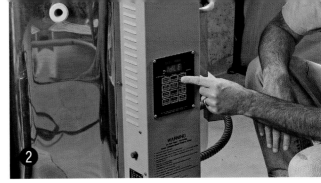

① Add increasing amounts of flint to the glaze formula.

② Fire the kiln to the correct temperature over a longer time.

③ Fire the kiln one or two pyrometric cones higher, but only if the glaze or clay body will not be adversely affected.

④ If many different types of glazes are crazing on the same clay body, first adjust the clay body.

⑤ Slowly cool the glaze kiln. Do not open the kiln door until the temperature is below 200°F (93°C).

⑥ If you use a low-fire body and the glaze begins to craze, try bisque firing one or two cones higher than the recommended glaze firing temperature.

⑦ If the glaze contains frit and is crazing, try using a frit with a lower coefficient of expansion.

⑧ Crazing can often be eliminated by applying a thinner glaze.

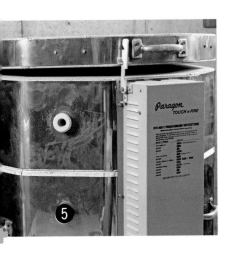

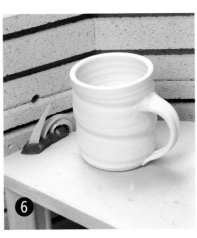

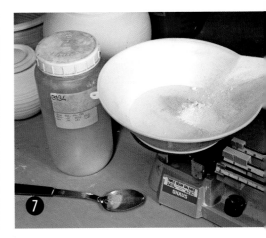

SHIVERING

Shivering is the opposite problem from crazing. Though statistically not as common as other defects, when shivering occurs, it can spoil the functionality of glaze on pottery. Shivering forms when a glaze is under too great a compressive load as it cools in the kiln, resulting in the glaze being too large for the underlying clay body. The defect looks like a paint chip peeling off the underlying clay body. Sometimes, shivering can reveal itself years later because the clay body/glaze combination is under constant stress. When the glaze is under extreme compression, it can buckle any time. While shivering is classified as a glaze defect, it can be corrected either through adjusting the glaze, clay body formula, or a combination of both.

Shivering can happen at any temperature range, and it can occur in oxidation- or reduction-kiln atmospheres. Frequently, glaze starts peeling on the edges or raised areas of the clay. Chips of shivered glaze range from $^1/_{16}$ inch (2 mm) to 2 inches (5 cm). Tapping seemingly stable clay/glaze surfaces with a hard object will cause a glazed area to flake off, sometimes removing part of the supporting clay body. The goal of any correction is to cool the clay body and glaze at a compatible rate, with the glaze coming under slight compression.

SHIVERING FIXES

Consider the following points before attempting to fix a glaze shivering defect.

- Clay body formulas containing too much free silica can cause shivering. Fireclays are known to have randomly high levels of free silica. Fine-grind grog that is high in silica also can cause shivering, especially if it's burnished or rubbed into the clay surface during the forming process. Low-expansion-rate, lithium-based feldspars used in clay bodies such as petalite, lithospar, lepidolite, or spodumene can cause shivering in glazes with higher-expansion-rate potassium and sodium-based feldspars used in glazes.

- Reduction causes instability and, therefore, shivering. Too much and/or too early reduction in a clay body causes an unstable carbon bond between the clay and glaze layer that can result in shivering.

- Thick glaze aggravates shivering. If any or all of the aforementioned conditions are present, a thick glaze application can exacerbate shivering. Apply a thinner layer of glaze to resolve symptoms, understanding that this "fix" will not alter the underlying cause of extreme glaze compression.

Above, shivering occurred at the base of this bowl, resulting in a peeled-paint look that indicates glaze under stress. At left, shivering glaze flakes off of the fired bowl, revealing the underlying clay body.

Other Methods

Keep in mind, some corrections can change glaze color, texture, light transmission, or maturing range. Other less practical methods for correcting shivering include the following:

- Lowering the maximum firing temperature
- A firing faster to the glaze maturation point
- Reducing the amount of lime or iron in the clay body to improve the glaze/clay body fit
- Substituting a sodium feldspar for a potash feldspar, because sodium feldspars have a higher coefficient of expansion (high shrinkage).

CORRECTING SHIVERING

In most instances, shivering can be corrected by adding sodium- or potassium-based feldspar, frit, or other high-expansion materials to the glaze, provided the clay body does not contain lithium-based feldspars. When shivering is very severe (glaze under extreme compression), it can tear or break the underlying clay body, causing the whole piece to crack apart upon cooling.

Other shivering correction methods involve adding high-expansion materials to the clay body and/or glaze (feldspars or other alkali bearing materials) or decreasing low-expansion materials in clay bodies and glazes, such as flint, petalite, lepidolite, lithospar, spodumene, and lithium carbonate. Sometimes a combination of all these methods is necessary.

Equipment

- Gram scale
- Glaze bucket
- Mixing spoon

Instructions

① If only one glaze is shivering on the clay body, correct shivering by adding 5, 10, or 15 units of measure of sodium- or potassium-based feldspar to the glaze. Or, add other alkali-bearing materials. (For example, if the glaze has 10 grams of feldspar, increase feldspar to 15, 20, or 25 grams. Do not change the amounts of other materials in the glaze formula.) Adding any flux or glass former will increase the chance of the glaze becoming glossy or running off vertical surfaces. The ideal fix is to get just enough feldspar or frit into the glaze to correct shivering but not overload the glaze with more flux than needed.

② Decrease the flint in a glaze by 5 or 10 units to adjust the clay body/glaze fit.

③ Add sodium- or potassium-based feldspar/frit to a glaze and take out flint from the glaze. In rare instances, this correction must also be carried out in the clay body.

④ If many different types of glazes are shivering on the same clay body, start the correction by adding 5, 10, or 15 units of sodium- or potassium-based feldspar (or other alkali-bearing materials) to the clay body.

⑤ Decrease flint in the clay body by 5 or 10 units.

S-CRACK ISSUES

At some point, every amateur or professional potter is disappointed and humbled by the sight of a crack in a favorite pot. Clay can fracture at any time during the forming, drying, or firing stages. There are several different types of cracks, all of which are preventable—most of the time. Identifying the type of crack is the first step in finding the cause and subsequent correction.

An S crack is one of the most common clay defects in wheel work. Understanding the configuration on how clay platelets are aligned in the centering and cone pulling up operation is essential to developing the techniques to prevent S cracks.

An "S" on the bottom of a piece of wheel-thrown pottery. The crack can reveal itself in the forming, drying, bisque, or glaze firing stages. The defect is caused by improper cone pulling up techniques before the clay is centered on the potter's wheel.

THE DISTINCT S-CRACK SHAPE

As the name implies, the crack is shaped like the letter S. They are found at the bottom of pots. S cracks develop during the forming stages of the pot on the wheel and appear in the drying, bisque-firing, or glaze-firing stages. As the pot dries (dry shrinkage) and during the bisque and glaze firing (fired shrinkage), the ware shrinks, causing the crack to fully develop and become visible. When a pot has been glazed, an S crack will appear with a round edge.

S cracks are formed in the initial stages of the throwing operation and can be eliminated by properly bringing the clay up into a cone shape on the wheel.

TIP

S-Crack Qualities

When do cracks form? Find out by determining whether the crack has a round edge or a sharp edge.

Round-edge cracks generally are covered with glaze and have rounded borders where the fired-glaze surface rolls back from the edge. These cracks are caused in the drying, forming, or bisque-firing stages before glaze is applied to the pot.

Cracks that have a sharp, hairline edge on a fired-glazed surface are cooling cracks. These occur after the liquid glaze has set or hardened on the pot.

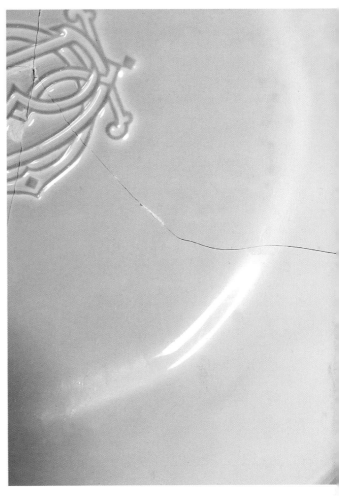

Sharp-edge cooling crack.

Comparison of Clay and Glaze Cracks

S Crack

exposed non-glazed crack with round edge

glaze surface

Round-edge Crack

Sharp-edge Crack

S-CRACK FORMATION

S cracks can occur on the inside or outside bottoms of wheel-thrown forms. Wider-based forms, such as plates, have a greater chance of producing S cracks. These cracks also occur in forms thrown "off the hump." (A hump is a large piece of clay from which small objects such as tea bowls are formed. The form is cut off and the next pot is formed from some of the remaining mound of clay.) S cracks also result from incorrect technique before pulling up the thrown form.

Now, let's examine the dynamics of S-crack formation. Clay bodies consist of numerous clay platelets that are held together by thin films of water. This unique bonding structure gives moist clay its plastic quality. S cracks can develop when clay platelets in the base of the pot are not aligned in concentric rings (see diagram). The crack forms when the base of the pot and its wall structure have different rates of shrinkage in the drying stage.

To correct S cracks, the clay platelets in the base of the pot must be aligned with the direction of the spinning wheel. This way, the base and walls of the pot have equal shrinkage rates.

Diagram A: Clay platelets are correctly aligned in concentric rings, which will prevent an S crack from forming.

Diagram B: Clay platelets are not aligned in concentric rings; this could result in an S crack.

FIVE STEPS TO PREVENT S-CRACKS

Prevent S cracks by pulling up clay into a cone shape and then pushing it down before the actual centering takes place in the throwing operation. Pulling the clay up into a cone, if executed properly, will prevent S cracks.

Note: The following directions apply to right-handed potters.

Equipment

• Moist clay

Instructions

① Make sure the left hand is positioned straight up at a right angle to the bat before pushing in toward the center. Apply equal pressure down with the right palm and in with the left hand, pushing the clay toward the center of the bat. Be sure to use water to lubricate the centering clay. During this process, rest your elbows on your knees or brace them close to your body to gain stability and improve leverage.

② As the wheel is turning, apply equal pressure inward with both hands to bring up the clay The compression will cause a convex "nipple" of clay to form at the top.

③ At this stage, the form should look more like a cylinder than a pyramid. When the form is complete, it should have a slightly wider base.

④ Sometimes, the form can take on a "mushroom" shape as it is pressed downward. Correct this by increasing the pressure with the left hand, pushing toward the center as the wheel spins.

⑤ Now consider the height and width of the object you will throw. Horizontal forms, such as plates, will start with a wider base than narrow forms, such as cups.

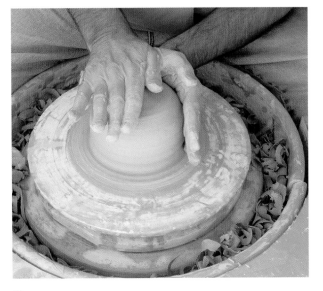

① Center the clay.

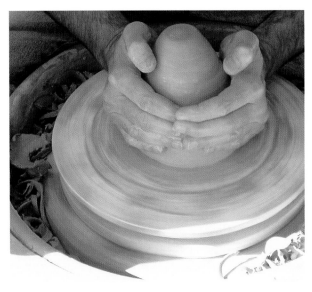

② Pull up the cone.

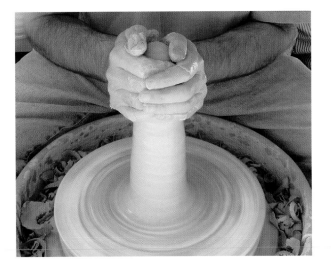

③ Create the cone shape.

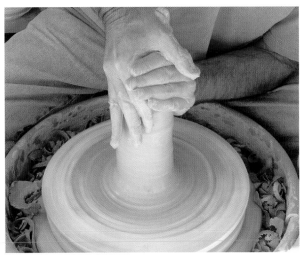

④ Push down the cone.

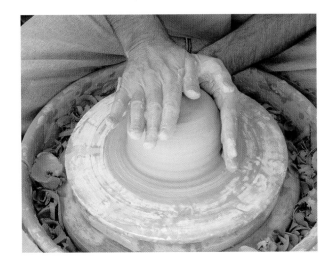

⑤ Determine a shape.

INCORRECT CONING TECHNIQUE

Improper technique when centering and coning clay on the wheel can allow S cracks to form in moist clay. There are several situations to avoid when pulling up the clay into a cone shape. Often, potters are discouraged when they attempt the cone-up procedure, only to eventually see an S crack appear in their ware in the leather-hard, bone-dry, bisque, or glaze-firing stages. At this point, review the cone-up procedure. This process is almost always the origin of an S crack.

First, when bringing the clay up into a cone shape, keep the base of the cone narrow. A wide base will defeat the purpose of the cone-up procedure. The correct cone procedure produces a form more like a cylinder (see photo A) than a pyramid shape (see photo B).

If the top of the cone develops a recessed or concave area (see photo C), the clay platelets are not aligned correctly. In many instances, an S crack is already in place when the cone is pushed down and the clay is finally centered on the wheel head. To prevent the defect, apply equal pressure with your index fingers and thumbs when arriving at the upper part of the cone (see photo D). The top part of the cone should never have a recessed area at any stage when bringing the clay up into a cone or pushing it down for the centering operation.

If the clay platelets are not aligned properly, there is a greater chance of an S crack forming because of centering technique and clay body formula. When using the correct cone-forming technique, a circular alignment of the clay body platelets helps prevent S cracks.

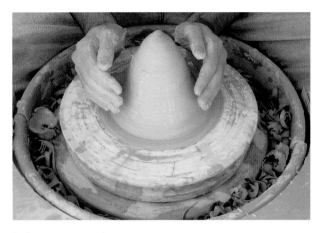

B. Incorrect cone shape

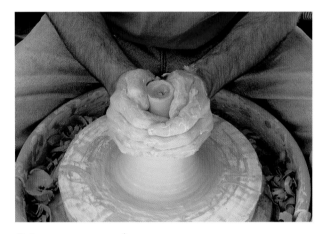

C. Incorrect concave shape

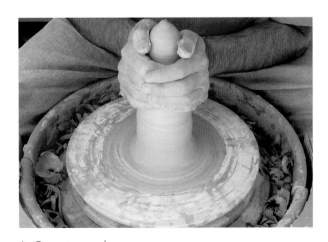

A. Correct cone shape

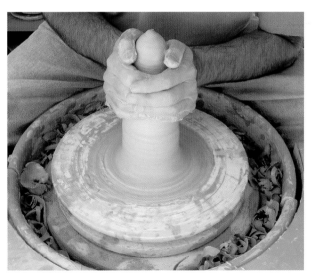

D. Correct convex shape

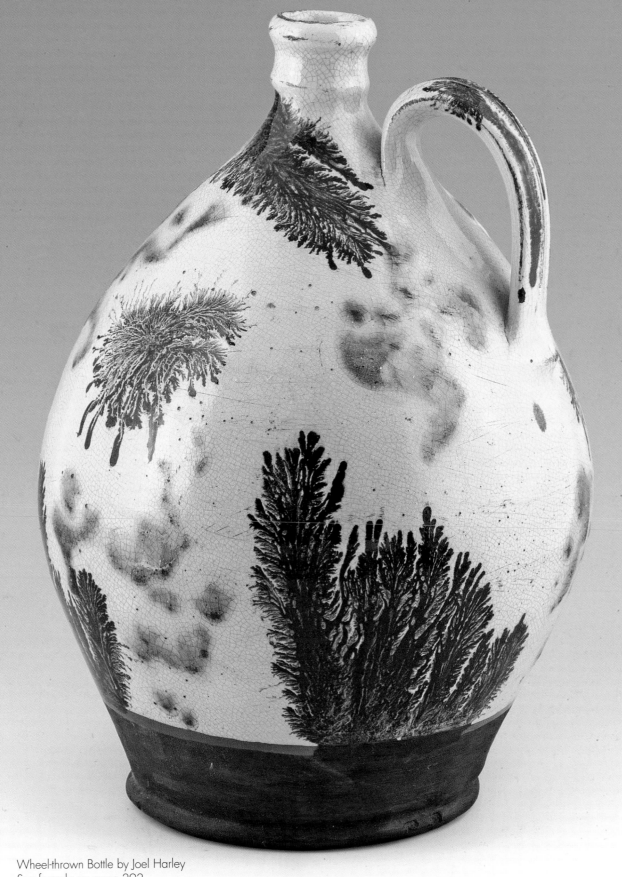

Wheel-thrown Bottle by Joel Harley
See formula on page 292

CERAMIC KILNS
AND FIRING WORK

P hysical changes through the exposure to high temperature and yet retains its shape. Because of the durable nature of clay, vessels that are thousands of years old are still being found, providing an insight into ancient cultures. Clay can withstand the test of time, and even when exposed to elements, fired clay will not decompose (though it is very vulnerable to impact and shatters easily). In this section, we'll talk about the different ways clay is fired.

TYPES OF KILN FIRING

There are a few ways that firings are differentiated from one another: type of kiln, temperature, and atmosphere. Type of kiln and atmosphere are linked because the type of fuel used affects the atmosphere. Firing temperature is an essential factor because clay bodies should be fired to their maturing range to reach the strongest state. Clay should not be over-fired or it will bloat, or worse: completely melt onto the kiln shelf and make a huge mess of expensive equipment, the kiln, and kiln shelves, nevermind the damage to your hard work.

Understanding the temperature that clay should be fired to will determine the glaze firing range. The type of kiln that work will be fired in will determine the atmosphere: oxidation or reduction.

BISQUE FIRING
Bisque firing is the first stage of clay firing in a kiln. This firing is at earthenware temperatures, between cones 010 and 04 (1648°F to 1940°F [898°C–1060°C]). During bisque firing, clay that is bone dry is placed in the kiln and the temperature is raised very slowly for the first 1200°F

◎ Glazed ware fired in a top-loading electric kiln to cone 6

(650°C). This is done to evaporate moisture and eliminate physical and chemically bonded water from the clay particles so the work has the opportunity to go through quartz inversion without damage to the piece.

Sometimes, pieces can explode or disintegrate during bisque firing. This is caused by moisture trapped in the clay walls. Moisture within air bubbles in the walls of pieces also promote the bursting of the clay. When water heats up beyond the boiling point, it evaporates into steam. If the moisture is allowed to steam quickly, it pushes so hard that the pot explodes. This is why thicker areas on ceramic pieces are susceptible to blowing out during firing and why even wall thickness and a slow heat rise is recommended.

Another way that pieces can be damaged during bisque firing is during quartz inversion. (See page 46 for an explanation of quartz inversion.) At around 1063°F (573°C), the alpha crystals change to beta crystals and then back to alpha crystals. The clay particles increase in size and change shape during the heat rise and decrease in size during the cool down.

During quartz inversion ceramic pieces are susceptible to developing cracks if there are areas of different wall thickness or if the work is very large. It's best to take work through this transition slowly. Another way to avoid problems during quartz inversion is to leave space around the work when glazed ware is loaded in the kiln. If a kiln is packed too tightly, glazed pieces may fuse together during quartz inversion because of the pieces, increase in volume.

GLAZE FIRING

Glaze-firing temperatures can be as low as bisque-firing temperatures, around cone 06 (1823°F [995°C]) or as high as cone 12 (2516°F [1380°C]). Most clays are not fired beyond cone 12. Glaze firing is usually the last firing that work will go through and is intended to mature the clay body and fuse the layer of glass on the surface of the clay to seal it and give the ceramic surface a decorative element. During a glaze firing, ceramic ware can be heated up a little faster than in the bisque cycle, but it is recommended that this firing also be slow.

With the exposure to high temperatures, clay particles fuse together and bond at higher temperatures, which helps make the clay less porous and more dense. If clay is fired to maturity, it is at the strongest, densest consistency and is referred to as vitrified. This means that the glass particles have melted and bonded to the clay particles.

Oxidation Firing

In oxidation firing, there is plenty of oxygen present in the combustion. Electric kilns fire in oxidation because there is no burning of fuels inside the kiln; the electrical elements emit only heat. It is a stable environment, so the glaze results are consistent and predictable. In oxidation firing of glazes, there is not much carbon present, to chemically alter the glaze.

Experienced potters can learn how to fire fuel-burning kilns in oxidation; the key is ensuring oxygen is in ample supply for mixing with the fuel as it combusts.

Reduction Firing

Most high-temperature firings occur in fuel-fired kilns and therefore use reduction firing as part of the effect. Reduction is literally the reducing of oxygen during the firing process.

With fuel-burning kilns, there is a constant introduction of fuel that combines with oxygen to combust. If there is too much fuel introduced or not enough air going into the kiln, there is a reduction atmosphere in which strong carbon particulate forms and creates deposits on the ceramic ware. Potters use reduction during the

firing process at specific temperatures and in differing degrees of intensity to manipulate visual effects.

When the flame is starved of oxygen, it draws oxygen from the clay body and glazes, affecting the base metals present, such as iron, copper, cobalt, and many more.

The amount of oxygen in the kiln is controlled by the burner at the fuel source and the damper in the chimney that affects the draw of air into the kiln. In a gas-fired kiln, the burners can be adjusted to control the air that mixes with the gas before it ignites affecting the reduction atmosphere. In a wood-fired kiln, the timing and amount of wood introduced in the kiln affects the reduction atmosphere. Potters get to know their kilns and control the air intake at certain temperatures to develop color in glazes and clay.

When reduction firing, there are two points during which potters typically reduce the air intake. This is achieved by adjusting the air intake of the kiln by closing down the damper in the chimney or adjusting the primary air intake. The first is for body reduction, that is to encourage the clay body to develop a toasty color before the glaze begins to melt between 1600°F and 1800°F (871°C and 982°C); the second is at about 2100°F (1149°C).

These are just approximate guidelines because potters develop their firing schedules and techniques based on the kiln, clays, and glazes they use. Fuel-fired kilns provide subtle differences in every firing. The flame pattern and flow can have a very dramatic impact on the ware, depending on its path. Potters who work with reduction firing enjoy the challenge of controlling the combustion and the variations that emerge from each firing.

The reduction process often makes stoneware clays toasty colored and the glazes bright and beautiful with a variety of effects, depending on the wares' position within the kiln. Typically, some locations in a kiln are more heavily reduced than others.

WOOD-BURNING KILNS

Until the twentieth century and the advent of liquid propane, natural gas lines, and electric kilns, virtually every kiln was fueled by wood or coal. Today, many people still choose to fire with wood for aesthetic and economic reasons.

Reduction occurs naturally in wood-burning kilns because as the wood is introduced into the kiln the initial igniting of the gases causes the atmosphere to be in reduction. Wood-stoking cycles are closely monitored to allow the wood to combust, reduce, and reoxidize during the temperature increase. This constant cycling between oxidation and reduction, plus the fly ash that is a byproduct of firing with wood, creates rich earth tones and flashes of color on the bare clay. Glazes are also affected in wood kilns so potters maximize the atmospheric conditions in the kiln to create work that looks good under these conditions.

Wood-burning kilns come in many different shapes and sizes. (In Asia, for example, some wood-burning kilns extend the full length of a football field and are fired by a whole community of potters.) Wood-burning kilns also have different designs for the fireboxes.

Some wood-burning kilns are very efficient at raising temperature with little fly ash, while other kilns (such as the anagama that I fire) need about a week to reach stoneware temperatures, all the while accumulating fly ash on the clay surface. The longer an anagama fires the heavier the coat of glaze.

In the United States, Europe, and Australia, the firing of Asian-style wood kilns has become a major area of study for clay artists. Conferences and publications are dedicated to further the

⊙ These two bowls have the same copper red glaze on a porcelain body. The red one (by Br. Iain Highet) was fired in a heavy reduction environment, but the green one (by Kristin Müller) was fired in an oxidized environment. The difference can be quite dramatic.

knowledge of wood-firing techniques that are relatively unknown outside of their place of origin.

GAS-BURNING KILNS

Gas-burning kilns are often used in industrial and production potteries as well as schools, art centers, and private pottery studios. They can be so huge that they require conveyer belts to move the clay pieces through their production. For example, factories of sanitary wares, such as sinks, toilets, bathtubs and sewer pipes, have entirely automated production and firing systems, which are truly incredible to observe! Institutions like to use large gas-burning kilns because they can fire a lot of work at once, therefore being cost efficient.

Most potters who fire with gas build their kilns from firebrick. Ceramic suppliers, however, now sell smaller studio gas kilns that are easy to fire and offer very predictable results. Manufactured kilns come with instructions and are very well insulated for efficiency.

SALT KILNS

A salt kiln is a special type of kiln. Salt kilns can be wood, oil, or gas fired. Salt is introduced at high temperatures of about cone 6. The turbulence of the combustion propels and vaporizes the salt, which lands on the surface of the clay, fusing to it and creating a glaze. This type of firing is often referred to as atmospheric or vapor firing. The salt emits very noxious gases, but it renders beautiful results. Salt kilns aren't very common because they need to be built outside and of ceramic-hard brick to resist the corrosive effects of the salt. Salt kilns can be fired in oxidation or reduction, depending on the desired effects.

RAKU KILNS

Raku is the name of a Japanese family that developed tea ware for the traditional Japanese tea ceremony. Although the family carefully handed down the technique from generation to generation, one British (but Hong Kong–born) potter named Bernard Leach was privy to the techniques and

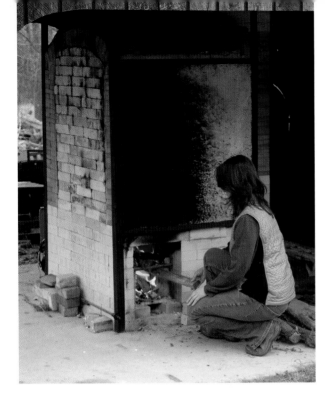

Pictured above is a fast-fire wood-burning kiln built by Douglass Phillips at the Abbey of Regina Laudis in Connecticut. This kiln has two fire boxes and is stoked intermittently from side to side. It reaches cone 10 in about 24 hours. It is used primarily to fire functional stoneware vessels.

wrote about it in his famous text *The Potter's Book*.

In the late 1950s in the United States, a ceramic artist named Paul Soldner, intrigued by what he had read in Leach's book, began experimenting with quickly removing ware from a hot kiln and crash cooling it. This eventually developed into a post-firing reduction technique that is known as American raku that differs from Japanese raku in several ways. A molten hot piece of pottery is removed from the kiln and placed into combustible material such as sawdust, leaves, or newspapers, and then covered. Since the work ignites the combustibles and has no source of oxygen other than the pot, the flame bonds with the oxygen, deposits carbon on the unglazed clay and develops wonderful colors with copper-rich glazes.

Raku kilns are best made with ceramic fiber blanket, because fiber blanket heats up very quickly. Fiber kilns are light and portable. Other raku kilns are made of soft insulation bricks. They take a little longer to heat up, but they retain the heat for subsequent firings.

American raku firing is a lot of fun and gives instant gratification because you can have a piece ready in about an hour as opposed to traditional firings that take about 24 hours for firing and cooling. It is a decorative firing technique that is very high risk though, because pieces can crack due to the thermal shock of quick heating and cooling.

ELECTRIC KILNS

Electric kilns produce heat from electrical current and do not burn a fuel inside the kiln. The emissions from an electric kiln are the organic materials burned off from the clay. Electric kilns fire in oxidation; there is no reduction of oxygen during the firing cycle. Electric kilns are designed to be used indoors, are easy to use, and give very predictable results.

An electric kiln is a good choice for a home studio because it can be used for a wide range of firings. They come in handy for testing clay bodies and glazes and are especially good for bisque firing. All electric kilns have an information plate attached to the exterior that lists the specs such as amperage, volts, interior dimensions, and maximum firing temperature listed in cones or degrees. These specs are usually listed in catalogs, too, and should be heeded carefully.

Electric kilns prefer low- to mid-range firing temperatures. Although a kiln may list cone 10 as the maximum temperature, firing to cone 6 to 8 will extend the life of the kiln elements. The elements in an electric kiln will need replacement after a number of firings; they do wear out. The less stress that is placed on the elements, the longer they will last. (See page 32, to see an electric kiln with manual controls and a venting system.)

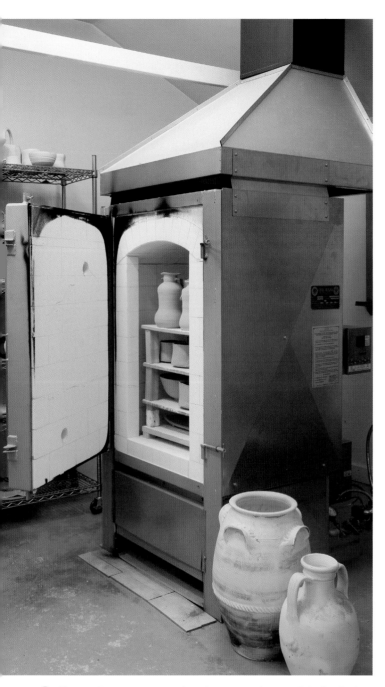

Shown above is a personal studio-size gas-burning kiln (by Geil Kilns) that is installed indoors. It requires serious venting and good air exchange during the firing. It also needs a lot of room around the kiln, but it shows that it is possible to have a gas kiln indoors. It is easy to fire, rendering very beautiful reduction firing results. But as you can see, even a small version of a gas kiln takes up a substantial amount of space.

PYROMETRIC CONES

Pyrometric cones were developed by two different people, Edward Orton Jr. and Herman Seger.

They each developed a system to measure heat absorption inside a firing kiln. Before the development of high-temperature pyrometers, it was hard to know if temperatures had been reached. Traditionally potters would pull small loops of clay with glaze on them called draw rings through spy holes in the hot kilns to see if the glaze had melted.

Pyrometric cones are special clay formulations shaped like elongated pyramids, stamped with the cone number corresponding to their melting points. They are lined up in **cone plaques** in temperature increments. When they reach their respective cone temperature, the cone melts. The bending of the cone is a visual indication of what is happening inside the kiln and the temperature reached.

Pyrometric cones measure heat work more than actual temperature. Heat work comprises the conditions in the kiln and what is happening to the ceramic ware.

Usually three cones are used in a cone plaque. One cone is rated below the desired temperature, one cone is rated at the desired temperature, and one cone is rated above the desired temperature, which is called the guard cone. When a cone melts halfway down, its temperature has been reached. When a cone melts flat, its temperature has been surpassed. If a cone does not bend, it indicates that its temperature has not been reached.

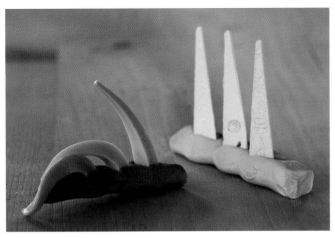

Cone plaques with large pyrometric cones used for measuring heat work in the kiln

Junior pyrometric cone in kiln sitter ready to be fired. When the cone bends, the kiln will shut off.

Cones have many applications besides establishing when a firing is finished. By placing cone plaques throughout the kiln, one can see the cooler and hotter spots in a kiln. If glaze results are not consistent, cones will reveal the variations of kiln temperature. The kiln sitter can be calibrated, or adjustments can be made to your firing. In an electric kiln, monitoring cone plaques can help determine whether or not the heating elements are worn out and if the kiln sitter settings are correct. In fuel-burning kilns, placing cone plaques in several spots can help to monitor the temperature throughout the kiln by peeking into spy holes during firing.

Junior pyrometric cones are smaller versions used in manual kiln sitters to activate the relay switch that shuts off the kiln. A manual kiln sitter has three prongs—two on the bottom and one on the top. A junior cone is placed in between so that when the heat rises and begins to melt the cone, the top two prongs move down, releasing the relay that turns off the kiln. This simple setup works very well if the cone is placed properly in the sitter.

A kiln sitter that uses a junior cone can be calibrated to shut off with a slightly less bent cone or a more severely bent cone by adjusting the sensitivity of the release of the relay switch. (The kiln manual will explain this more thoroughly.)

To calibrate a digital kiln controller, you may want to program the controller to fire one cone hotter or cooler depending on what the witness cones indicate.

How to Fire an Electric Kiln

For this studio handbook, I felt it necessary to give a solid starting point on how to use an electric kiln. My students often share their fears of connecting and firing a kiln. With some information and attention to detail, you can have years of fun firing your work. Know that a kiln is an insulation box; it will not catch fire. What will ignite are flammable materials and chemicals near a kiln and poor electrical wiring. If you take precautions to install a kiln properly and monitor firings, chances are that you will prevent any accidents.

CHOOSING AND PREPARING YOUR ELECTRIC KILN

Manufacturers of electric kilns offer kilns with different features such as the type of insulation brick used to house the electric elements that conduct the heat. Some models have elements on the floor of the kiln. As previously mentioned, there are options of purchasing a model with a manual kiln sitter or a digital controller. Each has its advantages, and choosing one over another is a personal choice. The size of the kiln will control the size of the work that can be fired and the amount that can be fired at once. A normal bisque or glaze firing takes between 8 and 12 hours to reach temperature. Consider the time that will be spent monitoring a kiln firing and then think about the size that will work best for you. Also consider the electrical requirements and the limitations of your space. Keep in mind when making or firing ceramics that slower is always better. Clay particles do not respond well to sudden changes.

For a home studio, an electric kiln that has interior dimensions of 7 cubic feet (about 2 cubic m) is ideal. It is easy to load because it's not too deep or too wide; the

◎ Porcelain bowl by Mother Perpetua Giampietro, of the Abbey of Regina Laudis

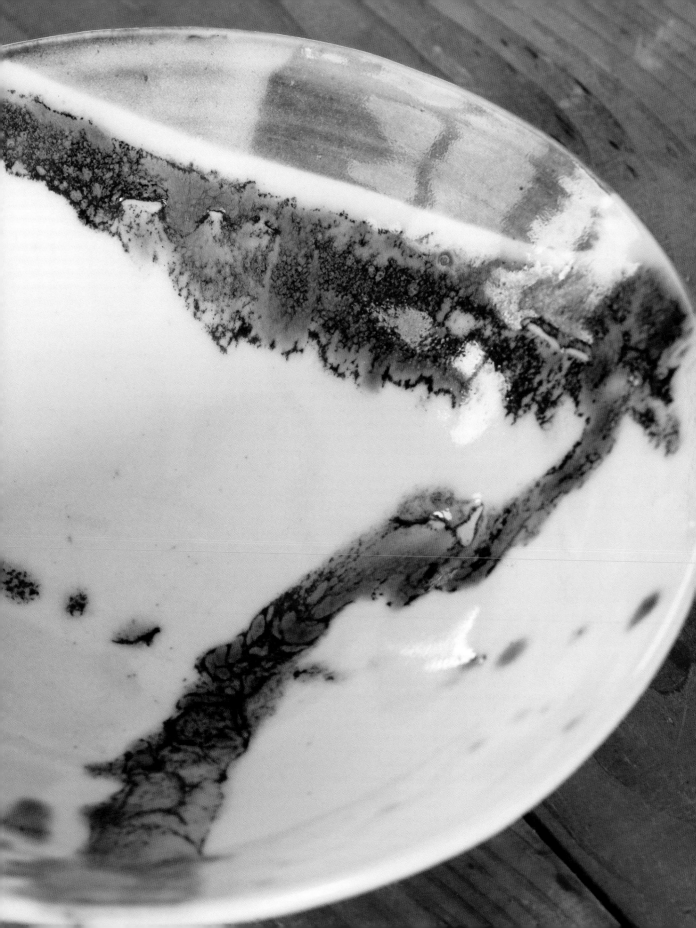

kiln shelves are of manageable size and weight. This size kiln is sufficiently wide and deep to make fairly large work and has enough interior space to fire plenty of functional ware too.

A kiln that can fire to at least cone 8 is recommended, even if most firing will occur to cone 6, which today is a standard mid-range firing temperature for electric kilns. There are many commercial glazes, recipes, and stoneware clays available in this temperature range. A cone 6 to 8 kiln will more than suffice for working in low-fire clays and glazes.

PRELIMINARY SETUP AND FIRING

Previously, we've discussed where to place your kiln. (See Chapter 1.) So now you're ready to get firing. Every new kiln will need to be first fired without work to allow the electrical elements to burn off residue. It is good to post kiln shelves as if you were firing work in the kiln and place a few cone plaques to check for temperature accuracy. Place cones on the bottom shelf, the middle shelf, and the top shelf so you can see how each reacts.

KILN SHELVES AND POSTS

Kilns require both kiln shelves and kiln posts for stacking ceramic wares inside a kiln. They are made of refractory materials that withstand high temperatures. Though the heat resistance makes them strong, they are brittle and will chip and break if they are not stored properly. When shelves are not in the kiln, store them upright in a secure manner so they do not tip over. Kiln shelves should never be stacked on top of one another.

Kiln posts or stilts come in different lengths to accommodate firing a range of ware heights. Store them by height to facilitate the loading process. Take care in handling them; they too will break very easily. Plan space for easy access and proper storage near the kiln.

APPLYING KILN WASH

Kiln wash, which is sold by ceramic suppliers, is a mixture of flint (silica powder) and refractory clay without any flux. It looks like white glaze and is carefully brushed onto the surface of kiln shelves to protect them from glaze drips. Kiln wash will bond to glaze drips so it flakes off the shelf.

Kiln shelves are expensive and delicate and should be protected. If glaze drips onto an unwashed shelf, it will permanently damage the shelf and the piece. If the kiln shelf has a good coat of kiln wash, it will be protected from permanent damage.

Before firing your kiln, brush some kiln wash onto the floor of the kiln also, just in case there is a firing mishap. Glaze drips on soft brick will corrode the brick. If the kiln has elements on the floor of the kiln, however, check the manufacturer's recommendations before applying kiln wash.

Applying kiln wash to new kiln shelves is fairly easy. Get a bucket of water, a large clean-up sponge, and a large flat brush.

1. Mix the kiln wash with water to a smooth, milky consistency. You do not want a thick application, but rather a layered one.

2. Wipe the surface of the kiln shelf with a damp sponge to remove dust and to add a little moisture to the porous shelf.

3. Using a large flat brush, coat the top of the shelf with brushstrokes in one direction in a smooth, even layer. Note: Avoid getting kiln wash on the edges of the shelf. Kiln wash is flaky when it is fired. If it is on the edges of the shelf and those kiln-wash flakes land on glaze ware, they ruin perfectly good pieces.

4. If you get a drip, wipe it off with the damp sponge.

5. Proceed to the next few shelves.

6. When the first coat is dry, apply a second coat
 with strokes in the opposite direction.

7. When the second coat is dry, apply a third
 coat with strokes in another direction.

8. It is helpful to quickly dip the ends of the
 kiln posts in the kiln wash; it's extra insurance
 against fusing if there is a kiln mishap.

9. Allow the shelves to thoroughly dry before
 loading them into the kiln.

POSTING KILN SHELVES FOR LOADING

After you've applied kiln wash to the floor of the
kiln and the kiln shelves, it's time to move on to
the next step, posting your kiln shelves.

The bottom kiln shelf needs to be elevated at
least an inch (a few centimeters) to allow heat
underneath it. At least six short kiln posts should
be used for this purpose.

Kiln shelves are always posted on three points
for balance. Subsequent postings should be
aligned with the posts underneath. If all the kiln
posts are aligned, the kiln shelves will not warp
during the firing and the load will be balanced.
Half shelves should be posted on each corner
and at the highpoint of the curve. Whole shelves
should be posted with four opposing points.
However, if you plan on posting half shelves on
the higher levels, post with six posts so that the
three points of the half shelf will align.

When posting shelves, be sure you have
enough clearance to accommodate ware. Some

people use a plastic triangle straight edge to
span from post to post for measuring height. It
is just as easy to hold the post size you are using
to the piece prior to loading to see if you have
enough clearance.

BISQUE FIRING

Once the ware is dry and properly loaded into
the kiln, you'll decide the bisque-firing tempera-
ture. The most common bisque-firing tempera-
ture is cone 06, but as previously mentioned this
temperature can be higher or lower depending
on the type of ware and decoration methods that
will be later used.

Typical bisque firing will take about 12 hours
to fire and another 10 to 12 hours to cool properly.

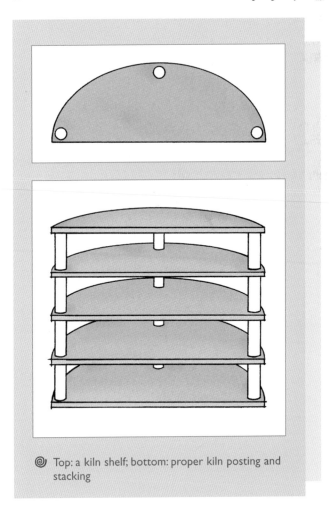

Top: a kiln shelf; bottom: proper kiln posting and
stacking

⊚ Green ware by Br. Iain Highet, ready to be fired in a front-loading kiln. Note the kiln posts in the front and one directly behind the ware and the cone plaque.

LOADING GREEN WARE FOR BISQUE FIRING

When the clay is bone dry, it can be loaded for bisque firing. Clay pieces can touch or even be stacked for bisque firing because in this firing the clay will not fuse to itself. It differs from loading glaze ware for firing, which does not allow ware to touch or stack. The main purpose of this firing is to drive off moisture and carbonaceous material. Green ware will shrink during the firing.

- Here are a few pointers for stacking ware. The key is to place lighter pieces on top of heavier ones. Make sure that the pieces that are stacked have equal wall thickness and that they have at least a ¼ inch (6 mm) clearance between them to prevent them getting stuck inside the other. Here are a few examples:

- Plates of equal weight can stack on each another (two high), but do not place a bowl with a foot rim on top of a plate or the isolated weight will warp the plate.

- Bowls can be nested provided they have enough clearance (see above).

- Cups should be stacked bottom to bottom. Stacking them lip to lip can cause stress on the lip, cracking, or warping. Bottle forms can stack inside of bowls.

- Lids should always be fired on the piece it is made for so they can shrink and move as one.

In general, keep pieces from touching the walls of the kiln. If a piece touches a wall, the heat transfer will be too strong and cause breakage.

- Keep in mind that a kiln load should be balanced to fire evenly. For example, if you have only a few pieces, spread them out from top to bottom. If you have a lot of work, be sure to pack the kiln with equal density.

- If you are loading a kiln with a manual kiln sitter, be sure to place the cone in the sitter before you load the shelf above it. Finishing loading only to realize that you have to unload the top shelf to reach the kiln sitter is frustrating.

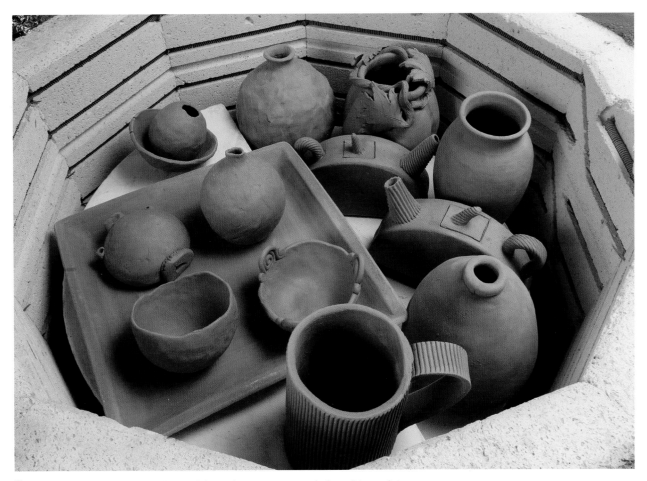

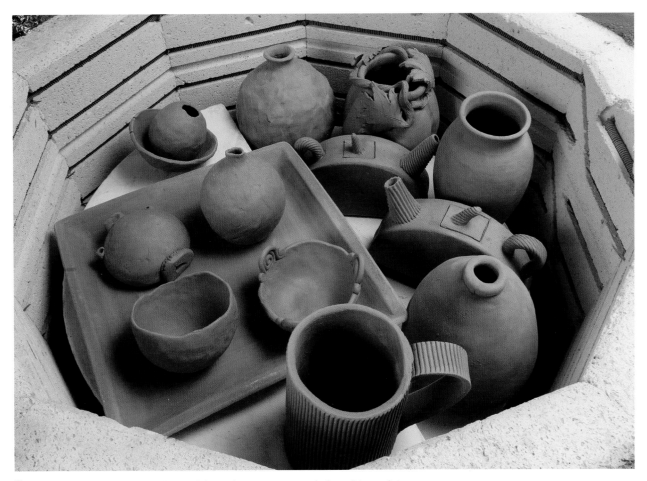 Top shelf of a top-loading electric kiln with greenware ready for a bisque firing

This initial firing of work is for driving off the chemically bonded water, and it is important that the water evaporation proceed in a slow and steady fashion. If the heat rise is too sudden, the steam pressure will blow out the walls of the ceramic pieces. For this and the quartz inversion that the clay will go through, the first 1200°F (649°C) must proceed slowly. The remaining heat rise can proceed at a faster pace.

Sample Bisque-Firing Schedule: If you are firing very thin work, the cycle can proceed at a quicker pace. On the other hand, if the work is larger, the cycle needs to be slower. This schedule is just a guide, and you will need to adjust it accordingly.

For a manual kiln:

1. Prop the kiln door open a few inches (or several centimeters) with a fire brick wedge, which should have come with the kiln.

2. Power on the ventilation system.

3. Set all switches on low for 3 hours.

4. Close the kiln lid and leave on low for 3 hours.

5. Set all switches on medium for 3 hours.

6. Set all switches to high until the firing completes—about 4 hours.

For a digital kiln:

1. Prop the kiln door open a few inches (or several centimeters) with a fire brick wedge. (One

should have come with the kiln.)

2. Power on the ventilation system.

3. Program the digital panel for the desired cone.

4. Be sure to choose the slow cycle or the work may be damaged.

5. Leave the lid propped open until the temperature reads 900°F (482°C), then close it.

If the work to be fired is thick, large, or has uneven wall thickness, it is important to slow the firing down further. One way to do this with a manual controller is to turn one switch on low for at least 3 hours. Then proceed to turn the next switch until they are all on, then follow the schedule.

With a digital controller, you can program a ramp hold mode. Program the kiln to hold a temperature slightly under the boiling point of water (which is 212°F [100°C]). I suggest drying at or under 180°F (82.2°C) for 6 to 10 hours.

A propped lid allows the gases to escape. Note that some ventilation systems that attach to kilns require that the kiln lid be closed throughout the firing cycle because they have air intake holes that provide continuous air exchange.

Also note that spy holes should all be closed, with the exception of the top spy hole, which is left open for air exchange. Some of the newer ventilation systems do require them to be closed. Refer to kiln and ventilation system instructions for proper air exchange.

CLEANING THE KILN

If work explodes during bisque firing, the kiln must be properly cleaned. Otherwise the electrical elements can become damaged in subsequent firings. First put on a mask and avoid inhaling the dust. Empty the kiln completely, unplug it, and use a shop vacuum cleaner with a soft brush attachment to remove all the tiny debris that

TIP
Before closing the lid of the kiln, you can do a moisture test. Hold a mirror in front of the propped lid. If it fogs up, wait to close the lid to allow moisture to evaporate.

may have gotten lodged on the element wires. Work from top to bottom and make sure to clean every row.

LOADING GLAZE WARE FOR GLAZE FIRING

Before glazed ware is loaded for firing, make sure the kiln shelves have a good coat of kiln wash. Also, check that the base of the ware is clean and free of any glaze drips. When loading a glaze kiln, always have a bucket of water and sponge available. Check every piece. Even if the bottoms were wiped already, it may have inadvertently come in contact with a dirty surface.

Keep an eye on drips or heavy coating of glaze at the very base of pots. Sometimes these need to be gently scraped to prevent a large drip from forming during melting.

When the pieces are loaded for glaze firing, keep them apart. Glazed pieces should not touch; they require at least a ¼ inch (6 mm) space between pieces. This is because quartz inversion will occur as the temperature rises and falls.

After the loading is finished, check to make sure that no glazed areas overhang the kiln shelf and that nothing is touching the kiln walls.

If you have a manual kiln, place the pyrometric cone in the kiln sitter. Also, be sure to place witness cones in front of the peep hole to check the accuracy of the kiln sitter or digital controller during the firing. The kiln manual will have detailed instructions on how to do this.

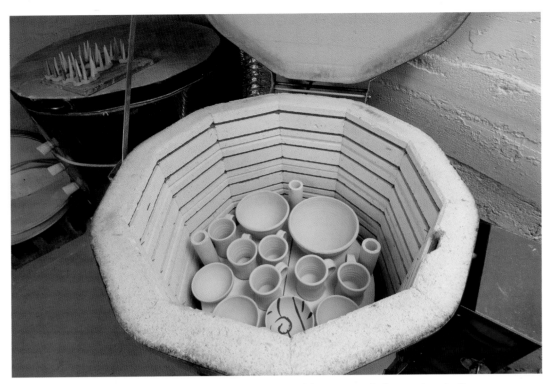

◎ Glazed pieces loaded into electric kiln. Notice the three kiln posts ready for another shelf.

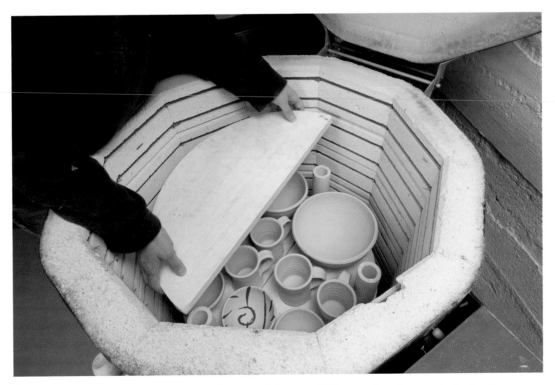

◎ A kiln shelf is placed over the ware and rests on kiln posts. Make sure that the ware is shorter than the posts.

As when the kiln was loaded for bisque firing, make sure to load it evenly. Even distribution of ware in the kiln will help build thermal mass and will even the heat distribution. A uneven load will render uneven results.

GLAZE FIRING

Glaze firing can proceed at a faster pace during the initial temperature rise than bisque firing, but it should slow down toward the end of the firing to ensure a good melt and bond with the clay body. One of the most common mistakes potters make is to fire a glaze kiln too quickly. Common glaze flaws such as pin holes, crawling, and crazing are caused by fast firing and cooling.

General Glaze-Firing Schedule

For a manual kiln:

1. Load the kiln with the proper cone in the kiln sitter.

2. Place witness cones in front of the spy hole and check for a clear view.

3. Close the kiln lid.

4. Power on the ventilation system.

5. Set all switches on low for 3 hours.

6. Set all switches on medium for 3 hours.

7. Set all switches on high until the firing is complete. Monitor the witness cones until temperature is reached. Be sure to use eye protection such as welding glasses to peer inside the kiln.

8. If the kiln shuts off before the desired cone bends, you can restart it and monitor every 10 minutes until the desired cone bends.

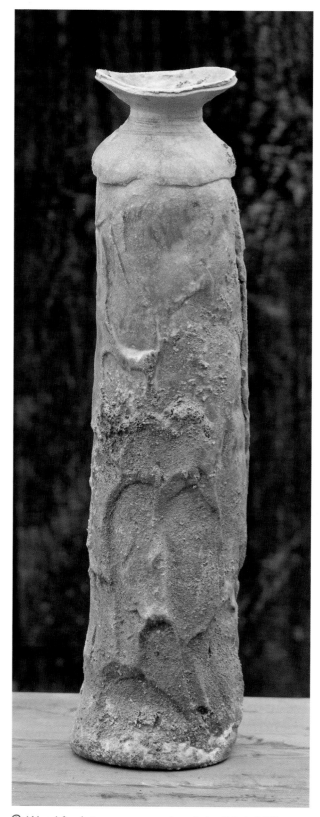

Wood-fired stone ware vessel made by Kristin Müller using a combination of hand-built and wheel-thrown parts

For a digital kiln:

1. Load the kiln.

2. Place witness cones in front of the spy hole and check for a clear view.

3. Close the kiln lid.

4. Power on the ventilation system.

5. Program the digital controller for the desired cone.

6. Program the speed of the firing. Most programs come with slow, medium, or fast. Slow or medium speeds are more suitable; avoid fast mode.

 Monitor the witness cones until the temperature is reached. Be sure to use eye protection such as welding glasses to peer inside the kiln.

7. If the kiln shuts off before the desired cone bends, follow the programming instructions to hold the temperature for 10 minutes and monitor progress. Refer to the programming instructions for details.

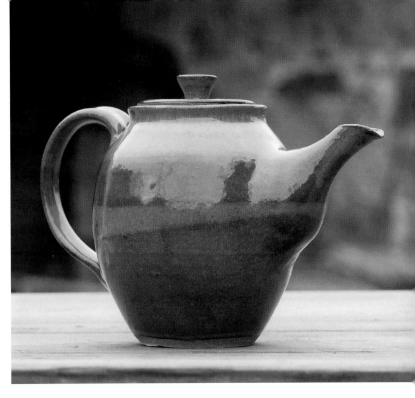

⊚ Teapot fired to cone 6 in oxidation in an electric kiln by Kristin Müller

Once the kiln is calibrated and working with favorite glazes, chances are each potter will make adjustments and develop personal firing cycles. Many books on glazing refer to soaking cycles, which means holding the temperature for a period of time to allow the glaze to bond to the clay. Soaking can provide a temperature hold that allows special effects to develop in glaze.

KILN SITTER

Junior pyrometric cones are smaller versions of the large cones and bend when they reach a specific temperature. The junior cone is placed in the prongs of a manual kiln sitter and when the temperature is reached the cone bends and releases the relay that shuts the kiln. This system works very efficiently if it is calibrated. The relay that drops can be easily adjusted to release when the cone is barely bent or more severely bent, which allows for some temperature control (see page 200). Witness cones placed in front of the top spy hole help gauge the temperature during and at the end of the firing. Placing witness cones on different shelves will give you a reading of the heat distribution of the kiln. If the kiln needs to fire a little higher or lower, the relay can be adjusted. Manual kiln sitters also have timers to back up the function.

Make sure that the prongs are free of clay and glaze and that glazed ware is not overhanging the kiln sitter or too close. If glaze drips it can cause the sitter to not work. Note that cones can only be fired once—even if a firing is interrupted, replace the cone because it will lose the ability to measure heat work.

With the digital controller or kiln sitter, there is no cone, just a probe (called a thermocouple) that reads the temperature for the digital pyrometer. They too should be checked for calibration

by using witness cones throughout the kiln and in front of a spy hole. If you find that the kiln is under-firing, the firing program can be adjusted to go slower or raise the cone. Conversely, if it shows that the kiln is over-firing because the witness cones are bending too far or the glazes are running off the work, the kiln can be programmed to fire faster or lower the cone. Do not make the assumption that digital is accurate. Always test for accuracy.

PYROMETRIC CONES AND CONE PLAQUES

Pyrometric cones are the most accurate measurement of heat work in a kiln. They reflect what is actually happening to the ceramic pieces inside the kiln. It is very easy to rely on pyrometers but they won't show the whole picture. Placing cones throughout a kiln and keeping records of the results will help track knowledge about the kiln that will help determine where to place the work and whether heating elements need replacing.

For assembling cone plaques, the convention is to place the desired cone in the middle with a lower cone to the left and a higher cone to the right. With three cones, the first one will indicate that temperature reached and the higher cone will indicate the temperature surpassed. Ideally, the lower cone will bend and touch the plaque, the desired cone will bend halfway over, and the higher cone will have softened edges. (Remember from Chapter 10, if cones are flattening they are over-firing, if they are standing straight they are under-firing. See page 200 for more on pyrometric cones.)

TIP
To make a cone plaque, roll a clay snake and insert cone aligning the cones at a slight angle (as shown in diagram).

KEEPING A KILN LOG AND A GLAZE JOURNAL

Two essential tools for the studio are a kiln log and a glaze journal.

KILN LOG

A kiln log is an a firing journal in which a record is kept of every firing. The type of information that should be included in a kiln log is:

- What clay and/or glazes are fired?
- What cone/temperature is the firing?
- What is the firing cycle's speed and length?
- What did the witness cones do? How far did they bend?
- What were the results?
- How much energy was used?

A kiln log will help keep track of what works and what doesn't. It will provide the information necessary to figure out the cost of firing. It will keep the actual record of how many firings the kiln has completed and may be useful in determining when it's time to replace elements.

GLAZE JOURNAL

A glaze journal should be kept in conjunction with the kiln log. It will provide a record of which glazes work best and how to fire them. By keeping thorough records, you will observe patterns that indicate failure and success. Over time, this record will be very helpful in recreating a particular result. The type of information that should be included in a glaze journal is:

- Clay bodies used and forming techniques
- Glaze recipes and quantities mixed
- Glaze application methods
- Pictures of results and descriptions of details
- Comments about the firing and results, perhaps a note on pyrometric cones and how far they bent
- As much information as can be put down will help later. (Trust me, in a few years you will not remember the details!)

COOLING THE KILN

Cooling is as important to the development of texture and color in a glaze as firing. In fact, many potters who use fuel-fired kilns experiment with cooling cycles for effect.

Pots can crack if they are cooled too quickly. Opening the kiln will cause its temperature to drop rapidly. It is recommended that a kiln not be open until the interior temperature is below 250°F (121°C). Waiting until the kiln has cooled prevents the work from cracking, and it also prevents the glaze from crazing. If pinging sounds are heard when the kiln is opened, close it up and let the work completely cool. The pinging sound is the glaze crackling because of the thermal shock.

◉ Slump-molded dish and small wheel-thrown bowl fired in an electric kiln to cone 6

UNLOADING THE KILN

Unloading a glaze kiln can be like unwrapping presents—there is always an unexpected result. When the ware is unloaded, take a few moments to check the bottom of pieces for any rough spots. Do not use your bare hand to do this—wear a leather glove. If the bottom is a little rough, try sanding the base with aluminum oxide sand paper (the black one used wet or dry for metal). It works wonders for rough clay bottoms.

If there are glaze drips in the kiln or on the pieces, be extremely careful handling the ware. Glaze drips are as sharp as razor blades. Resist the temptation to pick at glaze. Remove the drips with a piece of silicon carbide or a grinding tool with the appropriate grinding bit (either dia-mond or silicon carbide will work to grind the glaze). Note that ceramic materials are very hard and require special grinding bits.

Always wear eye and lung protection when working with grinders as they emit a lot of very fine dust and sharp debris that can injure unprotected eyes and pollute lungs.

If a pot is fused to the kiln shelf, gently tap the end of a metal putty knife with a hammer while holding it at an angle against the base of the piece. A gentle tap will usually suffice. If it's necessary to hit harder, chances are the piece is damaged from the glaze melting.

After a piece has been fused to a kiln shelf, the kiln shelf will have to be scraped and kiln wash should be reapplied.

REMOVING A VESSEL FUSED TO THE SHELF

To remove a pot fused to a kiln shelf, place a metal scraper at a 45-degree angle on the kiln, just at the base of the piece. Gently tap the handle of the scraper with a hammer, increasing intensity until the piece comes loose. Sometimes just a gentle tap will do the trick. Other times the kiln wash and edge of piece need to be tapped all the way around with some force to break the glaze bond.

To scrape glaze drips, lay the kiln shelf flat on a soft surface such as a wooden table. Wearing eye protection, use a metal putty knife or a chisel and with a hammer gently tap just beyond the drip to flake off kiln wash without damaging the kiln shelf. If tapped too hard the shelf can chip. Once the big drips are removed, rub a silicon carbide block over the surface of the shelf to remove any additional glaze and loose kiln wash. Use a damp sponge to slough off any remaining debris and apply three even coats of fresh kiln wash.

INSIDE THE KILN

Most miscalculations in the ceramic process occur during firing. Many clay body and glaze defects can be directly related to faults in the kiln's heating and cooling cycle. For a thorough and diverse knowledge of kiln firing, fire as many different kilns as possible, rather than learning to just fire one. Craft centers and college ceramics departments offer the best locations for this experience.

Wheel-Thrown Bottle
See page 288 for formula

Conduction

Conduction is the transfer of energy through matter (as in the movement of heat from an atom).

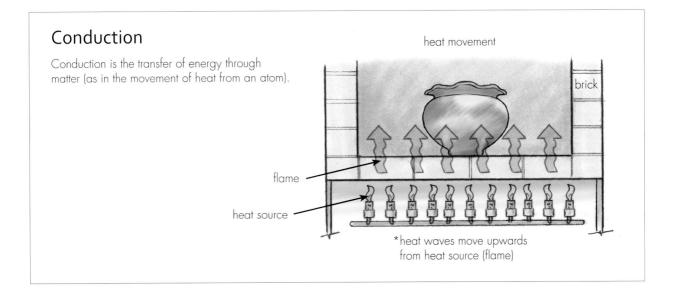

heat movement

brick

flame

heat source

*heat waves move upwards from heat source (flame)

Convection

The process by which heat is transferred through the movement of air. This method of heat transfer can be felt when opening a hot oven. Air molecules are heated from the heat source and then move about the kiln, heating the interior of the kiln, shelves, and pots.

Convection is the transfer of heat through mass-movement of either air or water.

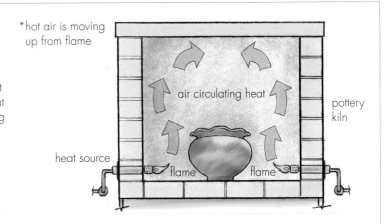

*hot air is moving up from flame

air circulating heat

pottery kiln

heat source

flame flame

Radiation

Heat is transferred through the kiln by energy waves. When a kiln is heated, it generates thermal mass in the kiln from kiln bricks, shelves, posts, and pots. The radiant heat is transferred to every object in the kiln. After the heat source is turned off, radiant heat still affects all objects in the kiln.

Radiation comprises electromagnetic waves that move energy directly through space (as the Sun's rays transport heat to the Earth).

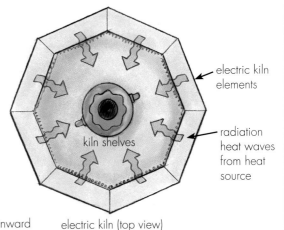

electric kiln elements

radiation heat waves from heat source

kiln shelves

*heat waves are radiating inward from the outside of the kiln

electric kiln (top view)

HEATING A KILN

Heat is a form of energy produced by the movement of molecules, capable of transmission through convection, conduction, or radiation.

Conduction: The transfer of heat through solids. When the kiln is fired, kiln shelves gather and release heat during and after the firing. The heat is transferred directly through the solid kiln shelf, posts, and other pots on the shelf. When the heat source is turned off, the overall kiln temperature drops, but the kiln shelves and other kiln furniture act as a thermal reserve, transferring heat to pottery on the shelf. Some materials transfer conduction heat more efficiently than other materials. (Anyone who has touched a pizza stone fresh from the oven has experienced burning conduction heating first-hand.) There is still a great amount of heat stored within the hard brick shelf, which takes a while to dissipate.

MELTING CHARACTERISTICS

Ceramic materials react or melt under specific conditions. The absolute, or end-point temperature is the most common factor causing clay and glazes to melt. The higher the temperature for any given ceramic material, the greater the degree of melting that takes place in the clay body or glaze. Glass formation (called vitrification) occurs when fluxing materials react with alumina and silica in clay and glazes. However, other factors that contribute to melting may not be so apparent to potters firing their kilns.

Convection: The process by which heat is transferred through the movement of air. This method of heat transfer can be felt when opening a hot oven. Air molecules are heated from the heat source and then move about the kiln, heating the interior of the kiln, shelves, and pots.

Radiation: Heat is transferred through the kiln by energy waves. When a kiln is heated, it generates thermal mass in the kiln from kiln bricks, shelves, posts, and pots. The radiant heat is transferred to every object in the kiln. After the heat source is turned off, radiant heat still affects all objects in the kiln.

Particle size: The particle size of ceramic materials also can affect the melting characteristics of glazes and clay body formulas. The smaller the particle size, the greater the melting potential of any ceramic material. Small particle sizes expose greater surface areas to heat.

Kiln atmosphere: Depending on the heating source, a kiln can be fired in oxidation, neutral, or reduction atmospheres. An electric kiln produces an oxidation-kiln atmosphere because the ratio of air is higher than fuel. In reduction-kiln atmospheres, the ratio of fuel-to-air is higher, producing carbon monoxide. This colorless and odorless gas is oxygen-hungry. When the gas is in the presence of easily reduced metallic coloring oxides found in clays and glazes, it draws an oxygen molecule from them, changing their color and lowering their melting characteristics. Other oxides found in clay and glaze formulas are not so easily reduced and need higher temperatures than pottery kilns can economically achieve.

Eutectics: These are combinations of two or more materials that cause melting at the lowest possible temperature. Eutectics can be formed when different oxides are brought together in glazes. The most common example is lead and silica. When the mixture is heated, it produces a lower melting point than lead or silica melted separately. A strong eutectic can develop when two or more glazes are overlapped on a pot. The mixture of glazes can cause blistering, pinholes, or glaze running off vertical surfaces, as well as pooling excessively in horizontal areas.

Metallic coloring oxides: Iron oxide, for example, can act as a strong flux (melting agent) in glaze if used in high percentages. On the opposite end of the spectrum is chrome oxide, which is a refractory or heat-resistant oxide. High percentages of chrome oxide can dry the surface texture of the fired glaze. Other metallic coloring oxides, to various degrees, can be classified as contributing a refractory or flux component to clay body or glazes.

Clay body: A clay body that is absorbent when fired can leach out fluxing oxides in the melting glaze during the firing. A dry surface texture and/or glaze opacity can result when some portion of the flux oxides in the glaze are leached into the clay body surface.

Glaze thickness: Whether a glaze is sprayed, dipped, or brushed on the ceramic surface, the actual thickness of the glaze can play an important part in its ability to melt. As a general rule, the thinner the glaze layer, the greater degree of melting. A thick glaze application can need more heat work (the time it takes to arrive at the maturing temperature of the glaze) to cause complete vitrification (glass formation) of the entire glaze layer.

Glaze application technique is critical for functional pottery, whether sprayed, dipped (like this piece), or brushed, in order to achieve a smooth defect-free fired surface.

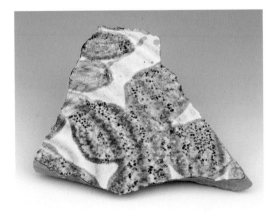

When overlapping one glaze with another there is always the possibility that the glaze materials will be incompatible due to an eutectic reaction, which can cause glaze blistering or dripping in the overlapped area.

THE KILN AT WORK

The heating and cooling cycle in a kiln firing can affect how clay and glaze materials melt. We refer to heating cycles and the stages of firing as "heat work." A significant amount of heat work must occur before the kiln reaches its end-point temperature. The kiln heats in stages, the first being a bisque firing. This prepares the clay for future glazing. The pot is fired again after glazing.

The three most common temperature ranges used to produce pottery and sculptures are: low fire, cone 06 (1,828°F [998°C]); medium fire, cone 6 (2,232°F [1,222°C]); and high fire, cone 9 (2,300°F [1,260°C]). Each temperature range has several qualities that can be beneficial to the function or aesthetic considerations of the ceramic object. Low-fire temperature ranges can produce glaze finishes in bright, crisp colors. Firing kilns to low temperature also enables faster heating and cooling cycles and less wear on kiln shelves, posts, and bricks.

The medium- to high-temperature ranges produce dense, glass-like, hard ceramic clay bodies and glazes. Clay and glaze may be integrated more fully when heated to medium or high temperatures. The greater interface development produces glazes that look integral to the clay body surface, as opposed to a "painted–on" superficial glaze coating found in low temperature clay body and glaze ranges. However, there are several exceptions where low fire-clay bodies can be formulated to create dense, nonabsorbent ceramic forms.

Slower bisque-firing times are necessary if pots are thicker than 1/2 inch (1.3 cm) or taller than 14 inches (36 cm). Longer bisque firing times are essential if plates, tiles, wide-based forms, or thicker forms are fired. A common

Kiln Heat Work	
As the kiln temperature rises, clay body and glaze undergo chemical changes that dictate the quality of the final product.	
Temperature	**Chemical Change**
212° to 392°F (100° to 200°C)	Mechanical or free water is removed from the clay body.
842° to 1,112°F (450°C to 600°C)	Chemically combined water is removed; shrinkage can occur during this temperature range.
1,063°F (573°C)	Quartz or flint components of clay body expand.
572° to 1,292°F (300° to 700°C)	Organic matter in clay is oxidized and removed; if the kiln is not fired in a complete oxidation atmosphere, carbon can cause bloating in the clay body at higher temperatures.
1,796°F (980°C)	Metakaolin, an intermediate product formed when kaolin is heated, changes to spinel, which ejects silica.
1,922° to 2,012°F (1,050° to 1,100°C)	Spinel changes to mullite; feldspar melts; vitrified clay body reacts with silica ejected in spinel/mullite formation.
2,195°F (1,202°C)	Clay body porosity decreases sharply.
2,012° to 2,282°F (1,100° to 1,250°C)	Silica or quartz in the clay body starts to change to cristobalite. If high amounts of cristobalite are formed in the clay body at this point, it can cause cooling cracks in the 392°F (200°C) temperature range. Cristobalite cracking in clay bodies is often encountered when a kiln stalls or takes an exceptionally long time after cone 8 (2,280°F [1,249°C]) to reach its final firing temperature.

firing mistake is firing functional pottery at a "safe" bisque-firing cycle, then firing plates or large sculptural pieces with the same cycle. The plates or larger pieces often crack or blow up, throwing small shards throughout the kiln. Larger and/or thicker pieces need slower temperature increases to safely release their mechanical and chemical water. Play with temperature settings and choose appropriate heating cycles for the work you are firing.

Firing Too Fast

A clay body can be strong and durable with the right clay body formula, appropriate end-point temperature, and correct time to temperature. A fast-fired clay body has not achieved its maximum strength potential. The clay might look dense, but functional pottery that is fast-fired often breaks or cracks in normal, daily use.

On the other hand, an overfired clay body can slump, bloat, shrink excessively, stick to the kiln shelf, or warp. If a kiln is fired to increasingly higher temperatures, any clay body can be eventually transformed into a glaze.

A fast kiln firing can affect glazes in several visible ways, resulting in a dry, rough, or dull surface texture, immediate glaze crazing, pinholes, blisters, a muted or dull glaze color, and a less durable glaze surface. Fast firing also can increase solubility in a glaze, which results in staining on plates or functional pots. A "soft" glaze surface might look perfect, but it can be easily scratched and dulled by abrasive cleaners or alkaline dishwasher liquids.

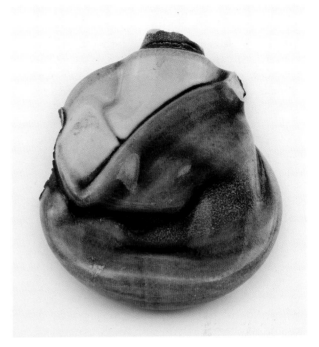

Any clay body can slump or deform past its maturing range, due to firing. Depending on the amount of overfiring, the pottery can warp, stick to the kiln shelves, or deform into a horizontal mass.

Take Your Time

A kiln can be programmed to hold at a specific temperature for a period of time. Holding at temperature increases melting, because the materials are given more heat work, resulting in greater glass formation. If you choose to hold at the maturing temperature of the glaze, there is always the possibility of boiling off lower constituent glaze oxides. This causes glaze blisters, running, or clay body bloating. The safe approach is not to hold the glaze at temperature. Instead, fire to the glaze-maturing temperature over a longer period of time. Or, down-fire the kiln, which delays the cooling cycle of the kiln. In electric kilns, down-firing can be achieved simply by turning on the element switches to low or medium after the kiln has reached its end-point temperature. In hydrocarbon-fueled kilns, such as natural gas or propane, leave the burners on a low setting after the kiln has reached its end-point temperature. Both techniques will expand the heating and cooling curve of the kiln firing.

KILN TYPES AND CONSIDERATIONS

The type of fuel used to fire the kiln can be a determining factor in studio location and the overall cost of producing pottery.

Kilns fired by hydrocarbon-based fuels such as natural gas, propane, wood, coal, or oil might require permits from the local fire department as well as a survey of neighbors for potential objections. For example, kilns require enough space for the potter to easily walk around for inspections during the firing process. Hydrocarbon-fueled kilns also require a room large enough to facilitate fresh air circulation to encourage combustion and then remove the products of combustion within the kiln. Also plan for the kiln stack and its exit through the roof structure.

The proximity of neighbors and the gases exiting from the stack during a firing are significant factors in kiln and subsequent stack location. Some potential studio kiln locations might be off-limits, due to local zoning restrictions or individuals and businesses that do not want a pottery close by. Research the existing area and the neighborhood. Kilns fired by propane require a storage tank. Consider placement of the tank, which can be large, in relation to the kiln and your outside surroundings.

Electric kilns should be installed by professional electricians. You need dedicated circuit breakers for each kiln used in the studio and sufficient electrical capacity to power kilns, equipment, and tools.

Active venting of the kilns to an outside source is also recommended to ensure a safe studio atmosphere. The fumes from improperly vented electric kilns can drift into the studio and other building occupants, causing complaints and possible legal action for eviction. Even outdoor electric kilns can require venting, depending on their location, to safely remove exhaust from the immediate environment or prevent exhaust from endangering other areas.

Kiln Size

Many potters use electric kilns for bisque firing their ware and gas kilns for glaze firing. On average, you can fill a kiln with 40 cubic feet (1.1 m3) of usable stacking space with 65 to 120 functional pots, depending on their size. Use these figures as a starting point for planning the kiln size that will fit your production requirements.

If you're interested in selling your wares, consider estimating the wholesale versus retail price of pots contained in a single kiln firing. Smaller kilns offer greater flexibility to meet production schedules or custom orders, but they are labor-intensive for stacking, firing, and unloading. On the other hand, larger kilns offer the economy of scale, because it takes just as much effort to fire a large kiln as it does to fire a small kiln. Ask for advice from other potters before you purchase or build a kiln.

A wood-kiln-fired pot (such as the pot in the middle below) allows ash deposits to fall on exposed pottery surfaces. Gas-kiln-fired pottery (such as the cup at right) offers reduction, oxidation, or neutral atmosphere options or combinations of atmospheres during the firing, all of which can change the color of the clay body and glaze. Electric-kiln-firing can produce consistent clay body and glaze colors (such as in the mug at left).

TIP

Electric Kilns

Electric kilns are easy to maintain and produce consistent fired results. Many potters work in small studios and basements, ideal locations for electric kilns.

Wheel-Thrown Disk
See page 288 for formula

Kiln Safety

All kilns require careful attention to safety. Different types of kilns, however, have specific safety requirements.

Wood-fired kilns require constant stoking to achieve a steady temperature increase. They also require a dry storage area for stacking wood that will be used in the firing. Large kilns might need one or more cords of wood per firing, depending on their size. It is not unusual for the firings to last two or three days.

Always observe the following safety considerations: Store the wood away from any possible heat sources. Keep the immediate areas around the wood-fired kiln free of any hazards that can cause injury to potters firing the kiln. Wear heat-resistant gloves for stoking the kiln and to prevent wood splinters. Someone should be present to monitor the entire firing process. A rotating staff is best, because the wood-firing process can be time-consuming, labor-intensive, and tiring.

Gas-fired kilns need monitoring and should be checked at frequent intervals to ensure appropriate temperature increases and the correct atmospheric environment for the ware.

Electric kilns can be programmed to fire automatically, but the safety aspects of being present during any kiln firing operation cannot be overlooked. An automatic shut-off device can turn off a kiln at the end of a firing, but you should not rely completely on this mechanism. If the shut-off device fails, all pots would be lost and the kiln damaged.

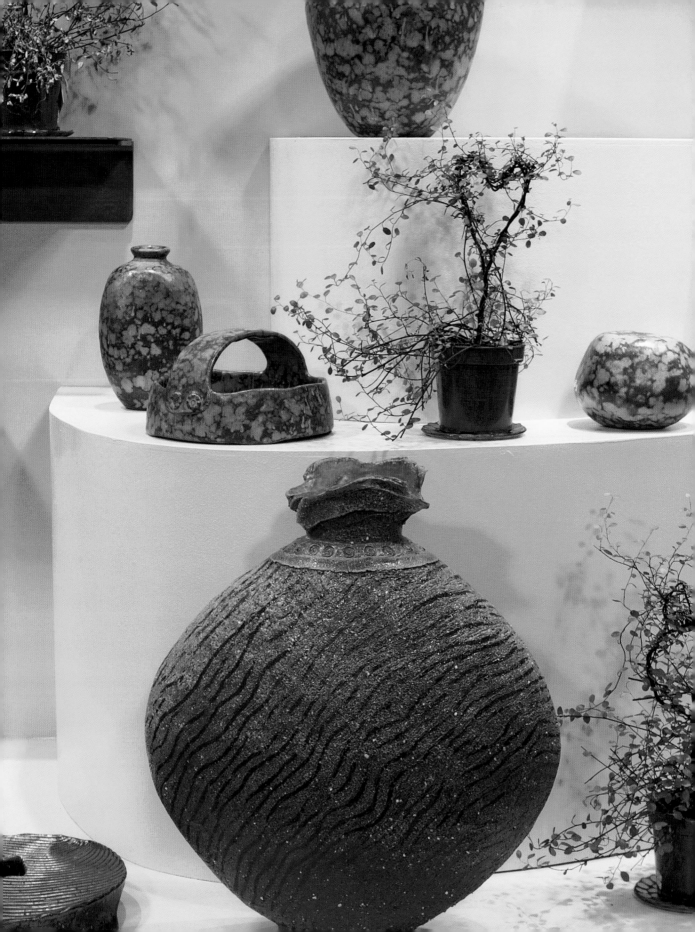

CHANGING CLAY COLOR

The individual properties of a clay body formula, kiln atmosphere, firing temperature, and special effects all work together to produce the fired clay body color. Each factor can have a major or minor influence on the final outcome of a fired piece of ceramic material. While clay body color variations are infinite, you can change the color of a clay body through firing techniques.

The clay body formula itself is a critical element in determining the fired color of the clay. Iron oxide is one of the strongest metallic coloring-producing agents found in clays. It is also very sensitive to changes in kiln atmosphere, which can bring about a color change in the clay body. You can incorporate iron oxide into a clay body formula by adding raw ore (the synthetic oxide form of iron oxide) or iron-bearing clays. Iron oxide is a strong flux, and when used in high percentages in the clay body, it can cause over-vitrification, resulting in bloating, slumping, and excessive clay warping in the fired state.

Other oxide components in the clay body formula can contribute to a lighter or darker fired color in the clay body. Clays containing iron and titanium dioxide with low percentages of alumina (less than 23 percent) will exhibit darker fired colors than clays containing iron and titanium, in which higher amounts of alumina in the clay cause increased mullite in the firing, which masks the fired color. Ball clays are composed of approximately 75 percent kaolinite ($Al_2O_3 \cdot 2\ SiO_2 \cdot 2\ H_2O$), which will fire darker than kaolins, which contain approximately 95 percent kaolinite and correspondingly fewer impurities, such as iron and titanium.

Manganese dioxide can also have a profound effect on the color of clay bodies. Manganese dioxide in various concentrations and particle sizes is often found in fireclays, ball clays, and stoneware clays. Manganese dioxide granules can cause black/brown specking in fired clay.

SPECKING EFFECT

If you fire an electric kiln, you can duplicate the specking that occurs in reduction atmospheres by adding granular manganese dioxide 60x mesh to the clay body.

Equipment

- Moist clay
- ½ percent manganese dioxide
- 60x mesh

Instructions

① Add ½ percent of manganese dioxide screened through a 60x mesh sieve (based on a total clay body of 100 percent) to the moist clay. This will result in approximately 200 specks per square inch in the fired clay surface. Form pottery by hand building or wheel work.

② Fire the finished pottery in an electric kiln. To see the specks, fire the clay body to maturity, which means the clay will be dense, hard, and vitreous when removed from the kiln.

Note: This speckling effect often looks uniform in the size and spacing of the specking, unlike the typical random specking found in clay bodies fired in a reduction-kiln atmosphere. Be careful. In some instances, the manganese can cause bloating in the fired clay body because part of the manganese goes off as a gas during the firing.

Granular, 60x mesh manganese dioxide sieved into the moist clay can produce black specking in the fired clay body.

White clay bodies often reveal the additions of metallic coloring oxides or stains better than dark bodies.

Dark-firing clay body formulas, which already contain high percentages of iron-bearing clays, can produce even darker fired color clays when metallic coloring oxides or stains are added to the clay body. For example, adding cobalt oxide to a clay body containing high percentages of iron-bearing clay will result in a black clay body color. Additions of metallic coloring oxides or stains to a clay body are also subject to the effects of the kiln atmosphere and temperature, which can produce many variations in color intensity.

SPECIAL GLAZE EFFECTS

As you experiment with clay body formulas, try these special effects that involve adding stain washes, metallic oxides, and clay slips.

Metallic oxide/stain wash: Try combining coloring oxides and their carbonate forms with water and paint the mixture on a raw or bisque-fired clay body to impart color to the fired clay.

 Coloring oxides: rutile, copper oxide, cobalt oxide, manganese dioxide, iron oxide, or chrome oxide

 Carbonate forms: copper carbonate, cobalt carbonate, or manganese carbonate.

Clay Handling Characteristics

Adding oxides can affect the clay's handling characteristics. Here's how:

 Metallic coloring oxides can affect the handling characteristics of moist clay. Adding red iron oxide to a clay body can produce a darker fired color. However, high percentages of iron oxide (more than 2 to 5 percent, based on the dry weight of the clay body) can cause moist clay to slump in forming operations and become gummy when moist.

 Iron oxide can act as a flux (melting agent), forming with other clay body fluxes, such as feldspar. The result is increased vitrification, shrinkage, bloating, and deformation in the fired piece. In reduction-firing conditions, increased percentages of iron oxide can cause brittle fired clay with low tensile strength. Iron oxide can be mixed with water, creating a wash. A watercolor-consistency iron oxide wash can be applied to the leather-hard, bone-dry, or bisque pottery, changing the fired color of the clay body.

Metallic oxide washes are suspended in water and applied to exposed clay. Metallic coloring oxides can be in the form of pencils, crayons, or water-soluble disks of dry pigments.

In the raku firing process, metallic coloring oxides are brushed on a bisque surface, heated, and then subjected to a reduction atmosphere when removed from the kiln. The metallic coloring oxides bond to the clay surface and produce various colors. Copper, as one of the most reactive oxides, can create gold, red, yellow, orange, purple, and blue flashing in reduction conditions.

Metallic oxide/stain fuming: Brush a kiln post or refractory surface with a paint-consistency mixture of oxide, carbonate, or stain. Then place the post close to the clay body or glaze surface. At temperature, the color fumes, or vaporizes, off the refractory painted surface and onto the clay surface, leaving a "blush," or vapor trail, of color. The pattern and color of the fume is dependent on the temperature at which the coloring agent volatizes, the shape of the refractory surface, the shape of the pot, the fuming agent, and the kiln atmosphere.

Metallic salt fuming/metallic lusters: Introduce fuming salts of tin chloride and bismuth sub-nitrate to the kiln during its cooling cycle, at approximately 1,292°F (700°C). Add strontium nitrate and barium chloride to tin chloride to produce red and blue lusters. As the salts volatilize, they land on exposed clay body surfaces. The pattern and area of coverage depends on the amount of salts introduced (100 grams per 40 cubic feet (1.1 m³) of interior kiln space is a workable ratio of salt to kiln space) and the point of entry. The salts can produce a thin, easily abraded, dull pearl-like iridescence on exposed clay body surfaces. The fuming effects on the fired clay look very much like oil on a water

Metallic Fuming Colors	
Blue	Parts
Stannous chloride	7
Strantium nitrate	2
Barium cloride	4
Red	
Stannous chloride	16
Strantium nitrate	2
Barium cloride	1
Pearl	
Stannous chloride	7
Bismouth subnitrate	3

surface. Vapors from metallic salt fuming are toxic. Use the correct respirator filter in a well-ventilated studio.

Or, try using gold and silver metallic lusters in an oil base. Lusters also can be applied directly to an unglazed surface by brushing, spraying, sponging, or other application methods. Fire to cone 022 (1,087°F [586°C]). At this point, the oil base is driven off, leaving a thin layer of metal that fuses with the underlying clay body. You can formulate luster colors or purchase them from a ceramics supplier.

Clay Slips (engobes): Slips can contribute color to a clay body surface; in fact, they are essentially colored clays. Slips contain water, clay(s), and other ceramic materials that adhere to a leather-hard or bisque clay body when brushed, dipped, or sprayed. Color the slip by adding metallic coloring oxides, metallic coloring carbonates, or stains. Although there is not enough glass formulation in the slip to result in a fired glaze surface, the slip will fuse to the underlying clay body and alter its color.

Terra sigillata: The Latin term *terra sigillata* means "sealed earth," and it is derived from a specific platelet size liquid clay, which is spread thinly on a leather-hard pot. After the terra sigillata coating dries out, it can be burnished to align the clay platelets parallel to the underlying clay body. When the terra sigillata surface is fired, it fuses slightly, causing a smooth, satin-colored clay surface. Experiment with clay base and metallic coloring oxides or stains to create different terra sigillata effects. As with slips and engobes, a white clay base will showcase colored additives.

Glaze Flashing: Change in clay body color can occur on the exposed clay edge of a glaze-fired surface. Salts contained in glaze migrate out into the clay body during firing, resulting in darker clay flashing along the clay/glaze line. A darker brown vapor line is prevalent when iron exists in the clay body and it is fluxed by the soluble salt migration from the glaze. The line of discoloration on the clay body can extend 1/4 to 1/2 inch (6 to 13 mm) past the glaze line.

A chrome oxide wash (left) is painted on the clay body and is deposited in the recessed areas. A black stain, mason #6600, (right) is applied using the same technique.

The refractory tile (left) is painted with cobalt oxide and fired next to an unglazed clay surface.

TIP

Glass Formation

Increasing the firing temperature of a clay body will produce additional glass formation within the clay. Any iron, manganese, or metallic coloring oxides found in the clay will cause the clay body to darken in the fired color as metallic coloring oxides flux.

This ceramic piece features blue slip trailing; it was fired in an oxidation atmosphere at cone 6 (2,232°F [1,222°C]).

A fishing lure with a metallic luster surface. Metallic lusters can be applied to a fired glaze surface. When fired at a lower temperature, the luster fuses to the underlying glaze surface.

Terra sigillata fired in an oxidation kiln atmosphere at cone 08 (1,728°F [942°C]). Artist: Richard Buncamper

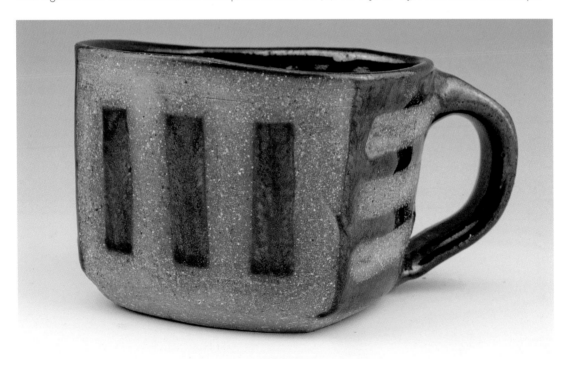

Glaze fuming on to the clay body. Some glazes go through a period during the firing where vapors are released from the melting glaze surface landing on the exposed clay surfaces.
Artist: Emily Pearlman

"The craftsman must practice skills
until they are in him. By doing so, arms,
hands, and tools can act as a conduit
for the heart and mind to create objects
of beauty that capture the spirit through
human nuance."
—Toshio Odate, author and sculptor

a step-by-step guide to hand-building

and pottery wheel projects

HAND-BUILDING
PROJECTS

The hand-building projects presented in this section build upon the basics presented in Chapter 5. Remember that joining techniques are as important as clean, dry hands when handling the clay.

Hand building requires patience to allow the clay to dry and just as in throwing, working in multiples is a good idea. In this section, you will find a few slab and coil projects to test your skills. By using your creativity you can expand on them easily.

You'll notice that precise measurements are not included for the projects. This is by design—these pieces should inspire you to experiment, to play, and to "sketch" with clay.

Once you feel comfortable hand building, there are a number of avenues for further exploration. Try increasing the scale of your work, experimenting with size and proportion. Another possibility is to embellish your wheel-thrown pots with surface decoration and additional application of clay. Also, consider building up the rim of a wheel-thrown pot with coils, which can lead to the creation of very sculptural forms.

◎ Two-part vase thrown by Kristin Müller and decorated with clay appliqué and turquoise glaze by Tommy Simpson

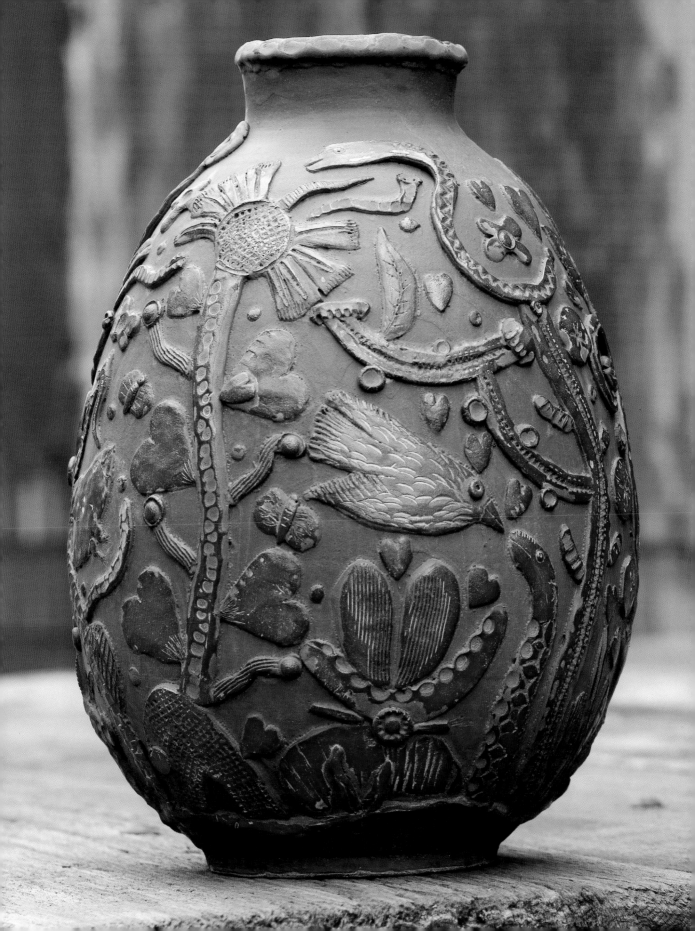

SLAB PLATES

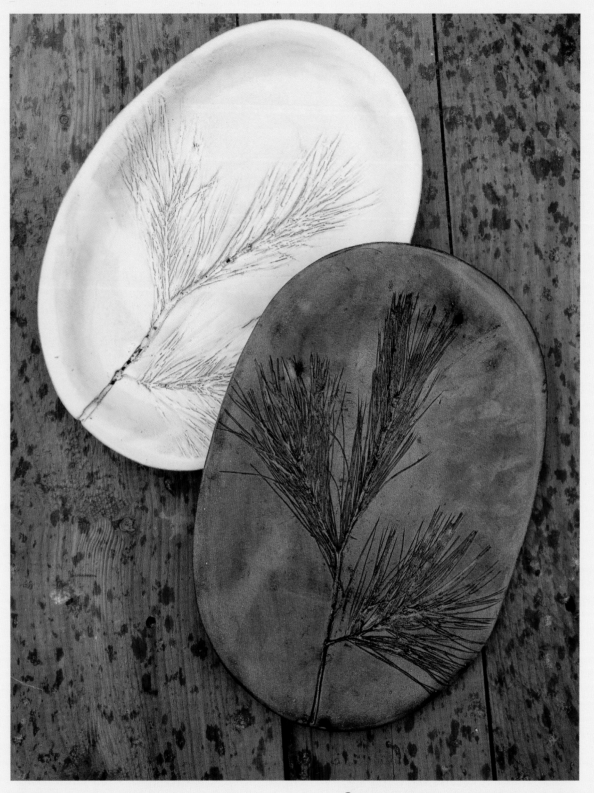

Slab dishes with pine impressions; one with white glaze, one with a dark glaze applied then wiped off

To make the following plates, you need canvas, a
rolling pin, and a few wooden slats on which to
roll the pin to get an even slab. Start with 2 to 3
pounds (1–1.5 kg) soft plastic clay. Slap the clay
to flatten and then roll between the slats, smooth
the surface, and lay your source of texture on the
slab. Note that the slump mold technique is used.

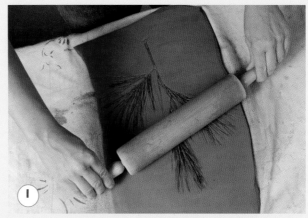

1. Roll pine sprigs into the surface of the clay slab.

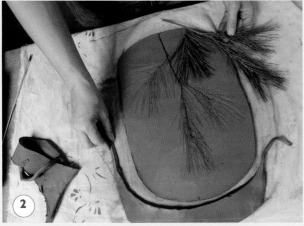

2. Cut the slab to the shape of the plate desired. Note that
the slab is placed on a wooden board.

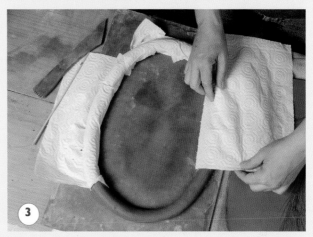

3. Make a clay coil that is the size of the slab for the slump
mold. You can create custom slump molds in different shapes
and sizes by using coils that will shrink at the same rate as the
clay slab. Cover the coil with paper towels to prevent the
draped slab from sticking.

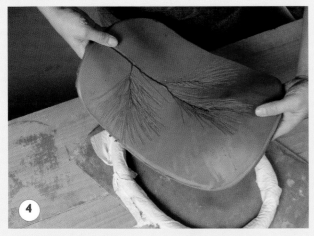

4. Lay the slab over the coil mold and tap into the form by
lifting and dropping the board. Gravity will feed the clay into
the form.

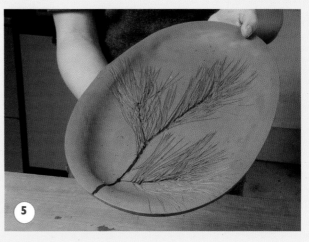

5. When the clay is leather hard, remove it from the mold
and clean up the edges.

WHIMSICAL TEAPOT

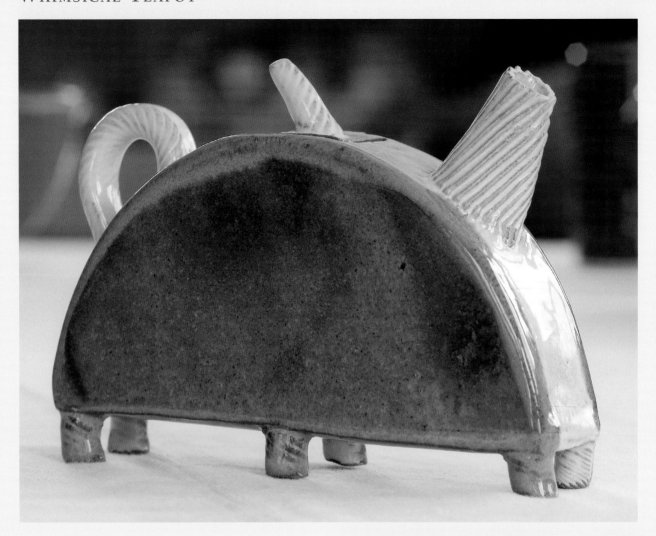

Using slabs, you can make teapots and vases in different shapes and sizes. Use heavy-weight paper to make templates of different shapes. To create a more permanent template use Quilter's Plastic, a lightweight plastic that is easy to cut and won't break down the way paper does.

This basic teapot derives its shape from a circle. Begin by rolling a slab of clay that is about ¼ inch (6 mm) thick. Trace a circle that has the diameter that measures the desired width of the teapot and remove extra clay.

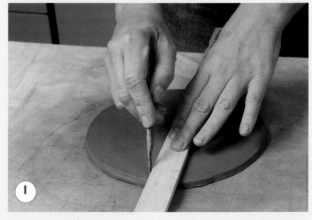

1. Cut the circle in half. The half circles will make the body sides of the teapot.

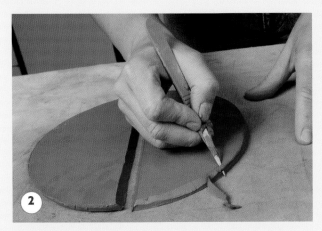

2. Be sure to bevel the cut edges of the slabs that will be attached.

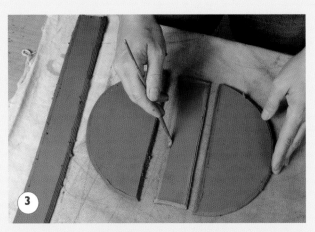

3. Cut a strip of slab with beveled edges to serve as the bottom of the teapot body. Score and slip the edges.

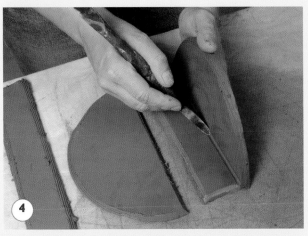

4. Attach the sides of the teapot to the base and join with a wooden modeling tool. Add a thin coil to strengthen the seams on the inside at the base of the pot.

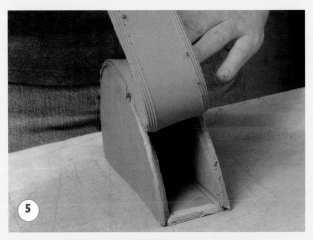

5. Cut and attach another slab of clay to close the body of the teapot.

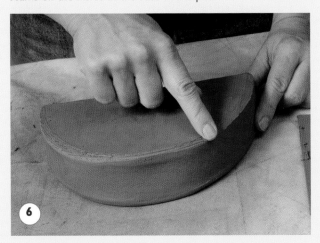

6. Join all the seams well by scoring and smoothing with the modeling tool or your fingers. It may be impossible to reach the interior seam so make sure the exterior is well joined.

7. Roll another slab for the spout. (The one in this photo was rolled over a textured mat to create the ridges.)

(continued next page)

WHIMSICAL TEAPOT (*CONTINUED*)

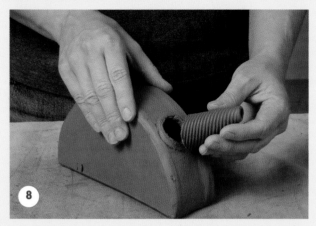

8. Fashion the spout, cut a hole in the teapot body, and raise the edge of the hole to ensure a secure seam.

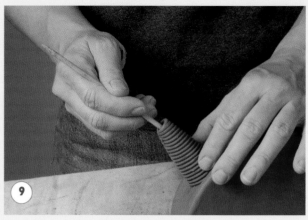

9. Use a long thin tool to get inside the spout and join the clay.

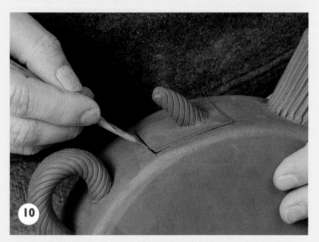

10. Attach a handle and a knob to the lid. When the clay is stiff leather hard, cut the lid with a sharp hobby knife at a beveled angle. By angling the bevel, the lid lifts up and rests easily in the top of the pot without falling in.

PROJECT NOTES

This teapot has six feet attached to the base that were made by rolling a coil with texture. The coil was sliced into equal sections, and then scored. The base of the teapot was scored and slip was applied, and then the feet were attached. As soon as the feet were attached, the pot was turned over to rest on them.

COILED AND PADDLED JAR

Large ceramic storage jars are a decorative arts tradition in many Asian countries. Today we admire the scale of the old jars and marvel at how they were made with such precision. There are several ways to make coils and build with them. Some ways are structurally stronger than others. This technique is very strong because the coil is formed between your hands and as it is formed the clay is compressed. This joining technique differs slightly from the technique shown in Chapter 5 because it uses a lot more wrist action to wedge the coil onto the coils below. For larger work it is easier on your hands and progresses at a faster, rhythmic pace.

You need a sturdy turntable for coil building because the pot needs to rotate manually as the coils are applied. An electric potter's wheel will not suffice, as they are belt driven and do not spin freely. A kick-wheel can work because the fly wheel allows the pot to turn with the coiling action. A good turntable will do. For this jar, there is a turntable resting on the potter's wheel. The height of the wheel was perfect for building the jar.

For this project, start with a mound of plastic clay. For a large jar you will need about 25 pounds (11 kg). (For larger jars, use more clay but start with a small amount and work your way up to more clay.) Make the base of the piece by pounding a circle to the desired diameter, the same way the base is made in Chapter 5; see page 113. Continue to create about ten to twenty coils by hand and cover them with plastic. The jar will require more coils, but this will get you started.

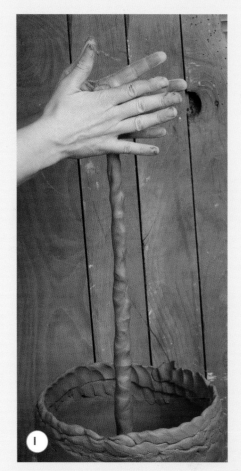

1. Roll coils by hand to attach to the body of the jar. (See Chapter 5, page 112, for how to make coils.)

2. Lay the coil on your arm and into your hand. Hold the clay coil in your hand between your fingers. As the coil is laid upon the wall of the clay, the index finger is curled under the coil. With the outer hand supporting the wall, twist the inner hand up pushing the coil into the wall and up.

(continued next page)

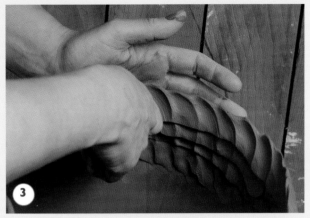

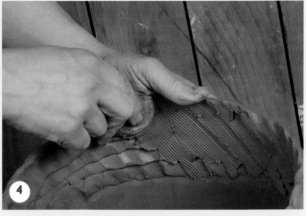

3. Feed more coil into your hand and move forward about 1 inch (2 cm) and repeat until you run out of coil. Pick up another coil and start where you left off.

4. When you have layered four or five coils, take the serrated rib and score the coils in an upward motion to strengthen the join.

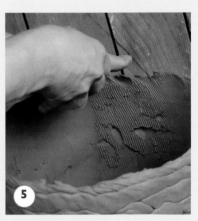

5. When the scoring is complete, use a smooth rib to smooth the interior. Always support the wall with the opposite hand. This is very important to keep the wall from getting out of center and misshapen.

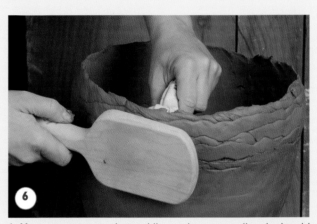

6. You can use a wooden paddle on the outerwall and a hand-held anvil on the inner wall to paddle the jar into shape. A handkerchief with a little sand in it works well as an anvil. You may choose to retain the exterior texture or smooth it out.

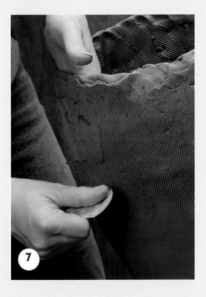

7. Continue building coils in sections, taking the time to score and smooth the coils for strength. Also check to make sure the shape is under control. If at any time during building the clay seems to be losing its shape, stop and allow the clay to dry slightly and then proceed. Timing is key with this technique.

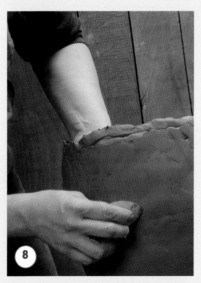

8. As the pot is smoothed, check the shape and narrow the top. If you have high points on the surface, score and smooth them away.

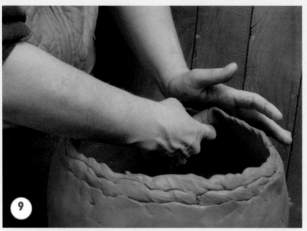

9. In order to narrow the top, the coils need to be applied at an angle. Notice that the outer hand is not parallel to the wall anymore. It is angled inward to allow the compression of the coil that is applied to be angled inward as well.

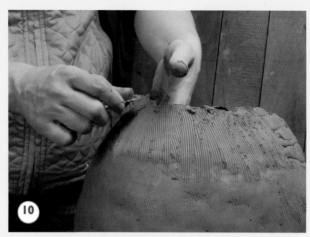

10. To continue narrowing the neck, the scoring is done carefully, directing and stretching the clay inward. The wall is supported by the inner hand.

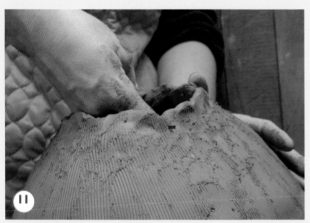

11. The final narrowing of the neck is done in preparation for the application of the rim coil. Notice that the edge is raised for a stronger seam.

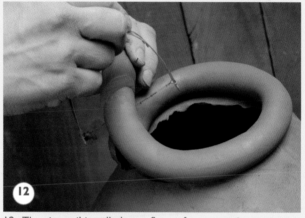

12. The rim coil is rolled on a flat surface to attain an even thickness and cut with a wire cutter at a bevel for an even seam. The interior of the coil is carefully joined to the edge of the body by scoring and smoothing, leaving the exterior untouched.

13. Wet the fingers and while gently turning the turntable, apply pressure on the rim.

PROJECT NOTES

Working rhythmically and evenly will help shape the jar. The ribbing action will, too. If a rounded curve is desired, use a round rib or a CD to smooth the interior of the jar. The ribbing stretches the wall of clay, shaping and thinning simultaneously. Be sure to apply the same pressure all the way around the pot to ensure the walls are even.

BEGINNING WHEEL PROJECTS

This chapter has a selection of projects that build upon throwing skills that get progressively more difficult. Refer to the basic throwing skills in Chapter 6 for information on wedging, centering, raising walls, and shaping techniques. As you tackle each project, you'll find that making at least ten of each form will help you understand the mechanics of each shape. This does not mean that every piece should be glazed and fired; in fact, it is best to generate a lot of work and keep only the best examples. Push yourself to evaluate and edit the pots.

Initially, throwing pots on the wheel should be considered a warm-up exercise, similar to playing scales on an instrument. Do not get caught up in the preciousness of a piece. Remember, throwing is a learning process, something new that will be difficult at times. You will be surprised at how quickly your skills develop. It is also important to glaze and fire the work to really see how you are improving.

◎ Throwing forms in multiples improves your skills as a potter.

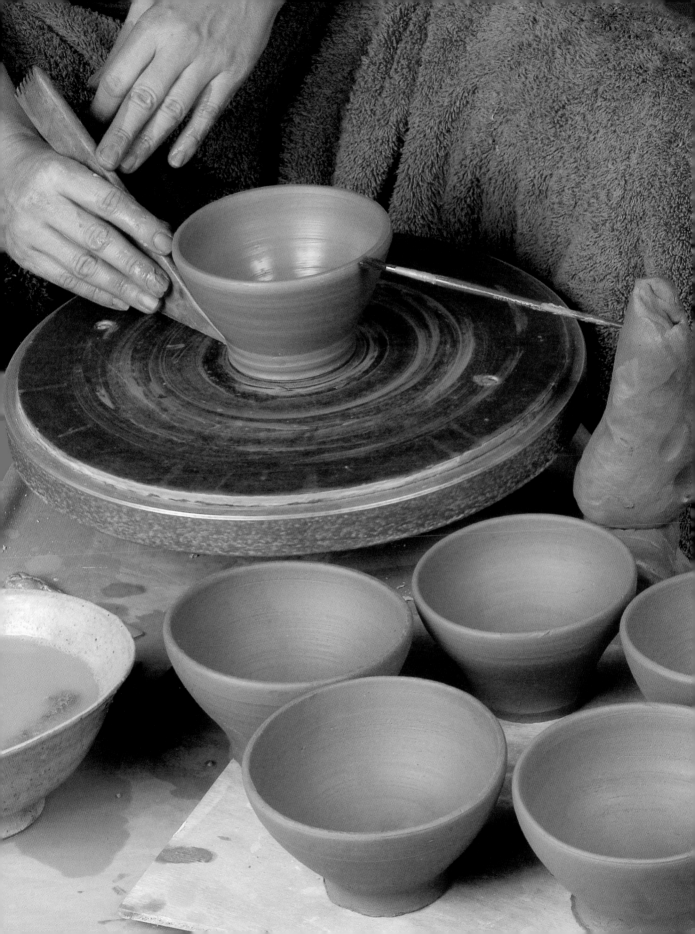

Proper Setup for Throwing Pots

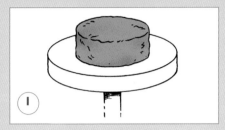

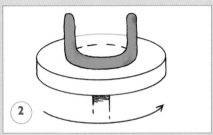

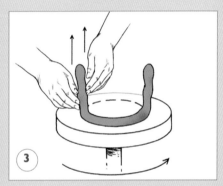

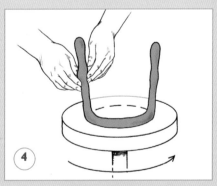

Diagram of properly centered mound opening and hand positions for raising of walls
1. Centered mound
2. Open mound with flat bottom. Note the wheel head is free of excess clay.
3. Initial raising of high point of clay
4. Displacing clay upwards and raising a wall. Note the outer hand is slightly below the high point.

Faceted Utensil Holder

This project is fairly simple and fun to make. It is a simple cylinder embellished by cutting away clay when it is freshly thrown. It may be difficult to slice away the clay if the clay is too wet. If you find that the clay cannot handle the pressure, let it set up a few hours and then try slicing it. You will need a cheese cutter or wire cutter to cut through the clay with ease. Some potters use other cutting tools or twisted wires to make cuts that have texture. The slices in this example are vertical, but they can be diagonal or anything you want them to be. In fact you can wait until the piece is leather hard and carve an intricate pattern instead.

Do not despair if you cut through the cylinder. It is bound to happen and will show you how thick the wall should be and how deep or shallow the slices should be. A thick cylinder will permit deep cuts, and a thinner cylinder much shallower cuts. The choice is up to you.

Prepare ten balls of clay that weigh about 3 pounds (1.5 kg) each.

1. Throw a straight cylinder, with even wall thickness that is not too thin. Compress the outer wall with a metal rib to straighten the wall and strengthen it by eliminating slip. Avoid curves on the shape or you may cut through the wall.

2. With a wooden tool, define the lip of the piece. This will give you a visual guide for cutting the facets.

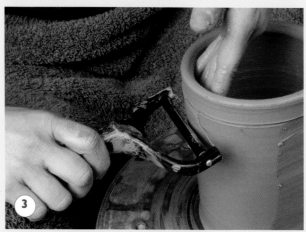

3. Wipe the wire with a wet sponge before making each cut. This will prevent the slice from sticking to the pot. Begin slicing away curved outer sections of the cylinder, from the top to the bottom.

(continued next page)

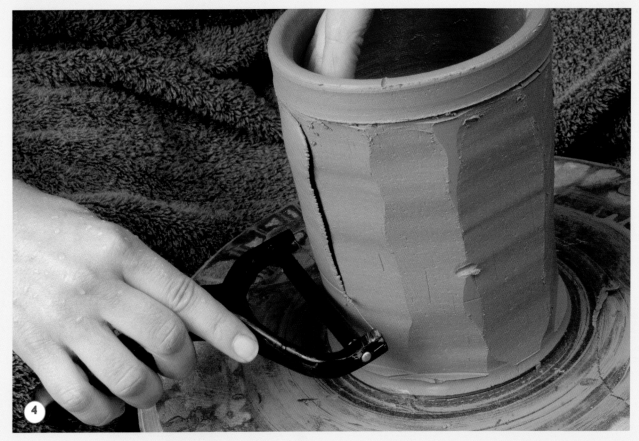

4. As you reach the base of the piece, pull the tool away swiftly to remove the slice of clay. Distribute the slicing evenly. The second slice should be 180 degrees from the first; the third slice should be halfway between the first two slices; the fourth slice 180 degrees from the third; and so on, until all surfaces have been faceted. This will ensure an even number of cuts.

5. When the cutting is finished, define the lip. Sometimes if the piece is sturdy and the clay is soft you can even throw the lip a little bit to refine the shape.

6. Use the wooden angle tool to remove excess clay and to define the base of the piece.

BOTTLES AND VASES

Throwing vase and bottle forms is a lot of fun and challenges your ability to throw cylinder forms with isolated pulls. The basis of these forms is a cylinder that narrows at the top. The form requires that the walls be pulled to a properly proportioned height for the amount of clay used, which differs from piece to piece. Even wall thickness is the goal. Once this is achieved, the belly of the vessel is formed as you introduce the curve to the mid-section of the cylinder and then stop as the shoulder is approached. Once the belly has been stretched to the desired curve, the neck is collared in carefully and then thrown to define the shape. It is important to pull the walls up quickly and efficiently so as to avoid over-saturating the clay. The use of metal or rubber ribs on the exterior wall compresses the wall and strengthens the curve; it will also remove excess moisture.

Practice the following steps to make narrow neck forms. It will take a few attempts to get the right pressure points. Begin with simple forms and progress to more dramatic shapes.

Prepare ten balls of clay that weigh about 3 pounds (1.5 kg) each.

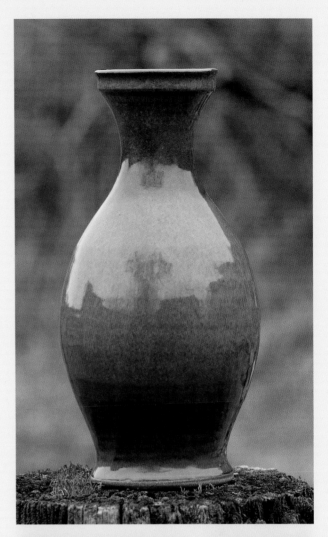

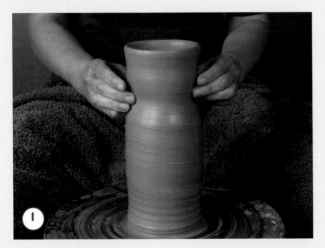

1. Throw a cylinder that has even walls and collar in the top.

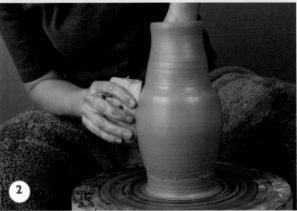

2. Shaping the piece will require isolated moves. With a rib on the outer wall, begin at the base of the piece to create the curve of the belly with the inner hand pushing gently against the rib. Be sure to stop as the shoulder is approached.

(continued next page)

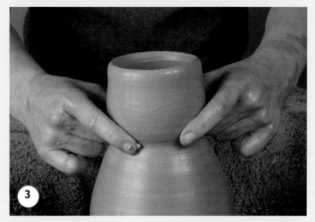

3. Gently apply slip to the neck of the piece and collar in by using three points of pressure (thumbs together and index fingers). Apply inward pressure and move upward swiftly as the wheel turns.

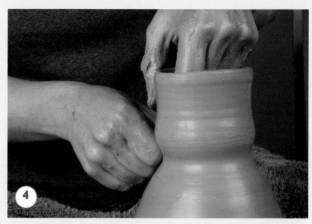

4. Gently check to make sure that the walls are lubricated and proceed to throw the neck upward, thinning the walls and narrowing the neck with the outer hand dominating the pull. Do this at a fairly slow wheel speed.

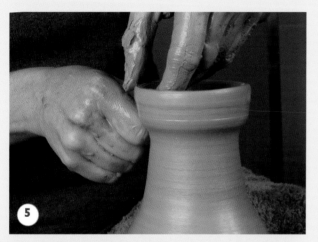

5. As the lip is approached, release pressure very gently.

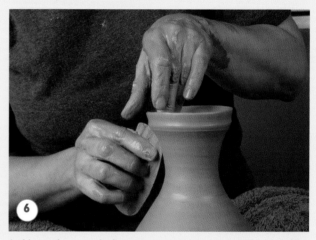

6. Use a thin metal rib to compress the outer wall and define the neck.

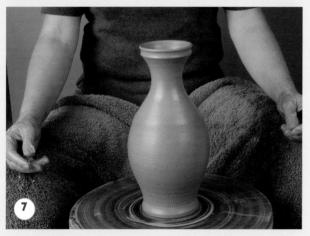

7. Note that as the neck is formed the wall remains vertical. As the final shaping occurs the curves are introduced.

PITCHERS

Pitchers are wonderful forms that not only serve liquid but can be used as decoration, too. The pouring vessel is found in all cultures, comes in the simplest or most intricate forms, and is used in rituals as well as everyday life.

Pitchers should be relatively lightweight because when they are filled with liquid they will be quite heavy and difficult to maneuver. They should have comfortable, well-attached handles to accommodate the weight of liquid and the pouring action. Their spouts should pour well and minimize dripping. Perfecting the spout is the trickiest component of making a pitcher, while the size and placement and alignment of the handle is the other challenging element.

As you practice making vases you might want to try forming a pitcher. They are a great way to practice curves on simple forms and can be embellished in many ways.

You can practice forming spouts on a simple cylinder before taking on the challenge of making a pitcher. To make the spout, wet your fingers and gently squeeze a section of the rim back and forth for the width of the spout. This will thin the edge and ensure a better pour.

Prepare ten balls of clay that are about 2.5 pounds (1 kg) each.

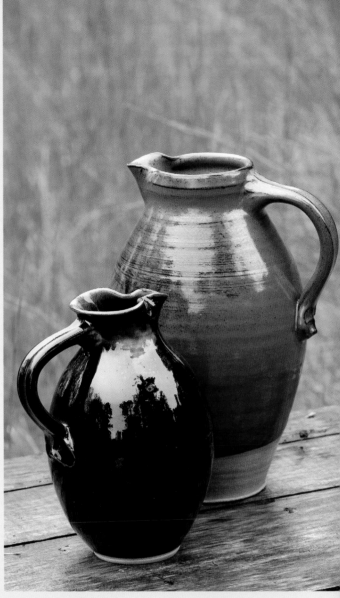

Pitchers by Chris Alexiades, reduction fired with iron-bearing glaze

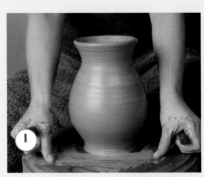

1. Begin by making a simple vase form with a lip that widens at the top.

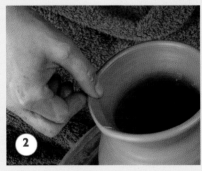

2. Place one hand underneath the spout and gently cradle the spout between your thumb and index finger.

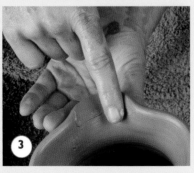

3. This position will counter the pressure from the top index finger as it moves back and forth forming the spout.

(continued next page)

PITCHERS (CONTINUED)

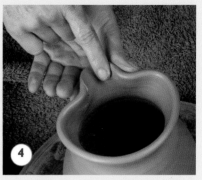

4. To finish the spout, use your index finger and thumb to push in at the edges and define the spout as the top finger pushes slightly downward.

TIP

Do not overwork the spout. The less it is touched, the better it will look. If the edge needs to be cleaned up, wait until the clay is leather-hard then clean with a sponge or finger. Resist the temptation to readjust it. A great way to practice making spouts is to throw a cylinder and make several spouts along the rim, slice them off, and repeat. By doing so, you will gain practice (and muscle memory) for making fresh, well defined spouts.

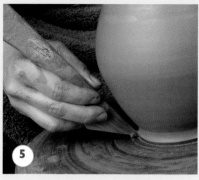

5. Trimming pitchers is not easy—try to throw a balanced, thin cylinder and remove excess clay from the base with the wooden angle tool before removing from the wheel.

The pitcher needs to dry until the clay is at the leather-hard stage. If it feels heavy, it will need to be trimmed. An easy way to trim a pitcher is to put a small amount of water on the wheel head and center. Wait a minute for the water to form a strong bond with the pot. Then turn the wheel at a slow/medium speed and use a trimming tool to trim the excess clay from the bottom of the piece. This will not give the pot a raised foot but it will take off extra clay with ease.

Once the pitcher is ready, it is time to pull a handle. As with throwing a pot, the clay should be wedged well and plastic. If it is too hard or too soft, it will be difficult to make a handle. Making several handles will ensure there are choices.

6. To pull a handle, form a carrot shape with the clay. Wet your hand and the clay with slip to avoid friction. Hold the carrot of clay with one hand and pull with the other. The clay will travel between the long section of the thumb and index finger; the other fingers do not touch the clay.

7. For a strap-like handle, keep your fingers straight and pull downward, turning the handle so that both sides are worked equally. It is also good to push upward for compression. Do not overwork or make too thin. Once the handle is attached to the pot, it can be pulled again to thin and shape. Pinch the handle off the carrot and lay it on clean plastic.

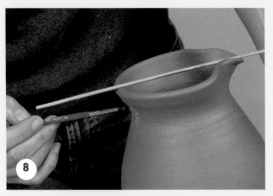

8. Use a bamboo skewer to align the handle with the spout. Score and apply slip to the handle attachment.

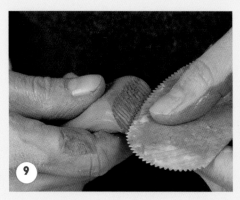

9. With clean, dry hands, pick up the handle and pinch off the end on a diagonal. Score the attachment with a serrated rib.

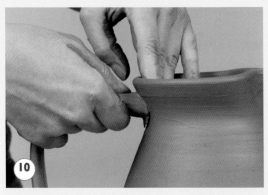

10. Being mindful of the alignment, attach the handle to the pitcher. Notice the inner hand counters the pressure from the handle attachment. Work the clay from underneath the handle for a strong join. Leave the top looking fresh; it will get filled in with glaze.

11. Once the handle is attached, it can be thinned and shaped. An upward pull is good for shaping and pushing soft clay into the join.

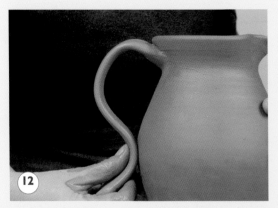

12. Attach the bottom of the handle, being mindful of the handle alignment.

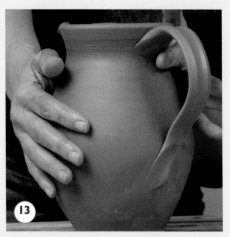

13. Once the handle is attached, mild adjustments to the curve can be made with clean, dry hands.

BATTER BOWL WITH HANDLE

A batter bowl is a great shape with which to practice spouts and handles. They are perfect for scrambling eggs and making pancake batters, and they make great gifts. You can practice with a small amount of clay and later make larger bowls with more clay. As with pitchers, be sure to keep the bowl fairly lightweight for easier maneuvering. The handle can be like a mug handle (shown below) or a simple lug handle (shown at right), like the ones on casseroles. A wide base is nice if you are going to use it as a mixing bowl. A narrow foot is not recommended because the bowl will be prone to tipping.

Prepare ten balls of clay that are about 2.5 pounds (1 kg).

◎ Batter bowl with lug handle

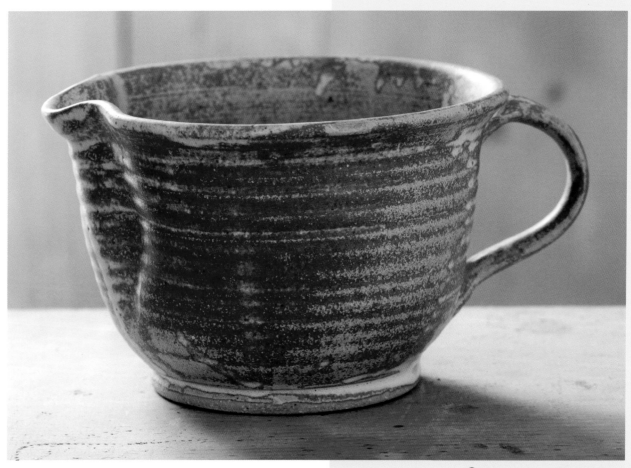

◎ Batter bowl with mug handle

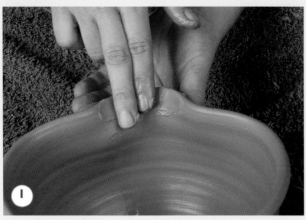

1. Throw a simple wide base bowl. Wet your fingers, thin the spout, and shape as seen in the pitcher project.

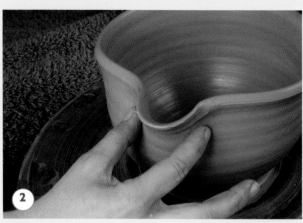

2. Shape the spout and define the pouring area by applying pressure with your index finger and thumb, moving up and down until the throat of the spout appears. Wait until bowl is leather hard, trim the foot, and pull a couple of strap-like handles from which to choose.

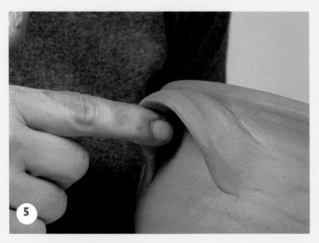

3. Align the handle attachments with the spout, score with a serrated rib, and apply slip.

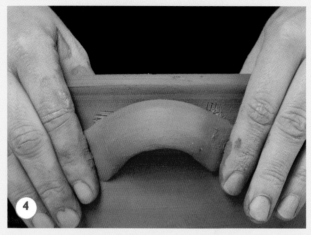

4. Align the handle with the score marks, check to make sure it is aligned with the spout, and press into the wall of the bowl. Notice that thumbs are countering the pressure from within the bowl.

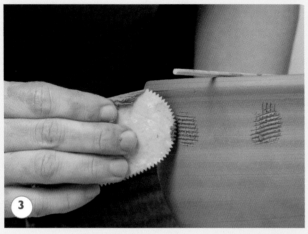

5. Adjust the handle so that it has a little lift and touches on the wall of the bowl on the inner edge.

ADDING A STAMP OR SIGNATURE

A finishing touch to the piece is the potter's stamp or signature. It can be placed on the foot of a piece. Placing it on the handle attachment, however, adds a decorative element, while the stamping action compresses the attachment. Glaze can pool on the texture.

SET OF MUGS

Mugs are often a first throwing project, but I believe that they are a challenging project for a beginner potter because centering a small amount of clay (about 1 pound [0.5 kg]) is actually more difficult than centering a larger amount of clay (about 3 pound [1.5 kg]). Once you are adroit at centering, mugs will be much easier to make.

Prepare ten balls of clay that weigh about 1 pound (0.5 kg) each.

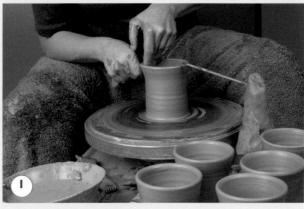

1. Begin by throwing the first mug to the desired height and width. Place a piece of clay with a paint brush sticking out to the top edge of the mug. This will be your visual gauge for size.

2. Use your index finger and thumb to make an inverted-V shape on the lip of the cup. A comfortable lip is important to a drinking vessel; any sharp edges will be even sharper once they are glazed.

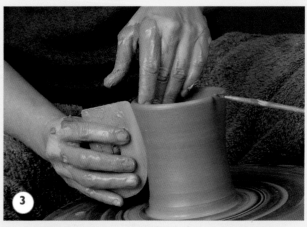

3. Use a rib to compress the wall. A straight-walled design can simplify making a set. Note that each mug will be slightly different and that it is the point of having something hand-made. Allow the mugs to dry to leather-hard stage. Prepare clay for pulling handles. Pull all the handles in one session for consistency in shape and size.

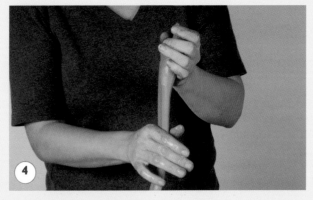

4. Make a carrot shape of clay, wet your hands and the clay, and pull the clay between your index finger and thumb until a strap-like handle is formed.

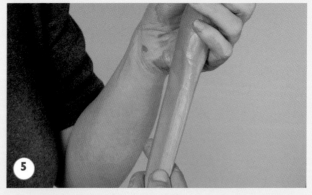

5. Wet your hands and the clay with slip and carefully apply pressure with the thumb on each edge to bevel the edge of the handle. This will give the handle the optical illusion of thinness and still provide the strength needed in a handle.

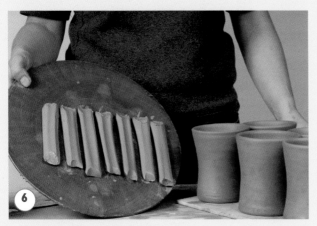

6. Leave all the handles slightly thicker than desired so that they can be pulled and adjusted on the mug once they are attached.

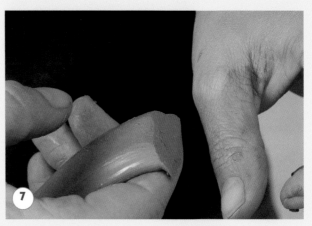

7. With clean, dry hands pick up the handle. Use the back of your thumb to scrape/pinch off clay in a diagonal.

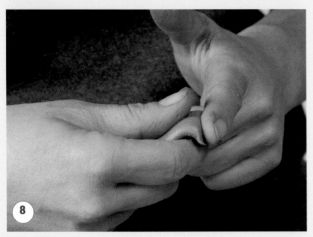

8. Tap the edge of the handle to compress and fatten up the clay.

9. Score the mug and handle, and if the mug seems too leather hard, apply slip to help create a homogeneous consistency. Attach the handle from underneath the mug.

10. Pull the handle to thin and finish shaping.

11. Be sure to secure the bottom attachment of the handle and that it is aligned with the top. Try not to touch the handle. The less it is touched, the better it will look.

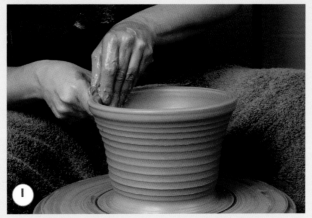

1. With a bat on the wheel head, open a basic cylinder and allow the inside hand to move the clay outward as the wall is raised. (Bowls are best thrown on bats to reduce warping.)

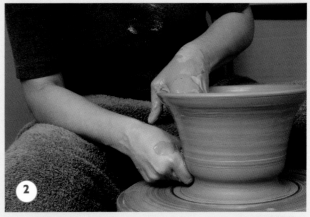

2. The outer knuckle compresses clay at the base to create a high point and raise the clay upward and outward. The inside hand counters the pressure and keeps the wall straight.

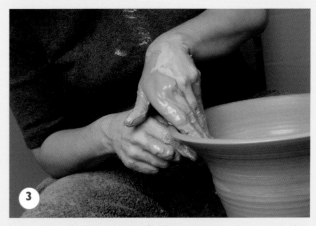

3. At the end of the third pull, allow the inner fingers to splay the clay out at 3 o'clock. This will form an upside-down, trapezoidal shape. Remember to compress the lip.

THROWING BOWL FORMS

Bowl forms depart from cylinders in that the interior base and wall of the open mound is not at a 90-degree angle. Instead it has a very slight curve in the transition area and the clay is not collared after two pulls.

Stage one: For a medium-size bowl, begin with 2 to 3 pounds (1–1.5 kg) of clay. The opening steps are the same as with a basic cylinder, however, establish the base with a slight curve before beginning to raise the clay. When you begin raising with pressure points at 3 o'clock, rather than coming in toward the center (as in forming a cylinder) the interior hand will be slightly dominant and widen the opening at the top as the clay rises. Be sure to compress the lip after each pull to define the rim and re-center the clay. Repeat this two to three times, keeping the wall without a curve in an upside-down, tall trapezoidal shape. Compress the lip again and splay it out toward 3 o'clock. Lubricate the interior.

Stage two: Begin at the center with your left hand pushing gently at 3 o'clock. As the wheel rotates slowly, draw the curve with your fin-

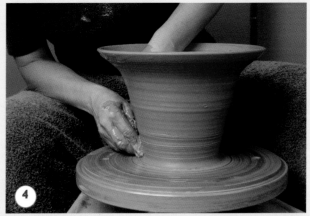

4. Once the trapezoid is formed, check to make sure the wall thickness is even, and lubricate the interior and exterior walls before shaping. (Remove excess slip from the interior.)

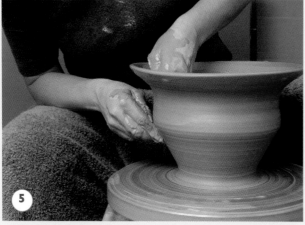

5. With the wheel at a medium-slow speed, use the inner fingers to draw the curve from the very base with delicate but steady pressure. First press down and then press out and up. Release pressure as the curve is completed.

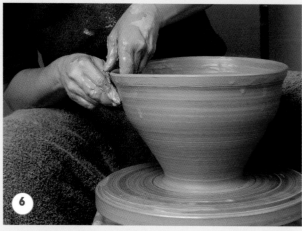

6. The outer fingers simply follow along to seal the clay wall and steady the curve. The inner pressure is stronger than the outer pressure. Pressure points are aligned to form the curve with an even line.

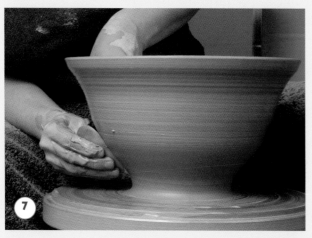

7. The shaping can also be done with a rib on the exterior to smooth and seal the surface of the clay as the inner hand creates the constant curve. The advantage of the rib is that it allows the clay to stay dry as it is shaped.

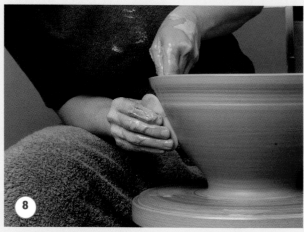

8. With each progressive shaping move, the wheel should rotate at a slower speed to allow for control of the form. As the final shaping finishes, be sure to ease the pressure as your hands move to the top.

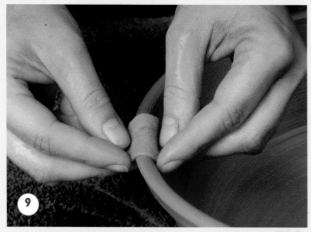

9. Use a chamois cloth between your fingers to support the wall as the lip is rounded. This final touch defines the rim of the bowl.

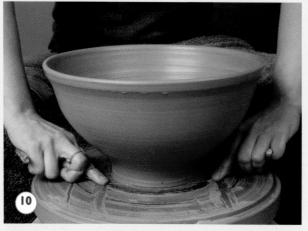

10. When the bowl is finished, wipe the excess slip from the bat and wire the bowl to release it from the bat. It's easier to move a bowl on a bat onto a shelf to set up before trimming.

gers pushing down and out and then releasing the pressure as the curve is laid into the lip of the bowl. With the exterior hand slightly under the interior hand, follow the curve to seal and compress the clay lightly. Do not interfere with the pressure of the interior hand or the curve will be weakened. Pay attention to the interior profile. A constant curve is structurally strong and is also inviting to a spoon scooping food from the interior of the bowl. Bumps and ridges should be avoided on the interior of bowl forms.

SHAPING A CONSTANT CURVE AND USING A THROWING RIB

The interior curve of a bowl will determine its exterior profile. It is best to strive for a constant curve and avoid showing the transition from the true base to the wall. Throwing ribs are very useful in creating rhythmic lines. They require practice to use successfully, but it is well worth the effort. Ribs come in all shapes and sizes and are made from many different materials, including wood, metal, plastic, Plexiglas, and rubber.

Ribs all serve the same basic purposes: to help shape the clay, dry the surface, and strengthen clay walls as they are formed. Which rib to use is a matter of personal choice that will be defined by the clay bodies used and by experience.

Wooden ribs, which are a little thicker than metal ribs, give the clay a very soft skin. They are not at all flexible and are great to use with larger forms.

Metal ribs have very sharp edges due to their thickness. They can be stiff or flexible, depending on the gauge of the metal, and they compress the clay very well.

Rubber ribs come in different hardnesses that range from super soft and flexible to quite stiff. The soft ones are great to use with fine clays and for finishing touches while the stiffer ones are interchangeable with metal and wooden ribs.

Compact discs are terrific substitute ribs for making large bowls; mini discs are great for small bowls. They are thin and can make beautiful constant curves.

Variation: Large Bowl

Making large bowls uses all the skills of making smaller bowls, but gravitational pull is much stronger and so precision with pressure points and mastering wheel speed will become essential. Centering a large amount of clay may be more challenging. Try using faster wheel speed, but too much speed will require more muscle. Make sure the clay isn't stiff because it will put unnecessary stress on your hands and wrists. As the wall is thinned and shaped, slow the wheel to reduce the stress from centrifugal force and gravity. By the time you finish the lip of the bowl, the speed should be very slow and the pressure very gentle.

PRINCIPLES OF TRIMMING

Trimming is often neglected and thought of as just a way to remove excess clay from a pot. In fact, trimming adds visual definition and is essential to finishing a piece.

When a pot is thrown, there is always excess clay at the base. If you examine the interior and the exterior, there is likely a slight difference in the shapes. To achieve even wall thickness and balance in a form, the exterior should be trimmed to conform to the inner shape of the piece.

A few elements to keep in mind when considering trimming:

The foot of a piece defines how the piece will sit on a surface and thereby give a piece a sense of weight or a visual lift from the surface. The foot can define the application of glaze, and it can contribute to the functionality of the piece

GUIDE TO SHAPING A CONSTANT CURVE

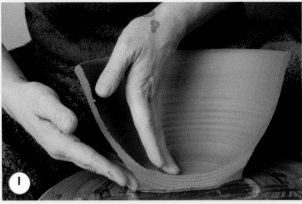

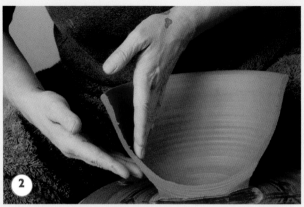

1. To form a beautiful curve, the inner hand has to do the most important work. By beginning at the center of the bowl, the curve begins at the very center, moving down and out. The outer fingers are poised to receive the pressure.

2. The inner fingers transition upward, and the outer fingers remain slightly below, supporting the newly formed curve.

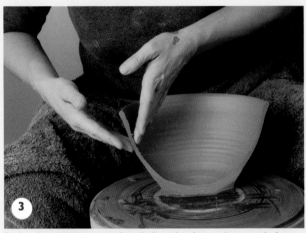

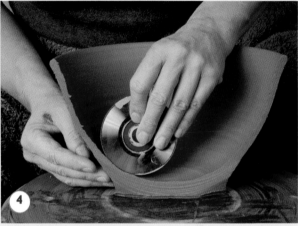

3. As the curve is completed, the wheel speed is steady but slow, and the fingers move to the top of the piece, applying gentle pressure.

4. A round throwing rib is especially useful at the transition point at the base. Gentle steady downward pressure will ensure a great curve as the rib is raised.

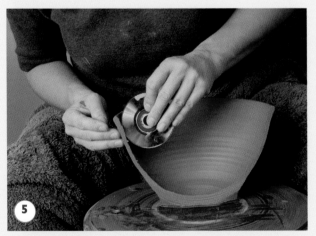

5. As the rib moves up the inner wall, there is almost no pressure. The rib is completing the move, sealing the clay, and removing excess slip while tightening the clay surface.

6. Cross-section of constant curve and trimmed foot. When the excess clay is trimmed, the bowl's profile mirrors that of the interior curve.

and its overall beauty. A messy, clumsy foot can make a piece look unfinished.

Variation: Set of Bowls

For making multiple forms, such as a set of bowls, muscle memory will be a very useful skill to develop. This will come with practice and repetition, but there are some tricks you can use to help along the way. Start by weighing out the same amount of clay for each bowl you wish to make.

As you form the first mound, make a mental note of the height and width of the mound. I prefer to use my fingers as a measuring gauge but some people use a ruler. The first few times you do this it will be helpful to measure each step and write the measurements down to create the steps for making the same shape. As you progress, training your eyes and hands will expedite the process.

You might also want to note how many pulls it takes to get the walls thinned out and ready for the curve. By using the same rib to create the inner curve the bowls should have the same interior shape, and when trimmed to even wall thickness they should have the same exterior curve. Placing a mound of clay with a paintbrush pointing into the wheel at the edge of the first bowl will help you make subsequent bowls to the same dimensions. (See page 263.)

Prepare ten balls of clay that are about 1 pound (0.5 kg). Follow instructions for Throwing Bowl Forms (see page 256) for each ball of clay.

TRIMMING MULTIPLE FORMS

When you have multiple forms to trim, it's helpful to make a trimming chuck, which is a clay shape

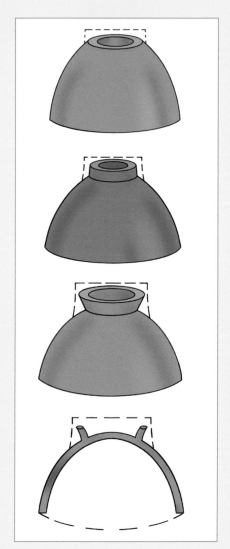

A few trimming options for similar bowl shapes are shown in the above illustrations. The foot design can dramatically change the look of a bowl.

1. Read the interior of the shape and mark with a needle where the thickness begins. It will be a visual reminder of where to trim clay.

2. Mark the true base of the pot. (The true base is one wall thickness to the inside of the base.) That is where the foot ring should be. This, too, will serve as a visual reminder of where to trim clay.

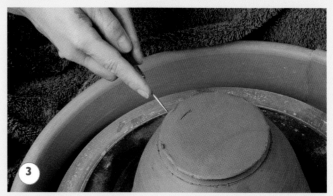

3. To center the piece to be trimmed, place a needle tool between 6 and 3 o'clock, close to the clay without touching it, and hold steady as the wheel turns slowly. Where the needle touches, the pot is farthest from center and should be gently positioned closer to center. The needle trick should be repeated until the mark is even all the way around, indicating a centered base. If you do not take the time to center, the trimming will leave the piece looking off center. (Centering will be more challenging with asymmetrical pots.)

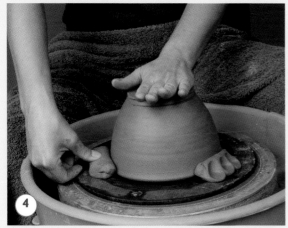

4. Once the piece is centered, it must be secured to the wheel head. Use three coils of clay evenly spaced and push down on each coil. Note that the pressure is on the outer edge of the coil so as not to misshape the pot or lip.

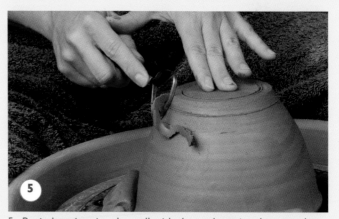

5. Begin by trimming the wall with the tool moving downward at a medium speed. Note how the left hand bridges the right for steadiness. A great way to check for thickness it to tap the pot before any clay is removed at the base and side. The thick wall will sound like a flat thud. As clay is removed and the wall is tapped, you will hear a more hollow sound.

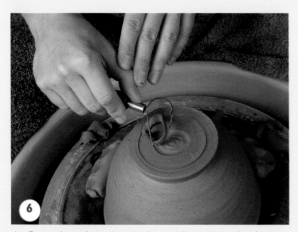

6. Once the side is designed, trim the excess clay from the center. Begin at the center and move outward to the edge of the foot while the wheel is turning at a medium speed.

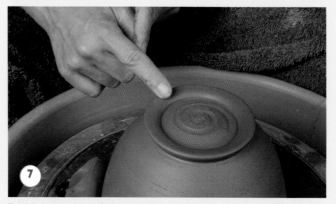

7. When you have finished trimming the clay, take a moment to burnish the foot ring with a dry finger. It will spread the fine particles of clay over the sandy clay and smooth the foot. Always pay attention to detail when the clay is still soft enough to correct. Rough edges on clay will scratch table tops once it is fired.

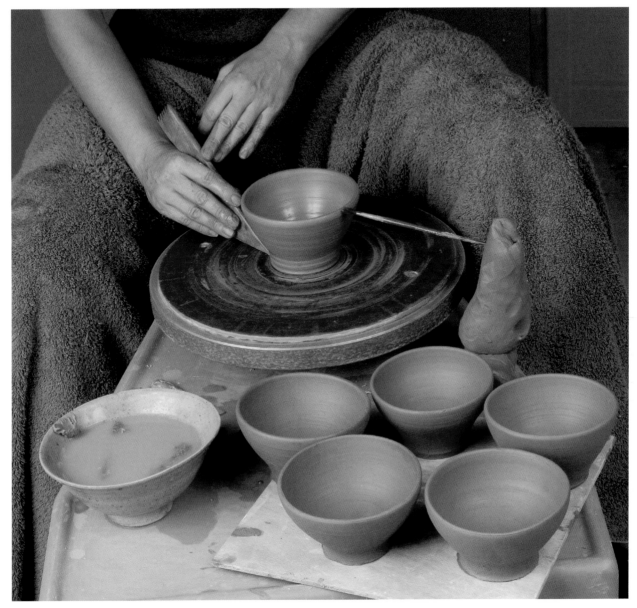

🌀 Using the same technique as for making a set of mugs, you can produce a set of bowls. The trick to creating identical bowls is to make the interior curve the same.

that a pot fits over or into. Pictured here is a chuck that fits inside bowls or cups. They are custom made by the potter to suit the dimensions of the work to be trimmed. They are extremely useful for odd-shaped rims. Make the chuck when the pots are thrown so that it will have the same dryness at the trimming stage. This technique only works with leather-hard clay; if the clay is almost bone dry it won't work.

GUIDE TO TRIMMING
MULTIPLE FORMS

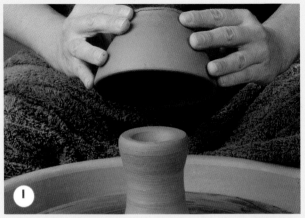

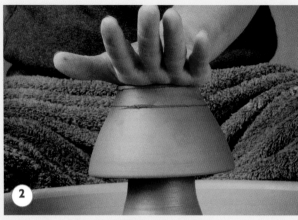

1. Center the chuck. (Keeping the chuck on a bat makes it easy to handle.) Place the bowl on the chuck and center.

2. Once the piece is centered, apply pressure from the base to attach the bowl to the chuck.

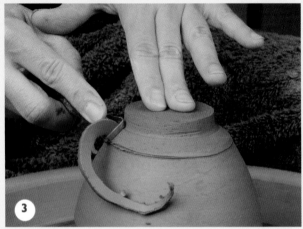

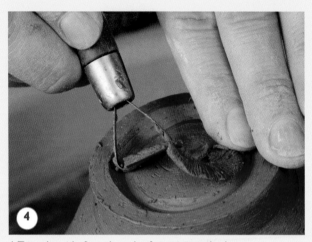

3. Use a small trimming tool to cut away clay. Apply pressure with your left hand while trimming with the right. Note the left thumb touching the right hand to steady it as it trims the excess clay.

4. Trim the side first then the foot ring at the base.

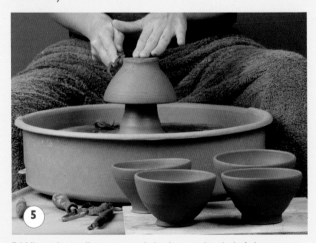

5. When the wall is centered the base is leveled, if the piece was cut evenly.

INTERMEDIATE
WHEEL PROJECTS

The following projects will further hone your throwing skills and help you progress in leaps and bounds. Some of the projects require focus and planning, such as the teapot. They will require you to think about the finished vessel before you begin to make it. This is a great leap forward in practicing design and construction. All the pots you make will inform your clay knowledge and help you make better work.

A mentor of mine once said that you should picture the finished piece—including its clay body, glaze, shape, and execution—before you even begin making it. A sketchbook can help organize all of your ideas. Even a rough sketch will help you envision your work, including its composition and scale. Also, imagining how the pot will be used allows functional details, such as handles or lids, to be incorporated into the sketch.

◎ Pit-fired pot by Kristin Müller with terrasigillata (clay slip) burnished, pit-fired, then rubbed with butcher's wax

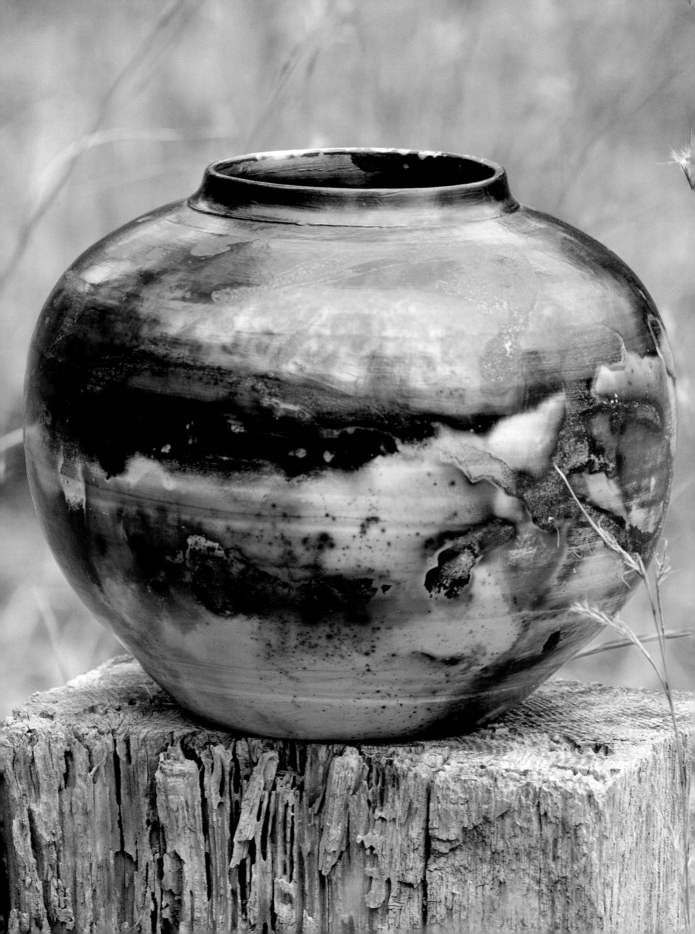

PLATES AND PLATTERS

Plates and platters are very low cylinders with lips or rims that can be simple or delicate and wide. The clay mound should be centered low and wide to accommodate the base of the plate. Opening the clay for a plate is different than for smaller, taller pieces. Instead of using your fingers to open the clay, it is recommended to use the bones at the base of the palm of your right hand. They will provide a strong, wide edge to displace the clay outward from the center. (With some practice, this technique will be useful for throwing large bowls, too.)

The advantage of using the bones from the palm of your hand is their added strength. If the clay is properly lubricated, there will be almost no hesitation in the opening move and it will be smooth. Fingers, on the other hand, can hesitate and create throwing rings in the center of the plate that are difficult to get rid of in the finishing moves. Also by using the palm, you can feel for the interior angle of the base of the plate.

Thinning the wall of a plate that will be the rim should be done carefully and purposefully. Once the wall is thinned and the edge is cleaned, the plate should be wired loose from the bat and then the edge of the rim should be splayed out. By wiring prior to finishing there is less chance of warping the rim. Clay has memory and in plates even the slightest movement will show up after the firing. Place plates on a level surface to dry to leather hard for trimming.

The amount of clay required to create a dinner plate will depend on the design and size. An average dinner plate requires about 3–4 pounds (2 kg) of clay. It may seem like a lot, but plates require clay for the wide span at the very base that will be trimmed to give it a raised foot.

1. Center the clay as you normally would but apply more pressure from the top and allow the left hand at 7 o'clock to relax slightly.

2. The top hand presses with the bones of the palm from 2 o'clock to the center then in an outward motion toward the left hand at 7 o'clock. The left hand gives way to the pressure but keeps the mound centered.

3. Repeat the opening move until the desired diameter for the base of the plate is achieved. Keep the interior base of the plate smooth—remember, this is where food and utensils will be placed.

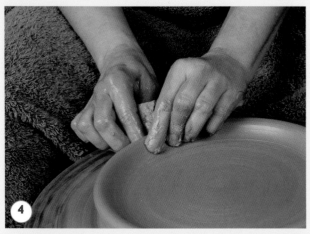

4. Recenter the rim of the mound to begin throwing the wall.

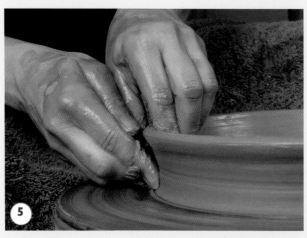

5. Pull up the wall as you would a cylinder. Pull up and out to thin the wall.

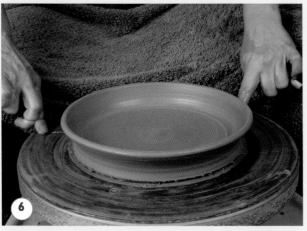

6. To prevent warping of the rim, clean up the base of the plate with a wooden angle tool and wire cut before laying out the lip.

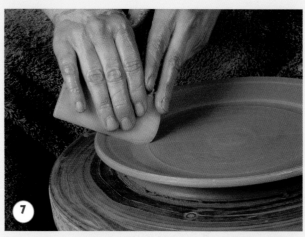

7. Use a rib to gently press down on the lip with the wheel turning at a slow speed. Use a chamois cloth to finish the rim edge.

8. You can embellish the surface by gently pressing a tool on the rim while the wheel is spinning. Some people leave a thick rim and carve the edges when the work is leather hard.

VARIATION: LARGE FLANGE PLATTER USING THE RIB

To make a plate with a large flange, be sure to leave enough clay to raise the wall to an even thickness. Clean up the interior, wire the base, and carefully take a rib to the edge and lay out the flange. A rib with a sharp edge is preferable because a dull edge will create too much drag and misshape the lip.

TRIMMING A PLATE

Trimming plates should be done with great care to avoid warping the piece. Consistency is very important because of the wide span at the base. If the clay is too soft it will collapse with the slightest pressure.

1. Cut a piece of foam to the size of the plate's interior diameter. This way, the plate will be supported during the trimming. Do not pick up the plate; instead use the bat and turn it onto another bat for trimming. This will facilitate the removal of the plate from the wheel.

2. Center the plate before starting to trim,. (See page 161).

3. Trim the edge first, and then mark the foot ring by removing some clay at the edge. This step will prevent any slip ups in the trimming that could damage the foot ring.

4. Carefully remove excess clay from the base of the plate, and then smooth the edge of the foot ring with your bare finger to soften the edges.

5. To remove the plate from the wheel, lift the bat, place a clean bat on the bottom of the plate, and flip over to dry evenly.

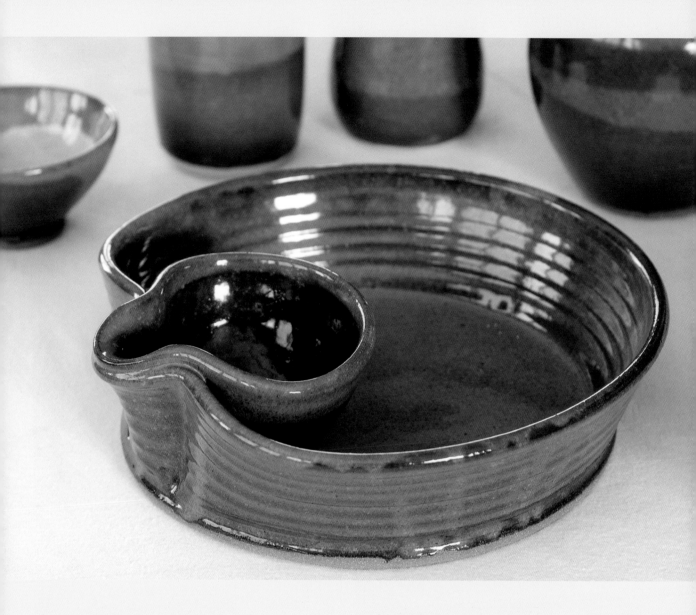

CHIP AND DIP DISH

This simple chip and dip is a takeoff on the platter concept. In essence, you will make a low cylinder and a small bowl that will be attached freshly thrown. This project is a lot of fun to make, and this interesting serving dish is sure to impress guests. Try making smaller versions of this project to serve small groups of people as well as larger ones for large gatherings.

(continued next page)

1. Center a 5 pound (2.5 kg) mound of clay. Leave enough clay to pull up a generous wall.

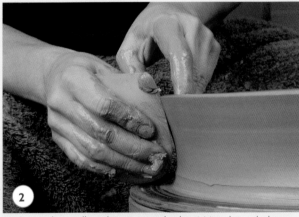

2. Raise the wall and compress the lip. Wire through the base and proceed to making the dip bowl.

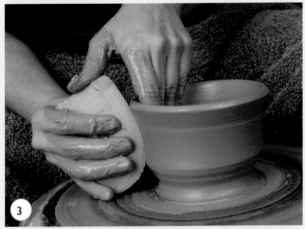

3. When making the bowl, check to see that the shape of the walls mirrors the walls of the platter so that they will fit nicely together.

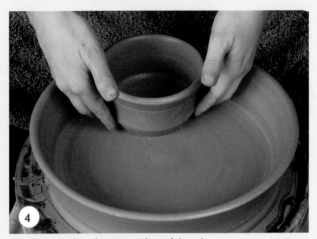

4. Place the bowl to one edge of the platter.

5 With clean hands, make a spout (see page 249 for how to make a spout). By pressing on the lip with one hand and supporting from underneath, both pieces of freshly thrown clay will be joined nicely.

6. Define the spout by pushing in from the outer wall.

CASSEROLE WITH LID AND HANDLES

Lidded casseroles are great for serving food as well as for baking. They benefit from low, open forms with shallow lids to prevent condensation from forming inside the lid. They need not be thin; some heft will help hold heat. Casseroles can be made to suit the number of people you plan to serve. Start building small lidded containers until you feel comfortable with all the elements of these forms.

Casseroles will need handles, a flange (or gallery) for the lid to rest on, a lid, and handle or knob for the lid. For the piece shown above, begin with 4 pounds (1.8 kg) of clay.

(continued next page)

1. Begin by centering and raising a wall in the same manner as the chip and dip dish. (See page 169.) This time, be sure to leave a generous amount of clay at the rim for the flange.

2. Making the flange is a little tricky and requires practice. (You may want to try making flanges on a thick cylinder first.) With the wheel spinning at a medium speed, press on the inner ring of the rim with your index finger while the outer index finger counters the pressure and raises the rim. It is called a shear movement because you are throwing in opposition: one finger down and the other up.

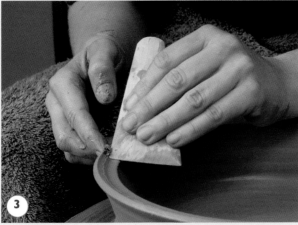

3. To define the edges, or if you are having trouble using your fingers, try applying pressure with a wooden tool with a right angle. It will give a nice crisp line. Wire the casserole base from the bat.

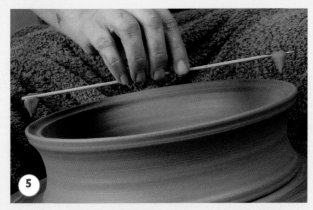

4. Calipers can be used to measure the diameter of a rim.

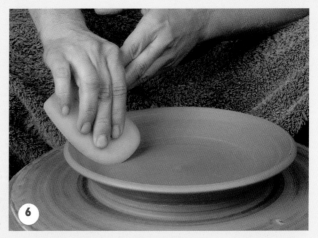

5. Alternatively, the diameter of a rim can be measured by using two little points of clay on a bamboo skewer. This shows how wide the lid will need to be in order to fit the casserole base. Remove the dish from the wheel.

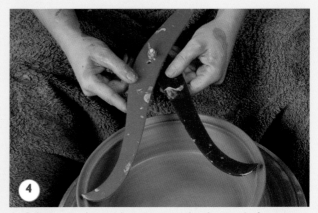

6. Throw the lid. A lid is a bowl shape, and a shallow lid is more like a low, open bowl. Use the calipers or skewers to control the size during the throwing.

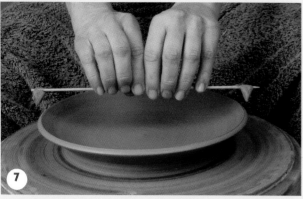

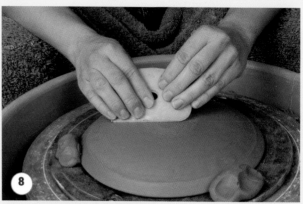

7. The final size check is done with the skewers or calipers. If the rim is too big, it can be trimmed with the needle tool. Allow all parts to dry to leather hard, trim, then proceed to making and attaching handles.

8. Trim the lid to even wall thickness. When shaping it, think about the profile and its relationship to the casserole base.

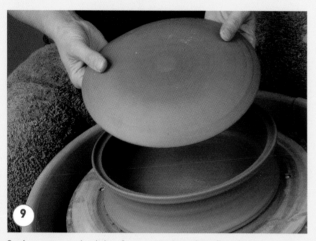

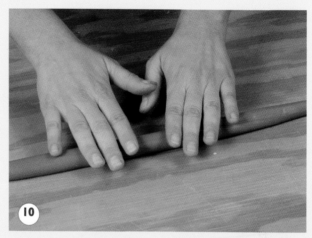

9. As soon as the lid is firm enough to handle, place it on the casserole base so that they dry together. (They should be fired together too.)

10. To make rolled handles, use both hands to roll clay between your fingers and palms. The clay needs to make a full rotation back and forth to stay round.

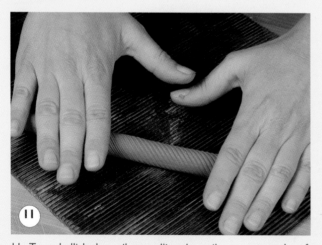

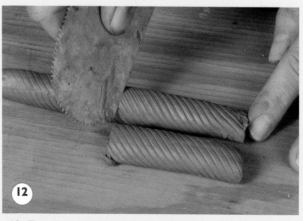

11. To embellish the coil, try rolling the coil on a textured surface.

12. To make a set of handles that are the same size, try making them from one long coil and cut in half (or to size).
(continued next page)

Casserole with Lid and Handles (*continued*)

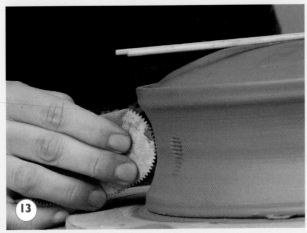

13. Align the handles by placing sticks parallel across the top of the lid, spacing them equally.

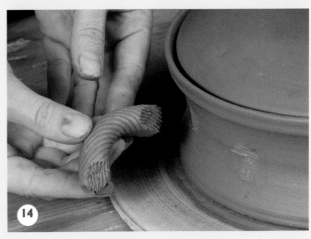

14. Score the handles before attaching them.

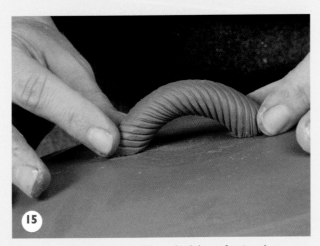

15. Score and slip the handle on the lid, reinforcing the attachment with a small tool if needed.

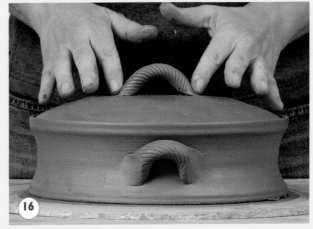

16. Check to see that the handles are well attached and that they are aligned for composition.

TEAPOT WITH LID, SPOUT, AND HANDLE

Teapots are one of the most complex pottery forms. In the world of ceramics, teapots are sculptural; they can be incredibly ornate or very simple. Potters love the challenge of making interesting teapots, and you probably will too.

Teapots not only require making several components—including the body, spout, lid, and handle or handle attachment—but they need to function well and look well designed. Assembling all the parts requires attention to detail and to the consistency of the clay. To make teapots, you should set aside enough time to not only shape all the parts but also to assemble them before they are too dry.

Making several teapots at a time will help you recognize what works and what doesn't and help you design better pouring vessels. The ease of the pouring action should help shape the design. The handle should be far enough away to hold comfortably without touching the hot surface. The lid should remain secure when in the pouring position, and the spout should not leak when the pot is full of water.

(continued next page)

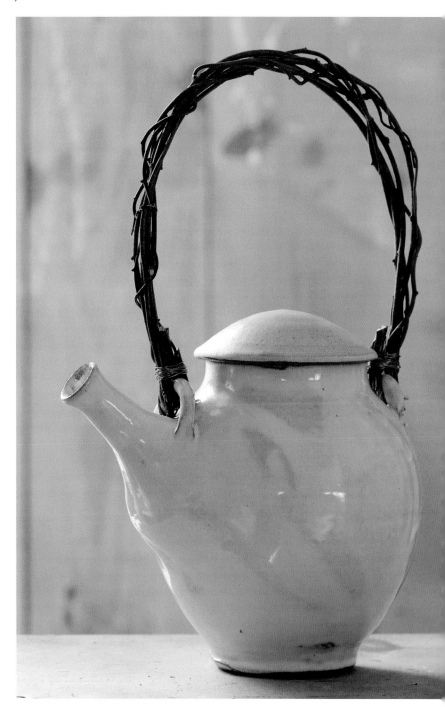

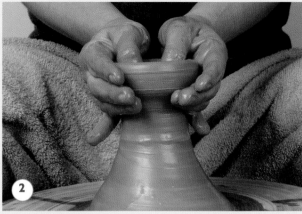

1. Begin with a 2.5 pound (1.1 kg) ball of clay. Throw to a cylinder, then turn it to a rounded vase shape. Determine the size of the vessel's mouth (you will use this measurement to later determine the size of the lid). Remove from wheel.

2. Center a generous amount of clay from which you will throw the lids and spouts. Cup a small amount in the center and open to make a lid. It will be trimmed round.

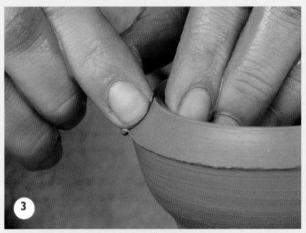

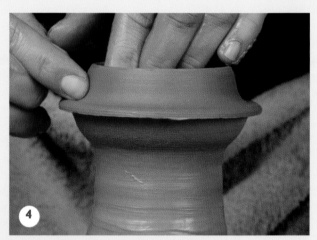

3. Measure to see that the width of the lid is close to the width of the teapot opening and proceed to make a flange in the lid by pressing downward with the outer finger and upward with the inner finger.

4. Define the lid and measure it for accuracy.

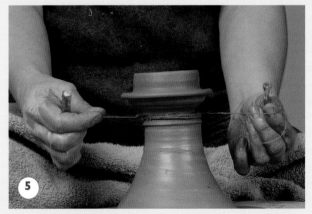

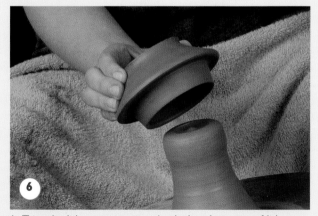

5. Hold the wire underneath what will be the top of the lid and turn the wheel to cut through evenly.

6. Trim the lid on a trimming chuck. Another type of lid (shown next) is made upright off the mound of clay.

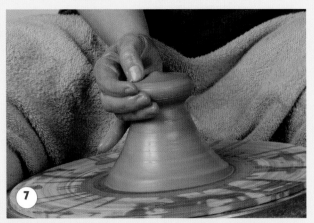

7. Cup a small amount of clay in your hand to center. Depress the clay just to the right of the center—this will leave a little nub of clay.

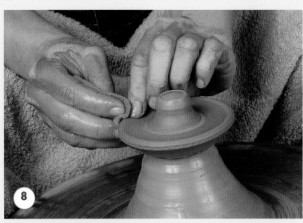

8. Throw the base of the lid to the desired width. Remember to measure its diameter.

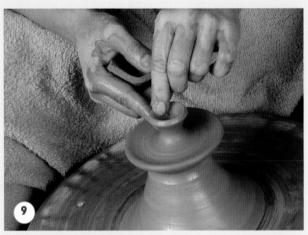

9. Gently throw the knob in the center.

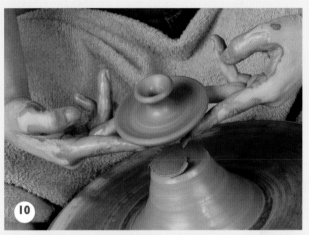

10. Carefully wire the lid from the mound.

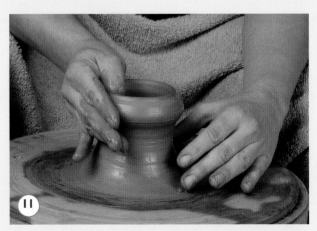

11. The spout is made from the mound of clay and is a bottle shape. A wide base for a spout is good because the spout will need to be cut at a diagonal to attach to the teapot. The spout should be wide to cover the straining holes. Cup a small amount of clay in your hands, center, and open wide.

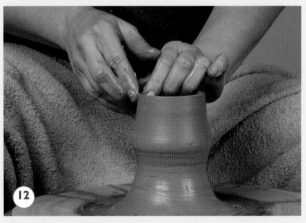

12. Raise the walls, narrowing as you pull.

(continued next page)

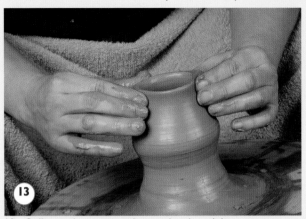

13. Collar in the spout and raise the clay while it narrows.

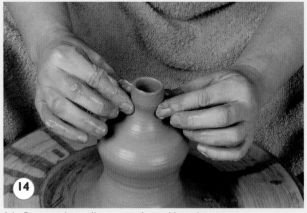

14. Repeat the collaring until you like what you see.

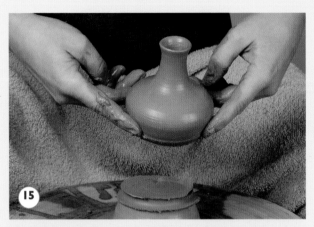

15. Define the spout and cut below the base to set it up for attaching. Assembling the teapot will require that parts be at a soft to medium leather-hard state.

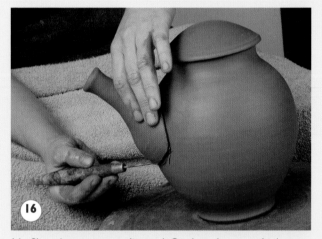

16. Slice the spout at a diagonal. Cut less than you think you need—you can always cut more but it's hard to replace the clay once it's cut. Hold the spout up against the teapot to see if the angle is good and remove clay accordingly. Trace around the spout placement with a needle tool.

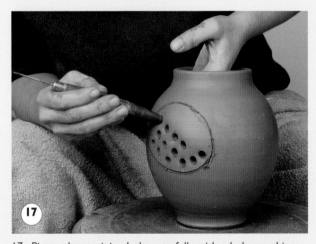

17. Pierce the straining holes carefully with a hole-punching tool. Note how the inside hand supports the wall.

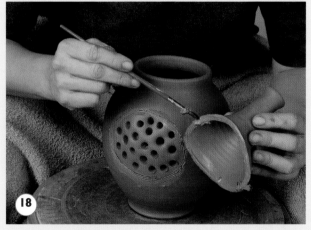

18. Score and slip the edge of the spout and the ring around the straining holes.

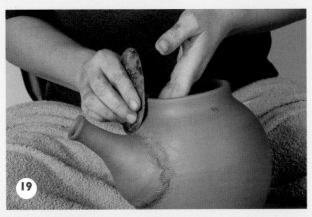

19. Apply the spout to the teapot, using mild pressure to make a strong connection. Score around the connection.

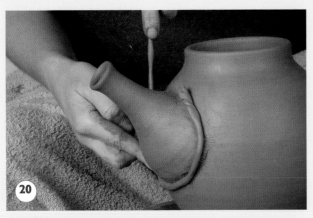

20. Roll a fine coil and place it around the seam and join into the soft clay for extra support. Smooth into the body of the teapot.

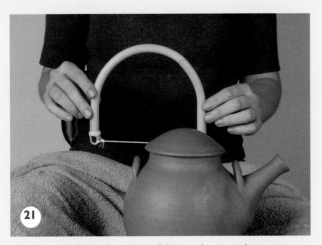

21. Attach coil handles that will be used to attach a non-ceramic handle after the firing. Bamboo handles or handles of other materials can be purchased, or handles can be fashioned from twigs or basketry materials.

TEAPOT-MAKING TIPS

When making a teapot that is meant to be used, there are a few details of which you should be mindful:

• The teapot should be relatively lightweight and easy to maneuver with one hand.

• It should have a sturdy handle that allows the teapot to be held comfortably, even when full of hot water.

• Water should pour freely from the spout. (Be sure not to glaze the strainer holes!)

• The teapot's lid should not fall out when tea is being poured.

• The top of the spout should always be placed above the pot's water level. Otherwise, the spout will leak when the pot is full.

Two-Part Vase

To make larger-scale work, it is necessary to learn how to attach sections of clay to one another. You can try making smaller two-part vessels to hone the skills to center and attach two pieces to make one. To make this vase, start with about 7 pounds (3 kg) of clay for each section.

TIP

Drying sections of the clay to the proper consistency is challenging. If you wrap the sections in plastic, they will be too soft to join. Try placing newspaper over the rims to hold some air inside the pieces. It will keep rims soft and allow the bottoms to set up. This is all dependent on your climate. If it is very damp, you may have to wait a day or so. If it is dry, a few hours might do the trick.

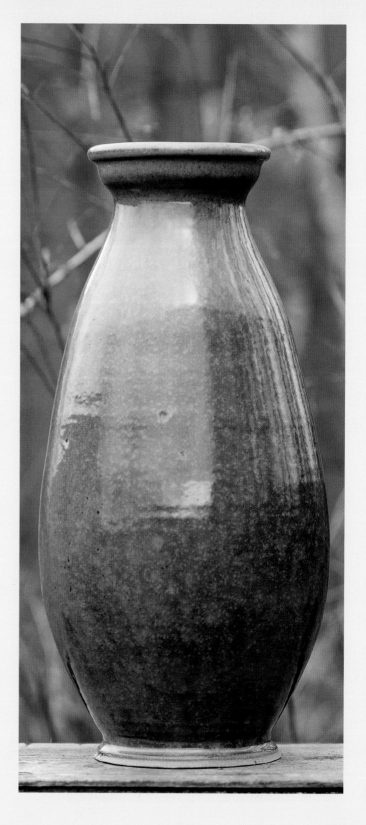

1. Throw the base of the pot to the desired shape but narrow the vessel at the top. Later when it's time to join, the rim can be widened, but it can't be narrowed. Leave enough clay at the lip to create a groove on which the top piece will fit. Measure the width.

2. Throw the top section. Notice that the base is narrow because it will be the neck of the pot. Leave a little extra clay in case you want to throw it a bit at the end. Do not wire from the bat (removal is done after sections are joined).

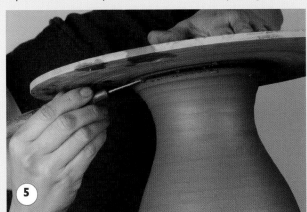

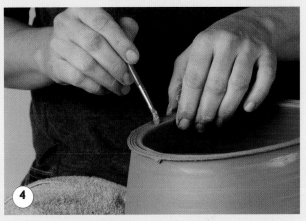

3. Take the top and place it on the rim of the bottom. Once it is on, check to make sure the top is aligned and centered with the bottom. If a rim needs to be widened, you can remove the top and make the adjustment with the wheel spinning.

4. When the pots are stiff enough to hold their shape, but soft enough still to be joined, score and apply slip to the rims.

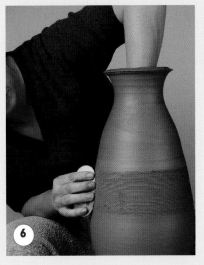

6. Score the inside and the outside seam with a serrated rib while the wheel is spinning slowly.

5. Place the top section on top of the bottom section, aligning both rims. Use the needle tool to score through the rim of the top and wire the top from the bat.

(continued next page)

Two-Part Vase (CONTINUED)

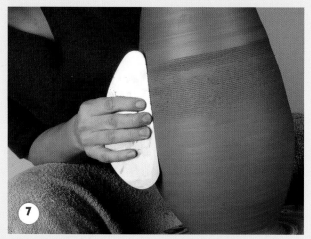

7. Use a large metal rib to smooth the seam and do some gentle shaping. If you try to change the form, the pot will become off center because it is already leather hard.

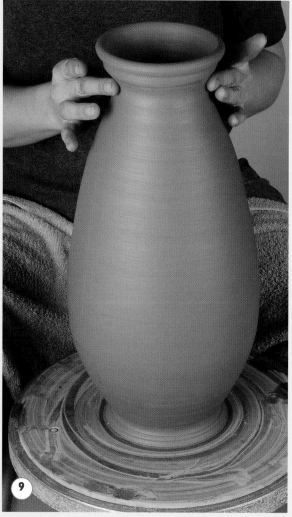

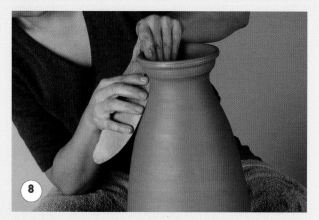

8. Trim about ¹/₂ inch (1 cm) from the rim to expose soft clay and finish throwing the neck and rim of the pot.

9. Gently define the rim of the vessel and check to see that it is centered and all seams have been integrated.

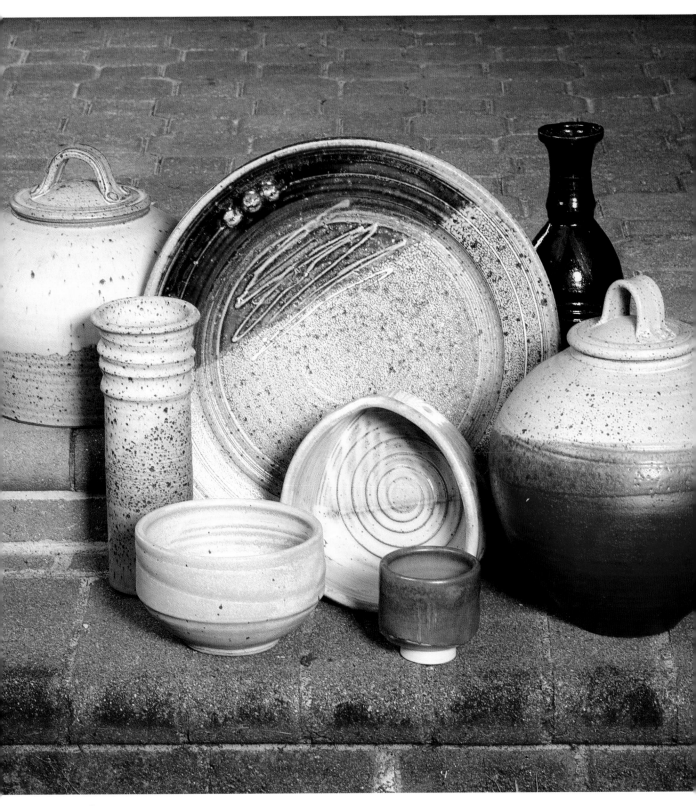

Functional stoneware pottery

CLAY AND GLAZE
FORMULAS

Potters often ask about other potters' work, "How did they make that?" The clay and glaze formulas here are yours to enjoy and experiment with. Clay body formulas, glaze formulas, forming, and firing methods often give insight into how potters accomplish their aesthetic goals. The technical aspects behind a piece can jumpstart your own work, but formulas alone are not the final arbiter of quality. Good pots are more than the sum of their parts. They are the result of experience, trial and error, practice, and persistence.

Because the formulations for clay and glaze components change over time, always test clay bodies and glazes to ensure an accurate result.

The glaze formulas and clay body formulas are listed in percentages. This allows potters to generate batches of material in any quantity desired. G-200 feldspar at 45 percent can be used as 45 grams, 450 grams, or 4,500 grams, as long as the other materials in the formula are increased by the same factor. The base clay body and glaze components total 100 percent, and coloring oxides, stains, grogs, gums, and other additives are added beyond 100 percent.

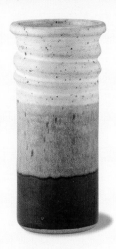

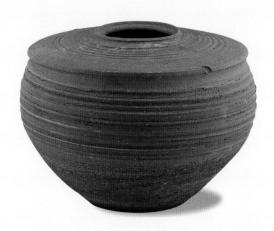

THROWN CYLINDER
7" (17.8 cm) tall, 3" (7.6 cm) diameter
Firing: Cone 9 (2,300°F [1,260°C]), reduction atmosphere

Clay Body Color: Brown/Stoneware	%
A.P.G. Missouri fireclay 35x	25
Goldart stoneware clay	41
Thomas ball clay	15
Custer feldspar (potassium)	12
Flint 200x	7
Grog 48/f	6

Glaze Color: Matte Yellow	%
G-200 feldspar (potassium)	45
Flint 325x	5
E.P.K.	25
Dolomite	22
Whiting	3
Red iron oxide	$1/4$

Glaze Color: Matte Red	%
G-200 feldspar (potassium)	48
E.P.K.	21
Dolomite	13
Whiting	8
Tin oxide	4
Bone ash (natural)	6
Red iron oxide	4

THROWN JAR
7 1/2" (19.1 cm) tall, 10" (25.4 cm) diameter
Firing: Unglazed, cone 01 (2,046°F [1,119°C]),
oxidation atmosphere (electric kiln)

Clay Body: Black	%
Goldart stoneware clay	34
Pine Lake fireclay	20
Tennessee ball clay #1	16
Nepheline syenite 270x (sodium)	16
Flint 200x	10
Redart earthenware clay	4
Grog 80x	6
Cobalt oxide	$1 1/2$

SQUARE-SIDED THROWN RAKU COVERED JAR

14" (35.6 cm) tall, 3 ³/₄" (9.5 cm) diameter
Firing: cone 04 (1,945°F [1,063°C]), reduction atmosphere

Clay Body: Gray/Black/Raku	%
Goldart stoneware	50
Tennessee ball clay #1	15
Pine Lake Fireclay	18
A.P.G. fireclay 28x	5
Custer feldspar (potassium)	7
Flint 200x	5
Grog 48/f	7
Glaze: Opaque White	
Gerstley borate	36
Custer feldspar (potassium)	32
E.P.K.	2
Flint 325x	30
Superpax	12

WHEEL-THROWN ALTERED OVAL

3 ¹/₂" (8.9 cm) tall, 7 ¹/₄ " (18.4 cm) wide
Firing cone 10 (2,345°F [1,285°C]), reduction atmosphere

Clay Body: Brown/Stoneware	%
Hawthorn Bond fireclay 50x	21
Goldart stoneware clay	50
Kentucky ball clay OM#4	15
Custer feldspar (potassium)	8
Flint 200x	6
Grog 48/f	8
Glaze: Gloss Red	
Custer feldspar (potassium)	57
Whiting	20
Ferro frit #3134	6
Flint 325x	15
Tin oxide	2
Copper carbonate	2 ¹/₂

WHEEL-THROWN UNGLAZED BOWL

7" (17.8 cm) tall, 7 1/2" (19.1 cm) diameter
Firing: cone 04 (1,945°F [1,063°C]) oxidation atmosphere (electric kiln)

Clay Body: White/Earthenware	%
Tennessee ball clay #1	47
Texas talc	50
Whiting	3
Wash: Brown/Black	
Red iron oxide	40
Rutile powdered lt.	40
Ferro frit #3195	20

WHEEL-THROWN/HAND-BUILT SCULPTURAL DISK

11" (27.9 cm) tall, 12" (30.5 cm) diameter
Firing: cone 9 (2,300°F [1,260°C]) reduction atmosphere, unglazed

Clay Body: Black/Stoneware	%
Goldart stoneware clay	38
Pine Lake fireclay	20
Tennessee ball clay #1	15
Nepheline syenite 270x (sodium)	12
Flint 200x	7
Redart earthenware clay	8
Grog 80x	14
Cobalt oxide	1 1/2
Red iron oxide	1

Clay Body: Brown/Stoneware	%
Goldart stoneware clay	25
Pine Lake fireclay	33
Tennessee ball clay #1	10
Nepheline syenite 270x (sodium)	20
Flint 200x	8
Redart earthenware clay	4
Grog 80x	12
Glaze: Satin Matte Green	
Cornwall stone	46
Whiting	34
E.P.K.	20
Copper carbonate	4
Tin oxide	4

SLAB CONSTRUCTION OVAL PLATTER
ARTIST: JIM FINEMAN

1" (2.5 cm) tall, 10 1/4" (26 cm) diameter
Firing: cone 9 (2,300°F [1,260°C]), reduction atmosphere

WHEEL-THROWN BOTTLE

9" (22.9 cm) tall, 4" (10.2 cm) diameter
Firing: cone 9 (2,300°F [1,260°C]), reduction atmosphere

Clay Body: Brown/Red Stoneware	%
Hawthorn Bond fireclay 50x	30
Goldart stoneware	35
Thomas ball clay	12
Newman red stoneware	10
Custer feldspar (potassium)	8
Flint 200x	5
Grog Ohio #3 40/f	12
Glaze: Gloss Brown/White	
Nepheline syenite 270x (sodium)	47
Soda ash	13
E.P.K.	15
F-4 feldspar (sodium)	10
Thomas ball clay	10
Redart earthenware clay	5

WHEEL-THROWN DISK

2 1/2" (5.7 cm) tall, 9" (22.9 cm) wide
Firing: cone 04 (1,945°F [1,063°C]), oxidation atmosphere (electric kiln)

Clay Body: Light Brown/Earthenware	%
Redart	85
Thomas ball clay	15
Barium carbonate	0.3
White Slip	
E.P.K.	25
Pioneer kaolin	15
Tennessee ball clay #10	10
Nepheline syenite 270x (sodium)	15
Flint 325x	10
Superpax	10
Soda ash	5
Ferro frit #3110	10

WHEEL-THROWN BOWL
6 1/2" (16.5 cm) tall, 7 1/2" (19.1 cm) diameter
Firing: cone 10 (2,345°F [1,285°C]) soda firing

Clay Body: Brown/Stoneware	%
Grolleg kaolin	25
A.P.G. Missouri fire clay 28x	25
Goldart stoneware clay	30
Tennessee ball clay #9	10
XX sagger clay	5
Custer feldspar (potassium)	5
Silica sand F-65 48x	4
Grog 48/f	4

Glaze: Green Gloss

Albany slip	80
Whiting	20

White Slip

E.P.K	35
Flint 325x	20
Tennessee ball clay #1	15
Superpax	5
Cornwall stone	25

WHEEL-THROWN OVAL CYLINDER
ARTIST: TOM WHITE
8 1/2" (21.6 cm) tall, 5" (12.7 cm) wide
Firing: cone 11 (2,361°F [1,294°C]) wood/soda/salt

Clay Body: Light Medium Brown/Stoneware	%
Hawthorn Bond fireclay 50x	33
Goldart stoneware	24
Lizella stoneware	10
Tennessee ball clay #9	12
Custer feldspar (potassium)	13
Flint 200x	8
Silica sand F-65 48x	12

Glaze: Gloss White

Custer feldspar (potassium)	30
Nepheline syenite 270x (sodium)	39
Soda ash	8
Tennessee ball clay #1	17
E.P.K.	6

White Slip

Helmer kaolin	65
Grolleg kaolin	20
Nepheline syenite 270x (sodium)	15

WHEEL-THROWN COVERED JAR
ARTIST: TOM WHITE

5¹/₂" (14 cm) tall, 5¹/₂" (14.6 cm) diameter
Firing: cone 11 (2,361°F [1,294°C]) reduction atmosphere
(soda firing)

Clay Body: Medium Brown/Stoneware	%
Hawthorn Bond fireclay 50x	20
Goldart stoneware clay	40
Kentucky ball clay OM#4	15
G-200 feldspar (potassium)	12
Flint 200x	8
Redart earthenware clay	5
Grog 20/48x	12

Glaze: Gloss Light Green with White Stripes	
Custer feldspar (potassium)	28
Flint 325x	34
E.P.K.	2
Talc	4
Whiting	18
Barium carbonate	12
Bone ash (natural)	2
Copper carbonate	2

White Overglaze

Custer feldspar (potassium)	49
E.P.K.	21
Dolomite	19
Whiting	4
Tin oxide	7

WHEEL-THROWN BOWL
ARTIST: TOM WHITE

2¹/₂" (7 cm) tall, 4" (10.2 cm) diameter
Firing: cone 6 (2,232°F [1,222°C]) reduction wood
firing then cone 10 (2,345°F [1,285°C]) soda firing

Clay Body: White/Stoneware	%
Cedar Heights bonding clay 50x	22
Goldart stoneware clays	19
Hawthorn Bond fire clay 35x	21
Tennessee ball clay #10	13
XX sagger clay	10
Flint 200x	9
Custer feldspar (potassium)	6
Silica sand F-95 70x	9

Glaze: Gloss Clear/Red White	
Custer feldspar (potassium)	49
E.P.K.	21
Dolomite	19
Whiting	4
Tin oxide	7
Copper carbonate	¹/₄

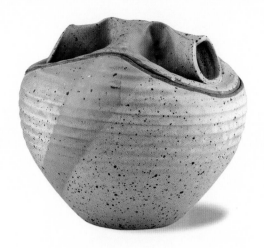

WHEEL-THROWN GOBLET

7 1/2" (19.7 cm) tall, 5" (12.7 cm) diameter
Firing: cone 10 (2,345°F [1,285°C]), soda firing

WHEEL-THROWN COVERED JAR

7" (17.8 cm) tall, 8" (20.3 cm) diameter
Firing: cone 10 (2,345°F [1,285°C]), reduction atmosphere

Clay Body: White/Porcelain	%
Grolleg kaoliin	50
Custer feldspar (potassium)	25
Flint 200x	25
Silica sand F-95 70x	8

Glaze: Gloss Brown

Albany slip	75
Whiting	20
Flint 325x	5

Green Slip

E.P.K.	35
Grolleg	40
Nepheline syenite 270x (sodium)	15
Ferro frit #3110	5
Flint 325x	5
Copper carbonate	2

Clay Body: Brown/Stoneware	%
A.P.G. Missouri fireclay 28x	21
Goldart stoneware clay	44
Tennessee ball clay #9	16
G-200 feldspar (potassium)	12
Flint 200x	7
Grog 48/f	12

Glaze: Matte Blue/Gray

Custer feldspar (potassium)	45
Flint 325x	5
E.P.K.	25
Dolomite	22
Whiting	3
Cobalt carbonate	1/2
Nickel carbonate green	1

Glaze: Matte Pink

Custer feldspar (potassium)	45
Flint 325x	5
E.P.K.	25
Dolomite	22
Whiting	3
Copper oxide (red)	1/2

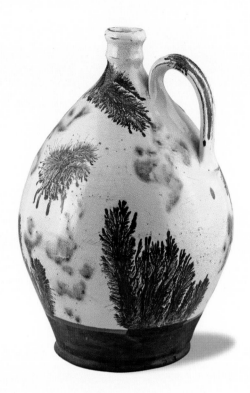

WHEEL-THROWN BOTTLE
ARTIST: JOEL HUNTLEY

9¹/₂" (24.1 cm) tall, 6 ¹/₂" (16.5 cm) diameter
Firing: cone 04 (1,945°F [1,063°C]), oxidation atmosphere
(electric kiln)

Clay Body: Brown/Earthenware	%
Redart	55
Cedar Heights bonding clay 50x	9
Thomas ball clay	17
M 44 ball clay	7
Custer feldspar (potassium)	6
Goldart stoneware clay	3
Flint 200x	3

Glaze: Clear Transparent Glossy	
Ferro frit #3269	90
E.P.K.	8
Flint 325x	2
Red iron oxide	1
Epsom salts	¹/₂

White Slip	%
E.P.K.	30
Thomas ball clay	25
M44 ball clay	10
Goldart stoneware clay	5
Flint 325x	20
Superpax	10
Bentonite	2

Yellow Slip Variation	
Mason stain Titanium Yellow #6485	10

Dendritic Slip: Brown/Black	
Manganese dioxide powder	20 grams
Water	29 grams
Apple cider vinegar	29 grams
Tobacco	0.75 gram (one cigarette)

Mixing

Mix all ingredients. Break open and add the contents of one cigarette to the dendritic slip (discard the cigarette filter). Age the slip for 24 hours, then place the liquid through a 100x-mesh sieve three times before using. Discard any material left on the 100x-mesh screen. The shelf life of dendritic slip is two weeks. After that the properties of the growing tree patterns rapidly decline.

Application

After the pot has been thrown, hand-built, or otherwise formed, apply the base slip to the moist and leather-hard clay surface as soon as possible to ensure a stronger bond between the slip and clay body. While the base slip is still wet, immediately dip a soft bristle brush in the dendritic slip mixture. Fill the brush with a small amount of the watercolor-consistency dendritic slip, then barely touch the surface of the wet white slip with the brush. The dendritic slip will flow off the brush onto the base slip, leaving a pattern. A tree-like tentacle decoration can be developed by holding the pot on the vertical. Concentric ring patterns can be obtained by applying dendritic slip to horizontal pot surfaces.

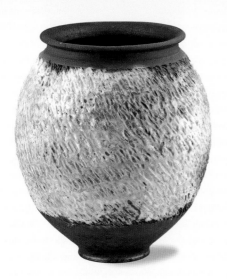

WHEEL-THROWN RAKU-FIRED VASE
ARTIST: STEVEN BRANFMAN

8″ (20.3 cm) tall, 7″ (17.8 cm) diameter
Firing: cone 04 (1,945°F [1,063°C]), fired in an oxidation
atmosphere and fast-cooled in a reduction atmosphere

Clay Body: Black/Gray	%
Hawthorn bond fireclay 50x	45
Talc	20
Kentucky ball clay OM#4	15
Goldart stoneware clay	20
Grog 48/f	20

Glaze: White Satin Matte	
Gerstley borate	65
Tennessee ball clay #9	5
Nepheline syenite 270x (sodium)	15
Tin oxide	10
Flint 200x	5

Overglaze wash: Yellow	
Mason stain Naples #6405	60
Ferro frit #3195	40

Overglaze wash: Green	
Mason stain Bermuda #6242	60
Ferro frit #3195	40

Overglaze wash: Red	
Mason stain Crimson #6003	60
Ferro frit #3195	40

PRESS-MOLDED BOWL

1 1/2″ (3.8 cm) tall, 5 1/2″ (14 cm) diameter
Firing: cone 9 (2,300°F [1,260°C]), reduction atmosphere

Clay Body: White Stoneware	%
Tile #6 kaolin	30
Tennessee ball clay #10	30
G-200 feldspar (potassium)	20
Flint 200x	20
Silica sand F-95 79x	8

Glaze: Light Brown/Yellow	
Cornwall stone	50
Whiting	30
Grolleg kaolin	20
Red iron oxide	4

WHEEL-THROWN BOWL

7½" (19.1 cm) tall, 8" (20.3 cm) diameter
Firing: cone 04 (1,945°F [1,063°C])

Clay Body: Red Earthenware	%
Redart earthenware	75
Sheffield earthenware	15
Goldart stoneware	6
C&C ball clay	4

Clay Body: White Earthenware	%
C&C ball clay	50
Talc	47
Whiting	3

WHEEL-THROWN SCULPTURAL RATTLE

5" (12.7 cm) tall, 12½" (31.1 cm) long
Firing: cone 9 (2,300°F [1,260°C]), salt-fired with red fiber flocking

Clay Body: Black Stoneware	%
A.P.G. Missouri fireclay 28x	20
Goldart stoneware clay	25
Ocmulgee stoneware clay	15
Kentucky ball clay OM #4	12
F-4 feldspar (sodium)	12
Flint 200x	10
Redart	6
Silica sand F-95 70x	12
Cobalt oxide	2
Red flocking (Cloth fibers sprayed on adhesive surface)	

WHEEL-THROWN JAR

8¹/₂" (21 cm) tall, 8" (20.3 cm) diameter
Firing: cone 9 (2,300°F [1,260°C]), salt-fired

Clay Body: White Stoneware	%
A.P.G. Missouri fireclay 28x	20
Goldart stoneware	40
Tennessee ball clay #1	18
G-200 feldspar (potassium)	12
Flint 200x	10
Silica sand F-95 70x	10

Blue Wash

Cobalt carbonate	80
Ferro frit #3124	20

WHEEL-THROWN CUP

3 ¹/₂" (8.8 cm) tall, 4" (10.2 cm) diameter
Firing: cone 9 (2,300°F [1,260°C]), reduction atmosphere

Clay Body: White Porcelain	%
Tile #6 kaolin	10
E.P.K.	16
Pioneer kaolin	6
Tennessee ball clay #10	25
G-200 feldspar (potassium)	23
Flint 200x	20

Glaze: Dark Brown, Glossy

Custer feldspar (potassium)	52
Flint 325x	24
Whiting	13
E.P.K.	7
Barium carbonate	2
Zinc oxide	2
Bentonite	2
Red iron oxide	8

GOING INTO THE
CERAMICS BUSINESS

The ability to sell what you make is seductive, and most potters will at some point face the question of when and how to sell their work. However, without a thorough knowledge of business practices, selling pottery can lead to a loss of money and time. Business people who become potters make money; potters who try to become businesspeople lose money. Business training makes all the difference.

At first, selling is easy. Relatives and close friends buy your goods, but before long, they will exhaust their need for pottery. Meanwhile, the pottery market has low barriers to entry: Expenses for starting the business are modest, and many potters sell their work with little initial effort. The initial influx of income from an immediate circle of supporters to cover equipment and supplies often is misleading.

To sell profitably requires developing skills necessary to run a business that just happens to focus on pottery. You must have an extensive knowledge of the market in which you hope to sell pottery. Handmade functional pottery competes with mass-marketed and mass-produced commercial pottery. You must ask yourself: How many people within a limited geographic market will buy a relatively expensive handmade piece instead of an inexpensive machine-made cup?

PLAN YOUR BUSINESS

Some potters' long-range plans consist of packing the car up for the next craft show. Whether the expense of going to the show will justify the anticipated revenues is often overlooked. Develop real plans for marketing and advertising your work that are based on research. Your plan should include an evaluation of prospective craft shows, a timetable to reach short- and long-term goals, and a listing of primary and secondary markets for your pots. The plan should also include a complete financial breakdown of direct and indirect costs of production, hourly wages for yourself, and profit margins. Committing your ideas to paper in the form of a business plan allows you to prioritize your goals. For example, projecting revenues for particular pottery shows allows you to establish production goals.

Keep accurate, up-to-date financial records so you can spot the first indications of business difficulty. Be sure to calculate fixed and variable costs so you can establish a wholesale and retail pricing structure. Fixed costs include studio insurance, rent or mortgage payments, heating and lighting costs, and any other recurring costs to do business. Variable costs include materials and supplies to produce pots, supplies for stationary, and studio clean-up materials.

In addition to keeping financial and inventory records, you will record the results of glaze tests and kiln firings so you can duplicate good results and continue to improve efficiency and, ultimately, profit margin. Develop numbering systems and file test-tile results so you can refer to them without sifting through a messy studio.

A Pottery Business Plan

A comprehensive business plan for your pottery should include the following topics.

Description of the product: What kind of pottery will be produced?

Marketing of the product: How will the company promote, distribute, and sell the pottery?

Financing of the company: Will personal savings fund start-up costs and operating expenses, or will you seek outside financing?

Management of the company: Will the business be staffed by a sole proprietor, or will you employ others?

Ask yourself the following questions as you develop a business plan.

What exactly is the market? Who will buy my pottery? What is their income range, education, history of buying pottery, and reasons for pottery buying?

Where are the customers? Do they live in-state, out-of-state, in the city, or country?

What are the customers' buying patterns? Do they buy pottery every week, month, year? Do they buy through craft shows, galleries, the Internet, catalogs, direct from potters?

Why should they buy pottery from my company? List specific value-added features in pottery, such as unique glaze colors, durability, ease of use, and wide assortments of functional pottery.

Should I concentrate on the whole market or a segment? Should I try to sell pottery to everyone or to potential customers who are craft-oriented?

What is the competition? Are other potters making similar pottery? Are pottery imports a larger part of the market?

What are the competition's strengths and weaknesses? Examples: The competition produces equal- or superior-quality pottery. However, the competition does not make custom pottery.

How can I improve my product over the competition? Should I use unique glazes? Should I specialize in making pottery sets? Should I customize the pottery with slogans or names of customers?

Is the market stable, growing, shrinking? Are people buying more pots this year than in the past five, ten, or fifteen years? What is the projected growth of the handmade-pottery market?

What is my plan for growing the business? I plan to advertise in a local newspaper. I plan on hiring studio help to increase production. I intend to send literature to past customers notifying them of future pottery sales.

There is a great deal more to learn about running a pottery business; we've given the topic an extreme overview. Check into business classes and workshops at local community colleges and ask other professional potters to share their successes and failures. The more you educate yourself about the business of your pottery, the better you will fare when selling your work.

PLAN YOUR PRODUCTION TIME

Making pottery is a demanding, labor-intensive, and repetitive activity. It can be doubly harsh if you don't like the actual pots you are making. Design and formulate pots that are fun to turn out. Then search for a suitable market, so they will sell. Succumbing to trends (such as a popular glaze color) might produce short-term results but may eventually make potting a dull job. Many potters compromise and produce objects they know will sell, even though the pottery might be less than interesting to produce. Once the "guaranteed-income pots" are finished, they create the work they enjoy. If you choose this path, maintain a balance between the "paycheck pots" and those that express your aesthetic statement and beliefs.

As you strike a balance, be sure to set limits. Pottery making requires planning, execution, and evaluation of the outcome. Time is your most important commodity, and your greatest business expense. Calculate your time carefully, and don't underestimate the time invested in all stages of production.

Avoid the following common time traps.

Don't make custom individual pots to order. Turning down a request for a personalized plate or bowl is often difficult, but almost every potter has been placed in this situation by family, friends, and customers. It can easily turn into a time and cost trap. If custom work is needed, first show samples of what the customer can expect and don't stray from the sample options in fulfilling the order.

Don't make replacements to a set you no longer produce, and do not make a replacement for a set by another potter. Changes in raw materials, firing cycles, glazing techniques, and other variables make it difficult to reproduce a pot precisely to match other pieces you made in the past. Consider making extra pieces in a set during the original production run. While storage and handling of the extra pots may be a problem, future time and effort is saved.

PLAN YOUR PURCHASES AND PRICING

Keep your clay body and glaze formulas simple by using as few raw materials as possible. Many basic versions of clay body and glaze formulas produce the same fired effect as formulas containing numerous raw materials. Fewer raw materials in the studio translates to easier and faster weigh-outs of glaze or clay body formulas. It also simplifies ordering.

Make buying decisions with care. Research moist clays, tools, equipment, and raw materials before committing to a ceramics supplier. Before choosing a supplier, decide if you need a full-service supplier, with a store location displaying equipment, tools, books, supplies, and a sales staff, or a discount ceramics supplier, which might not have a store or an extensive selection but offers competitive pricing. Always inquire about return policies. Also, ask other potters about their experiences with specific suppliers.

When pricing your pots, figure in all production costs, including hourly wage and profit margin at every stage. Cut costs where possible, but think how a cost reduction can impact the whole system. One potter decided to eliminate the bisque-firing process, thereby saving time and fuel costs. However, he did not adjust the glaze formulas for raw glazing and single firing. Several glazes peeled off of the wares during glaze-firing, and he lost many pots.

The Retail Studio

A pottery studio located in a commercial district can attract walk-in customer traffic. While you'll pay higher rent for a space in a high-traffic area, the extra expense can pay off in product sales when passersby are intrigued by beautiful window displays filled with your finished work. Potential customers who are interested in handmade objects are naturally drawn to viewing the process. A studio/retail combination gives the public a chance to watch the potter at work, which is always a crowd pleaser. A display area within or adjacent to the studio exhibiting the finished ware also can help generate sales.

Retail tip: Don't forget to develop a mailing list of your customers. Send them an invitation before a kiln is due to be opened. This gives an interested population the opportunity to view and purchase pots warm from the kiln.

A window display with attractive pottery lures passersby into this working gallery.

Before moving into a new studio or remodeling a studio space, always be sure there is more than adequate electrical supply for all lighting and appliances. Electricians familiar with kiln operations and kiln manufacturers are good sources of information on meeting the electrical capacity for the studio.

WATER

Having a source of clean hot and cold water in the studio is a critical resource for any pottery producing operation. Water is used in mixing glazes, clay-forming operations, and in studio cleanup procedures. A water source within the studio is also an important safety factor because any time water has to be carried in from outside of the studio, there is always the possibility of spillage and creating a slippery floor. If that water mixes with any clay left on the studio floor, it can create an especially slick, unsafe surface.

A deep sink with a gooseneck hose will allow you to clean glaze buckets and tools quickly and efficiently. If possible, the sink should be located near glaze mixing areas and centrally located in your studio. Try to avoid a situation in which a sink is located on another level from the studio area. Constantly walking up and down stairs to obtain water is labor-intensive, time consuming, and possibly hazardous.

Because sink wastewater will contain a percentage of solid particles from glaze materials and clay, research the correct drain installation traps, so pipes and leach fields or sewer systems do not become clogged with solids. You can make a catch trap yourself or buy one. Several commercial catch traps fit under sinks, allowing the solids to accumulate in a container and the liquids to proceed down the drain and out of the studio. Whether you make a catch trap yourself or buy one, clean out the solids container frequently.

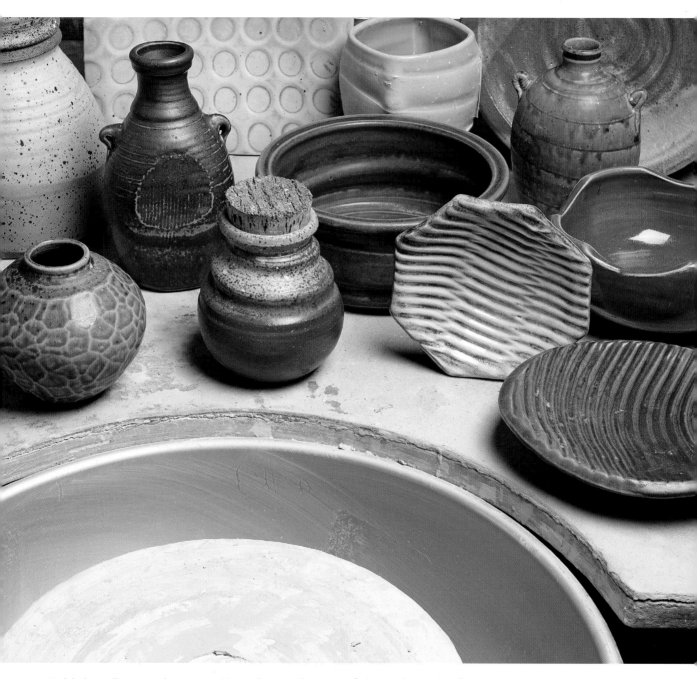

Task lighting illuminates this pottery. Notice that a wide variety of glaze colors and surface textures are easily apparent. A well-lighted studio is important to view work. Good lighting also reduces eye strain and promotes an efficient production cycle.

Venues for pottery sales range from going to craft fairs to selling directly from your studio. Consider the following factors when deciding where to sell pottery: cost structure, location, personal contacts, individual style of pottery, and supplemental income.

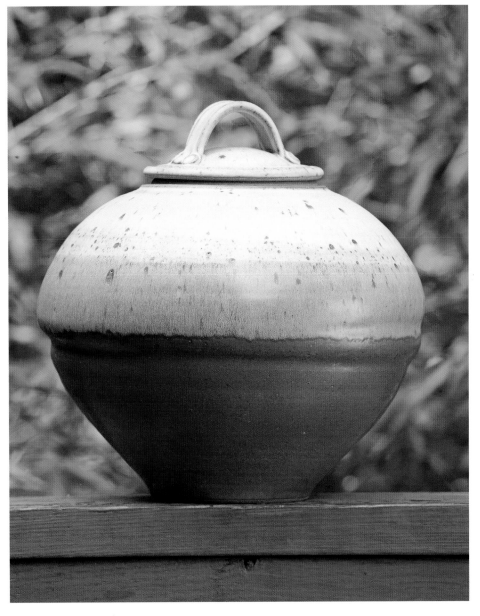

Wheel-thrown jar with cover.

Creative Marketing

One potter traveled to several local nurseries that sell miniature trees (Bonsai plants) and sold planters to the stores. Planned diversification of sales outlets will ensure the best chance of future sales. However, too many marginal venues can lead to loss of product or no income for the effort of shipping and stocking.

Galleries selling to the public either acquire pottery on consignment or purchase pots directly from the potter for retail sales.

You may sell your pottery in one venue—art shows or craft fairs, for example—or you may diversify by targeting several of the following outlets. Through trial and error (and hopefully, some number-crunching and strategy on your part), you'll discover which sales avenues produce the highest profit margins and income.

THE STUDIO GALLERY

Selling directly from your studio offers several benefits. First, customers are attracted to the idea of purchasing a pot hot from the kiln. You can even notify customers about your firing schedule. Packing and shipping costs are avoided, and there's no risk of breakage during transport. (This is a concern when traveling to craft shows, for instance.) Ideally, your studio should be located in an area with lots of foot traffic, and attractive display windows are important. Otherwise, shoppers will not know what's going on inside.

CRAFT SHOWS

Craft shows can generate fast income compared to other selling methods, such as waiting for customers to buy your pots from a gallery or retail store. Some craft shows are structured to sell wholesale and retail. Buyers from retail stores and art galleries are invited into the show the first day or two, after which the general public is admitted. Wholesale selling presents a different set of challenges to the potter and should be carefully investigated. (We'll talk more about wholesale selling on page 149.)

Regardless of your pricing, an inviting booth is the most important tool for increasing sales. Display business cards and post photographs of your work. Customers may wish to contact you after the show to make a purchase. To take advantage of high foot traffic, provide a sign-up book for customers to leave their names, street addresses, and email addresses. Use this later to market your work through post cards or email announcements.

CONSIGNMENT SALES

A gallery or retail store will exhibit your pottery on consignment: you give the store free inventory and you will receive payment, less consignment sales, when the pottery is sold. This type of sales has several negatives. The store and the potter have to keep exact records of transactions. Often, tracking the sale of pottery, restocking pottery, and the payment are time-consuming repetitive efforts. The potter must rely on the store's personnel to maintain and exhibit the pottery without loss or neglect. Finally, pottery on consignment is not available for sale in other venues in which money collection is immediate.

WHOLESALE OPPORTUNITIES

You can sell pottery wholesale through art/craft galleries, retail stores, craft shows, or catalogs. Investigate the reputation of the seller before signing any business contract. The first sale of pottery should be for cash-on-delivery or a prepaid order. Generally, the wholesale price of pottery is one-half the retail price, but this percentage can vary. Decide on some ratio of wholesale-to-retail sales to ensure a consistent revenue source.

Always look for new wholesale markets and develop relationships with buyers. This applies to one-time retail sales, wholesale selling, or pottery exhibited to sell in galleries. Consider enlisting a representative (a friend with a marketing brain or a polite family member).

Before committing to any venue, make sure you can meet any eventual demand for the pottery. A potter may be pleased when his work is highlighted in a catalog, but can be ill-equipped when a high volume of orders is generated.

INTERNET SALES

Traditionally, Internet sales of pottery have not produced a high level of income for potters. The best use of the Web has been to lead people to a potter's studio or store where the pottery is being sold. Most customers want to handle pots before committing to a purchase. That said, the Internet is an invaluable marketing tool today, and a professional-looking website will attract customers who are serious about buying quality pottery. The most productive websites feature professionally photographed, clear images and well written, descriptive text of the pottery. If sales originate from the studio, a detailed map listing hours of operation and directions will lead customers easily to your pottery shop. List retail store and gallery locations, along with customer testimonials.

Pottery on display represents functional and sculptural work by professional potters.

CREATING FUNCTIONAL SETS TO SELL

A complete set of dinner plates, lunch plates, cups, bowls, pitchers, and other forms is enticing for prospective customers. In many instances, customers do not intend to buy sets until they see the display. When customers are faced with grouping individual pots to form a set, they may be overwhelmed and, instead, will purchase nothing at all. Make the buying decision easy by creating and displaying sets of various glaze colors, sizes, and details.

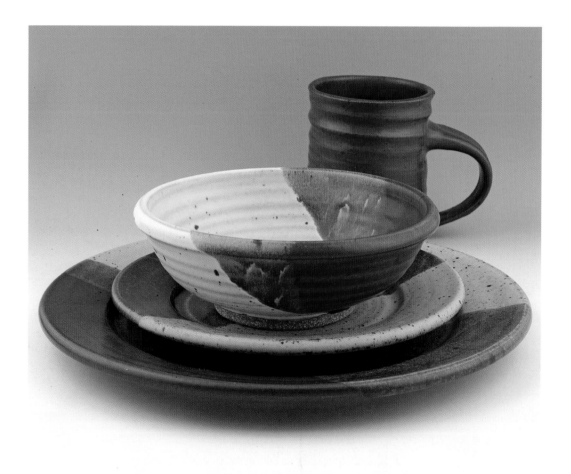

A set can be similar in size, glaze-color combination, or forming technique.

WHAT IS A SET?

A set can consist of any number of pottery forms. To create a set, choose the defining characteristics of the group. Will all the bowls be the same size, shape, or glaze color? Will all pieces have the same surface design elements and clay body color?

The next question is how many pieces comprise a set. A set should be apparent to others when in use or on display. Simply put, when customers enter a pottery display booth or visit a studio, they should recognize without question that a designated group of pottery objects is a set.

An important but simple rule to consider is that functional objects need to function. Bowls should hold liquids and solids, stack easily in the cupboard, be easily cleaned, and generally fit into the kitchen workspace. A pitcher should pour liquid without dribbling down its spout. The lids of covered jars should fit properly. Before creating sets, make several prototype pieces and use them in your own kitchen for a trial run. Tweak your design, if necessary, then begin creating the sets.

Sets should have a common design element that unifies them visually and/or structurally. All of the pieces don't have to be exactly alike, but they should be similar on some level. Just as human beings are unique, handmade pottery sets should reflect that intrinsic aspect of their production.

CREATING A SET

Usually, the first few pots in a set are "stiff" and self-conscious in form, while succeeding pots becoming more fluid and confident in structure. After several kiln loads or production cycles, you'll begin to make improved editions of individual pieces within the set.

Equipment

- Moist clay
- Scale

Instructions

1. Weigh out a fixed amount of clay for each pot in the set. This ensures a degree of uniformity in all pots. For instance, if you weigh out four 1-pound (454-g) pieces of clay, you will throw four coffee cups close in size. Apply the same weighing technique to hand building to duplicate the scale of an object. This is your first step toward standardizing the clay form. Also, each piece of clay should contain the same moisture content to achieve consistency in the forming process. The main idea in producing sets is to eliminate as many variables as possible, so you can concentrate on making each piece similar.

2. Think functional. While some degree of random qualities or handmade features are a definite promotional point in functional pottery, selling items to the public requires a number of basic constraints as to the size and shape of the pottery. For example, it would not improve the selling qualities of plates if they could not fit into a standard dishwasher or kitchen cabinet. Likewise, dinner plates with deep recessed throwing ridges may appear attractive, but plates without a flat surface on which to cut food are not functional. The general public is interested in handmade products, but they don't want to spend extra time washing or alter the way they would typically use a plate to accommodate "artistic license."

3. Make a set during one sitting. Repetition yields efficiency. On the wheel, most functional pottery can be thrown within a few minutes of starting to form the clay. Making a set of six cups within one working session should be possible. The average time to throw a small cup should be one to two minutes. If you throw one or two cups but wait until later in the day or the following week to finish, they'll be inconsistent.

④ Make a series of the same form. Series also qualify as sets. A series can denote a slight but intentional change in each piece. The evolution can be in shape, scale, glaze, or pattern. A wheel-thrown cylinder shape offers an excellent example of one way to think about series. Starting from $^1/_2$-pound (227-g) balls of clay, you can form small cylinders to make teacups, coffee cups, and small vases. The same procedures can be applied to creating a set or series of nesting bowls, just by increasing the amount of clay used to make the same bowl shape in varying sizes.

⑤ Experiment with glaze techniques. It is often easier to try various glaze patterns or glaze colors on similar forms. Working from a standard object (similar pots or sculpture pieces in a set or series), apply glazes in numerous patterns. For example, glaze one piece blue, another yellow, the next green, and so on. It is usually most productive to choose one type of form and work out the glazing techniques either through repetition or slight variations.

⑥ Stack pots in a set to best use kiln space. Because all of the pieces in the set will be the same, or at least have some common design elements, stacking the pots in a bisque or a glaze kiln allows the wares to fit in limited kiln space more efficiently. In the bisque kiln, save space by placing nesting bowls within each other. In the glaze kiln, place cylinder sets very close to each other, using every part of the kiln shelf. Denser stacking of the bisque and glaze kilns translates into more pots per cubic foot of kiln space, greatly reducing fuel costs.

TIP

Make Extra

Always turn out more pieces than required to complete a set. Making additional pieces will ensure at least some will come through the pottery-making process without defects. It will also allow for choosing the best pieces to form the set. The extra time and effort required to produce the work is nothing compared with the disappointment of not being able to assemble a complete set.

A set should feature pieces that are relatively similar in theme, such as glaze color, size, or form.

SOURCES OF INSPIRATION

Discovering a personal style is part of the intellectual journey of an artist. It is a journey of discovery and constant peeling away of visual layers. Sometimes there are so many choices that it can be daunting, but each individual has preferences. We are all attracted to different visual cues. Keeping an inspiration journal can be beneficial and illuminating as well. You needn't sketch; you can keep a collage of designs that you like from catalogs and magazines. Or, photograph objects or scenery that you find beautiful and consider how you can integrate these elements into your work.

I often suggest going to a museum to look at historic pieces or to a store that has tableware to observe the scale and proportion of vessels. Industrial designers are trained to design shapes that function well and are pleasing to the eye. Learn from good and bad designs. If you don't like something, ask yourself why not. Even if you don't like to draw, push yourself to do it. If you draw the shapes you want to make, they will be imprinted in your mind. You will have thought about the shapes in a different way, which will be helpful when you get to the studio.

CONCLUSION

I hope that this text inspires you to pursue clay and the ceramic process. It is a vast universe unto itself, one that can take a lifetime to master. To take on any creative endeavor is to take on the challenge of problem solving and of applying knowledge, instinct, and imagination. It is a challenge through which one must endure a series of trials and errors to gain an understanding of the tools, the materials, and the body, developing skills to bring forth ideas in any given medium.

The Potter's Studio Handbook is a solid introduction to the ceramic process from start to finish. There are hundreds of books in print that cover specific areas of each part of the process. If there is an area that interests you, read about it at greater length to further inform yourself. The Internet is an incredible resource, as are the many ceramic periodicals. The more you learn about clay, the more fun you will have in the studio. Don't be afraid to try different approaches to forming clay, put your own ideas to work, and remember, it's only clay, a plentiful and recyclable resource.

◉ Wheel-thrown bottle wood-fired in an anagama by Kristin Müller

RESOURCES

BOOKS ON CERAMICS

Here is a list of inspiring, helpful books to begin with.

Berenshon, Paulus. *Finding One's Way with Clay: Pinched Pottery and the Color of Clay.* New York: Simon & Schuster, 1972.

Burleson, Mark. *The Ceramic Glaze Handbook: Materials Techniques and Formulas.* New York: Lark Books, 2003.

Cardew, Michael. *Pioneer Potter.* New York: St. Martin's Press, 1976.

Cooper, Emmanuel. *A History of World Pottery.* 2nd rev. ed. New York: Larouse, 1981; and 3rd ed., Radnor, Pennsylvania: Chilton, 1988.

Leach, Bernard. *A Potter's Book.* New York, London: Transatlantic Arts, Faber & Faber, 1946: 18th ed., 1965

Peterson, Susan. *The Craft and Art of Clay.* New Jersey: Prentice Hall: Simon & Schuster, 1992.

Rhodes, Daniel. *Pottery Form.* Radnor, Pennsylvania: Chilton, 1976.

Rhodes, Daniel. *Clay and Glazes for the Potter.* Radnor, Pennsylvania: Chilton.

Yanagi, Soetsu. *The Unknown Craftsman: A Japanese Insight into Beauty.* Adapted by Bernard Leach. Tokyo, New York: Kodansha International, 1972; re-issued 1986.

For the most complete listings of ceramic books, contact:

The Potter's Shop
31 Thorpe Road
Needham, MA 02494 USA
Phone: 781-449-7687
Fax: 781-449-9098
E-mail: pottersshop@aol.com
http://thepottersshop.blogspot.com

INTERNET RESOURCES

The American Ceramic Society
www.ceramics.org

American Craft Council
www.craftcouncil.org

Ceramic Material Information
www.ceramic-materials.com

Ceramic Sculpture
www.ceramicsculpture.com

The Ceramics Web
http://ceramics.sdsu.edu

Clay Art
www.potters.org

The Craft Emergency Relief Organization
www.craftemergency.org

Critical Ceramics
www.criticalceramics.org

The Edward Orton Jr. Ceramic Foundation
www.ortonceramic.com

Kristin Müller
www.kristinmuller.net

Material Safety and Data Sheets Online
www.msdsonline.com

NCECA; The National Council on Education for the Ceramic Arts
www.nceca.net

Pottery Information
www.robertcomptonpottery.com

Virtual Ceramic Library
www.ikts.fhg.de/vl/VL.artistic.ceramics.html

Wood Fire Website
www.sidestoke.com

Worldwide Ceramics Pottery Directory
www.clayzee.com

CERAMIC SUPPLIERS

Alpine Kilns
www.alpinekilns.com
Kilns

American Art Clay Co Inc.
www.buyamaco.com
Ceramic supplier

Axner Pottery Supply
www.axner.com

Bailey Ceramic Supplies & Bailey Pottery Equipment Corporation
www.BaileyPottery.com
Ceramic equipment and supplies

Bennett Pottery Supply
800-432-0074
www.BennettPottery.com
Kilns, wheels, and other equipment

BigCeramicStore
www.bigceramicstore.com
Online ceramic supplier

Bluebird
www.bluebird-mfg.com
Clay-mixers and pug mills

Bracker's Good Earth Clays, Inc.
www.brackers.com
Ceramic supplier

Ceramic Supply
www.7ceramic.com
Ceramic supplier

Continental Clay Co.
www.continentalclay.com
Ceramic supplier

Dolan Tools
www.dolantools.net
Specialty trimming tools

Geil Kilns
www.kilns.com
Gas kiln manufacturer

L&L Kilns
www.hotkilns.com
Electric kilns

Laguna Clay Co.
www.lagunaclay.com
Clay manufacturer and ceramic supplier

Mud Tools
www.mudtools.com
Rubber ribs and tools

North Star Equipment
www.northstarequipment.com
Slab rollers, extruders and dies, shelving, and more

Olympic Kilns
www.greatkilns.com
Electric and gas kilns

Paragon
www.paragonweb.com
Electric kilns

Peter Pugger Products
www.peterpugger.com
Clay-mixers and pug mills

Runyan Pottery
www.runyanpottery.com
Clay manufacturer and ceramic supplier

Sheffield Pottery
www.sheffield-pottery.com
Clay manufacturer and ceramic supplier

Shimpo Ceramics
www.shimpoceramics.com
Potter's wheels and tools

Skutt Ceramic Products
www.skutt.com
Electric kilns

Standard Ceramic Supply Co.
www.standardceramic.com
Clay manufacturer and ceramic supplier

Tucker's Pottery Supplies, Inc.
www.tuckerspottery.com
Ceramic supplier

PERIODICALS

American Ceramics
9 East 45th Street
New York, NY 10017 USA

Ceramics: Art & Perception
35 William Street, Paddington
Sydney, NSW 2021, Australia
www.ceramicart.com.au

Ceramics Monthly
P.O. Box 6102
Westerville, OH 43086-6102 USA
www.ceramicsmonthly.org

Ceramic Review
21 Carnaby Street
London WIV IPH UK
www.ceramicreview.com

Ceramics Technical
35 William Street, Paddington
Sydney, NSW 2021, Australia

Clay Times
P.O. Box 365
15481 Second Street
Waterford, VA 20197 USA
www.claytimes.com

Pottery Making Illustrated
The American Ceramic Society
735 Ceramic Place
Westerville, OH 43018 USA
www.potterymaking.org

Studio Potter
P.O. Box 65
Goffstown, NH 03045 USA

The Log Book
P.O. Box 612 Scariff
Co. Clare, Republic of Ireland
www.thelogbook.net

GLOSSARY

Alumina: Part of the clay molecule and used as the fitter or stabilizer in a glaze formula; highly refractory and controls the viscosity of a glaze. One of the three components of a glaze.

Anagama: A tube-like kiln that is fueled by wood and usually slopes up toward the chimney.

Anthropomorphic: The attribution of human form or characteristics to non-human objects.

Ball mill: A device for finely grinding ceramic pigments or glaze; a ceramic jar containing ceramic balls that rotate on driven rollers.

Batch formula: Glaze ingredients stated in weighable amounts.

Bisque (or biscuit): Unglazed clay that has been fired once at a low temperature to about 1800°F (982°C).

Bisque firing: First firing of clay to remove chemically combined water and carbonaceous materials.

Bone dry: Clay that is completely dry and is no longer plastic; greenware that is ready to be fired.

Blisters: Refers to bubbles in the glaze that are a result of firing that is too fast or cool.

Bloating: Refers to clay bodies when they are over-fired and begin to become misshapen.

Burnishing: The polishing of leather-hard clay with a smooth tool or stone. Also refers to polishing of applied terrasigillata. Typically fired below 2000°F (1093°C) to retain its sheen.

Carbonate: A less intense concentration of a metal colorant (oxide is a stronger form).

Carving: Removing or cutting of clay from the surface of a piece, usually done in the leather-hard state.

Centering: The action of pushing a mound of clay into center while it rotates on the wheel.

China clay (or kaolin): High refractory primary clay that is used in glazes as a fitter to help glaze adhere to the pot. A source of alumina in glazes.

Chuck: A clay cylinder used for trimming a pot on the wheel. They are used to support pots upside-down and centered.

Clay: Finely grained igneous rock which, when pulverized, becomes plastic when wet, leather hard when dry, and upon firing is converted to a permanent rock-like mass.

Clay body: A combination of primary and secondary clays especially combined for certain properties of plasticity, firing temperatures, texture, color, and density.

Coil: Rope-like clay used to build walls of clay.

Colorant: A metal oxide or carbonate used to give color to a glaze. Some colorants can affect the melting point, texture, and translucency of a glaze. They are used in small percentages, alone or in combination with other colorants. Stains are synthetic colorants manufactured for the ceramic industry.

Cones: Represent specific temperatures of pyrometric cones that measure heat work in a kiln.

Crackled glaze: The surface of a glaze that has cracked under the surface tension of the clay; usually caused by disproportionate expansion and contraction between clay body and glaze formula.

Crawling: Glaze that peels away from the clay surface during the firing; can be caused by too thick a layer of glaze, or firing too soon after glazing (the steam pushes the glaze out of its path). Sometimes a raw material in the glaze can cause crawling.

Dampware room (or box): Place to store uncompleted projects; keeps pieces damp and workable.

De-airing: The process of removing air from plastic clay by using a machine such as a pug mill or wedging clay by hand.

De-flocculant: A chemical such as sodium silicate or Epsom salts added to a liquid glaze to help suspend particles.

Dipping: Technique for covering the surface of a piece by quickly submerging it in glaze, slip, or engobe.

Dry foot: The bottom and ¼ inch (2.5 mm) up the sides of a piece kept free from glaze so the piece will not adhere to the kiln shelf when fired.

Earthenware: Low-fired, porous clay that contains organic materials.

Engobe: Colored liquid clay with a little added flux, which is applied to unfired or bisque ware, most often under a transparent glaze.

Epsom salts: Magnesium sulfate used to as a de-flocculant in a glaze. This helps suspend all of the particles in the water.

Eutectic point: The point at which a combination of ceramic materials lowers the melting point of any or all materials.

Extruder: A tool that produces a particular shape by forcing clay through a specially designed opening or die.

Feldspar: A mineral found in granite that is also used in glazes as an alkaline flux.

Fettle: To trim edges and smooth the surface of clay with a fettling knife.

Fire clay: Secondary clay that is highly refractory, that is, it can withstand very high temperatures.

Firing: Heating of clay to a specific temperature in order to chemically change its composition.

Flange: (Also *gallery*) A small shelf on the lip of a pot that allows the lid to rest upon, or the long area of a lid that fits inside a pot.

Flint: Powdered form of silica, which is the glass former in a glaze; one of the three components of a glaze.

Flux: Chemical, or combination of chemicals, used in glaze to help melt silica, also used in clay bodies to promote density. Flux is one of the three basic glaze ingredients.

Foot: Bottom or base of ceramic ware.

Frit: A mixture of previously fired glaze that is quickly cooled, pulverized, and used to improve the glaze, stabilizing toxic ingredients.

Fusion: Ceramic fusion, the melting of different materials into a homogeneous mass.

Glaze: A layer of glass-like coating that is fused onto a ceramic surface by heat.

Glaze batch: A glaze recipe written as the molecular unity formula in parts or weight. The basic recipe from which one can run glaze tests or one multiplies the materials to make a large amount of glaze.

Glaze fire: Firing cycle where glaze melts on to the vessel and the clay reaches maturity.

Glaze fit: The harmony of glaze and ceramic body with regard to thermal expansion and contraction.

Glaze run/viscosity: The amount by which glaze moves under heat and gravity.

Grain size: Particle size. A term used when referring to the fineness or coarseness of materials.

Greenware: Unfired clay objects.

Grog: Aggregate added to clay to make it stronger and reduce shrinkage; usually consists of previously fired, pulverized clay.

Impressing: Pushing an object into plastic clay to leave a print or design for decoration.

Incising: Engraving.

Kiln: A structure made of ceramic insulation materials used to fire ceramic wares.

Kiln furniture: Shelves and posts made of refractory clay.

Kiln wash: Used to coat kiln shelves to protect shelves from unfired glazes that may drip or run.

Kinesthetic cues: The perception or sensing of the motion, weight, or position of the body as muscles, tendons, and joints move. Also called *muscle sense.*

Leather hard: The condition of unfired clay that is firm enough to hold its shape but still soft enough to be worked easily.

Majolica/maiolica: Brightly colored, ornate, tin-glazed earthenware that originated in the Mediterranean region in the thirteenth century.

Matte glaze: Dull or flat (non-glossy) glaze surface.

Maturing range: When a clay body reaches its correct strength and compactness through vitrification, which comes from exposure to high temperature.

Mold: A form made of plaster in which to shape clay, either by pouring clay slip or pressing or draping plastic clay.

Neutral fire: A firing atmosphere that is not totally oxidized or reduced.

Opacity: The depth that light is allowed to penetrate a glaze; a glaze's opacity is inversely proportional to its translucency.

Opacifier: Ceramic raw material such as Zircopax or tin oxide that makes glaze opaque (nontransparent).

Outgassing: The process by which gasses from chemicals and organic materials are released from the clay during firing.

Oxide: Often used as a pure pigment in glaze a pure form of metal.

Oxidation firing: A firing where there is plenty of oxygen present to combine with the firing pots; the opposite of reduction atmosphere.

Peep hole: (Also *spy hole*) A hole in the wall of a kiln used to monitor the firing. Usually covered with a piece of fire brick that can be removed to view the pyrometric cones.

Pinching: A forming technique in which just the hands rhythmically pinch the walls of clay to form a piece.

Plasticity: Qualities of moist clay that allows it to be easily manipulated and still maintain its shape until fired.

Porcelain: White firing clay that is vitreous and translucent when fired to high temperatures.

Potter's wheel: A tool designed to rotate a base on which clay is thrown. Can be electric powered or man powered.

Porosity: The ability of fired clay body to absorb water by capillary action.

Press-mold: Forming pots by pressing plastic clay into molds.

Primary clay: Found at original site of decomposing rock.

Pug mill: A machine with revolving blades for mixing and compressing plastic clay.

Pyrometer: A calibrated instrument that reads the temperature during a firing. It's connected to a thermocouple, a probe inside the kiln.

Pyrometric cones: Pyramid-shaped clay structures calculated to melt at specific temperature. Cones are the most accurate way to gauge the heat absorption/temperature inside a kiln.

Quartz inversion: At around 1100°F (590°C), the silica/quartz in clay change form from alpha crystal to beta crystal and then back to alpha crystal. It is critical that clay fire slowly through this process to prevent damage to work.

Raku: A fast firing technique in which pieces are removed at around 1800°F (980°C) and quickly reduced in combustible materials and cooled. Originated in Japan but was Americanized by Paul Soldner in the 1960s.

Reduction: The action of taking away oxygen from metal oxides. This is achieved by controlling the atmosphere of the kiln during the firing process, resulting in altered coloration of metal oxides. This is the opposite of oxidation firing. In a fuel-fired kiln, the combustion is incomplete resulting in color changes in the ceramic ware.

Refractory: Resistant to high temperature.

Secondary clay: Clay that is not at the original site of decomposing rock and has moved, picking up contaminants.

Shrinkage: Contraction of clay and glaze during the drying and firing process.

Silica: Glass-forming component of clay and glaze. Flint is the powdered form; one of the three components of glaze.

Silicosis: The sealing of lung capillaries by lung tissue, which surround inhaled silica particles.

Sinter: The act of clay particles beginning to fuse and harden during firing to transform the raw clay into bisque ware.

Slake: To break down dry clay or ceramic powders in water.

Slip/slurry: A homogenous mixture of clay and water that is loose and thick, used for joining plastic clays and also for slip casting forms in molds.

Soak: In ceramics, holding temperature in a kiln for a period of time.

Spiral wedging: Kneading clay with a pivotal motion to remove air and create a homogenous mass of clay.

Stains: Commercially made ceramic colorants that can be used in place of, or in combination with, coloring oxides. They provide potters with an expanded color palette.

Stoneware: A hard, strong, and vitrified ware, usually fired above 2100°F (1150°C) between cone 6 and cone 11.

Terra-cotta: Low-fire iron-colored earthenware clay.

Terra sigillata: Low-fired fine clay slip applied to clay, burnished, and low fired to retain a sheen.

Thermal shock: Stress created within a ceramic object by temperature change.

Throwing: The process of making pots on a rotating wheel with the hands, using water for lubrication.

Underglaze: Ceramic colors usually applied to bisque ware and covered with a transparent glaze.

Unity molecular formula: States the specific number of molecules of a given ceramic material in a glaze recipe. This is converted to a glaze batch recipe that lists ingredients in parts by weight.

Vitrification: Furthest stage to which a clay body can be taken without deformation.

Wax resist: A commercial, soluble wax used to dry a piece's foot or decorate a surface so that glaze will not adhere to it.

Wedging: A hand-work process of preparing plastic clay that involves mixing and compressing the clay to remove air.

Witness cones: Pyrometric cones placed inside the kiln and monitored through the peephole in the kiln to gauge heat work in the kiln. Usually there are three cones in a cone plaque: one under the temperature, one at the desired temperature, and one as a guard cone to indicate whether the kiln has over-fired. Witness cones are placed in the top, middle, and bottom to calibrate the temperatures in the kiln and with the pyrometer or kiln sitter. The potter can monitor witness cones to be sure that the automatic shut-off on a kiln is working properly.

INDEX

About the Authors

Kristin Müller is a ceramic artist who has been working in clay since 1987. Her specialty is in wood-fired ceramics, and she maintains a studio with an Anagama hybrid kiln in Dingmans Ferry, Pennsylvania. She uses forming and firing techniques of Japanese origin to make contemporary work based on a traditional aesthetic.

Kristin was born in Panama and raised in Argentina, Chile, and the United States. She enjoys learning, nature, reading, photography, travel, and meeting people of diverse cultures. She loves spending time with her two daughters, working in her peaceful studio in Pennsylvania and cooking delicious meals for her friends and family.

Kristin is the education director for Brookfield Craft Center and schedules more than 400 classes a year in all fine craft disciplines, and she also teaches ceramics in the vintage barn studio.

To view Kristin's artwork, visit her website at www.kristinmuller.net.

Jeff Zamek walked into a studio thirty six years ago and started his career as a potter. After completing a degree in business from Monmouth University in New Jersey he acquired BFA/MFA degrees in ceramics from Alfred University in New York. While at Alfred he developed the soda-firing system at the college and went on to teach at Simon's Rock College and Keane College. In 1980 he started Ceramics Consulting Services in Southampton, Massachusetts, through which he offers technical advice on clays, glazes, kilns, raw materials, ceramic toxicology, and product development for individuals, companies, and the greater industry. His clay body formulas are presently used in the pottery industry.

To view Jeff's artwork, visit his website at www.jeffzamek.com.